COLLECTING **African American** HISTORY

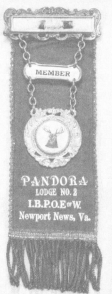
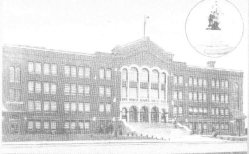
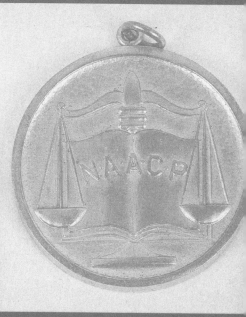

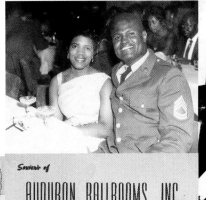

STARS OF THE NEGRO LEAGUES

A SET OF 36 CARDS

COLLECTING Africa n

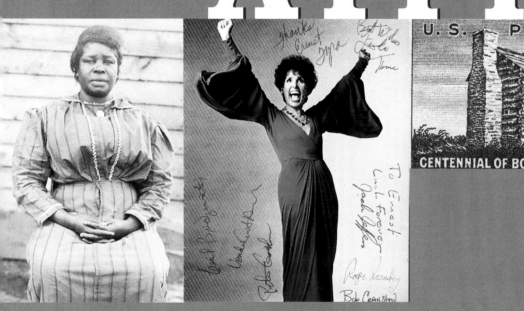

CENTENNIAL OF BOOKER T. WASHINGTON

U.S. POSTAGE 3¢

LANGSTON HU

& MARGA
DAN
WRITERS O
REVOLU

A CELEBRATION OF AMERICA'S BLACK
HERITAGE THROUGH DOCUMENTS,
ARTIFACTS, AND COLLECTIBLES

American

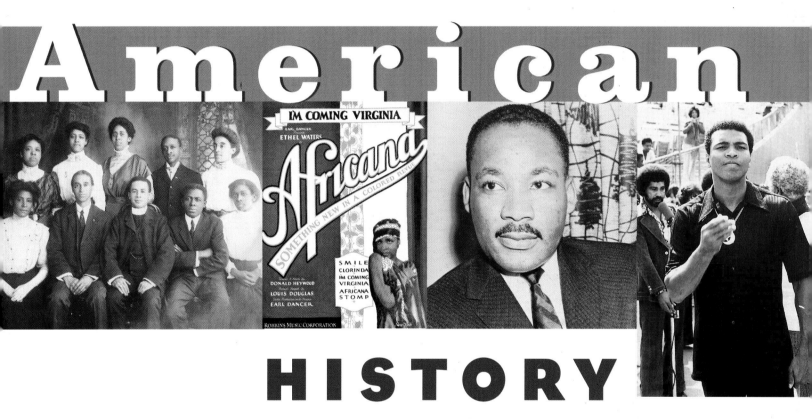

HISTORY

Elvin Montgomery Jr., Ph.D.

Stewart, Tabori & Chang / New York

Published in 2001 by

Stewart, Tabori & Chang

A Company of La Martinière Groupe

115 West 18th Street

New York, NY 10011

Library of Congress Catalog Card Number: 2001095085

ISBN: 1-58479-056-3

Edited by Marisa Bulzone

Designed by Galen Smith and Niloo Tehranchi

Graphic Production by Pamela Schechter

The text of this book was composed in Meridian; the captions are Akzidenz Grotesk and Clarendon.

Printed in Italy by Milanostampa

10 9 8 7 6 5 4 3 2 1

First Printing

This book is dedicated to my parents, Elvin and Rita Weaver Montgomery, who gave me a good upbringing, much love, and a very good education. And also to my grandmother Octavia Thompson and all the rest of my family—her descendents.

Table
of Contents

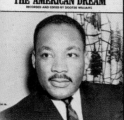

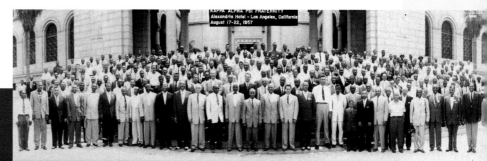

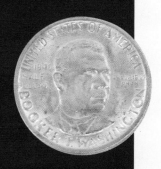

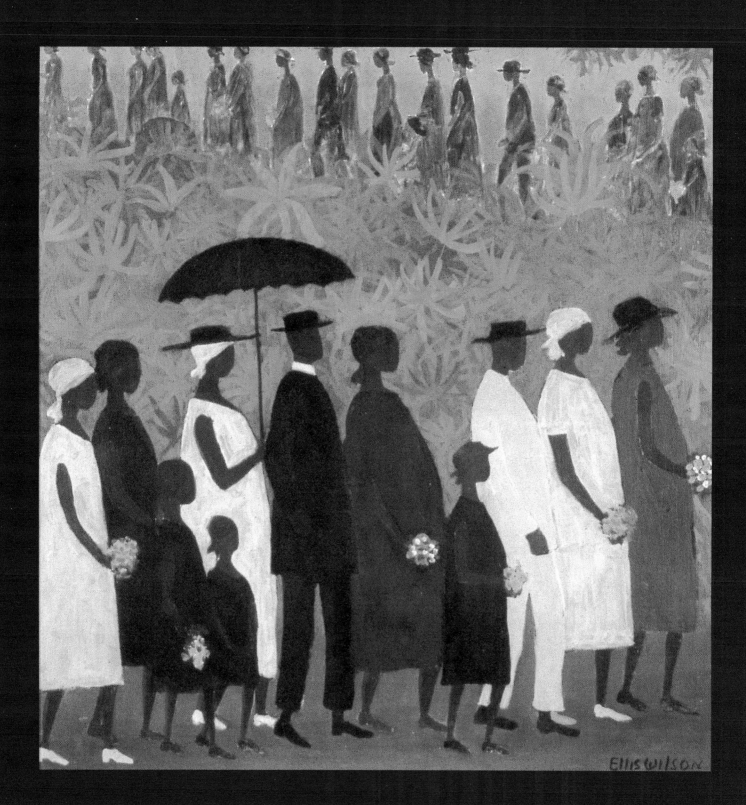

Introduction

Understanding African American Collectibles

OPPOSITE PAGE AND NEXT TWO SPREADS: The emergence of museums and other public collections of African American artifacts has had an enormous impact on the appreciation of these items. Rare is the collector who would find items such as these on the open market today. Opposite: *Funeral Procession* (1940) by Ellis Wilson (1899–1977), courtesy of the Amistad Research Center. Although Wilson was recognized during his lifetime for his paintings of daily African American life in the southern United States and Haiti, this painting became instantly recognizable from a print that hung in the Huxtable living room on TV's *The Cosby Show*. Page 11: The doctoral gown of W.E.B. Du Bois from the University of Ghana, Legon, Ghana, West Africa, today resides at the DuSable Museum of African American History. Pages 12 and 13: Also part of the DuSable collection are materials belonging to famed aviatress Bessie Coleman, such as the vintage portrait and her 1921 pilot's license, issued by the International Aeronautical Federation.

THE AFRICAN AMERICAN PAST AND ALL IT HAS PRODUCED IS now the focus of a collecting explosion. An increasing number of people and organizations want to do more than just hear about African American history, celebrate it, read about it, or argue about it. They want to own it and accumulate it. Learning about history is one thing, but actually seeing and holding it in the form of tangible objects is a higher level of involvement with much greater personal reward.

This book explains the seeking and accumulation of objects associated with African Americans, what they have said, done, produced, and experienced. It does not tell the African American story but is instead a guide to seeking, finding, and understanding the physical evidence of the African American experience in its many interesting forms.

A book such as this has been needed for a very long time. Though much has been written about African American history and culture there is little explanation or guidance about the intricacies of collecting it. While interest and prices have soared, so has the need for information and collecting savvy. Even those who don't collect per se are interested in being knowledgeable about this growing and complex field.

Before proceeding, a few important clarifications about concepts and words are needed. The term "collector" as used here refers to any person, organization, or group that accumulates objects pertaining to African Americans. This includes not just individuals but institutions and corporations seeking to build a collection for public reference or private investment, and not just hobbyists but scholars, researchers, writers, artists, and performers who find such material a critical resource for their work. There are many types of African American, or Black history collectibles and there are a variety of specialties in the field. The term "Black history collectible" describes any object that expresses the experiences or culture of African Americans: books, docu-

ments, posters, autographs, photographs, artworks, tapes, films or artifacts (three-dimensional objects such as records, political buttons, Masonic medals, slave-made quilts and furnishings).

Black history collectibles are different from so-called "Black memorabilia," which usually portrays Blacks in a derogatory manner in accordance with someone else's stereotype. Such "Mammy-bilia" items are more evidence of racist perceptions of Blacks than of the history of African Americans and are unrelated to their culture and experiences.

The use of the word "Black" also requires explanation. What to call persons of African descent who live in the United States has been an issue throughout history. Over time, this has included African, Negro, Colored, Black, and now African American. Ironically, there are people who collect evidence of the evolution of terminology and names for African Americans. Though there are some differences in the implications of the terms African American and Black American, here they are used interchangeably—for several reasons. First and foremost, what to call African Americans is not considered as important here as the collecting, preservation, and use of their experience. In addition, the term Black history has been used for many decades and is now enshrined in key usages associated with African Americans, such as the celebration of Black History Month. Certainly, in the Civil Rights period the term Black was used with pride and assertiveness. Therefore, many people born before the 1990s are perfectly comfortable interchanging the words Black and African American. In common, everyday language many people use both terms, and since "Black collectibles" is the term often encountered in the antiques and collectibles field, we will also use them interchangeably.

Why Collect African American Objects?

The African American story has not been told well or accurately over the years. Most people are only now becoming aware of the true nature and dimensions of the African American experience. Each newly uncovered chapter in that history brings greater interest to a formerly unknowing world that increasingly recognizes its need to know more. People (all types of people, not just persons of African descent) can learn and benefit greatly from this history, just as they have benefited from African American labor and culture over the years.

Being interested in a fascinating group of people is one thing, but devoting time, energy, and money to accumulating objects about them is quite another thing. Why should anyone seek, buy, accumulate, research and display objects pertaining to African Americans? Why can't people simply enjoy the aspects of Black culture they care about or see it on television or in the movies occasionally? After all, many people feel that African American history is outside the mainstream of what they have been taught to think is important. It is also true that African American history raises many unpleasant issues and represents much suffering, which most people would rather avoid. Even some African Americans undervalue their own history when it comes to being personally involved with historical objects. Many African Americans, especially the young, are not exposed to their history enough to want to know more and own it. Others may feel that being African American and celebrating one's own heritage is more than sufficient. Why, they may ask, should they bother collecting what they are already living every day? And some might see the pursuit of upward mobility as incompatible with an involvement with African American history and therefore seek to de-emphasize that heritage in the interests of apparent social or economic success. There are indeed compelling answers to these questions that make collecting and preserving the African American experience imperative, not only for African Americans, but for all thinking citizens of the world.

All history is important because it determines how our world has gotten to be the way it is. People need to understand how they got where they are in order to have any control over their lives and improve their existence. In addition, there is no American history without African American history. African Americans have contributed much that has made America a strong, rich, and powerful nation. Issues pertaining to African Americans are and always have been at the center of this country's history—whether it is the long struggle against slavery resulting in the Civil War, the Civil Rights movement, or the cultural and creative successes of twentieth-century America.

African American history has not yet become adequately known, taught, or appreciated. Ignorance of African American history has caused much pain and suffering for all people. The way we perceive others—as individuals and as groups—determines how we treat them. Even a basic understanding of Black history would do much to improve the fate of African Americans and all Americans.

The African American experience is not just about African Americans. The struggle against slavery and the Civil Rights movement have served as inspiration for many other liberation movements around the world. African Americans have much to teach about surviving extreme and enduring adversity, creating a viable and emotionally powerful culture from the depths of oppression, the blending of cultures, and of course spirituality. By discovering and preserving new or challenging information contained in historical objects, collectors cause previous beliefs to be revised. And although there are many well-known areas of African American history that are popular with collectors right now, other aspects of the past—equally important but not yet publicized—are rapidly being lost. Collecting rescues objects that would otherwise be forgotten.

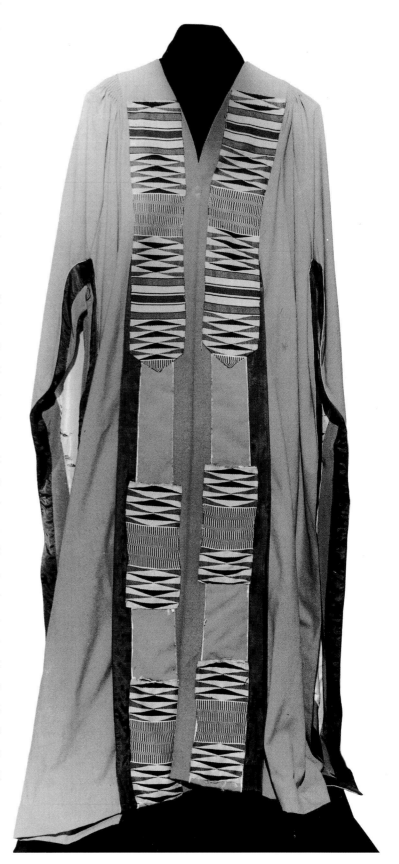

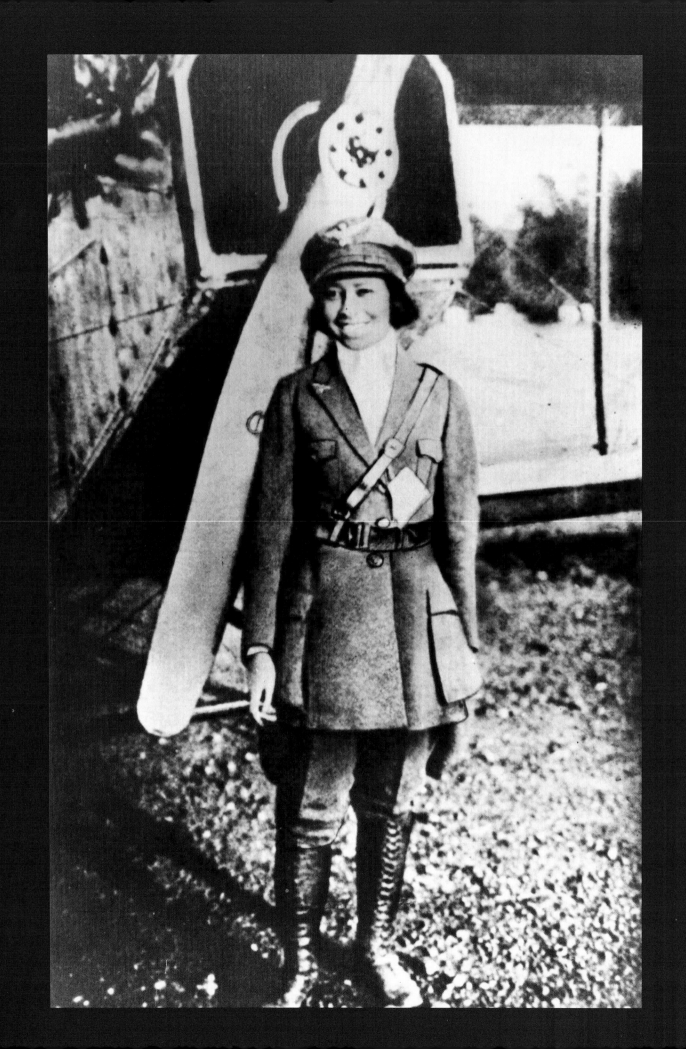

The Focus of This Book

Not every topic in African American history collecting can be discussed in single publication and this book is more oriented toward appreciating and collecting certain types of items than others. Though there are many types of Black collectibles, the focus here will be on objects that, above all, contain information and pertain to actual events, issues, and people who really existed. We have also focused on material through which African Americans express their own perspective. African American history has often been written by others. Although outstanding celebrities are certainly given their due on these pages, we hope to point out that items reflecting the African American community in general are just as deserving of accumulation and study. Finally, this book is not merely a catalog of museum and library holdings or items well beyond the reach of the typical collector. Modern collectors need guidance on what they can still acquire and use. The goal here is for people at all income levels to be able to collect and enjoy African American history. Therefore, a special effort has been made to discuss items that are still relatively accessible and affordable. The African American story is a fascinating one and any item that helps to tell it has value.

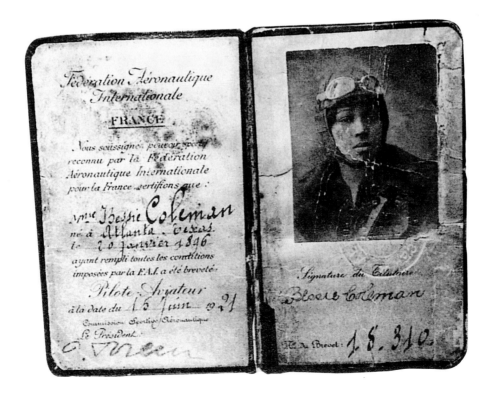

AIN'T MISBEHAVIN'
(I'M SAVIN' MY LOVE FOR YOU)

Harry N. Nickerson, Jr.

Doris I. Gardner

CONNIE'S
HOT
CHOCOLATES

Lyrics by
ANDY RAZAF

Music by
THOMAS WALLER
and
HARRY BROOKS

Staged by
LEONARD HARPER

AIN'T MISBEHAVIN'
OFF TIME
RHYTHM MAN
DIXIE CINDERELLA
GODDESS OF RAIN
THAT SNAKE HIP DANCE
SWEET SAVANNAH SUE
THAT JUNGLE JAMBOREE
WALTZ DIVINE
CAN'T WE GET TOGETHER?

MILLS MUSIC
INC
Music Publishers

CHAPTER ONE
The Current
State of African American Collecting

OPPOSITE PAGE AND NEXT TWO SPREADS: Collectors of today will find a host of items that satisfy many areas of interest. For example, this vintage sheet music of a very popular song would please any music or Fats Waller fan—but its great graphic style makes it a worthy addition to any visually oriented collection. Page 17: Collectibles need not be large or space-consuming. This vintage postcard is a small reminder of a larger issue: segregation in America. Page 19: Muhammad Ali is one of the most famous African Americans in the world, and enthusiasts will rush to add anything associated with him to their collections. But even those with modest budgets can find material that they're able to afford. Special and commemorative publications like this one are still available in reasonable condition at good prices.

TO UNDERSTAND THE COLLECTING OF AFRICAN AMERICAN history now, and try to anticipate where it is going in the future, a full appreciation of the field is necessary. Many new fans and participants have created a large, diverse, and growing market. The sellers and buyers of Black history items today are not only who they used to be and not only whom one might think. Traditionally, Black history objects were of interest mainly to a few culturally conscious Blacks, scholars, and cultural or sociopolitical leaders. But things have changed.

Today, many people are interested in Black history collecting: committed collectors, cultural professionals (curators, dealers, and gallery personnel), educators, young and old, Black and non-Black, cultural and community activists. In addition to serious collectors, there are occasional collectors (sports fans and music buffs, for example), researchers who have a point to prove about African Americans, and filmmakers, writers, and other creative people seeking historical background and creative inspiration for their work. Surprisingly (from the point of view of the past), investors are an increasing presence among collectors. Those who know that certain types of Black history objects are rising in value see them as worth including in their speculative investment portfolios. The market for Black history collectibles today is as broad as the range of items that are available to collect.

From both the collecting and investment point of view, a number of interesting trends and notable developments can now be seen. Foremost of these is that, in one form or another, African American history collecting is growing, diversifying, and increasing in public awareness and acceptance. In addition, collectors are constantly seeking out and rediscovering lost or ignored chapters in Black history.

Because of this, prices are rising and a now-common complaint is heard that Black history collectibles cost so much that desirable items are beyond the reach of many interested in owning them. This is a reality faced by old and new collectors alike. The fact is, many people are trying to cash in on rising interest and rising prices by investing and speculating in Black history objects.

The commercial use of African American historical items also has increased tremendously. Advertisers, publishers, software developers, filmmakers, designers, and others connected with sports and entertainment have all become interested in Black history and seek to profit from its popularity. Commercial consumers of Black history, music, images, and objects find that they provide fresh, arresting and absorbing experiences with considerable commercial usefulness.

More people are becoming interested in their own Black history instead of history as it relates to nationally known personalities, issues, and events The rise of widespread interest in local events, genealogy, and occupations among African Americans is part of this trend. Collectors now are seeking items more closely related to them in content, time frame, geography or personal significance.

Many collectors now focus on visual objects suitable for display. Photography, always a very important collectible area, is now all the rage and cuts across numerous specialty topics.

The upper echelon of the collecting field has become more specialized and sophisticated. Rather than collect material generally related to any area of Black history, collections are more focused in a particular subject area (a specific sport or segment of the entertainment industry, for example). Experienced collectors have seen—and may already own—that which is commonly available and are looking for a greater degree of scarcity.

Some bursting of the so-called "Black Memorabilia" bubble is becoming evident. Many people started off collecting memorabilia but have moved into historical items as they become more sophisticated about the issues. Rising prices for Black Memorabilia have seriously moderated as early collectors—jaded by objects that all have a similar racist message and reproductions flooding the market—sell off their collections in an attempt to cash in before it is too late.

At the same time, many major Black history and culture collections of books, documents, art, and artifacts (some forgotten for many years) have been "rediscovered," changed hands, or become the subject of renewed scrutiny or controversy. While a growing number of institutions are being founded to collect, preserve, and promote Black history and culture, this has sometimes resulted in an outflow of valuable historical items from the Black community to those who can afford to acquire them.

New Collecting Specialties and Themes

Black history is a living, growing field that will continue to evolve. In addition to the established areas of Black history, newer, cutting-edge topics emerge, bubbling up "from below" and then cross the radar of the historical and collecting establishment. New interests, themes, perspectives and insights arise and exert an influence on collectors, scholars, dealers and the public at large. Thus, perceptions change about what should be known, collected, and considered important or valuable to own.

Traditional aspects of Black history that will always be important include slavery, music and entertainment, and sports. Other areas have become well established within the past thirty years—Black military history and art, for example. Change, though, comes from new collectors entering the field, or veteran collectors developing new interests. This brings new energy, the pursuit of new specialties, and the exploration of new themes.

New specialty areas are the entry points for new collectors, "hip" collectors who like "offbeat" items, those of ordinary or limited means, and people who have a special reason to be interested. Many people want to know where and how they can get involved in emerging specialties before prices get too high, availability gets too low, and their avant-garde chic gets too common. It should be noted that emerging areas are highly speculative and risky from an investment point of view and no one making purchases in these areas should expect a

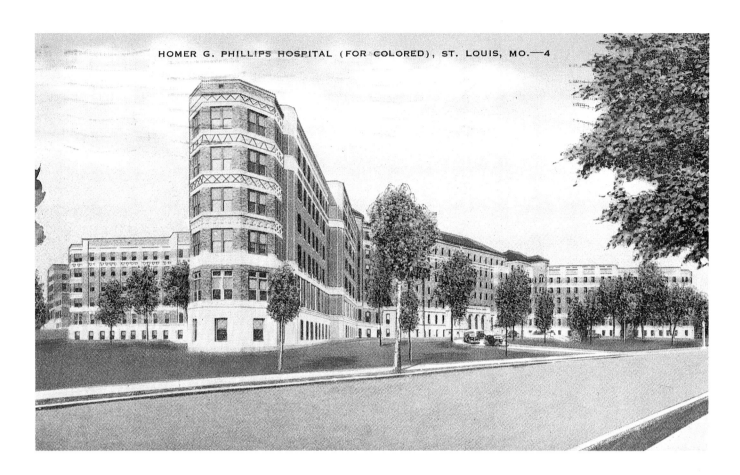

HOMER G. PHILLIPS HOSPITAL (FOR COLORED), ST. LOUIS, MO.—4

guaranteed or quick return on their investment. Still, interesting vintage material in good condition in a number of emerging areas is beginning to become collectible or may become even more so.

Blacks and Work. Information and objects about Black occupational history is gaining attention. Interest is not just in professional, organized, and well-known occupations, such as doctors, teachers, and sleeping car porters, but also in "humble" work. The lives and occupations of domestic service workers—maids, butlers, chauffeurs—are important to document because many if not most Blacks did such work in the past.

Local History and Genealogy. Blacks are increasingly interested in their family histories. The popularity of the book *Roots* inspired many family reunions, research on slave ancestors, and reignited interest in long forgotten ancestral lands in the South. Similarly, there is increased interest in material about Blacks in specific places. There

are now several dozen Black history museums and historical societies in the nation, most of which focus on Black history in the areas where they are located. Thus the market for old books, documents, photographs and artifacts on specific Black families in specific places, and information about Black living conditions in these places at specific times is growing rapidly.

The Civil Rights Era. The Civil Rights struggle of the 1960s and 70s was the most important event in twentieth-century Black history. Though recent by traditional antiques standards, the Civil Rights era is definitely collectible. Original, interesting artifacts pertaining to civil rights and associated topics (Black Is Beautiful and Black Power) are eagerly sought after.

Lesser-Known Artists of the Civil Rights Era. Black artists of the 1960s and 70s who never achieved great fame are now being heavily collected by savvy, future-oriented art fans. Trend-setting collectors often seek period character-

istics in such art: militant or protest subject matter, or indicators of Black pride like African facial features and large, impressive Afro hairdos. In effect, what is really being collected is art that reflects the change in consciousness that occurred in Blacks at that time. Since most people cannot afford the astronomical prices of the works of established Black artists, relatively undiscovered Black artists whose work reflects their era are attractive. In fact, the artist's obscurity is sometimes the primary attraction. For many people, the Civil Rights era was their own formative generation and they seek artistic evidence of its powerful emotional impact.

Black Organizations. An increasing number of people and institutions collect material pertaining to Black organizations: fraternities, sororities, Masonic organizations, unions, social clubs, and political and civic groups. Although many of these organizations no longer exist or do not exert the influence they had in the past, they still have great historic significance and are of interest to collectors, researchers, and scholars.

Blacks in Film. This is one of the fastest growing emerging fields, so widespread that it is now practically an established collectible specialty with many adherents. People collect all kinds of movie memorabilia: lobby cards, posters, autographs, souvenir booklets, videotapes, and so on. Some like the vintage films of the 1930s and 40s while others like the "Blaxploitation" movies of the 1970s. Notably, a few of the 1970s Black-oriented movies are being remade, a revival which will add more interest and followers to the ranks of Black movie collectors.

Black Colleges and Schools. Historically Black colleges have been and continue to be the cradles of the Black middle and professional classes. Not surprisingly, people are beginning to collect memorabilia related to Black colleges, and not just the ones they went to. Black college collecting is a burgeoning area that will only grow stronger since every city in America has Black college

alumni. Even non-alumni are interested in the subject since these schools have had a major historical role in sports, civil rights, literature, and art. Black college collectors accumulate everything from graduation programs and souvenir booklets to football jerseys.

Cultural Issues Within the Black Community. Items related to such topics as Black hair, skin color, and miscegenation were once considered too ordinary or sensitive to be collected. This is no longer the case.

Black Religion, Spirituality, and Mysticism. Religion touches almost every aspect of Black culture, from music to political struggles. Whether traditional southern Protestantism, slave religion, occult subjects (such as voodoo), or Islam, the subject of Blacks and religion is on many collector's minds.

Blacks and Food. Blacks have been associated with food and food service for most of their history in this country. Some of the earliest books by African Americans were about food and some of their earliest businesses were catering establishments. Collectors have turned their love of "soul food" and traditional cooking into a collectible interest in old Black recipes, cookbooks, and memorabilia about food-related businesses and events.

Blacks and Native Americans. There are many strong connection between Blacks and Native Americans, not the least of which is that many African Americans have Native American blood though they often do not know what kind or how much. These factors, along with the fact that Native Americans were also the victims of racism and exploitation have created much interest among Black history collectors.

Recreation and Social Life. Black culture contains much joy and emotional transcendence over oppression. Ironically, Blacks have always been able to make others feel good, even when they themselves feel bad. Thus, items reflecting good feelings or good fellowship among Blacks are hot collectibles.

$2.95

FDC 63473

Ali...Ali...Ali

A Special Publication Covering The Entire Career Of The World's Boxing King

From His First Conquest To His Last Hurrah

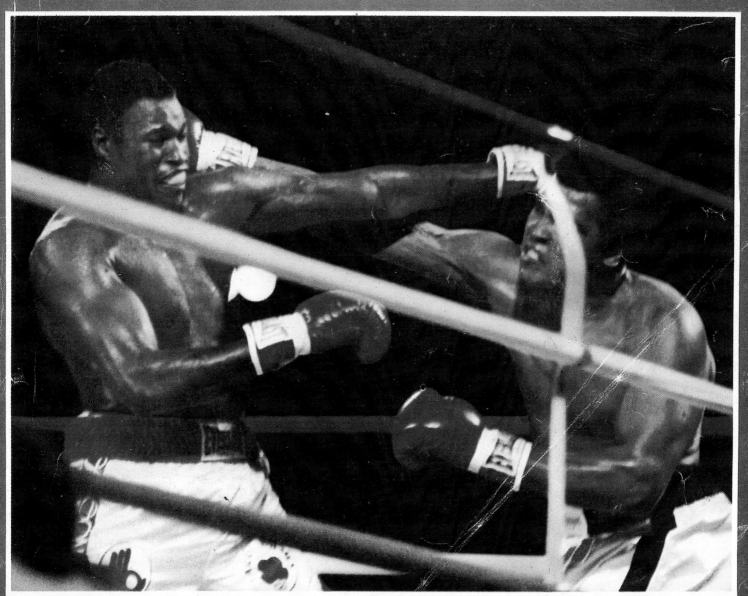

- The Molding Of A Star • The Look Of Title Timber •
- The Reaching Of Titledom • An Exiled Champion •
- In Quest Of His Throne • Growing Up With Ali •
- The Second Wearing Of The Crown • Another Moment Of Glory •
- Hints Of A Sliding Champion • In Controversy • Disability Of Age •
- A Heavyweight Miracle • Retirement •
- Stats Of A Boxing Wizard • Complete Ring Record •
- Special Color Poster Centerfold •

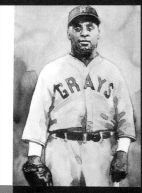

OSCAR CHARLESTON

SAMMY T. HUGHES

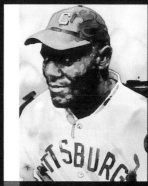

JUD WILSON

LOUIS SANTOP

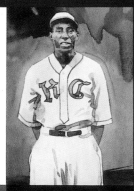

JOSE MENDEZ

BRUCE PETWAY

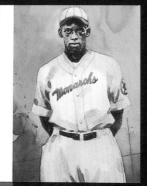

NEWT ALLEN

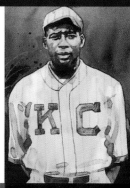

BULLET ROGAN

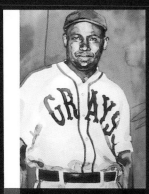

BUCK LEONARD

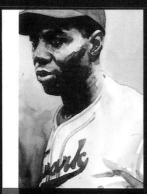

DICK LUNDY

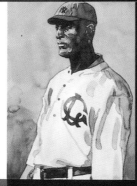

SMOKEY JOE WILLIAMS

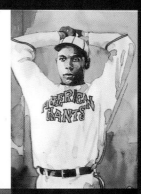

WILLIE FOSTER

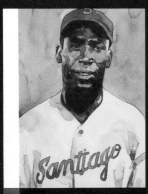

MARTIN DIHIGO

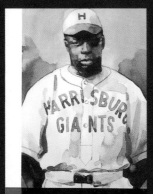

JOHN BECKWITH

MULE SUTTLES

SATCHEL PAIGE

CHAPTER TWO
Advice
to the Collector

OPPOSITE AND NEXT TWO SPREADS: Although all antiques and collectibles are judged by certain criteria of authenticity and condition, some items will be of interest to collectors of African American history for the information they contain or the period of time they represent. For example, this set of baseball cards depicting players from the Negro League teams is not authentic to the era when these men played the game—no such cards existed at that time. But this commemorative set would still be of interest to a sports collector. Page 22: Few magazines (especially those of general interest) are found in pristine condition. Yet, despite some condition problems, this 1948 issue of *Our World* would provide an of-the-period perspective to a collector interested in politics. Page 25: Collectors of high-school and college annuals often seek out those books that might feature a celebrated figure at an early age, but this record of a nursing school graduating class exhibits the early contributions of African American women to the profession and would be valued by collectors of many different specialty areas.

THE CURRENT TIDAL WAVE OF INTEREST IN BLACK HISTORY and collectibles is having radical repercussions in the marketplace. This field has expanded so rapidly in the past decade that there is no single standard for determining desirable collectibles. A worthwhile African American historical collectible is whatever you feel is important enough to accumulate. Nonetheless, when buying a collectible as an investment, it is important to bear in mind the reason you are collecting.

Whether your collection pertains to a specific historical period, an activity, key events, or nostalgic objects, recognize that authentic historic collectibles must pertain to events, people, or issues that have actually occurred.

Of course, there is no magic formula to successful collecting in any genre. We all learn from trial and error. Learn from collectors with experience in antiques and in buying and selling Black history collectibles; their trial and errors will help you build a meaningful collection from the start.

The term "collector" probably conjures up an image of someone with disposable income and a certain level of education, awareness, and taste that is more upscale than your average folk. Perhaps this is why many people resist calling themselves collectors. Despite these connotations, collecting is one of America's passions. Nowadays, thanks to the Internet, flea markets, and garage sales, you can track down affordable and authentic items that document the African American experience.

Ten Types of Collectors

Just as there are numerous types of Black history collectibles, there are various types of collectors. Knowing about them can help you understand most buying patterns:

1. **The "non-collecting" collector:** This person is put off by the term "collector" yet enjoys hunting for historical objects in flea markets, antique shops, bookstores, and garage sales. This collector is motivated by the social aspects of collecting in addition to the thrill of finding a bargain.

OUR WORLD

A PICTURE MAGAZINE FOR THE WHOLE FAMILY

JULY 1948

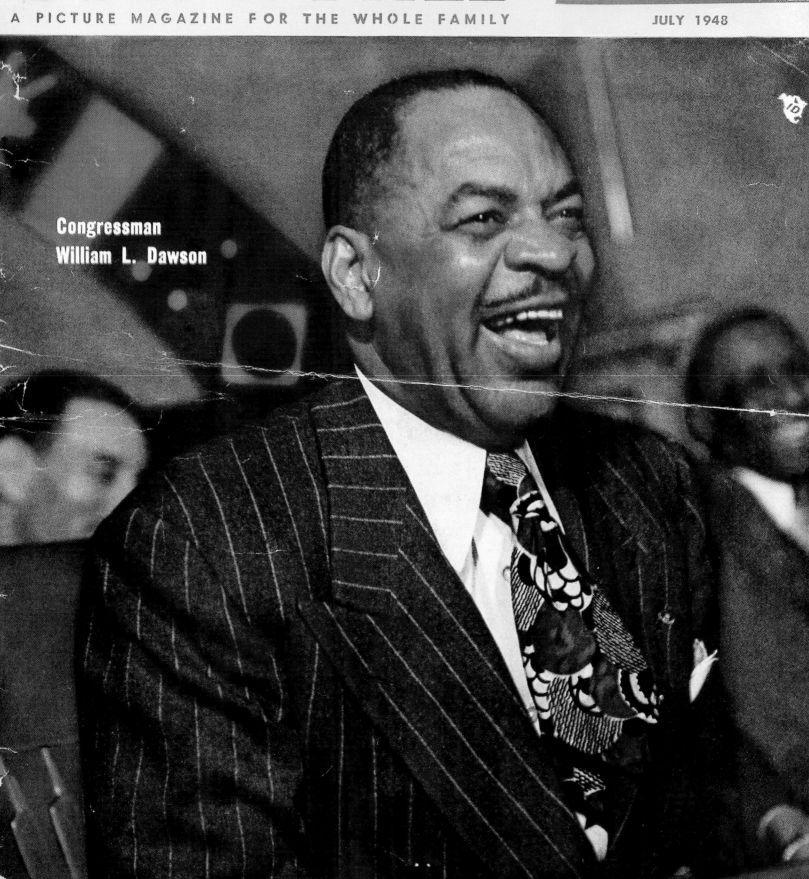

Congressman
William L. Dawson

2. **The serious collector:** The serious collector has a systematic approach in accumulating certain types of items. They are attracted to unusual items and seeks artifacts that fill the gaps of an existing collection. Often the casual collector becomes serious when one item hits home emotionally.

3. **The "single purpose" collector:** These enthusiasts often get drawn into collecting after conducting historic research for a specific project. Curators, book and film researchers, designers, decorators, teachers, and exhibition planners often fall into this category. An individual may become a single purpose collector after locating objects for an exhibition, lecture, or family reunion. Or they might have to research a property that was recently inherited. Many long-term collectors discover a passion for specialty collectibles this way.

4. **The rare item collector:** This highly driven serious collector seeks elite or rare items, the finest or most exceptional objects within a specialty. A subcategory of rarity collecting is seeking out high quality objects pertaining to an unusual, emotionally charged aspect of history, such as photographs of lynchings, torture equipment, or funeral items.

5. **The fashionable collector:** The fashionable collector looks for whatever is most popular at the moment. They enjoy feeling like a part of a movement or trend.

6. **The contrarian collector:** At the other end of the collecting spectrum, contrarian collectors seek items that others don't. A contrarian collector often proves to be a savvy investor, willing to take a risk, often buying objects that become fashionable and/or more valuable later on.

7. **The celebrity and historic event collector:** Many African American history collectors focus on individual celebrities or great moments in history.

8. **The aesthetic collector:** Directed from within by a strong sense of beauty, the aesthetics collector chooses art and artifacts that preserve the look and feel of the past. Their strategies are visual.

9. **The utility collector:** In contrast to the aesthetics collector, the utility collector seeks practical things that can be used in everyday life: clothes, books, tools, furniture, and prints. Things that have an economic, practical, or decorative purpose will be attractive to the utility collector who believes in creating a collection of useful assets.

10. **The investor:** A collector who buys art or artifacts with the intention of selling them for a profit is an investor. While he may start collecting as a hobby, his main concern is buying low and selling high. Professional dealers often start out as investors in an area of specialty collectibles.

Five Steps to Unexpected Finds

The thrill of collecting sometimes comes from finding a treasure in an unexpected place. Whether you collect coins, stamps, paintings, or postcards, you will get a rush from finding something meaningful to add to your collection at a flea market, garage sale, or the Internet. Here are five tips to making surprising discoveries:

1. **Look in unfamiliar places.** Good Black history items can lurk in any number of places, including those not specifically labeled African American. Rummage through used bookstores, music stores, or vintage clothing stores. Search through a stack of sheet music or a carton of vintage glassware, and you may be surprised by what you find.

2. **Invest in reference books.** Reference books on important historical events and people are critical to building your skills for identifying collectible material and knowing what you have.

3. **Cultivate good sources.** Good sources are key to building a quality collection. When you find good sources, treat them well and help them learn to recognize the items and price range that will keep you doing business with them for a long time.

4. **Keep track of emerging trends.** By reading, visiting galleries, networking with other collectors, and keeping your eye on this dynamic and changing field you will be able to spot a trend and begin collecting it before prices go up. This is especially important if you plan to collect African American history for investment purposes.

5. **Look for key themes in different forms.** It cannot be repeated often enough that the Black experience has been recorded and can be collected in many forms—all of which usually relates to basic, underlying historical themes. Though the written word is most frequently encountered, Black history and its major themes are also reflected in art, coins, games, recordings, stamps, toys, wearables (for example, T-shirts and jewelry), and many other forms. Thus, there's a Black history object and a thematic message for every age, taste, circumstance, and lifestyle. No matter what collectors have already acquired, there are always other items that document important Black history themes that they can still collect.

Authenticating a Collectible

Depending on why you are collecting and the prices you pay, authenticity can be important. If you are seeking and paying for old, rare or original items, ask for written guarantees of authenticity.

Caring for Your Collection

It goes without saying that anyone who collects African Americana does so out of respect for Black history. Concomitant with this respect is a responsibility to care for historic objects so they can help future generations interpret the African American experience. When preparing a space to house a new or existing collection, it is essential that each object be housed so its condition, appearance, and informational quality remain intact.

Here are some general guidelines for maintaining your collection:

1. **Protect every collectible's physical condition and appearance.** Refrain from storing objects in containers or environments that will change their appearance or composition. Avoid wet, hot, or chemically active environments since they can cause rusting, decomposition, deterioration, mold, and discoloration.

2. **Never repaint or recolor an antique or historic collectible.** Doing so destroys its historic and resale value. Even if an object is damaged, leaving it alone is preferable to retouching it. If it is in such poor condition that it needs repair, take it to a professional restorer.

3. **Identify each object accurately.** Index each object with the name, date, and historic context associated with each item. For example, photographs should be kept in scrapbooks that identify the subjects in the images. If you have knowledge about an object through an oral tradition, prepare a written version and store it with that object. Be sure to include the source of the oral wisdom and the date and place it was transmitted to you.

4. **Keep all paper documents and objects flat, dry, and dark.** Many historic collectibles are made of paper. Regardless of whether they are books, documents, photographs, posters, or flyers, it is imperative that they be kept flat and dry, away from direct light, and in a chemical-free environment. Creasing or bending shortens the life of old paper and destroys the informational value of the object. Moisture can lead to mold, fungus, discoloration, and stains. Bright light can cause paper to fade and discolor.

Modern packaging and ink emit subtle chemical vapors that eventually weaken old paper and cause it to disintegrate. Store old paper in acid free containers.

5. **Keep textiles flat, dry, and unstressed.** Hanging by a decorative, thin, or weak section of cloth will cause it to rip or tear.

6. **Avoid permanent mounting materials.** Glue, tape, paste, and other permanent adhesives are enemies of historic preservation. The chemicals in these adhesives will damage a collectible's color, strength, and composition. Likewise, avoid the use of nails, screws, or metal handles.

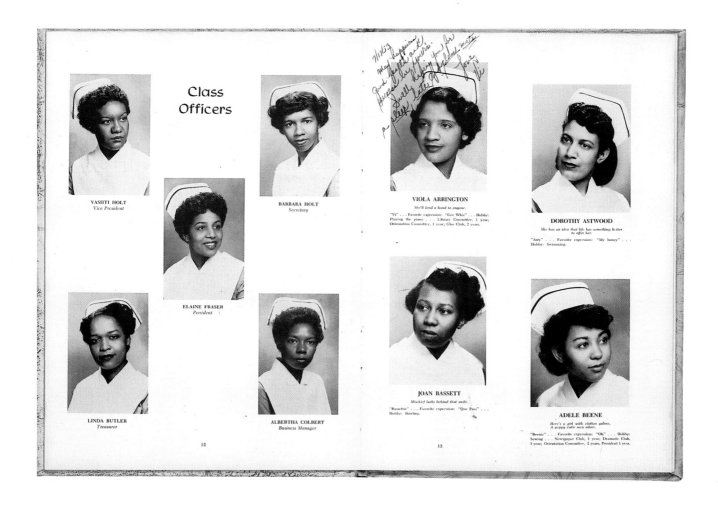

Timeline
of African American History

IT IS SIMPLY IMPOSSIBLE TO DESCRIBE African American history in just a few pages. But without a general chronological sense of major historic developments, it is equally impossible to begin collecting in a purposeful way.

Public Sale of Negroes,

By RICHARD CLAGETT.

On Tuesday, March 5th, 1833 at 1:00 P. M. the foll[owing] [sl]aves will be sold at Potters Mart, in Charleston, S. C. [...] Miscellaneous Lots of Negroes, mostly house servants [o]r field work.

Conditions: ½ cash, balance by bond, bearing interest fro[m] [...] sale. Payable in one to two years to be secured by a mortgage [...] [n]egroes, and appraised personal security. Auctioneer will p[...] [th]e papers.

A valuable Negro woman, accustomed to all kinds of house work. [...] [pl]ain cook, and excellent dairy maid, washes and irons. She has four child[ren...] [a] girl about 13 years of age, another 7, a boy about 5, and an infant 11 mo[nths...] [One] of the children will be sold with mother, the others separately, if it best [...] [pu]rchaser.

A very valuable Blacksmith, wife and daughters; the Smith is in th[e prime of] life, and a perfect master at his trade. His wife about 27 years old [and their da]ughters 12 and 10 years old have been brought up as house servants, and [ar]e very valuable. Also for sale 2 likely young negro wenches, one of wh[om...] [th]e other 13, both of whom have been taught and accustomed to the duties [of house se]rvants. The 16 year old wench has one eye.

1514

Padre de Las Casas, a Spanish priest, suggests that Africans be used as slaves instead of Native Americans because they are more plentiful and a hardier breed.

circa 1500

Native Americans are captured and forced into slavery by European colonists. They die from trauma and European diseases from which they have no natural immunity. A large percentage of the New World's indigenous population is dead within a few years.

1518

First cargo of African slaves arrives in the West Indies.

1526–1527

Black slaves are transported to South Carolina by a Spanish explorer. They later escape and join a tribe of Native Americans in the Midwest.

SLAVERY ERA

1400s–1863

During the four centuries of the slavery era, an estimated 15 million Africans were captured and shipped to the New World where they were sold into slavery. Although the majority of slaves went to plantations in the Caribbean and South America, and only four to seven percent ended up in the colonies that became the United States, the descendants of this small minority of the slave population later had a huge impact on world events.

1400s

European traders plunder the west coast of Africa for slaves. The Portuguese, Dutch, French, and British become active players in the theft and sale of African human beings for profit.

1442

A Portuguese sea captain, sailing under King Henry the Navigator, captures several Moors of noble birth. The Moors offer to pay for their freedom with ten Africans. The Portuguese accept and then sell the Africans in a Lisbon marketplace.

1492

Pedro Alonso Negro, a Black seaman, sails with Christopher Columbus to discover America.

1527

Estevanico, a Spanish-speaking African who was reportedly shipwrecked, joins a Spanish exploration team to the southwest territories that are now New Mexico and Arizona. A natural linguist, he is able to learn Native American dialects and serve as interpreter and guide to the Spaniards. (Historic records indicate that Blacks also accompanied explorers Balboa, Pizarro, Cortes, and DeSoto.)

circa 1600

Anthony Johnson, the first known English-speaking African, is listed in the records of Jamestown, Virginia, as a free man. During the next two centuries, an estimated 10 percent of Blacks will live in relative freedom; although they are not slaves, they are still considered inferior to Whites and subjected to indignities and persecution.

1619

A Dutch ship "sold us twenty negars," John Rolfe of Jamestown writes in his journal.

1628

First Black slave is sold to a Canadian settler in Quebec.

1688

In Pennsylvania, Quakers speak out against slavery, calling it morally wrong.

1700–1750

Thousands of slaves are shipped to the American colonies each year. Slaves outnumber White settlers in the South, 2:1. In the North, slaves make up a much smaller percentage of the population. Over time, slave labor becomes less profitable in Northern factories and small farms.

1710

The total slave population in British North America stands at 44,866; 36,563 of these slaves reside in the Southern colonies.

1712

Slaves stage a small uprising in New York City.

1716

The first Black slaves are imported to French Louisiana.

1730

The North American slave population swells to 91,021, with the Southern slave population more than doubling to 73,698.

1770

Runaway slave Crispus Attucks is the first of five American patriots killed in the Boston Massacre of March 5, making him the first person to die in the conflict leading to the American Revolution.

"An Elegiac Poem, on the Death of the Celebrated Divine…George Whitefield" written by Phillis Wheatley, a slave in a Boston household, is published.

1775

Peter Salem and Salem Poor, both African American soldiers, fight in the Battle of Bunker Hill. Throughout the Revolutionary War, the British fan the flames of unrest among the Black slave population by offering freedom to any slave who will join the British Army. Thousands of slaves run away and defect to the Redcoats.

1775–1783

Approximately 5,000 Blacks serve in Washington's Army in the Revolutionary War.

1776

The population of African American slaves in the United States stands at 700,000 out of a total population of 2.5 million.

1778

Benjamin Franklin, Noah Webster, and John Jay speak out against slavery. Virginia becomes the first state prohibiting the import of slaves.

1780

Pennsylvania abolishes slavery.

1783

Massachusetts abolishes slavery.

1784

Rhode Island abolishes slavery.

1787

U.S. Constitution is drafted, including a section prohibiting Congress from outlawing the importing of slaves until 1808.

Richard Allen withdraws from St. George's Methodist Episcopal Church in Philadelphia and establishes a new congregation in an old blacksmith's shop. It is the first Black church in the United States.

1790

Census count puts African American slave population at 698,000.

1792–1806

Former slave-turned-mathematician Benjamin Banneker of Maryland publishes almanacs, which are praised by Thomas Jefferson.

1793

Cotton gin invented. The cotton gin makes picking cotton much quicker and cost-effective; as the demand for Southern-grown cotton rises, slavery becomes an institution of the South.

U.S. Congress passes the first Fugitive Slave Act, making it illegal to help a runaway slave. North of the border, the Canadian Parliament passes a law that prohibits the import of slaves and promises the emancipation of every child born to a slave mother when the child reaches the age of 25.

1799

New York State begins the eventual abolition of slavery.

1800

Gabriel Prosser plans the first major slave uprising in Richmond, Virginia. Violent rainstorms wash out local roads and bridges, preventing the revolt but increasing fear among the White population of the South.

1804

Slaves revolt in Haiti, winning independence from France.

1808

Congress passes legislation outlawing the import of slaves but the new law is not enforced and the price of slaves doubles.

1810

In defiance of the Fugitive Slave Acts, Quakers and other antislavery groups establish the Underground Railroad to help slaves escape from the South to the free states in the North.

1812

Louisiana gains statehood, and its sugar plantations create additional demand for slave labor.

1816

American Colonization Society looks for land outside the United States (in Africa) where all free African Americans can be exiled. This territory eventually becomes Liberia.

1820

The Missouri Compromise grants Missouri statehood as a slave state while Maine enters the Union as a free state. Slavery is outlawed in all new Northern Plains states.

THE BUFFALO SOLDIERS

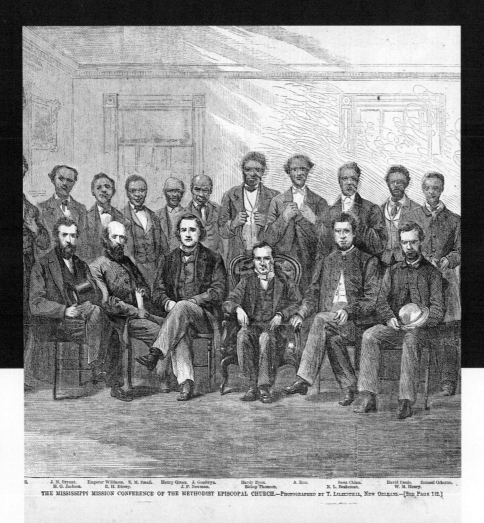

J. M. Bryant. Emperor Williams. S. M. Small. Henry Green. J. Goodwyn. Hardy Ryan. A. Ross. Scott Chinn. David Ennis. Samuel Osborne.
H. G. Jackson. R. H. Dinsey. J. P. Newman. Bishop Thomson. N. L. Brakeman. W. M. Henry.

THE MISSISSIPPI MISSION CONFERENCE OF THE METHODIST EPISCOPAL CHURCH.—Photographed by T. Lilienthal, New Orleans.—[See Page 112.]

1826

Sojourner Truth, an African-born slave, runs away from her Dutch owner in upstate New York. Freed under state law in 1827, she becomes an outspoken activist for the abolition and women's rights movements.

1827

Freedom's Journal, the first newspaper written, edited, and published by African Americans is founded by Samuel Cornish and John Russwurm.

1831

William Lloyd Garrison becomes chief spokesman for the movement to abolish slavery. He begins publication of the *Liberator* newspaper. New England Anti-Slavery Society formed.

Slave Nat Turner leads a revolt of seventy-five slaves in Southampton County, Virginia. Fifty-seven Whites are killed in the revolt before Turner is captured and hanged.

1833

American Anti-Slavery Society established in Philadelphia.

1837–1838

The British abolish slavery in the West Indies.

1840

African American population estimated at 2.87 million, almost 17 percent of the total U.S. population.

1847

Fugitive slave Frederick Douglass publishes *North Star,* an abolitionist newspaper.

1849

Harriet Tubman escapes from slavery and helps other African Americans escape via the Underground Railroad.

1850

Congress enacts the second Fugitive Slave Act. African American population is estimated at 3.6 million, representing 15.7 percent of the total U.S. population of 23.2 million Americans. About 88 percent of the African American population live in slavery.

1857

U.S. Supreme Court hands down the Dred Scott decision, which declares African Americans are not U.S. citizens.

1859

Activist John Brown and eighteen followers raid the Federal Arsenal at Harper's Ferry, Virginia (now West Virginia). Instead of capturing weapons and leading a slave revolt, Brown himself is captured, charged with treason and hanged. Abolitionists praise him as a martyr. The folk ballad "John Brown's Body" eulogizes him and later becomes the melody for the "Battle Hymn of the Republic."

1860

African American population reaches 4,441,830; nearly 4 million are slaves.

THE CIVIL WAR AND EMANCIPATION

1861

Southern states secede from the Union. Pro-slavery Confederate forces attack Fort Sumter in Charleston, South Carolina, on April 12. Approximately 186,000 African Americans join the Union Army during the Civil War—almost half of the soldiers are runaway slaves. In the North, thousands of defectors are returned to their masters by troops, in part because they lack the means of providing food and shelter for the escapees. Those who enlist do not have an easy time, either, since the Union Army pays them less than White solders and

discriminates against them by assigning them to hard labor crews. Southern forces taking African American soldiers as prisoners consider them escaped slaves and make them examples to other slaves by executing them.

1864

At the Battle of Fort Pillow, Tennessee, on April 12, Confederate General Nathan Bedford Forrest reportedly orders the massacre of 300 Black soldiers upon their surrender. After impressing or seizing Black slaves into service as cooks and construction workers for the war effort, the Confederate Congress passes a bill ordering 200,000 African American slaves to enlist in the Confederate Army. The Civil War ends before the bill is enacted.

1863

President Abraham Lincoln issues the Emancipation Proclamation, abolishing slavery in the United States.

1865

Confederate General Robert E. Lee surrenders. On April 9, he meets with Union General Ulysses S. Grant at the Appomattox Court House in Virginia to negotiate terms for ending the most devastating war in American history. More than one million men have been killed or wounded. The number killed by disease—618,000—is greater than the number killed in battle. The total financial cost of the war is a staggering $15 billion, a sum which includes reparation to landowners for the value of slaves who have been set free under the terms of the Emancipation Proclamation.

RECONSTRUCTION

1865

Racial tension intensifies as the newly reunited country attempts to get back on its feet and rebuild politically, socially, and economically. In the aftermath of the Civil War, thousands of Americans are poor and homeless, particularly in the South

where most of the fighting of the past four years has taken place. The economy of the North, which has remained stable during the four years of war, continues to flourish while southern cities, plantations, farms, roads, and railroads lay in ruins. Unprepared to cope with the massive relief effort required, the federal government has only the federally funded Freedmen's Bureau to help newly freed slaves and former owners adjust. Southern states, where the majority of African Americans live, pass "Black Codes," restrictive laws protecting White superiority. Under these Draconian laws, African Americans cannot bear arms, attend schools with Whites, or sit on juries; unemployed Blacks are vulnerable to arrest for vagrancy.

1865

President Abraham Lincoln is assassinated in Washington, D.C. on April 14. Vice President Andrew Johnson succeeds him as Commander-in-Chief. The Ku-Klux Klan, a secret White supremacist society with an agenda of violence against Blacks, is formed.

1866

Despite a veto by President Johnson, Congress adopts the Civil Rights Bill to counteract the "Black Codes," preventing states from discriminating against citizens (defined as adult males) because of race.

1867

The Reconstruction Acts call for voter registration of all adult males, Black and White, upon compliance with a

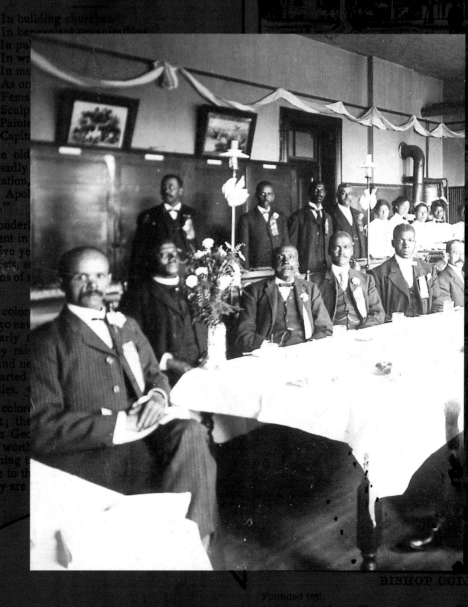

loyalty oath. President Johnson vetoes the Reconstruction Act but Congress overrides the veto and 703,000 African Americans and 627,000 Whites are registered to vote in ten unreconstructed states.

1876–1877

In an attempt to capture the African American vote, carpetbaggers move in from the North to persuade Blacks to vote Republican. U.S. Army regiments composed of Black and White soldiers are sent to protect southern state legislatures from White supremacist factions such as the Ku-Klux Klan and the Knights of the White Camellia. In 1870 and 1871, the Federal government passes three "Force Bills," authorizing troops to protect African Americans' rights. But racist southerners create new paramilitary organizations under the so-called "Mississippi Plan" in which members of White paramilitary groups throughout the South go to the polls heavily armed to frighten African Americans away. In 1870, Congress also adopts the Fifteenth Amendment to the Constitution,

granting suffrage to adult Black males. But Southern politicians impose severe literacy tests and poll taxes to keep African Americans from voting. Upon discovering that many southern White males are failing those same literacy tests, they adopt "Grandfather Clauses," which waive the test for any male whose grandfather had been allowed to vote, in effect disqualifying Blacks.

1870–1880

Twenty-three Black colleges are founded, although few African Americans can afford to attend them. Many former slaves receive literacy education through the Freedmen's Bureau, which provides aid to establish Howard University, Hampton Institute, Atlanta University, and Fisk University.

POST RECONSTRUCTION

1881

Educator Booker T. Washington, a former slave, founds Tuskegee Institute in Tuskegee, Alabama, for African Americans. In urging Blacks to further

their education and vocational training, he advocates building "friendly relations with white men."

1882

Tuskegee Institute begins collecting data on African American lynchings. By 1964, Tuskegee records will document the lynching of 4,742 Blacks.

1885

W.E.B. Du Bois becomes the first African American to receive a Ph.D. from Harvard University. Du Bois opposes Booker T. Washington's position on race relations and says that Blacks should fight for equal rights.

1896

Scientist George Washington Carver joins Tuskegee Institute staff. Carver's research on sweet potatoes, peanuts, and pecans leads to agricultural diversification in the South.

1900–1920

During "The Great Migration," more than 300,000 African Americans move to northern cities from southern rural areas in search of opportunities. The Black populations of Washington, D.C., New Orleans, Baltimore, Philadelphia, and New York City each swell to more than 500,000. Urban life proves difficult for Blacks who find limited work and housing opportunities. Many are forced to pay high rent to live in overcrowded, unsafe slums where crime rates soon increase despite the creation of social agencies to support African American families.

1910

The National Association for the Advancement of Colored People (NAACP) is founded in New York City. W.E.B. Du Bois is named director of publicity and research. The NAACP launches a full-scale campaign to end lynching and discrimination in all forms.

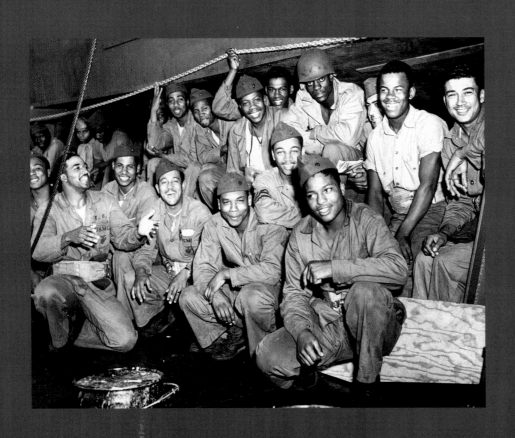

1914–1917

More than 360,000 Black Americans serve in the U.S. military. Despite "Jim Crow" segregation policies, African Americans benefit from educational programs and vocational training. During World War I, many Blacks find work as laborers in the manufacturing industry.

1920s–1940s

The Harlem Renaissance—a cultural movement also known as the "New Negro" movement—creates an environment where Black music, art, dance, and writing can flourish. Black musicians W.C. Handy, James P. Johnson, Fats Wailer, and Louis Armstrong redefine blues and jazz, becoming emissaries to White America and the world at large.

1928

Chicago Republican Oscar de Priest becomes the first northern Black elected to Congress.

1935

Track star Jesse Owens sets world records in the 110-yard dash, 220-yard low hurdle, and the running broad jump.

1936

Owens win gold medals in the 100 and 200-meter dash and the running broad jump in the Berlin Olympics.

1920–1940

African American entertainers Paul Robeson, Bill Robinson, Josephine Baker, Ethel Waters, Roland Hayes, and Charles Gilpin achieve stardom and fame in the United States and Europe.

1941–1945

Nearly one million African American men and women serve in the U.S. Armed Forces during World War II: more than 701,000 in the Army; 165,000 in the Navy; 17,000 in the Marine Corps; and 5,000 in the Coast Guard. Four thousand African American women sign up for the Navy's

volunteer emergency service and the Women's Army Corp. Benjamin Davis becomes the first African American Brigadier General in the U.S. Army. His son, Benjamin O. Davis, Jr., later becomes the first Black Major General in the U.S. Air Force. At home, hundreds of thousands of African American civilians receive education and job training for the war effort. After the war, the G.I. Bill helps pay college tuition for servicemen and women of all races. (By 1950, 113,735 African Americans are attending mainly Black colleges, compared to 1940 when 23,000 Blacks attended college.) Other benefits allow those who had served in the military to buy their own homes.

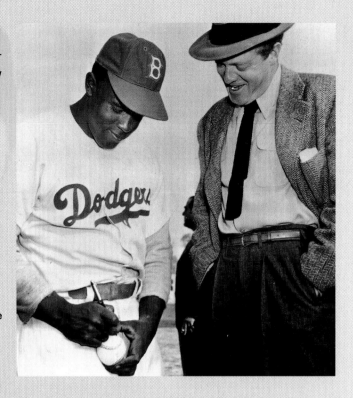

1946

The Supreme Court rules that a Virginia state law allowing segregation of Blacks and Whites on interstate buses is unconstitutional.

1947

Jackie Robinson signs with the Brooklyn Dodgers, becoming the first African American Major League Baseball player.

1948

President Harry S. Truman issues an executive order to integrate Blacks and Whites in the U.S. military. The Supreme Court rules that restrictive covenants preventing the sale or transfer of real estate to minorities will no longer be upheld in Federal or state courts.

1950

Poet Gwendolyn Brooks becomes the first Black American to receive the Nobel Prize in Literature. Ralph Bunche becomes the first African American to win the Nobel Peace Prize for his work as a United

Nations negotiator in the Middle East, where he mediated an armistice. In comparison to the early 1900s, when 90 percent of the Black population was illiterate, the year 1950 sees a reversal of those ratios, although schools remain segregated throughout the South.

CIVIL RIGHTS ERA

1954

On May 14, the Supreme Court declares that "separate but equal" education is unconstitutional, reversing its 1896 decision. The landmark ruling heralds the start of the Civil Rights movement.

1955

The Supreme Court demand that its 1954 ruling be carried out with "all deliberate speed."

1955

On December 1, Rosa Parks is arrested after refusing to give up her seat on a bus in Montgomery, Alabama. Five days later, Blacks begin a boycott of Montgomery city buses.

1956

On January 30, a bomb explodes at the house of Martin Luther King, Jr., leader of the Montgomery bus boycott.

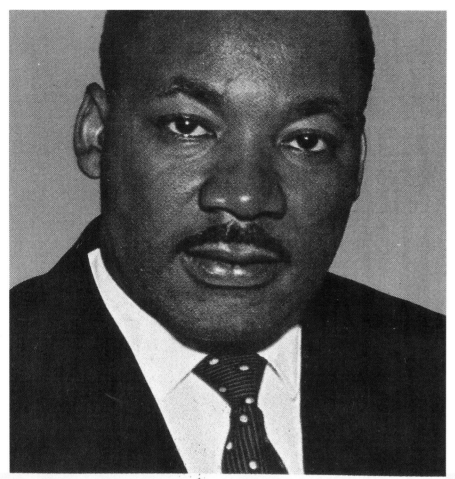

Dr. Martin Luther King, Jr.
Born January 15, 1929
Died April 4, 1968

On February 1, the U.S. District Court considers a motion calling for an end to segregation on buses. On November 13, the Supreme Court rules bus segregation to be illegal.

1957
In September, Federal troops are ordered to enforce court-ordered desegregation of schools in Little Rock, Arkansas. The Civil Rights Act of 1957 leads to the creation of a six-member panel to investigate claims of civil rights violations.

1960
The Civil Rights Act of 1960 reinforces African Americans' voting rights. Protestors stage the first attempt to integrate lunch counters in Greensboro, North Carolina.

1961
Black and White students and civil rights activists join protesters on buses travelling through the South. Termed "Freedom Riders," they test desegregation in the deep South. Federal troops are dispatched after they are attacked. In September, rioting breaks out at the University of Mississippi when the first Black students arrive.

1963
On August 28, almost 250,000 people march on Washington to demand full civil rights for African Americans: an end to segregation; the prohibition of discrimination in employment and education; and an end to federal funding of discriminatory programs. Standing on the steps of the Lincoln Memorial, Dr. Martin Luther King,

Jr. declares, "I have a dream." His dream of a country where Blacks and Whites can live in equality inspires millions around the world. On September 15, four African American children are killed in a church bombing in Birmingham, Alabama. On November 22, President John F. Kennedy, a civil rights advocate and hero to many African Americans, is assassinated in Dallas, Texas. Vice President Lyndon B. Johnson succeeds him.

1965
Malcolm X, a Muslim leader who articulated the concepts of Black pride and Black nationalism, is assassinated while speaking to a crowd of followers in front of the Audubon Ballroom in Harlem on February 21. *The Autobiography of Malcolm X,* written by Alex Haley from a series of interviews he had conducted with Malcolm X and published shortly before the assassination, becomes an instant classic.

1966
President Johnson continues to push civil rights legislation through Congress, vowing to wage war on poverty and build what he calls "The Great Society." Stokely Carmichael becomes chair of the Student Nonviolent Coordinating Committee (SNCC), an organization he first joined while at Howard University in 1960. During a march in Mississippi, he rallies those present toward the founding of the "Black Power" movement. In Oakland, California, Huey Newton and Bobby Seale found the Black Panther Party. Its original purpose is to patrol Black ghettoes to protect residents from acts of police brutality.

1967
During a long, hot summer, racial riots in Detroit, Toledo, Grand Rapids, and Nashville claim 225 lives. About 4,000 people are wounded as violence spreads through the inner cities, including Harlem

in New York City. "We Shall Overcome" becomes the anthem of the Civil Rights and Anti-Vietnam War movements. Thurgood Marshall becomes the first Black justice to sit on the U.S. Supreme Court.

1968

African Americans become more vocal about claiming their legacy to equality. On April 3, Dr. Martin Luther King arrives in Memphis to support the sanitation workers' strike and plan a demonstration. Undeterred by threats of violence, Dr. King says, "I'd rather be dead than afraid." The next day, Dr. Martin Luther King is shot while standing on the balcony outside his motel room. The 39-year-old leader dies in the emergency room of a Memphis hospital. Over the next few days, riots break out in 130 cities.

POST–CIVIL RIGHTS ERA

1973–1977

ABC-television broadcasts the miniseries *Roots* based on Alex Haley's novel of the same name about the author's search for his African roots. It becomes one of the most popular broadcasts in U.S. television history. As a result of the miniseries, African Americans discover a shared passion for genealogy and tracing their descendants.

1977–1990

Educated and talented Blacks move into the upper middle and wealthy socioeconomic classes while poverty, drugs, crime and the disintegration of the family took their toll on the millions of African Americans living in and barely out of poverty. Although discrimination is against the law, Black professionals and executives prevented from advancing because of a "glass ceiling" come to understand that racial prejudice, however subtle, still exists in the United States.

2001

At the beginning of the twenty-first century, there are 34.3 million African Americans living in the United States compared with the 1960 census count of 18.9 million. Despite equal opportunity laws that guarantee equal rights in voting, education, and housing, Black Americans continue to experience prejudice. The work of the great Civil Rights leaders of the 1960s and 1970s remains unfinished.

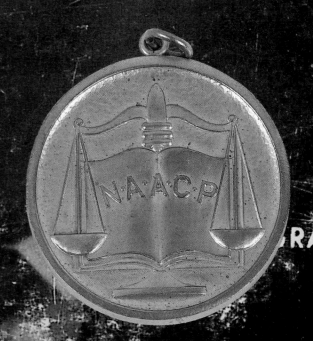

Public Sale of Negroes,
By RICHARD CLAGETT.

On Tuesday, March 5th, 1833 at 1:00 P. M. the following Slaves will be sold at Potters Mart, in Charleston, S. C. Miscellaneous Lots of Negroes, mostly house servants, some for field work.

Conditions: ⅓ cash, balance by bond, bearing interest from date of sale. Payable in one to two years to be secured by a mortgage of the Negroes, and appraised personal security. Auctioneer will pay for the papers.

A valuable Negro woman, accustomed to all kinds of house work. Is a good plain cook, and excellent dairy maid, washes and irons. She has four children, one a girl about 13 years of age, another 7, a boy about 5, and an infant 11 months old. 2 of the children will be sold with mother, the others separately, if it best suits the purchaser.

A very valuable Blacksmith, wife and daughters; the Smith is in the prime of life, and a perfect master at his trade. His wife about 27 years old, and his daughters 12 and 10 years old have been brought up as house servants, and as such are very valuable. Also for sale 2 likely young negro wenches, one of whom is 16 the other 13, both of whom have been taught and accustomed to the duties of house servants. The 16 year old wench has one eye.

A likely yellow girl about 17 or 18 years old, has been accustomed to all kinds of house and garden work. She is sold for no fault. Sound as a dollar.

House servants: The owner of a family described herein, would sell them for a good price only, they are offered for no fault whatever, but because they can be done without, and money is needed. He has been offered $1250. They consist of a man 30 to 33 years old, who has been raised in a genteel Virginia family as house servant, Carriage driver etc., in all which he excels. His wife a likely wench of 25 to 30 raised in like manner, as chamber maid, seamstress, nurse etc., their two children, girls of 12 and 4 or 5. They are bright mulattoes, of mild tractable dispositions, unassuming manners, and of genteel appearance and well worthy the notice of a gentleman of fortune needing such.

Also 14 Negro Wenches ranging from 16 to 25 years of age, all sound and capable of doing a good days work in the house or field.

THE STATE OF MISSISSIPPI.

TO *Elijah J. Brown, Freeman Agee, Highdale Watkins*

GREETING:

This is to authorise you jointly to appraise the goods, chattles, and personal estate of *Reynolds Manning* late of *Hinds* county, deceased, so as they shall come to your sight and knowledge, each of you having first taken the oath or affirmation hereto annexed: a certificate whereof you are to return, annexed to an inventory of the said goods, chattles, and personal estate you appraised; in dollars and cents, and in the said inventory, you are to set down in a column or columns opposite to each article the value thereof.

WITNESS *A. G. Moore*

Judge of Probate of the county of Hinds.

ISSUED 25th day of *February* 183_

The Charleston Courier.

FRIDAY MORNING, AUGUST 18, 1830.

125.
Manning Reynolds
Invt. & Appraisements
1833 March 25 Recorded

Manning's Estate
of one negro
March term
Rec'd page 64

Recorded page 64

Slavery

TYPES OF ARTIFACTS

Books: Slave journals and narratives, scholarly references, and histories.

Documents: Transmission papers, shipping manifests, property transactions, employment documents, and runaway slave posters.

Slave chains, manacles, and shackles

Slave tokens, badges, and identification items

Items made by slaves: Quilts, furniture, handicrafts, and clothes.

Anti-slavery literature

Civil War and items related to the military

Images: Illustrations, photographs, and art.

Underground Railroad material

Journal and magazine articles

SLAVERY AND RELATED TOPICS ARE THE MAJOR AREAS of Black history collecting. Authentic vintage slavery objects are rare and expensive, when they do come on the market. As historians, filmmakers, authors, teachers, and students continue to explore the powerful stories emerging from the centuries of slavery, there will be new books and movies on this subject coming out every few years. These can provide collectors with a cost-effective alternatives.

What to Look For

Since slaves were often the most financially valuable of the slaveholder's assets, look for records pertaining to real estate, inheritance, taxes, and the death or marriage of the slaveholder. A "crime report" from slaveholders can turn out to be a document pertaining to a minor slave revolt.

Specific, detailed information is a key element to look for when evaluating any slavery collectible. An object or document that lists a slave's name, a specific plantation or county, and/or a transaction will have greater historic and financial value than an object with fewer details. Generally, tax documents and statements of policy are considered less important and less valuable than documents like wills, in which individual slaves are named as property.

Look for items that add information to existing knowledge about a place, historical personage, or event. An item that concerns a transaction (sale, punishment, or emancipation) which had a direct effect on the life of that slave will be considered more valuable than a more generic transaction.

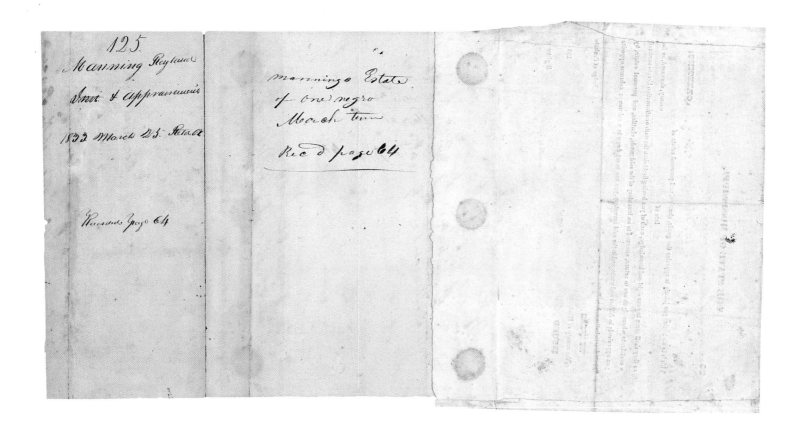

Remember that the history of slavery is complex and greatly tied to the economics of the eighteenth- and nineteenth-century South. It was tobacco in Virginia and rice in coastal South Carolina and Georgia that created much of the earlier demand for slaves. Cotton created an even greater demand later on. Thus, artifacts related to tobacco and rice harvesting may be older than those pertaining to cotton. Slaves were bred for sale and families broken up to provide labor farther south and to the west. Later artifacts reflect this sad period.

When considering expensive items, be sure to seek written verification of authenticity. Many high-grade, hard-to-detect reproductions of slavery collectibles are finding their way into the marketplace, and even experienced dealers have been known to make mistakes in verification.

THIS SPREAD: This kind of slavery document is more historically useful than some others because it provides a name, place, and a date which is essential for researching both the slaves and the slave holders.

THE STATE OF MISSISSIPPI.

TO *Elijah I Brown, Frederic Spann, Hezekiah Walker, David Slay, James M. Daniel every one of you* **GREETING:**

This is to authorise you jointly to appraise the goods, chattles, and personal estate of *Rigeland Manning late* of *Monroe* county, deceased, so far as they shall come to your sight and knowledge, each of you having first taken the oath or affirmation hereto annexed a certificate whereof you are to return, annexed to an inventory of the said goods, chattles, and personal estate, by you appraised; in dollars and cents, and in the said inventory, you are to set down in a column or columns opposite to each article the value thereof.

WITNESS *A G Moore* ———————— Judge of Probate

of the county of Hinds.

ISSUED *25th* day of *February* 183 *3*

R I James Depy Register

An Inventory of Goods and Chattles and personal Estate of Rigeland Manning late of Monroe County decd Alabama

A negro woman Chany — $500.00

The State of Mississippi Hinds County

We the undersigned appraisers of the Est of Rigeland Manning decd late of Monroe County, alabama after being sworn certify that we have appraised the property above named — Given under our hands the 5th March 1833

David Slay
Frederic Spann
E I Brown
Hezekiah Walker
James Mc Daniel

The State of Mississippi Hinds County

The Charleston Courier.

No. 6444.] FRIDAY MORNING, AUGUST 18, 1820. [VOL. XVI

Notice to Auctioneers.

THE City Treasurer hereby gives notice to the several Auctioneers whom it may concern, that the Vendue Tax for the last six month, ending the 26th inst. is now due; he therefore calls on them for their respective returns, and payment of the same conformably to law; and trusts this notice will be duly attended to, otherwise he will be constrained to report all defaulters to Council, and suits will be immediately commenced thereafter.

WM. ROACH, C. T.

City Treasury Office, June 20, 1820.

The Subscriber

CONTINUES to transact *Factorage and Commission Business* on Magwood's wharf, where all orders confided to him will be punctually executed, and the interest of his employers diligently attended to.

ISAAC COURSE.

July 1

City Marshal's Department,

July 15, 1820.

REGULATIONS FOR CARTS AND DRAYS.

THE following extract from the City Ordinances, is published for information, and will be strictly enforced, by

JOHN J. LAFAR, *City Marshal.*

4. That no carts or drays shall stand or ply for hire in any of the streets, lanes or alleys, but be divided and placed by the City Marshal, under the direction of the intendant, for the time being, at such place or places as now be pointed out by him. And any driver or conductor of carts, drays or other carriages, who after having their stands appointed shall quit the same, or ply for hire in any other place, unless going to work, or to their respective homes, such driver or conductor, if a white man, or free person of color, of a cart or dray, shall forfeit and pay for every such offence, the sum of three dollars, and if a slave, the said sum shall be paid by the owner or employer.

The following Stands for CARTS:

South-Bay, south side,
Prioleau's wharf, south side,
Chisolm's upper wharf, south side,
Williams' wharf, north side,
Gadsden's wharf, east side.

The following Stands for DRAYS:

From the corner of East-Bay and D'Oyley's wharf, to the corner of East-Bay and Crafts' south wharf, east side.

From the corner of East-Bay and Crafts' north wharf, to the Custom-House, east side.

From the Custom-House, east side, to Lothrop's wharf.

From the corner of East-Bay and Lothrop's wharf, to the corner of the Market, east side.

All drivers not found with their carts or drays while at their stands, will be dealt with agreeably to the City Laws.

THEOLOGICAL BOOKS,

ENGLISH EDITIONS,

For sale by E. THAYER, No. 25 Broad-street.

SIMPSON'S PLEA for the Deity of Jesus, the Doctrine of the Trinity, with a Memoir of the Author, and the spirit of Modern Socinianism exemplified.

Stanhope's Paraphrase and Comment upon the Epistles and Gospels appointed to be used in the Church of England. 4 vols.

Gordon's (Sir Adam) Fifty-two Lectures on the Catechism of the Church of England. 3 vols.

Do. Discourses on several subjects, being the substance of the Homilies of the Church of England. 2 vols.

Robinson's Scripture Characters, or a practical improvement of the principal histories in the Old and New Testament. 4 vols.

Rogers' Lectures on that part of the Liturgy contained in the Morning Prayer. 2 vols.

Smith's (Sydney) Sermons. 2 vols.

Hamilton's General Introduction to the study of the Hebrew Scriptures, &c.

Porteus' (Bishop) Works. 6 vols.

Burder's Memoirs of eminently Pious Women. 5 vols, with 18 portraits.

Murkhouse's Discourses on various subjects, with copious Annotations. 3 vols.

Wogan on the Proper Lessons appointed by the Liturgy to be read on Sundays and Festivals, throughout the year. 4 vols.

Massillon's Sermons. 3 vols.

Alix's Reflections upon the Books of the Holy Scriptures, to establish the truth of the Christian Religion.

Pearson's Exposition of the Creed. 2 vols.

Doddridge's Lectures on the principal subjects in Pneumatology, Ethics and Divinity. 2 vols.

Parkhurst's Hebrew and English Lexicon.
Do. Greek and English do.

Dodd's Comforts for the Afflicted, under every distress, with suitable devotions.

Bower's Life of Luther, with an account of the early progress of the Reformation.

Johnson's (Samuel) Sermons, left for publication by John Taylor, L. L. D.

Drelincourt's Christian Defence against the fears of Death.

Burnet's Exposition of the Thirty-nine Articles.

Moore's (Hannah) Search after Happiness.

Dodd's Reflections on Death.

Wesley's (Samuel) History of the Old and New Testaments in ver. 3 small vols.

Office of Comm'rs. Streets and Lamps,

June 15, 1820.

THE City Council having directed the Commissioners of Streets and Lamps, to prosecute all persons violating the "third section of the ordinance relative to the Commissioners of Streets and Lamps," and as the undersigned is now required to prosecute all persons "who may erect any building, wall or fence, before applying to a Commissioner for the true and proper line"—an extract of said Ordinance is published for information.

OTHNIEL J. GILES, *Ch. C. S. L.*

"3. That no owner or builder of any house, or other building, in the city, shall dig or lay the foundation therein, in front of any street, lane, alley, or open court, or shall erect any wall or fence fronting as aforesaid, or shall lay, or cause to be laid, any side pavement fronting as aforesaid, before he, she, or they, shall have applied to one of the Commissioners of Streets and Lamps, to lay off, and mark out the line...

COUNCIL CHAMBER,

AUGUST 15, 1820.

PUBLIC notice is hereby given, that an election will be held on the first Monday, being the 4th day of September next, for an INTENDANT of the City of Charleston, to be elected from among the citizens—and TWELVE WARDENS, to be chosen from among the residents of the Ward for which they shall be elected, viz:—three Wardens for Ward No. 1; two Wardens for Ward No. 2; three Wardens for Ward No. 3; four Wardens for Ward No. 4.—The election to be held at the Court-House and the Centre-Market. To be managed and conducted at the Court-House, by Othniel J. Giles, Thomas R. Sabine, and William Evans, Esquires;—and at the Centre-Market, by George Thatcher, Thomas Gadsden, Jun. and Francis J. Lee, Esquires. The Polls to be opened from 9 o'clock in the forenoon, and continued to 5 o'clock in the afternoon.—At which time and places of election, all persons qualified to vote, are summoned to attend and give their suffrages.

DANIEL STEVENS, *Intendant.*

By the Intendant,

WM. ROACH, Jun. *Clerk of Council.*

AN ACT,

To alter and amend an act, entitled an act to alter and amend so much of the second clause of the charter incorporating the City of Charleston, as relates to the qualification of voters for Intendant and Wardens, and for other purposes therein mentioned, passed on the eighteenth day of December, in the year of our Lord one thousand eight hundred and seventeen.

WHEREAS it is right to guard the elective franchise from abuse, and to preserve purity in the exercise of it; and no mode consistent with the extensive use of this right is deemed so effectual for the accomplishment of this great and desirable object, in a populous city, as the establishment of a registry of the names of all the voters prior to the election:

Be it therefore enacted by the honorable the Senate and House of Representatives, now met and sitting in general assembly, and by the authority of the same, That an act entitled an act, to alter and amend so much of the second clause of the charter incorporating the city of Charleston, as relates to the qualification of voters for Intendant and Wardens, and for other purposes therein mentioned, passed on the eighteenth day of December, in the year of our Lord one thousand eight hundred and seventeen, be so far altered as that the operation of the said act shall extend to all persons qualified to vote for Intendant and Wardens of the city of Charleston, and that the said voters shall register their names at least one month before the day of election; and at the time of registering their names, likewise register the place of their residence; but that after registering their names and places of residence prior to any election, it shall not be necessary to register the same for any future election.

And be it further enacted by the authority aforesaid, That the managers of the election shall read to each person, who offers to vote, that part of the constitution which relates to the qualification of voters, and shall administer to him the oath prescribed by the same.

In the Senate House, the eighteenth day of December, in the year of our Lord one thousand eight hundred and nineteen, and in the forty-fourth year of the Independence of the United States of America.

BENJAMIN HUGER,
President of the Senate.

PATRICK NOBLE,
Speaker of the House of Representatives.

Part of the Constitution relative to the qualification of Voters, alluded to in the second clause of the act published above:—

"Every free white man, of the age of twenty-one years (paupers and non-commissioned officers and privates soldiers of the army of the United States excepted) being a citizen of this State, and having resided therein two years previous to the day of election, and who hath a freehold of 50 acres of land, or a town lot of which he hath been legally seized and possessed at least six months before such election, or not having such freehold or town lot, hath been a resident in the election district, in which he offers to give his vote, six months before the said election, shall have a right to vote for a member or members, to serve in either branch of the Legislature, for the election district in which he holds such property or is a resident."

BY THE GOVERNOR

Of the State of North-Carolina.

A PROCLAMATION.

WHEREAS, by an act of the General Assembly of the State of North-Carolina, the...

DOGS.

City Marshal's Department,

August 11, 1820.

THE following clauses of an Ordinance to prevent DOGS running at large, is published for general information.

JOHN J. LAFAR, *City Marshal.*

1. Be it ordained, That from and after the passing of this Ordinance, no dog shall be suffered to go at large in any street, lane, court, or alley, or on any wharf of this city; and in case any dog shall be found going at large as aforesaid, the owner of such dog shall forfeit a sum not less than ten dollars, and not more than twenty dollars, to be recovered in the Inferior City Court; the same to be applied to the use of the informer.

2. That it shall not be lawful for any negro, mulatto, or person of color, to be owner of a dog or dogs; and each and every of them are hereby prohibited from having or keeping any dog whatever, in any yard, lot or enclosure, either public or private, within the city; unless such dog shall be secured, so as to do and cause no damage and injury in the day time; and also have fixed round the neck a collar, with the name of some creditable white person engraved thereon, which said white person shall be considered as the owner of the dog, and shall be held responsible and liable for any damage or injury that may be committed by such dog. And every free negro, mulatto, or person of color, who shall have in his possession any dog, contrary to the condition above expressed, shall forfeit a sum not less than five dollars, and not more than ten dollars, to be recovered before the Inferior City Court, with the costs of suit; the same to the use of the informer: And in case any slave shall have in possession any dog, contrary to the condition above expressed, the said slave shall be liable to, and shall, by order of one or more of the Wardens of this city, receive at the Work-House, a correction not exceeding twenty lashes, unless the owner of the said slave shall pay the sum of five dollars to the informer. And in case any dog in possession of a slave shall appear at large in any part of the city, the said slave shall be liable to, and shall, by order of one or more of the Wardens of the city, receive at different times, as shall be prescribed, two corrections, not exceeding twenty lashes each, at the public market, unless the owner of such slave shall pay to the use of the informer a sum of ten dollars. And in case any dog in the possession of, and kept by a free negro, mulatto, or person of color, on the condition before expressed, shall appear at large in any part of this city, the said free negro, mulatto or person of color, shall be subject to the forfeiture and penalty expressed in the first clause of this ordinance, to be recovered in the manner there expressed.

3. That all persons are hereby authorized to kill any dog or dogs going at large in manner aforementioned, or kept within the city, contrary to this ordinance; And that any person producing proof of his having killed any dog pursuant to this ordinance, before any of the Wardens, shall be entitled to receive a reward of fifty cents, to be paid by the City Treasurer on the certificate of such Wardens, countersigned by the Intendant. And all persons who so act in obedience and conformity hereto, shall be indemnified and saved harmless.

4. That the City Marshal, and the person or persons employed by him, and each and every of them shall be protected in the execution of his or their duty prescribed by this ordinance. That they and each of them be empowered to enter any lot or enclosure within this city, occupied by negroes, mulattoes or persons of color, in quest of any and every dog kept contrary to this ordinance; and any and every person who shall assault or obstruct them, or any of them, in the discharge of his or their duty, in executing any part of this ordinance, shall forfeit and pay to the use of the city a sum not exceeding fifty dollars, to be recovered with costs in the Inferior City Court; and if a slave, that slave shall receive such correction or corrections, at the public market, as shall be ordered to be inflicted by the committee of Council, who shall attend at the Guard House.

5. That whenever any dog shall be removed from one part of the city to another, or from any vessel or boat at any wharf, to any part of the city, the said dog shall be secured by a sufficient rope, cord or chain, and one end thereof shall be held by the person or persons who shall have the charge of the dog. That every person coming to the city by land, or going out of the city accompanied by a dog or dogs, shall cause each and every of them to be secured. That every butcher's dog shall be secured to or under the cart of the said butcher, while coming into or going out of the city; and no dog shall appear, or be brought into the markets on any account, or in any manner. And every person who shall be accompanied by a dog in the streets or in public, shall have the said dog secured by a sufficient rope, cord or chain, and one end thereof, shall be held by the said persons. And in case of neglect, each and every dog shall be considered as going at large, and shall be liable to be killed, and the owner thereof subject to the forfeiture herein before expressed. And also, in every case where any dog, although secured in manner abovementioned, shall bite or injure any person, the said dog may be killed, any thing herein expressed to the contrary thereof notwithstanding.

City Marshal's Department.

NOTICE.

WHEREAS, the lives of the Inhabitants on the west side of the city, being much endangered by the firing of Guns, Pistols, and other fire arms, &c. the following extract, from the 23d clause of an Ordinance, passed November 6th, 1806, is published for general information.

That no person, or persons, shall fire any squibs, crackers or other fire-works, within the city, except at times of public rejoicing, and at such places, when and where the Intendant, for the time being, may permit by licence under his hand; or shall burn any chips, shavings, or any combustible matter in any street, lane, alley, or open or enclosed lot within the city (Coopers excepted, who shall be permitted to make fires below the curtain line, with the consent of the proprietors of the lots where they carry on their work respectively) or shall fire any Gun, Pistol, or other fire arms, within the limits of the City, unless it be on occasion of some military parade, and then by the order of some officer having the command; or shall raise or fly any Kite, or other like paper in any part of the city; under a penalty of Ten Dollars, for each...

City Marshal's Department,

July 26, 1820.

The following extract from the City Ordinance, is published for general information.

JOHN J. LAFAR, *City Marshal.*

15. And be it further ordained, That any person or persons who shall wilfully break down, destroy, injure, or remove any of the trees planted or growing, or which shall be planted and grow on the edge of any foot pavement in the city, or any of the boxes encompassing the same, shall for each and every such offence, forfeit and pay the sum of twenty dollars if a white; or if a negro or person of color, shall receive such correction as shall be adjudged by any Warden of the city, not exceeding twenty lashes. But the Commissioners of Streets and Lamps, or any of them, shall at all times have power and authority to order any tree or trees to be removed by the City Scavengers in their respective divisions, as they may think proper; and likewise to order any tree or trees shading or obscuring the light of any of the lamps, to be trimmed by the City Lamp-Lighters in their respective divisions. And every person molesting, opposing, or abusing either of the City Scavengers, or either of the City Lamp-Lighters, in the performance of any of the aforesaid services, shall for each and every such offence, forfeit and pay the sum of fifty dollars; or if a negro or person of color, shall receive such bodily correction for each and every such offence, as any Warden of the city may adjudge.

16. And be it further ordained, That any white person or persons who shall wilfully break any lamp or part thereof, whether public or private property, already set up, or hereafter to be set up in this city, or who shall remove any lamp or lamp post from the place where it is fixed, shall for each and every such offence, forfeit and pay to the use of the city, the sum of ninety dollars, and to the use of the Lamp-Lighter ten dollars, for every such lamp so broken or injured in his respective division; and every negro or person of color committing any such offence, shall be confined in the Work House for one month, and during said month receive three corrections at the public market, in Queen or Market street; each correction not to be less than twelve nor more than twenty lashes, and to be adjudged by any Warden of the city.—And if any person or persons shall extinguish any such lamp, or take a burner or burners from any lamp or lamps, every such person, if a white, shall forfeit and pay for each and every such offence, to the use of the city five dollars, and to the use of the Lamp lighter in his respective division, one dollar for each and every burner so taken away; or if a negro or person of color, shall receive such corporal punishment as...

Harbor-Master's Department.

The following clause of the Health Ordinance is published for general information:

"7. And be it further ordained, &c. That all vessels having two decks, lying in the port and harbor of Charleston, at any time between the first day of May and the first day of November, shall be compelled to have at least one wind sail, extending to the hold of each and every such vessel; and the consignee, or master of any such vessel, which shall not be provided with such a sail, agreeably to this ordinance, shall forfeit and pay the sum of ten dollars for every day such vessel shall remain thus unprovided—and each and every vessel having two decks, at the wharves in this port, during the above period shall be compelled, under the eye of the Harbor Master or his Deputy, to admit a certain quantity of air into her hold, and to have the same pumped out at least twice in every week: And if the owner, consignee, or master of any such vessel, shall neglect or refuse so to do, he or they shall be liable to a penalty for each and every refusal or neglect. And the Harbor-Master, is hereby instructed and required, in case of any refusal or neglect, to have the same done at the expence of the consignee or master, and recovered, together with...

Public Sale of Negroes,

By RICHARD CLAGETT.

On Tuesday, March 5th, 1833 at 1:00 P. M. the following Slaves will be sold at Potters Mart, in Charleston, S. C.

Miscellaneous Lots of Negroes, mostly house servants, some for field work.

Conditions: ½ **cash, balance by bond, bearing interest from date of sale. Payable in one to two years to be secured by a mortgage of the Negroes, and appraised personal security.** *Auctioneer will pay for the papers.*

A valuable Negro woman, accustomed to all kinds of house work. Is a good plain cook, and excellent dairy maid, washes and irons. She has four children, one a girl about 13 years of age, another 7, a boy about 5, and an infant 11 months old. 2 of the children will be sold with mother, the others separately, if it best suits the purchaser.

A very valuable Blacksmith, wife and daughters; the Smith is in the prime of life, and a perfect master at his trade. His wife about 27 years old, and his daughters 12 and 10 years old have been brought up as house servants, and as such are very valuable. Also for sale 2 likely young negro wenches, one of whom is 16 the other 13, both of whom have been taught and accustomed to the duties of house servants. The 16 year old wench has one eye.

A likely yellow girl about 17 or 18 years old, has been accustomed to all kinds of house and garden work. She is sold for no fault. Sound as a dollar.

House servants: The owner of a family described herein, would sell them for a good price only, they are offered for no fault whatever, but because they can be done without, and money is needed. He has been offered $1250. They consist of a man 30 to 33 years old, who has been raised in a genteel Virginia family as house servant, Carriage driver etc., in all which he excels. His wife a likely wench of 25 to 30 raised in like manner, as chamber maid, seamstress, nurse etc., their two children, girls of 12 and 4 or 5. They are bright mulattoes, of mild tractable dispositions, unassuming manners, and of genteel appearance and well worthy the notice of a gentleman of fortune needing such.

Also 14 Negro Wenches ranging from 16 to 25 years of age, all sound and capable of doing a good days work in the house or field.

OPPOSITE: Evidence of slavery is scarce and expensive, forcing collectors to find more creative and affordable sources for slavery era material. Old newspapers with slave ads can still be found (though the supply of these, too, is becoming scarce). This old Charleston newspaper contains a few advertisements for slaves (often runaways) that show what life was really like for African American slaves and the mentality of the slave owners.

ABOVE: The sale of slaves is a subject of great interest to collectors and historians. This kind of document reveals not only the methodology of slavery but is also reflective of how captive Blacks were viewed by their purchasers. Collectors should exercise caution since items such as this are often forged or reproduced. The origin of this document has not been verified.

1947 1948

Fairmount Social Club

First Anniversary

SUNDAY, APRIL 25, 1948

AT SAVOY PLAZA
537 North Grand Street

—

LEROY BOSTIC'S MUSIC

BANQUET ENTERTAINMENT

DANCING

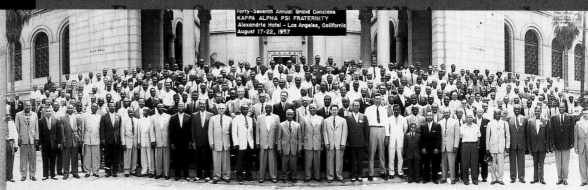

Forty-Seventh Annual Grand Conclave
KAPPA ALPHA PSI FRATERNITY
Alexandria Hotel - Los Angeles, California
August 17-22, 1957

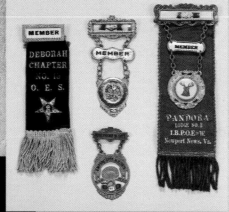

Compliments of

The

SAINT IGNATIUS CHURCH

✝

43rd Street at Wallace Street

Compliments

Philadelphia Phone New York Phone
ALlegheny 4-3455 EDgecombe 4-7230
4-3456

LENERTE ROBERTS

REAL ESTATE

101 North 52nd Street

FAIRMOUNT SOCIAL CLUB HISTORY AND AIM

The Fairmount Club was formed in March 1947 by a group of former athletes who had since the year of 1928 participated in all branches of sports and gave a good account of themselves throughout many States, for the purpose of improving, advocating, sponsoring recreational activities, and to create a consolidated community program.

The first venture undertaken was to sponsor a picnic for the children of this community. It was a gigantic affair with four (4) chartered trolleys and many automobiles being used for transportation. The children were taken to Druid Hill (Diary Field) in the beautiful Fairmount Park for the entire day, and 946 kids had the time of their young lives with plenty to eat and drink. Many games were played and competitive athletics participants were awarded valuable prizes. Returning home after 6:00 p. m.

In early September, the adults of the community were taken into our program, we sponsored an outing for them and many who couldn't afford a summer vacation to Wildwood, N. J. where provision for a picnic for the entire day was held. Nine (9) chartered buses were required for this gala throng.

During the entire summer, committees of club members were formed to take groups of boys to see Major League Baseball games, a total of 1000 for the season. Many were taken to the Circus, and through the courtesy of the Arena, twenty-five (25) boys and girls were well entertained at the Rodeo. Many other minor affairs were visited by boys and girls of this vicinity through the courtesy of other agencies by the club to have a complete program for the welfare of the community.

This coming season the club has on its agender the same plans, but on a larger scale.

The Fairmount Social Club thanks every one for his or her co-operation in helping us complete a very successful year in building better community relation.

Local History
and Genealogy

TYPES OF ARTIFACTS

Local history books and
 pamphlets

Journals devoted to state
 and local history

Slavery documents naming
 specific places and people

Family scrapbooks or hometown
 documents

Memorabilia of places, events
 and activities that your
 family enjoyed

Yearbooks of local Black schools

County and plantation histories

Church congregation histories

Convention booklets

Lodge records and receipts

Membership cards and certificates

Records of dues paid to organiza-
 tions and charities

Invitations to upcoming events

Souvenir programs commemorat-
 ing events, anniversaries,
 and conventions

Uniforms, hats, insignia, pins,
 and rings

Implements of office: gavels
 and chains

Awards and trophies

Letterheads with logos

WHEN ALEX HALEY'S BEST-SELLING NOVEL *ROOTS* became a network television miniseries, it accelerated a nascent African American genealogy movement that has since become something of a growth industry unto itself. Millions of Black families have become passionate about collecting records, photos, and documents from the times in which their grandparents, great grandparents, and ancestors lived, worked, and died. What better way to link up with history than through mementos, records, and artifacts that belonged to someone from your own lineage?

What to Look For

The slavery experience robbed African Americans of most of their heritage information and was designed to eliminate knowledge of identity and descent. Most slaves were not literate and there unable to create records that family research usually depends upon. Until recently, many Black Americans regarded the past as a source of pain—when family elders died, written records or oral histories that maintained their links with the past were not preserved. Massive migrations and urbanization have led many Blacks to lose touch with their roots in the rural South.

But this attitude has changed. Any item, such as a document pertaining to a Black church or a slave transaction, that identifies a name, place, or event can become a bridge connecting a present-day individual with his or her ancestors.

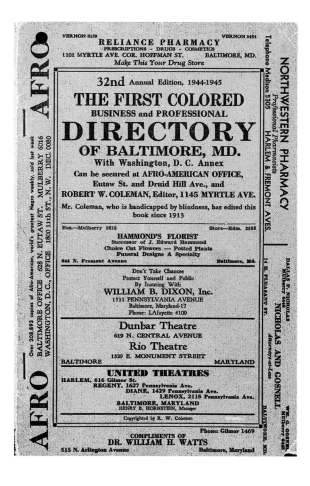

The first step in conducting personal genealogical research is gathering information about the lifestyles of your grandparents, great grandparents, and their siblings. Knowing what they did for a living, what church they attended, the lodges to which they belonged, and what trips they took will lead you to the next step: finding the kinds of old books, records, and documents that will help you piece together your family history. Old books, records, and documents contain lists of names, places and dates of religious events, community gatherings, and contributors to special projects. Read each list carefully to see if you can find a name you recognize.

Go outside your personal collection of family records. Libraries and historical societies maintain logbooks, family records, and business records that can be invaluable. Don't forget to check out plantation histories and factory records from a relevant time period. Military collectibles, in particular, can be an excellent resource for tracing male ancestors.

Organizational collectibles can be very helpful in researching family history, for they may contain lists of names, places and events. Never pass up or discard old souvenir programs, convention booklets, membership lists, minute books and similar information about African Americans from the past. Collectibles from small, local social clubs, neighborhood associations, or occupational societies can also turn into treasure troves of listings that can help trace a family's history. Some modern organizations (especially the Afro-American Historical and Genealogical Society) specialize in helping african Americans search for ancestors.

Organizational memorabilia is likely to turn up in estate sales of people who held onto old documents. Dealers usually obtain organizational memorabilia from heirs of a deceased relative who was a member of that organization.

ABOVE AND OPPOSITE:

Local history directories such as this one from the 1940s are now quite scarce, very useful for research, and tell much about how people lived. At this time the African American community was segregated and much more self contained than it is today. These directories tell much about who was doing what in specific places, information that is now often lost and usually unobtainable from other sources. Family history researchers are especially in need of such information sources. Most of the businesses and many of the social organizations listed here are not in existence now and would be forgotten if it were not for directories such as this.

— 18 —

BALTIMORE INFORMATION

	NEGRO COLLEGE	PRESIDENT
1.	Alabama State Teachers College, Montgomery, Alabama	H. Councill Trenholm
2.	Miles College, Birmingham, Alabama	W. A. Bell
3.	Agricultural and Mechanical Inst., Normal, Alabama	J. F. Drake
4.	Talladega College, Talladega, Alabama	Buell G. Gallagher
5.	Tuskegee Institute, Tuskegee, Alabama	F. D. Patterson
6.	Agricultural, Mechanical and Normal, Pine Bluff, Arkansas	
7.	Arkansas Baptist College, Little Rock, Arkansas	T. W. Coggs
8.	Philander Smith College, Little Rock, Arkansas	M. Lafayette Harris
9.	Shorter College, North Little Rock, Arkansas	J. W. Clayborn
10.	State College for Colored Students, Dover, Delaware	H. D. Gregg
11.	Howard University, Washington, D. C.	Mordecai W. Johnson
12.	Miner Teachers College, Washington, D. C.	Eugene A. Clark
13.	Florida A & M College for Negroes, Tallahassee, Florida	J. R. E. Lee
14.	Atlanta University, Atlanta, Georgia	Rufus E. Clement
15.	Clark College, Atlanta, Georgia	James P. Brawley
16.	Morehouse College, Atlanta, Georgia	Benjamin E. Mays
17.	Spelman College, Atlanta, Georgia	Florence M. Read
18.	Fort Valley State College, Fort Valley, Georgia	Horace M. Bond
19.	Georgia Normal College, Albany, Georgia	J. W. Holley
20.	Georgia State College, Industrial College, Georgia	B. F. Hubert
21.	Morris Brown College, Atlanta, Georgia	William A. Fountain, Jr.
22.	Paine College, Augusta, Georgia	Edmund C. Peters
23.	Kentucky State College, Frankfort, Kentucky	R. B. Atwood
24.	Louisville Municipal College, Louisville, Kentucky	Raymond A. Kent
25.	Dillard University, New Orleans, Louisiana	Albert W. Dent
26.	Leland College, Baker, Louisiana	J. A. Bacoats
27.	Southern University, Scotlandville, Louisiana	Felton G. Clark
28.	Xavier University, New Orleans, Louisiana	Mother M. Agatha
29.	Coppin Teachers College, Baltimore, Maryland	Miles W. Conner
30.	Morgan State College, Baltimore, Maryland	Dwight O. W. Holmes
31.	Princess Anne College, Princess Anne, Maryland	
32.	Alcorn A and M College, Alcorn, Mississippi	William H. Bell
33.	Campbell College, Jackson, Mississippi	S. L. Greene, Jr.
34.	Jackson College, Jackson, Mississippi	Jacob L. Reddix
35.	Mississippi Industrial College, Holly Springs, Mississippi	W. M. Frazier
36.	Rust College, Holly Springs, Mississippi	L. M. McCoy
37.	Tougaloo College, Tougaloo, Mississippi	Judson L. Cross
38.	Lincoln University, Jefferson City, Missouri	Sherman D. Scruggs
39.	Stowe Teachers College, St. Louis, Missouri	Ruth M. Harris
40.	Agricultural and Technical College, Greensboro, North Carolina	
41.	Barber-Scotia Junior College, Concord, North Carolina	L. S. Cozart
42.	Bennett College, Greensboro, North Carolina	David D. Jones
43.	Fayetteville State Teachers College, Fayetteville, North Carolina	J. W. Seabrook
44.	Johnson C. Smith University, Charlotte, North Carolina	Henry L. McCrorey
45.	Livingstone College, Salisbury, North Carolina	W. J. Trent
46.	North Carolina State College, Durham, North Carolina	James E. Shepard
47.	St. Augustine's College, Raleigh, North Carolina	Edgar H. Goold
48.	State Teachers College, Elizabeth City, North Carolina	Harold L. Trigg
49.	Winston-Salem Teachers College, Winston-Salem, North Carolina	F. D. Atkins
50.	Wilberforce University, Wilberforce, Ohio	Charles H. Wesley
51.	Langston University, Langston, Oklahoma	G. L. Harrison
52.	Cheyney Training School for Teachers, Cheyney, Pennsylvania	Leslie Pinckney Hill
53.	Lincoln University, Lincoln University, Pennsylvania	W. L. Wright
54.	Allen University, Columbia, South Carolina	Samuel R. Higgins
55.	Benedict College, Columbia, South Carolina	J. J. Starks
56.	Clarlin College, Orangeburg, South Carolina	J. B. Randolph
57.	Morris College, Sumter, South Carolina	J. P. Garrick, Acting
58.	State N. I. A. & M. College, Orangeburg, South Carolina	M. F. Whittaker
59.	Fisk University, Nashville, Tennessee	Thomas E. Jones
60.	Knoxville College, Knoxville, Tennessee	William Lloyd Imes
61.	Lane College, Jackson, Tennessee	J. F. Lane
62.	Le Moyne College, Memphis Tennessee	Fred Brownlee
63.	Morristown N. & I. College, Morristown, Tennessee	J. W. Haywood
64.	Tennessee A. & I. College, Nashville, Tennessee	
65.	Bishop College, Marshall, Texas	Joseph J. Rhoads
66.	Houston College for Negroes, Houston, Texas	E. E. Oberholtzer
67.	Jarvis Christian College, Hawkins, Texas	P. C. Washington
68.	Paul Quinn College, Waco, Texas	George J. Davis
69.	Prairie View State College, Prairie View, Texas	W. R. Banks
70.	Samuel Houston College, Austin, Texas	Stanley E. Grannum
71.	Texas College, Tyler, Texas	Dominion R. Glass
72.	Tillotson College, Austin, Texas	Mary E. Branch
73.	Wiley College, Marshall, Texas	M. W. Dogan
74.	Hampton Institute, Hampton, Virginia	
75.	Virginia State College, Ettrick, Virginia	John M. Gandy
76.	Virginia Theological Seminary, Lynchburg, Virginia	W. H. R. Powell
77.	Bluefield State Teachers College, Bluefield, West Virginia	H. L. Dickason
78.	Storer College, Harpers Ferry, West Virginia	Henry T. McDonald
79.	West Virginia State College, Institute, West Virginia	John W. Davis

— 19 —

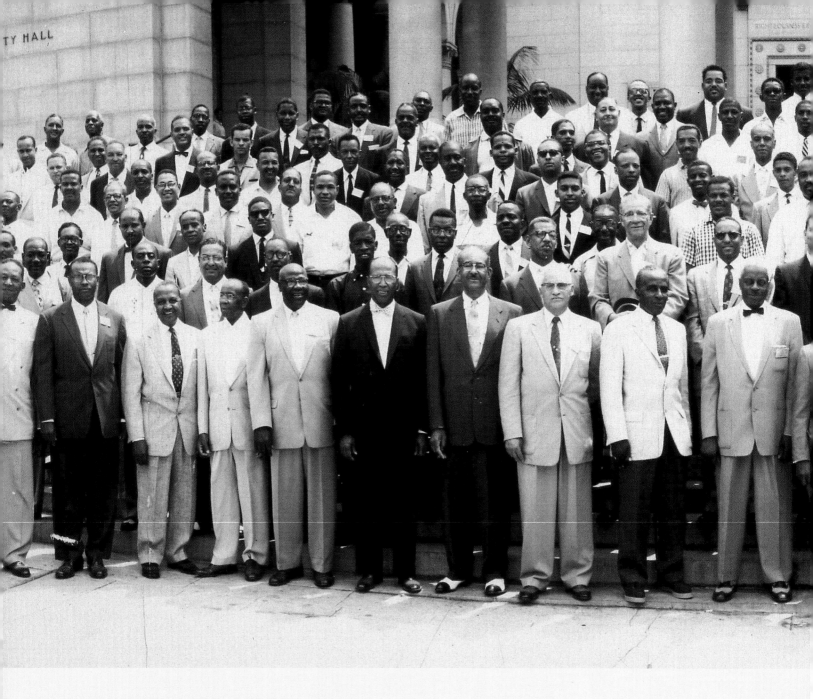

THIS SPREAD:

Fraternity conventions are a major force in the African American community (and rightly so) with national participation. They, along with the many other organizations that are national in scope, help to knit together African Americans (and their views) from many different places in a big country.

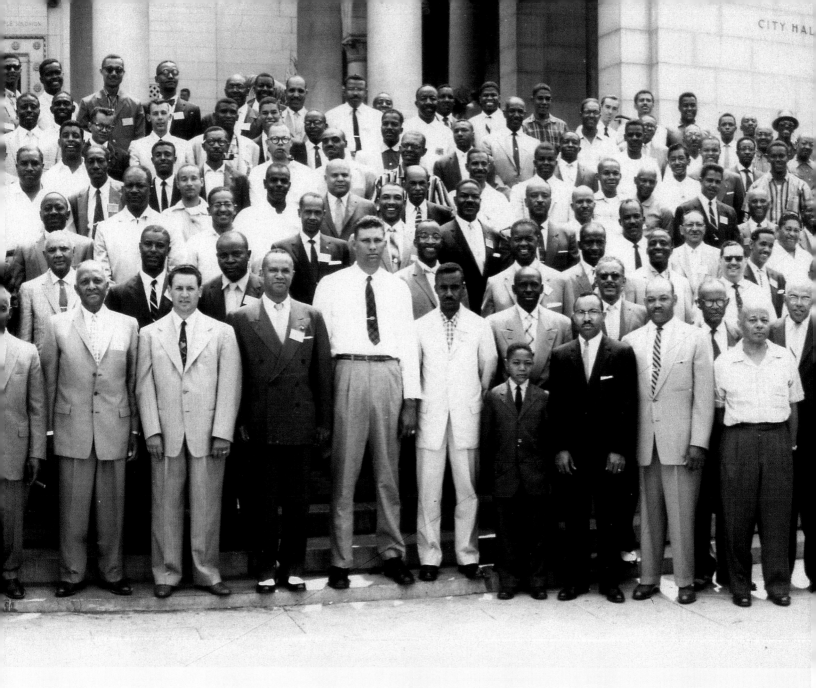

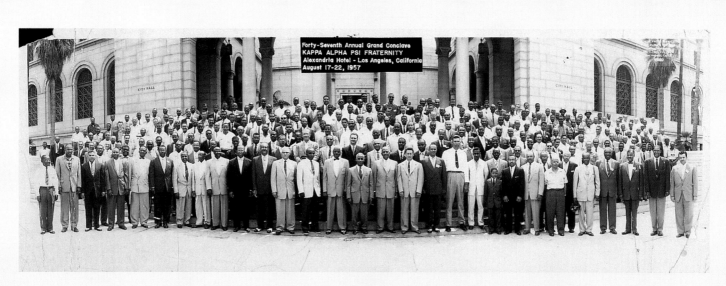

Forty-Seventh Annual Grand Conclave
KAPPA ALPHA PSI FRATERNITY
Alexandria Hotel - Los Angeles, California
August 17-22, 1957

1947

1948

Fairmount Social Club

First Anniversary

SUNDAY, APRIL 25, 1948

AT SAVOY PLAZA

837 North Broad Street

—

LEROY BOSTIC'S MUSIC

BANQUET ENTERTAINMENT

DANCING

Compliments of

The

SAINT IGNATIUS CHURCH

✝

43rd Street at Wallace Street

Compliments

Philadelphia Phone
ALlegheny 4-3455
4-3456

New York Phone
EDgcombe 4-7230

LENERTE ROBERTS

REAL ESTATE

101 North 52nd Street

FAIRMOUNT SOCIAL CLUB HISTORY AND AIM

The Fairmount Club was formed in March 1947 by a group of former athletes who had since the year of 1928 participated in all branches of sports and gave a good account of themselves throughout many States, for the purpose of improving, advocating, sponsoring recreational activities, and to create a consolidated community program.

The first venture undertaken was to sponsor a picnic for the children of this community, it was a gigantic affair with four (4) chartered trolleys and many automobiles being used for transportation. The children were taken to Druid Hill (Diary Field) in the beautiful Fairmount Park for the entire day, and 946 kids had the time of their young lives with plenty to eat and drink. Many games were played and competitive athletics participants were awarded valuable prizes. Returning home after 6:00 p. m.

In early September, the adults of the community were taken into our program, we sponsored an outing for them and many who couldn't afford a summer vacation to Wildwood, N. J. where provision for a picnic for the entire day was held. Nine (9) chartered buses were required for this gala throng.

During the entire summer, committees of club members were formed to take groups of boys to see Major League Baseball games, a total of 1000 for the season. Many were taken to the Circus, and through the courtesy of the Arena, twenty-five (25) boys and girls were well entertained at the Rodeo. Many other minor affairs were visited by boys and girls of this vicinity through the courtesy of other agencies by the club to have a complete program for the welfare of the community.

This coming season the club has on its adgender the same plans, but on a larger scale.

The Fairmount Social Club thanks every one for his or her co-operation in helping us complete a very successful year in building better community relation.

THIS PAGE AND OPPOSITE:

Many souvenirs of past events can tell much that is now forgotten about lifestyles, key people, and activities at a community level. They are now not so easy to find.

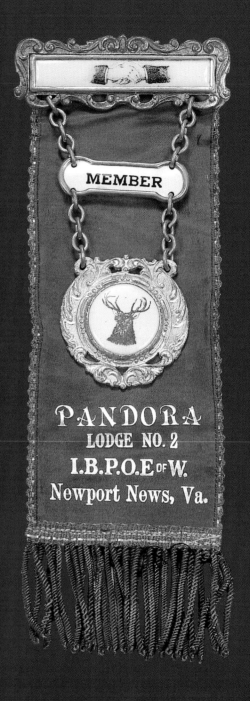

ABOVE: Among the most interesting artifacts that are often found are old badges and medals from lodges. They are colorful and easy to store., but more importantly, they often have family associations and personal meanings to collectors.

This makes them more than collectibles—instead they are treasured heirlooms, since many African Americans of the past were lodge members and participated in their local and national gatherings.

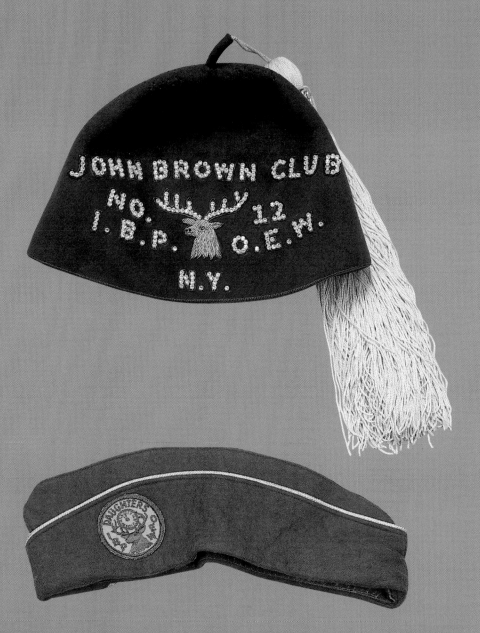

ABOVE: Past African American generations had benevolent organizations and lodges of various kinds that took care of them when they were hungry, sick, and old. These organizations often allowed them to pool their resources to help start and maintain businesses and gave them social status and a forum for group action. The lodge tradition has deep roots in West African secret societies.

RIGHT: Age is not always the only or primary factor in what people pay for collectible material. The artifacts usually found among the possessions of elderly African Americans often include lodge items, but rarely do they include swords—which were included in the paraphernalia of only a few of the male Masonic groups. Thus, even though this sword is not old by most standards, it is relatively rare since few are in general circulation. The fact that the original owner of this sword was identifiable and verifiably African American in addition to the fact that it comes with its the leather case enhances its appeal (and thus its price potential) even further.

FREEDOM IN ALBANY,

a documentary on

featuring "The Eagle Stirreth Her Nest"

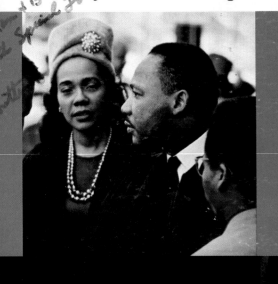

CAEDMON TC 9300

MY LIFE WITH MARTIN LUTHER KING, JR.
Told by Coretta Scott King

Build For Her

Y.W.C.A.

and Omaha's Future
Campaign November 9-16

Politics
and Civil Rights

TYPES OF ARTIFACTS

Letters and telegrams

Flyers and stickers

Posters and banners

Buttons and badges

Photographs

News film, videotape, and
 audiotape

Implements: pens, desk items,
 and letter openers.

Sample ballots

News clippings

Personal belongings of political
 leaders

Autographs

Speeches

Books and magazines

Objects reflecting the change in
 racial identity, from Negro to
 Black: Afro combs, records,
 poetry, and Black is Beautiful
 advertising

Newsletters of civil rights and
 Black pride organizations:
 NAACP, the Urban League,
 Congress On Racial Equality
 (CORE), Black Panthers,
 The Nation of Islam, Southern
 Christian Leadership
 Conference (SCLC)

Programs and tickets to events:
 benefits, rallies, and protests

THE AFRICAN AMERICAN POLITICAL EXPERIENCE IS ONE of the most important and emotional genres of collecting Black history. African American political advancement efforts do not follow a straight or upward path. Rather, there has been a rough pattern of two steps forward, one step back—sometimes even one and a half steps back—and yet later, another step forward. As researchers, scholars and well-taught collectors have found out, African Americans have been through a long history of great victories followed by heartbreaking defeats tempered by new hope and gradual resurgence in a later generation. The fact that the Civil Rights movement and the increase of Blacks in politics occurred relatively recently and raised issues that remain pressing concerns for African Americans makes this one of the hottest fields in Black collectibles.

What to Look For

When evaluating African American historical collectibles, it is generally true that older artifacts are worth more historically and financially but when it comes to political collectibles, this is not always the case. Though comparatively recent in historical terms, original material from the Civil Rights movement is among the most highly sought. The demand for civil rights memorabilia and for political memorabilia from the 1920s through the 1950s has outpaced the supply and prices are going through the roof. Though it is a relatively recent period by historical standards, 1960s and 1970s Civil Rights items are not easy to come by anymore. Ironically, many of those vilified at the time are among the most collected today: anything to do with Malcolm X, the Black Panthers, the Nation of Islam, or other leaders and groups promoting Black Power are in great demand.

Canons of Race Progress

Industry, economy, improvement of time and of the mind. Temperance in all things. Obedience to lawful authority. Forgetfulness of past difficulties. Hopefulness and activity for the future. Live peaceable with all men. Get hold of the land. Own your own home. Support your own institutions, avoiding charity. Govern them and thus develop capacity. In the clash of conflicting interests WEALTH is mightier than intellect. Both combined sway the world. To every child a trade. Patience, steadiness, perseverance, conquer all things.

But knowledgeable, enterprising scouts are discovering collectibles pertaining to less famous, historically important people from the Civil Rights and Black Power movements. When researching lesser-known political figures, the best sources are people who were politically active in those movements at that time. You may find that many of them are saving their own Black political memorabilia to pass on to their children, or donate to research institutions or libraries, but any African American who lived through the turbulent political climate of the 1950s through the 1970s can be a helpful resource. At the very least, someone with firsthand experience can lead you to books that can help you build your own expertise and advance your search for political memorabilia. And don't forget to bring a tape recorder so that you can record your interviews and conversations. Each person's account of what he or she lived through is part of the African American oral tradition.

Interpreting the Informational Value

The heart of any piece of Black political memorabilia is its informational value. When examining and interpreting a particular document, photo, or other object, be sure to gather key information about the time period, political era, location, personalities, and significant events. This informational quality can also tell you about the political ideologies surrounding this particular object and lend insight into a specific historic event.

As when researching a collectible pertaining to a sports or entertainment celebrity, it is equally important that you gather as much information about how an object that pertains to a political figure helps you understand a particular phase of that person's life and career.

Anything which gives new insight into a politician's or leader's life will be considered rarer and more valuable than something more obvious.

ABOVE AND OPPOSITE:
This influential 1886 partial broadside describes a credo of Black self-reliance, self-advancement, and business progress as well as depicting several Black educational institutions. It contains quotes from leading Black thinkers of the time in a light blue central panel: Richard Greener (nineteenth-century scholar-activist and first Black graduate of Harvard College), J.C. Corbin and W.S. Scarborough, the scholar and college president. It lists a ten-point creed of "Lines Of Advancement" for Blacks that advocates capitalism but also includes initiatives such as building churches, writing books, and interestingly, female physicians and painters. Though part of it (the upper and left edge portions) seems to be missing, the part that is present is extremely interesting and advanced for its time. This is an extremely important and rare historical document about nineteenth-century racial advancement beliefs and strategies.

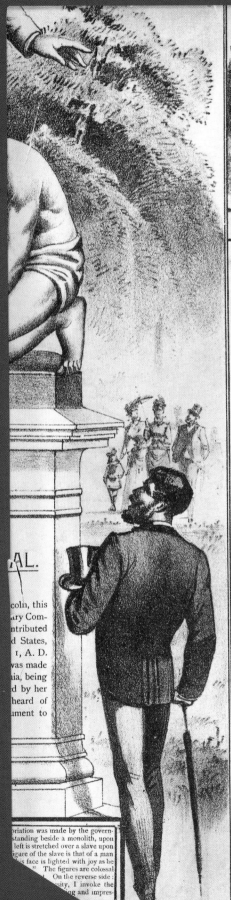

Branch Normal College of Arkansas Industrial University, Pine Bluff, Ark.
Opened 1876. One Large Building. Average attendance 225.
Faculty of Three. Valuation of Institution, $25,000.
JOS. C. CORBIN, A. M., Principal.

LINCOLN INSTITUTE, Jefferson City, Mo.
Founded 1866. Two Buildings.
Average attendance 157. Faculty of Seven. Valuation of Institution, $66,000.
INMAN E. PAGE, A. M., President.

LELAND UNIVERSITY, St. Charles Ave., New Orleans, La.
Founded 1870. Two Buildings.
Average attendance 250. Faculty of Twelve. Valuation of Institution, $200,000.
REV. HARVEY R. TRAVER, A. M., President.

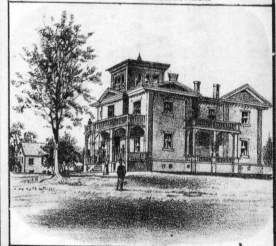

TOUGALOO UNIVERSITY, Tougaloo, Miss.
Opened 1869. Four Buildings.
Average attendance 300. Faculty of Seventeen. Valuation of Institution, $65,000.
REV. G. STANLEY POPE, A. M., President.

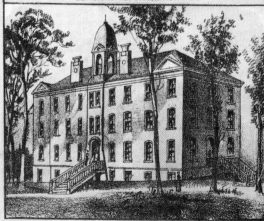

BISHOP COLLEGE, Marshall, Tex.
Founded 1881. Five Buildings.
Average attendance 255. Faculty of Six. Valuation of Institution, $55,000.
REV. S. W. CULVER, A. M., President.

Canons of Race Progress

Industry, economy, improvement of time and of the mind. Temperance in all things. Obedience to lawful authority. Forgetfulness of past difficulties. Hopefulness and activity for the future. Live peaceably with all men. Get hold of the land. Own your own home. Support your own institutions, avoiding charity. Govern them and thus develop capacity. In the clash of conflicting interests WEALTH is mightier than intellect. Both combined sway the world. To every child a trade. Patience, steadiness, perseverance, conquer all things.

"The most hopeful sign for the negro of to-day is his indisposition to be carried and cared for. He aspires to own his own house, manage his own plantation, conduct his own business, teach his own school. It is not his fault that he cannot rid himself of the professed philanthropist and professed politician. They will insist, despite the negro's protest, upon paying, thinking, preaching, voting and caring for him."

RICHARD T. GREENER.

LINES OF ADVANCEMENT.

I. In building churches.
II. In benevolent organizations.
III. In publishing newspapers.
IV. In writing books.
V. In musical culture.
VI. As orators.
VII. Female physicians.
VIII. Sculptress. Miss E. Lewis.
IX. Painter. R. S. Duncanson (deceased).
X. Capitalists.

"The old African gentleman who used to wander sadly around creation 'stil longin' fur de ole plantation,' is now in Washington trying to have his son, Apollo Nicodemus, appointed a foreign minister."
J. C. CORBIN.

"Wonderful progress!! Unprecedented advancement in art, science and literature! Within twenty-five years the colored race has developed philologists, scientists, artists, theologians, jurists, physicians of rare merit and with recognized standing."
W. S. SCARBOROUGH.

The colored people of the United States have nearly 150 newspapers, teach 20,000 public schools, with nearly 1,000,000 pupils, and it is estimated that they raise annually 150,000,000 pounds of cereals and nearly 3,000,000,000 pounds of cotton. They started in 1863 with nothing except their own bodies. Can this peerless record be equalled?

The colored people of the South are coming to the front; their wealth is estimated at $100,000,000. In Georgia alone, they pay taxes on $10,000,000 worth of property. The colored people are learning that wealth and education are indispensable to the final solution of the race problem, and they are using every effort to obtain wealth.

AL.

coln, this ary Com- ntributed d States, , A. D. vas made ia, being d by her heard of ment to

opriation was made by the govern- standing beside a monolith, upon left is stretched over a slave upon figure of the slave is that of a man s face is lighted with joy as he The figures are colossal On the reverse side : sity, I invoke the g and impres-

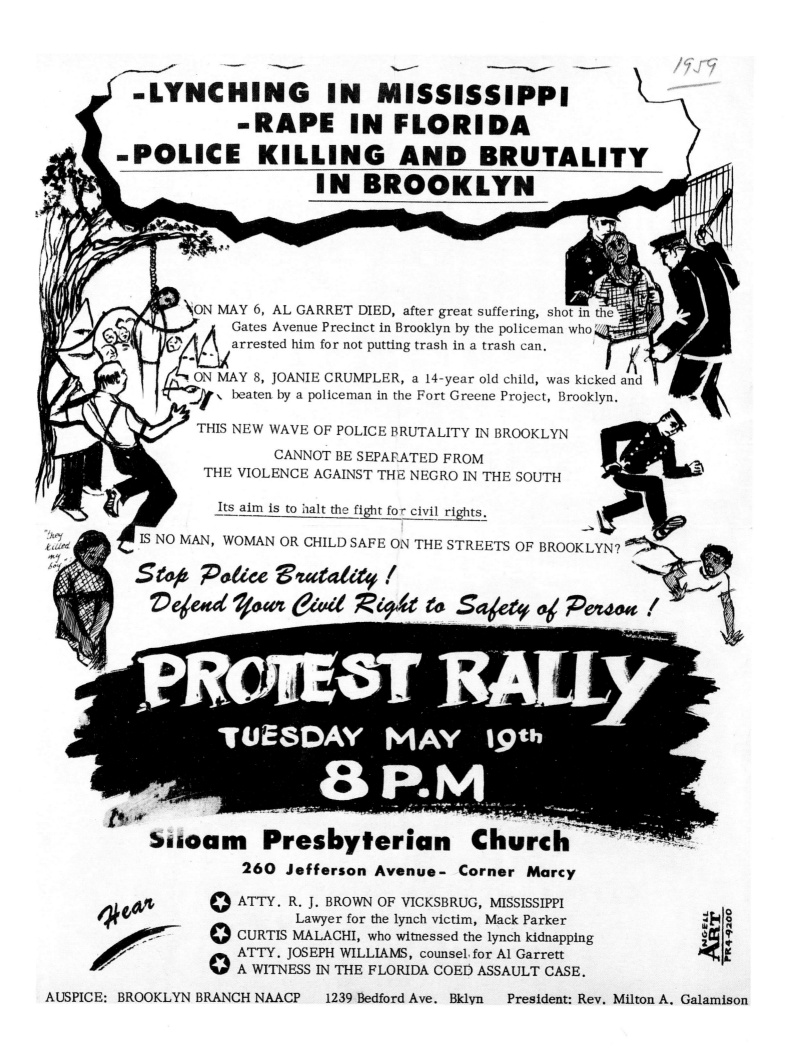

1959

-LYNCHING IN MISSISSIPPI
-RAPE IN FLORIDA
-POLICE KILLING AND BRUTALITY IN BROOKLYN

ON MAY 6, AL GARRET DIED, after great suffering, shot in the Gates Avenue Precinct in Brooklyn by the policeman who arrested him for not putting trash in a trash can.

ON MAY 8, JOANIE CRUMPLER, a 14-year old child, was kicked and beaten by a policeman in the Fort Greene Project, Brooklyn.

THIS NEW WAVE OF POLICE BRUTALITY IN BROOKLYN

CANNOT BE SEPARATED FROM
THE VIOLENCE AGAINST THE NEGRO IN THE SOUTH

Its aim is to halt the fight for civil rights.

IS NO MAN, WOMAN OR CHILD SAFE ON THE STREETS OF BROOKLYN?

Stop Police Brutality !
Defend Your Civil Right to Safety of Person !

PROTEST RALLY
TUESDAY MAY 19th
8 P.M

Siloam Presbyterian Church
260 Jefferson Avenue - Corner Marcy

Hear

✪ ATTY. R. J. BROWN OF VICKSBRUG, MISSISSIPPI
 Lawyer for the lynch victim, Mack Parker
✪ CURTIS MALACHI, who witnessed the lynch kidnapping
✪ ATTY. JOSEPH WILLIAMS, counsel for Al Garrett
✪ A WITNESS IN THE FLORIDA COED ASSAULT CASE.

ANGELL ART
PR 4-9200

AUSPICE: BROOKLYN BRANCH NAACP 1239 Bedford Ave. Bklyn President: Rev. Milton A. Galamison

RIGHT: W.E.B. Du Bois was one of the most important Black protest leaders of the first half of the twentieth century. A determined leader, towering political figure, and deep thinker, Du Bois was one of the founders of the National Association for the Advancement of Colored People in 1909 and edited its magazine, *The Crisis,* from 1910 to 1934. Anything related to him—especially uncommon items—is worth finding and keeping.

OPPOSITE: This flyer shows the mobilization of the African American community against a long-standing problem in both the north and the south. Lawyers, ministers, and the membership of the local NAACP were at the forefront of the issue. Fragile and easily thrown away, very few such evidences of both the problem and the community's response have survived. They are now highly treasured and useful for remembering forgotten local events.

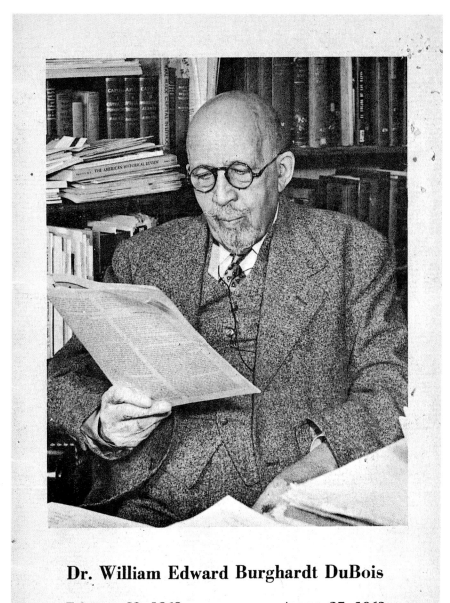

Dr. William Edward Burghardt DuBois

February 23, 1868 **August 27, 1963**

THIS PAGE: As this Ku Klux Klan magazine demonstrates, racism was still a real threat well into the twentieth century, affecting African Americans in the North as well as the South. At the same time the Harlem Renaissance was gathering steam in New York City, militant racism was being promulgated in the same state.

OPPOSITE: In addition to their legal and political leadership, an important function of civil rights organizations was their ability to recognize and honor accomplishments of those who made key contributions to race advancement.

40th
Spingarn Medal

Awarded to

Dr. Carl Murphy

NAACP's Annual Convention
Atlantic City, New Jersey
June 24, 1955

A
Century of Negro Progress
June 15 to November 15, 1936
At
LAKE COMO, Fort Worth, Texas
The Frontier Centennial City

HEADQUARTERS:
509 Grove St.
Phone 2-0191

May 14, 1936.

Mr. Euclece Peacock
Temple University,
Philadelphia, Pa.

Dear Sir:

There is being staged in Fort Worth, Texas, "A Century of Negro Progress". This Exposition will run concurrently with the Frontier Centennial Exposition which will be staged here under the auspices of the White Citizens of this City and State. The Exposition, "A Century of Progress", is being staged under the auspices of the Colored Citizens of Fort Worth, Texas and Texas to serve as a depiction of the transitional stages through which Negro Life has evolved. As one of the celebreties in your field, and further, being a member of the Negro Race, you are requested to be present to play a conspicuous part in this Exposition, "A Century of Negro Progress." Please write me at your earliest convenience just about what time and under what conditions you can be present. I would like for it to be at such a time when I can secure other Stars such as: Jesse Owens and Ralphe Metcalf. I trust that you will arrange to be present as this promises to be the most unusual attraction ever attempted by Negroes in America for the purpose of creditably reflecting the finer qualities and worth while achievements of our people.

I shall expect an immediate answer from you regarding this matter, after which, I will be able to write you in detail.

Very truly yours,

T. S. Boone,
General Manager
"A Century of Negro Progress"

TSB/ejl

Build For Her

and Omaha's Future
Campaign November 9-16

RIGHT: In this letter to the Black track star of the 1930s, Eulace Peacock, General Manager T.S. Boone requests his participation in the exposition and stating that other celebrity athletes (Jesse Owens and Ralph Metcalfe) will be invited also. Written on behalf of the colored citizens of Ft. Worth, it states that the purpose of the Century Of Negro Progress exposition is to reflect "the finer qualities and worthwhile achievements of our people." This correspondence is a rare embodiment of organized efforts to assert Black worth in the southwest in the Depression years. Note the original envelope that accompanies the letter; the completeness of this piece of correspondence adds to its value.

THIS PAGE: YWCAs and YMCAs played a very important community role in the past and still do. They were community centers, educational resources, residential facilities and youth development agencies all rolled into one. Their reach extended even to places where there was not a large African American community.

North Side Branch
Young Womens Christian Association

2306 North 22nd Street
Omaha, Nebraska
Phone Webster 1539

Seventy Thousand Dollars

Needed to Carry on the 1921
Program of
THE YOUNG WOMEN'S CHRISTIAN ASS'N

HOW IT WILL BE SPENT

Budget Difference for 1921......$42,200
Bills Payable......................$ 4,000
Camp Brewster Equipment......$ 8,000
Residence Equipment...........$ 1,030
Residence Deficit................$ 6,000
Colored Branch Property and
 Equipment....................$ 8,800

Total - - - - - $70,000

WHAT THE Y. W. C. A. IS DOING
FOR THE COLORED GIRLS
OF OMAHA

Work for the Colored girls was begun January, 1920. The Association has purchased a property, two lots and bungalow, 22nd and Grant Sts., for use as a Colored Center. It is being remodeled to furnish dormitory, large recreation room, kitchen and secretary's headquarters. This building will be opened early in November.

Omaha has a colored population of 15,000. Everyone is urged to participate in this campaign and help send the Y. W. C. A. over the top.

What Will Your Contribution Be?

The Y. W. C. A. provides
girls with

Educational Classes	Study Club
Business Course	Recreation
Rooms Registry	Millinery
Dressmaking	Cooking

Employment Department

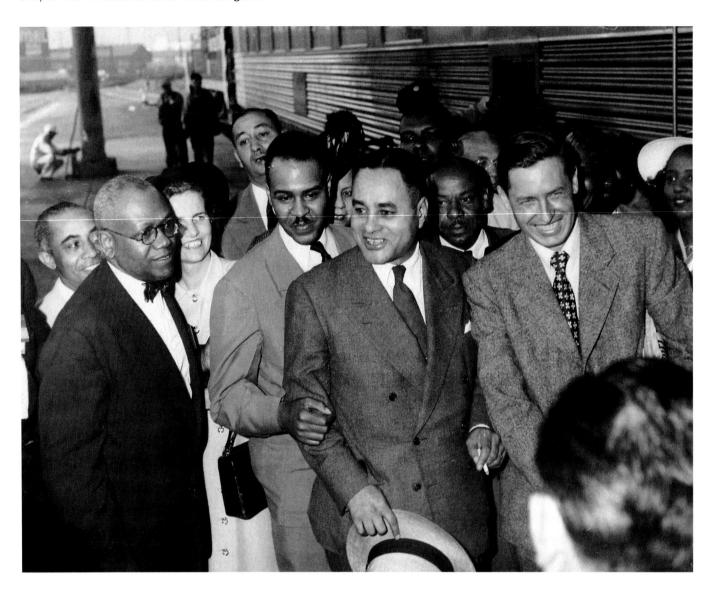

ABOVE: This 1949 photograph of Ralph Bunche, Roy Wilkins (who had been named acting executive secretary of the NAACP that year), Henry Moon, and Congressman Bob Rodgers was taken upon Bunche's arrival at Union Station in Los Angeles, where he had traveled to receive the NAACP Spingarn Medal. Although historically important, this is a candid shot, capturing the smiles of participants and the feeling of the moment.

OPPOSITE: Ralph Johnson Bunche—statesman, diplomat, scholar and civic leader—was a leading figure of the Civil Rights movement and beyond. He is best known for his work as a diplomat, negotiator and peacemaker for the United Nations, but he had a long and distinguished career even before that. Instrumental in negotiating a 1949 armistice between warring Palestinian Arabs and Jews, he was awarded the Nobel Peace Prize in 1950. He was the first Black recipient of that honor. This photo is from that important period.

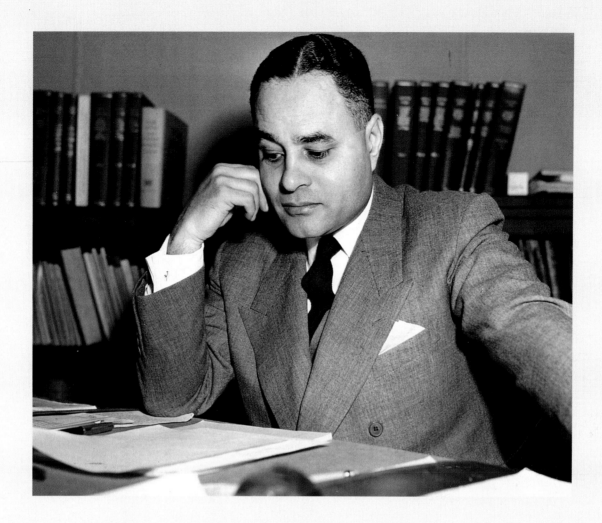

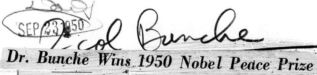

Dr. Bunche Wins 1950 Nobel Peace Prize

Receives Award for Work as Palestine Mediator; First Negro So Honored

By The United Press

OSLO, Norway, Sept. 22.—Dr. Ralph J. Bunche, forty-six-year-old American educator and United Nations official, today was awarded the Nobel Prize for 1950. He became the first Negro ever to win the Nobel award.

Dr. Bunche received the honor for his services as United Nations mediator in the Palestine war. He will be presented with $31,410 and a gold medal.

The Nobel Prize committee of the Norwegian Parliament, which announced the award, did not disclose the names of other candidates under consideration, but they were known to include President Truman, Winston Churchill, Gen. George C. Marshall and Indian Prime Minister Jawaharlal Nehru.

Dr. Bunche was assistant to Count Folke Bernadotte, Swedish U. N. mediator who was assassinated Sept. 17, 1948, while trying to bring peace to the Holy Land. After the assassination, Dr. Bunche became acting mediator and was successful in arranging cease-fire agreements between the Arab countries and the state of Israel.

Dr. Bunche was on the Mediter-

(Continued on page 4, column 5)

Dr. Ralph J. Bunche at his desk in the United Nations
United Nations

(Background as is)

5/8

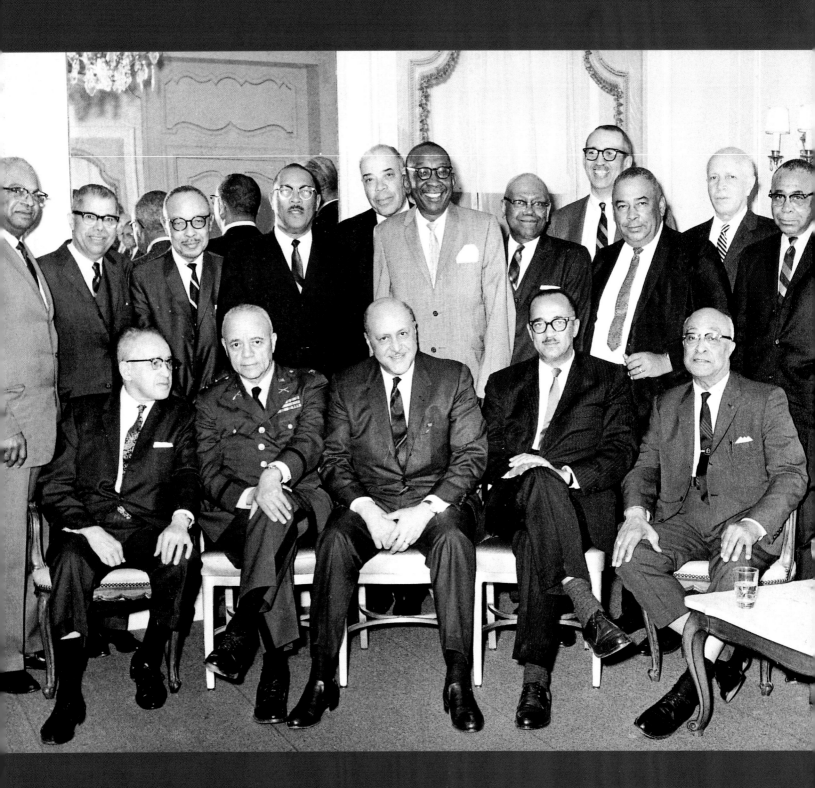

ABOVE: Robert Weaver was the first Black cabinet member, appointed by President Kennedy to head the Housing and Home Finance Agency in 1960. In 1966, President Johnson named him head of the new Department of Housing and Urban Development. This 1961 photograph features sixteen prominent Black men who were celebrating Weaver's cabinet appointment. Weaver was a Harvard graduate and noted economist and the dinner guests were prominent people, including Judge William Hastie, who was the first African American federal magistrate and the first African American governor of the Virgin Islands.

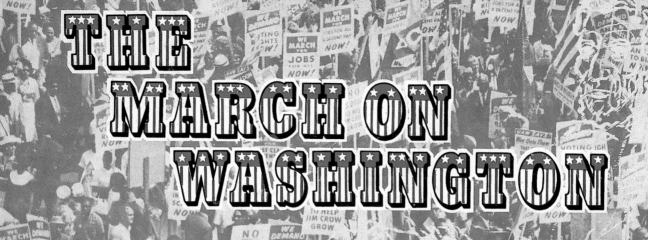

THE MARCH ON WASHINGTON

A Chronological History of Negro Contributions

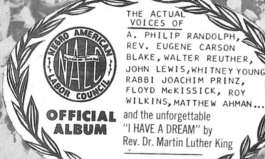

THE ACTUAL VOICES OF A. PHILIP RANDOLPH, REV. EUGENE CARSON BLAKE, WALTER REUTHER, JOHN LEWIS, WHITNEY YOUNG, RABBI JOACHIM PRINZ, FLOYD McKISSICK, ROY WILKINS, MATTHEW AHMAN...

OFFICIAL ALBUM and the unforgettable "I HAVE A DREAM" by Rev. Dr. Martin Luther King

NEGRO AMERICAN LABOR COUNCIL

NARRATED BY RALPH COOPER

Mr. Maestro

ABOVE: There are several March On Washington recordings, all of which were once abundant but are now gradually becoming less common. This one is among the more uncommon ones and has a few distinctions that the others do not. For example, it is described as the official album and was narrated by actor and stage personality Ralph Cooper.

OOTO DTL 841

MARTIN LUTHER KING
THE AMERICAN DREAM
RECORDED AND EDITED BY DOOTSIE WILLIAMS

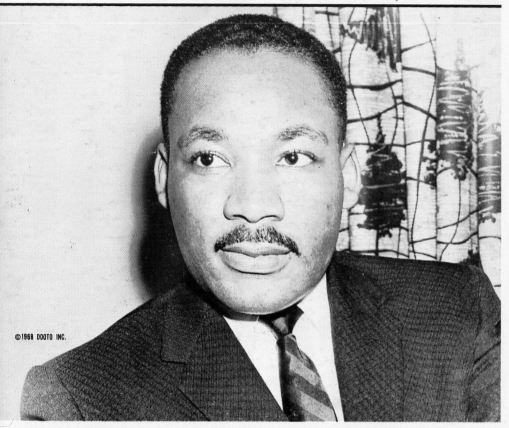

©1968 DOOTO INC.

1

THIS SPREAD AND NEXT PAGES: Dr. Martin Luther King, Jr. was the preeminent African American leader, liberator and hero of the twentieth century. Because King's life and work embodies freedom, civil rights, and racial advancement, he is justifiably honored and remembered by commemorative objects and images in many forms, becoming a collectible subject unto himself. Some of the many types of King memorabilia are presented here:

(1) This relatively scarce record is one of many featuring his speeches. (2) Mrs. Coretta Scott King has become a leader and celebrity in her own right, carrying forward King's message and his work for social justice for all people. This record bears her personal inscription and autograph. (3) This casket portrait of Dr. King is rarely seen. (4) The image on this commemorative plaque can be found in homes, churches, funeral parlors, barber and beauty shops, and many other places all over Black America. (5) The commemorative coin and accompanying portrait of Dr. King is not too common and shows the tremendous outpouring of grief that resulted from his death. (6) Items related to the King family that are not widely published or media related are naturally scarce and desirable. (7) This key chain is another piece of Martin Luther King memorabilia that used to be more common than it is now. (8) These pendants show the variety of objects displaying Dr. King's image. These items are inexpensive but deeply meaningful and have an emotional and often religious appeal to those who own them. They represent one of the major forms in which the multitude celebrates, accumulates, and displays African American history.

CAEDMON TC 9300

MY LIFE WITH MARTIN LUTHER KING, JR.
Told by Coretta Scott King

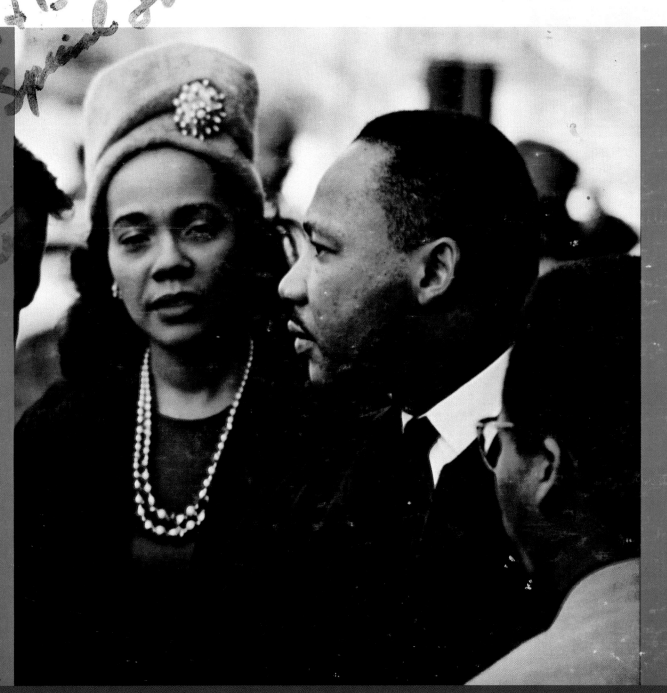

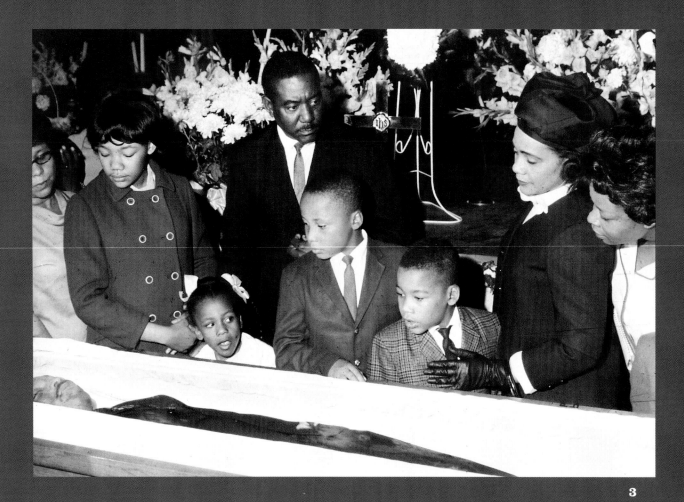

3

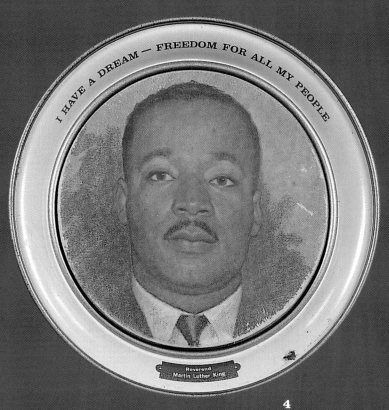

I HAVE A DREAM — FREEDOM FOR ALL MY PEOPLE

Reverend
Martin Luther King

4

5

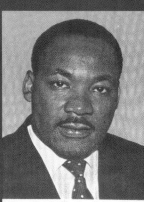

Dr. Martin Luther King, Jr.
Born January 15, 1929
Died April 4, 1968

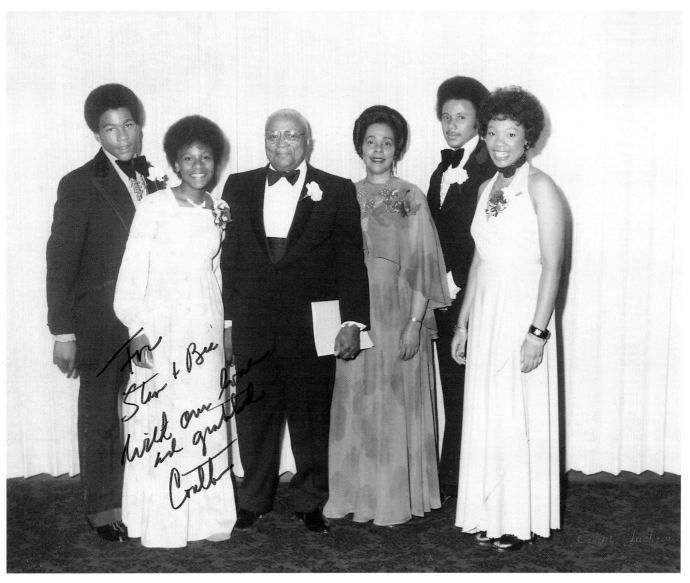

6

7

8

MALCOLM X

a first
NEGRO BOOK CLUB, INC.
special edition

Speaks Again

LP-100 VOL. 1

GRAND RECORDS

ABOVE: Malcolm X is now accepted, revered and celebrated as one of the greatest Civil Rights leaders—a status that was often denied to him when he was alive. This recording of his speeches by a now-defunct organization cannot be found easily.

OPPOSITE: Civil Rights memorabilia is now heavily collected and sometimes shockingly expensive. This recording from earlier in the Civil Rights movement reflects the mood of the demonstration period and was produced by the Student Nonviolent Coordinating Committee (SNCC).

FREEDOM IN THE AIR

a documentary on

ALBANY, GEORGIA

STUDENT
NON-VIOLENT
COORDINATING
COMMITTEE
SNCC-101

featuring "The Eagle Stirreth Her Nest" Rev. Ben Gay

1961
1962

ORIGINAL IDEA & FIELD WORK — GUY CARAWAN PRODUCED BY ALAN LOMAX & GUY CARAWAN

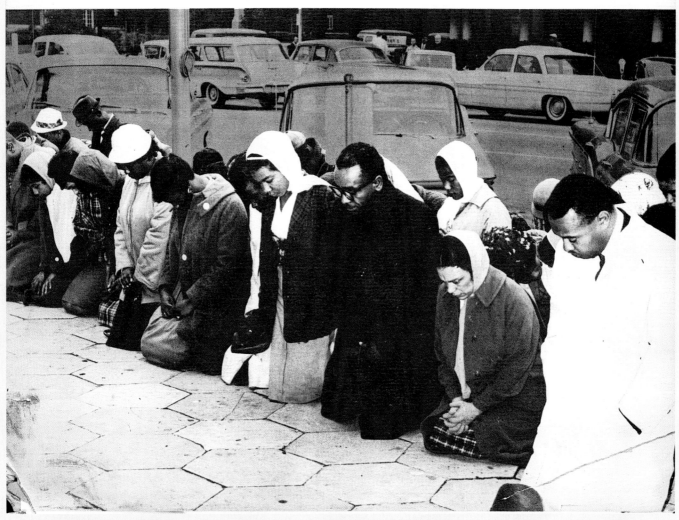

EIGHTH ANNUAL

AFRICAN-AMERICAN DAY PARADE

SOUVENIR JOURNAL

September 12, 1976

THIS PAGE: Many local communities developed their own heritage celebrations in the 1970s. The souvenir journals from these events are excellent repositories of history, often featuring key personalities and their communal contributions.

OPPOSITE: The letter relates to the activities of a local NAACP chapter in Pennsylvania.

Grand Marshal
JUDGE BRUCE WRIGHT

▪

Parade Marshals
HON. ESTELLA DIGGS
HON. CHARLES RANGEL
HON. PERCY SUTTON
HON. ARTHUR BARNES

▪

HONORARY GUESTS

Senator Vander Beatty	Assemblyman Woodron Lewis
Judge William Booth	Commissioner Benjamin Malcolm
Assemblyman Guy Brewer	Senator Carl McCall
Dr. Eugene Callender	Floyd McKissick
Congresswoman Shirley Chisholm	Assemblyman George Miller
Ossie Davis	Queen Mother Moore
Ruby Dee Davis	Commissioner Eleanor Norton
Dave Dinkins	Senator Major Owens
Commissioner James Dumpson	Basil Paterson
William K. DeFossett	Councilwoman Mary Pinkett
Marshal England	Commissioner Lucille Rose
Assemblyman Arthur Eve	Councilman Fred Samuels
Minister Lonis Farrakhan	Harold Sims
Assemblyman Herman Farrell	Councilman Archie Spigner
Assemblyman Thomas Fortune	Judge Thomas Sinclair
Senator Joseph Galiber	Gloria Thomas
Paul Gibson	Assemblyman Al Vann
Assemblyman Edward Griffith	Rev. Wyatt T. Walker
Assemblyman Charles Hamilton	Dr. Benjamin Watkins
Gladys Harrington	Judge James L. Watson
Dr. John Holloman	Roy Wilkins
Roy Innis	Councilman Sam Wright
Vernon Jordan	Judge Livingston L. Wingate
J. Bruce Llewellyn	(List Incomplete)
William H. Johnson, Jr.	

Ossie Davis in 1969 parade

*Livingston Wingate and the late Adam Clayton Powell, Jr.
in 1970 parade*

Norristown Association for the Advancement of Colored People

OFFICE—14 WEST ELM STREET
NORRISTOWN, PA.

OUR TRIP TO LURAY CAVE AND OTHER

POINTS.

Saturday morning September 17th we left Norristown enroute to Harpers Ferry to matriculate my son Daniel for Storer College. Our party consisted of Dr. O. Wilson Winters, Daniel A. Wilson Jr., Dr. D. A. Wilson and myself.

When we left Norristown at 6:45 it was raining, on we went through the mist and rain, reaching Paoli, on through Downingtown and Lancaster arrived at Gettysburg at 11:00. There we had lunch mailed some cards and started on our journey.

On through Gettysburg, Jefferson, Thurston and Fredrick, Md. Arrived at Harpers Ferry at half past three Oclock P.M. The trip from Fredrick to Harpers Ferry was very enjoyable to me, those huge mountains and beautiful scenery I had never seen the like before.

We went on through the mountains to the College, A splendid structure situated on a mountain, over looking a vast territory of beautiful and historic scenery.

The president greeted us in a most cordial manner, we were shown through the building, and every thing being satisfactory we departed for the nearest town, to find lodging for the night as we were all tired out and very hungry. We throughly enjoyed the trip from Harpers Ferry to Charlestown W. Va. We were directed to the beautiful home of Mr. and Mrs. Hughes where we were well cared for until the next day.

Charlestown is quite a historic place, it was there that John Brown was tried sentenced and hanged. The Court House in which his trial took place is still standing on Main St. Near this town is a cave where it is said, George Washington with other prominent men held Masonic meetings.

Now for our trip to Luray Va. We left Charlestown Sunday morning about ten o'clock on we went through Winchester, Strasburg, Edinburg, Mt. Jackson, New Market to Luray Va. Our trip was through the most beautiful historical Valley of Shenandoah, this famous valley, as a frontier of the colonies which experienced the horrors of Indian massacres as the battle grounds of the French and Indian war; as the point Daniel Morgan conducted operations against the British in the Revolution; and later as the scene of Stone Wall Jackson's Valley campaign and of Sheridans Ride, will ever be a region of interest to Americans.

The scenery of the Valley is very beautiful. One approaches it through the mighty gateway of Harpers Ferry where the Potomac River breaking through the Blue Ridge joins the Shenandoha, and the road dropping to the river level climbs and climbs again until from the top of the towering

Norristown Association for the Advancement of Colored People

OFFICE—14 WEST ELM STREET
NORRISTOWN, PA.

Washington about 7:30 had dinner at the White Law Hotel then to the beautiful and hospitable home of our friend Mrs. A. A. Thomas found her much improved in health and we enjoyed our stay there very much. Wednesday at noon we went to the station to see Dan off as he had to return to Harpers Ferry. With tears and smiles we said good-bye to Daniel at 1-22. We left Washington for home; coming through Baltimore, Willmington, West Chester to Norristown. Just as we reached West Chester rain began to fall it was so dark at times we could not see our way but we were anxious to get home so on we came. We had crossed some grand and beautiful bridges but old De Kalb Street bridge looked better to us than any other. It was eleven o'clock when we rolled into Norristown and it certainly did look good to us for we were tired, chilly and hungry.

Norristown Association for the Advancement of Colored People

OFFICE—14 WEST ELM STREET
NORRISTOWN, PA.

cliff it looks down upon the confluence of two great rivers, the valley Pike proper begins at Winchester and winds delightfully along the broad and fertile slopes of the valley, the serrated line of the Alleghany blue against the sky in the west the Blue Ridge escarpment on the east while about half way down the valley the singular short range called the Massanutten rises abruptly and parallel to the other ranges, its rugged masses and sharp precipices in dramatic contrast to the grave and quiet sky line of the Blue Ridge, many clear springs and swift brooks and streams hurrying to join the river do their part for that fertility which has given the valley its so thrilling and traggical place in history. Rich in fruit and grain live stock grist mills, all the necessities for the support of an army, it was well called the grandery of the confederacy, Possessed by confederates, desired by the federal army, the valley became the campaigning ground the great valley Pike, the beaten track of both armies the scene of much brilliant strategy and many hard fought battles and suffered at the close of the war, and almost complete devastation. There are marked places all along the way giving account of the battles fought and the troupes engaged.

Winchester Va. Is the second oldest city in Va. it was here that George Washington after Braddocks defeat built Ft. Loudoun and established his head quarters during the French and Indian War, General Dan'el Morgan of the Revoluternary fame is burried there.

Strasburg, due to its location commanded the entrance of both halves of the valley and there a stategic center in Stone Wall Jackson's battle campaign which he initiated by compelling General Bankes to evacuate hg town

New Market is one of the oldest and most beautifully situated town in the valley, the north fork of the Shenandoah river flows behind a range of hills that rises high above the town to the north west, to the South east flows Smiths creek a winding mill stream at the foot of the Massanutten Mts, In the battle of New Market was fought along the edge of the town, charged the charge of the V. M. I Cadets, one of the most remarkabl episodes of the civil war this batallion of boys, from fourteen to twenty years of age was ordered from school at Lexington Va. to join the forces of General Breckenridge, in a desperate crisis of the latest months of the war.

From New Market to Luray is a Long, rugged, rough and lonely road over the Mts. we were very glad when we had crossed over. Luray is a quiet but popular resort especially in summer, because of its high altitude its unrivaled splendor of landscapes, its historical association and the wonderful caverns.

We arrived there about five o'clock inquired our way to the Slater House where we were to stop over night. After a good southern dinner we started for the cave. There were six in our party so we were given special interest as is the custom when the party numbers six or more.

The caves were discovered in 1778 and shortly after were opened to

Norristown Association for the Advancement of Colored People

OFFICE—14 WEST ELM STREET
NORRISTOWN, PA.

the public, Their great extent was not then known, or even dreamed of and not until thoroughly equipped exploring parties had penetrated seemingly endless chambers and passages with their boundless riches disclosed and made accessible to visitors. Since that time the fame of the caverns has penetrated the uttermost parts of the earth. Visitors from all over the world, scientists, explorers and tourists have wandered through the wonderful chambers, and the general verdict of the united testimony is that Luray caverns excel all others in their calcite formations.

On entering the cave the first emotion is one of mute wonder. The mind fails to grasp the grandeur revealed in such a majestic manner. Queer shapes present themselves at every turn, aping grotesquely the objects of the outer world now suggesting some growth of animal life, now resembling some familiar vegetable formation or taking the shape or form of some creation of many glittering stalactites blaze in front, fluted columns draperies in broad folds, and a thousand tints cascades of snow white stone illuminated by the glare of the electric lights, fill the mind with curious sensations of wonder and admiration. Various apartments and objects have been named in honor of some distinguished personage or after something to which they bear a striking resemblance. The Elfin Ramble is the play ground of the princess of this fairland. It is perfectly wonderful, Pluto's Chasm, a wide rift in the walls, contains a spectre clothed in shadowing draperies

Hoveys Hall adorned with statuary and stalactic draperies which for beauty and coloring cannot be excelled. Grants Hall is a vast space embracing several chambers, Heroic sentinel forms loom up on every side guarding the marvelous beauty of Titians veil, and watching over the crystal water of Dinas Bath. The Saracensfont, the cathedral, with its grand organ and bridal chamber, all bear striking resemblence of the objects for which they are named. Hades a region sparkling with limpid lakes and peopled with gob goblins, receives the name from the bewildering windings through which the tourists must tread his way, not with standing its uninviting name, it is a very attractive portion of the cave and contains many wonderful formatin The Ball Room a magnificent apartment, georgeously furnished and full of interest, Cambells Hall named for the discoverer of the cave is rich in beautiful and enchanting ornamentation.

In addition to the solid formation of stone and crystal a number of beautiful lakes are found in various parts of the cave. Columns grand and beautiful and pieces representing statuary both in bronz and marbel are abundantly interspersed throughout the cavens the guide lights the cave as we went along and explained everything in detail. Some scientists believ that the formations have been forming since the flood.

After one hour and a halfs journey through the cave and two hundred and fifty feet below the level, we came out very tired as it was first up and then down steps through rough and narrow passage ways we had to go. Then we went back to the Hotel where we spent a very comfortable night. After breakfast the next day (Monday) We left enroute to Harpers Ferry.

We left Harlers Ferry for Washington about five o'clock arrived at

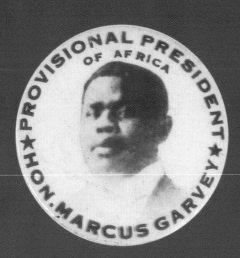

★ PROVISIONAL PRESIDENT ★ of AFRICA HON. MARCUS GARVEY

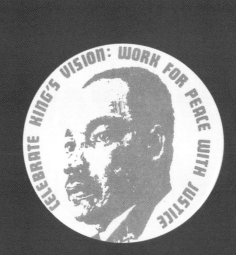

CELEBRATE KING'S VISION: WORK FOR PEACE WITH JUSTICE

EMANCIPATION MARCH
AUGUST
28
1963
ON WASHINGTON

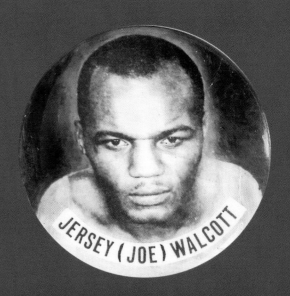

JERSEY (JOE) WALCOTT

NEW YORKERS for
Jesse
Jackson
'88

VOTE
FOR
EVERS

THIS PAGE: Stamps are the smallest kind of African American history "documents" that most collectors will encounter. The stamps depicted here were produced in the 1940s and are collectible because they represent one of the best early examples of African Americans receiving recognition on a nationally distributed official object.

OPPOSITE: This selection of buttons again illustrates the many forms African American history can take. Most are related to political themes or racial advancement (with the exception of the scarce sports-related Jersey Joe Walcott button that is probably form the 1950s). The rarest and most expensive button is of course the Marcus Garvey button— judging from its back, it is probably from the 1930s or 40s. Though the great majority of pinback buttons are newly made and thus constitute cheap, mass-produced forms of collectible history, do not be lulled into a false sense of price security. Rare and desirable buttons can easily reach two- or three-digit price levels as collector's items. On the other hand, occasionally, the lucky collector can find interesting and valuable old buttons among the possessions of an older friend or family member.

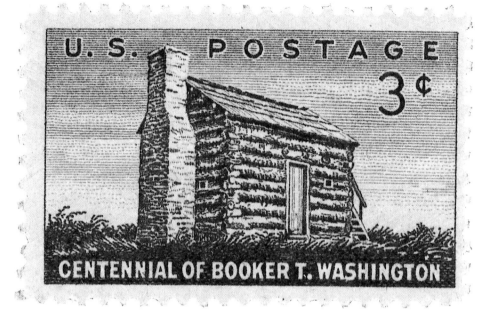

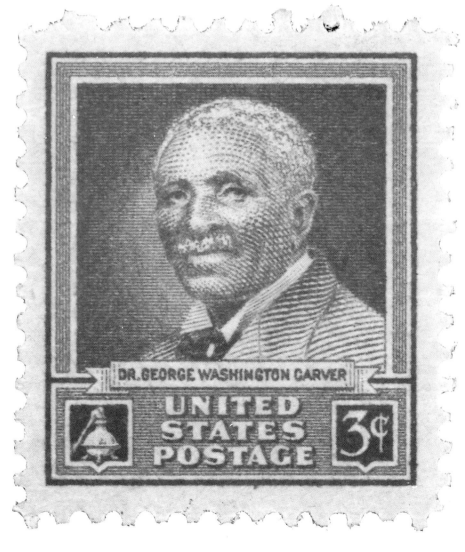

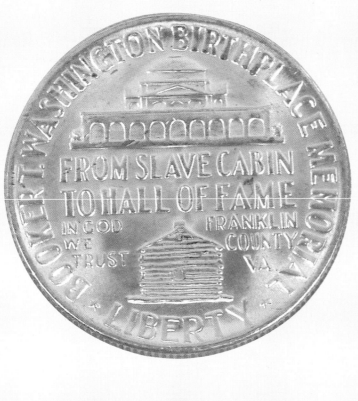

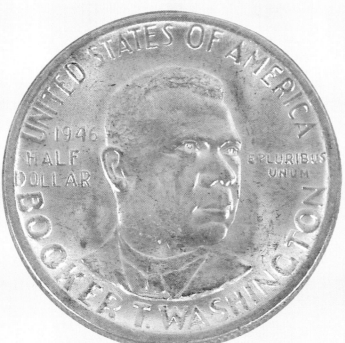

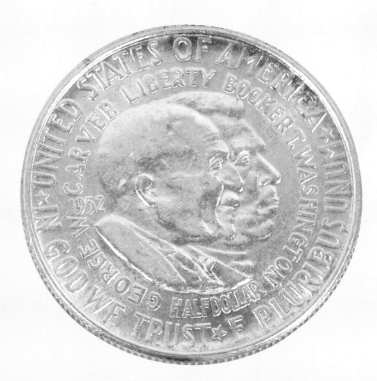

ABOVE: There are few instances of African Americans appearing on official coins. Among the first "positive" images of African Americans on coins were a set of coins bearing the image of Booker T. Washington and George Washington Carver in the mid-twentieth century. The recognition of these men is a reflection of the great respect with which their work on behalf of African American education was greeted. Thankfully, these coins are still in good supply and are not prohibitively expensive.

OPPOSITE: This NAACP supporter medal is worth owning, but not easily found on the open market.

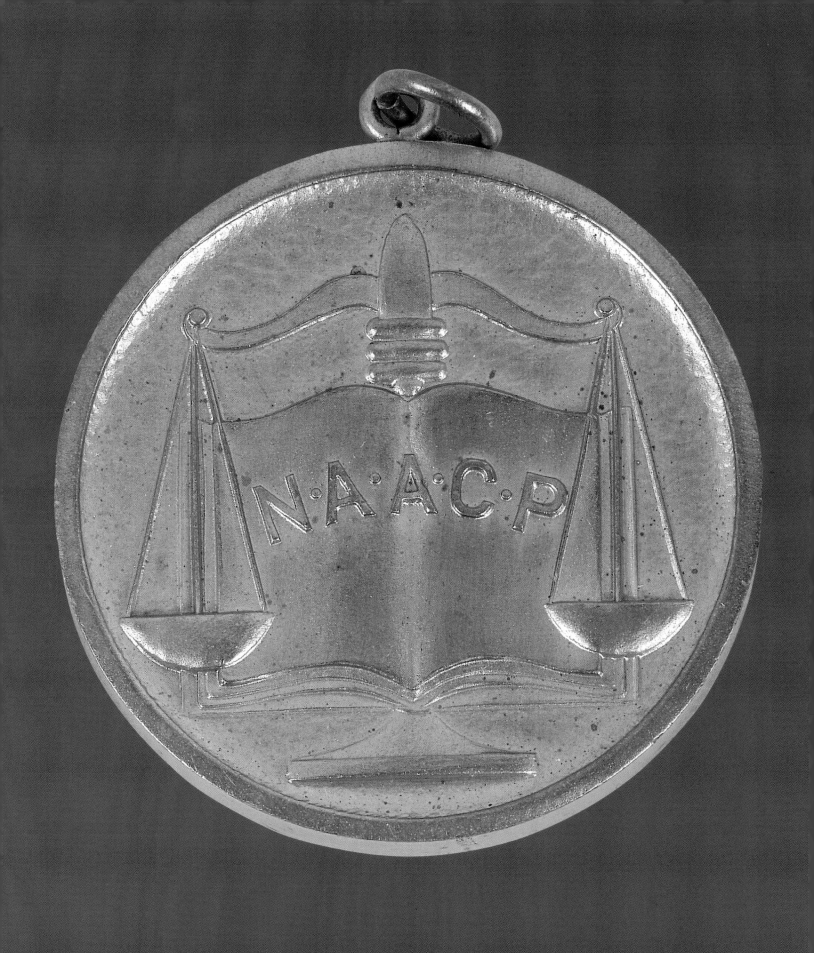

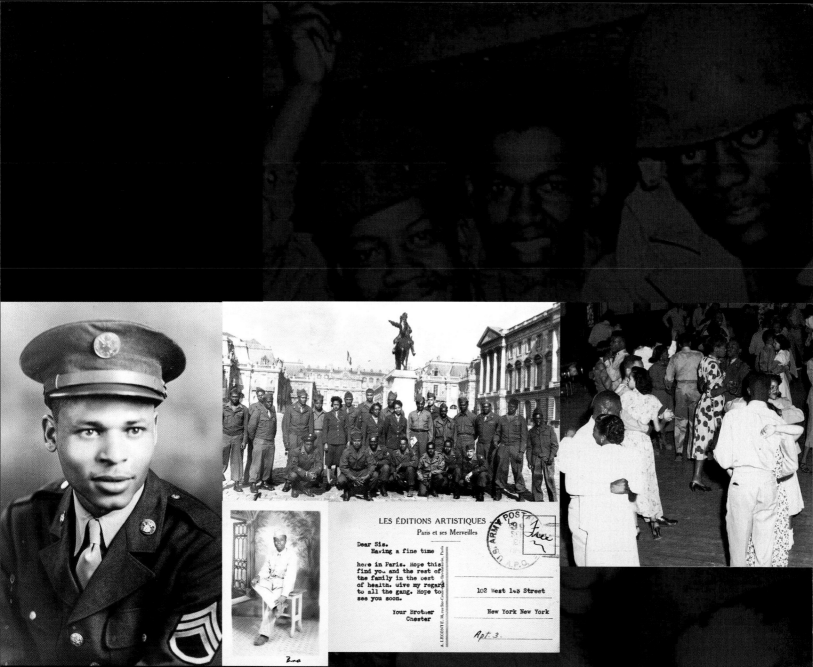

LES ÉDITIONS ARTISTIQUES
Paris et ses Merveilles

Dear Sis.
Having a fine time
here in Paris. Hope this
find you and the rest of
the family in the best
of health. Give my regard
to all the gang. Hope to
see you soon.

Your Brother
Chester

102 West 143 Street

New York New York

Apt. 3.

Military History

TYPES OF ARTIFACTS

Personal military records and papers: discharges, evaluations, letters, commendations, and certificates

Wartime letters and telegrams

Original posters

Medals, awards, buttons, and badges

Photographs

Uniforms and hats

Magazine articles and news clippings (general)

Scrapbooks

History books and journals

Military unit newspapers and magazines

Artwork: prints, paintings, or carvings made by servicemen or women

Personal effects

EVER SINCE PETER SALEM AND SALEM POOR FOUGHT IN the Battle of Bunker Hill, African Americans have played an honorable role in the nation's military forces. While their participation has been, for the most part, underreported and underrecognized, Black servicemen and women were an integral segment of the armed services for most of the twentieth century.

In the past thirty years, there has been a surge of interest in collecting Black military history. No longer the domain of historians, military collectibles are now sought by generalists, hobbyists, and amateur genealogists. With a constant stream of new books, museum exhibits, and movies coming out on themes related to this phenomenon, African American military collectibles will surely be even more popular in the future.

What to Look For

Generally, any item created during wartime is more desirable to a collector of military history than an object created later on, as is an object pertaining to a famous battle, military leader, or controversy.

Military collectibles tend to be varied and can include both paper-based materials such as books, documents, news clippings, photographs, and posters as well as three-dimensional objects made of other materials such as insignia, weapons, and uniforms. Three-dimensional military collectibles are rarer than paper-based ones. Collectibles related to Blacks serving in the U.S. Navy,

Marines, and Coast Guard are rarer than materials pertaining to African Americans in the Army. This is because out of all the branches of the armed forces, the Army has had many more African Americans in service over the years. Before and during World War II, Black military personnel in the Navy, Marines and Coast Guard worked as cooks, laborers, carpenters, and messengers.

Rare and noteworthy—and probably more expensive—finds include photographs that show Black military officers or military personnel with some distinguishing characteristic and anything that shows a Black woman in the military in a role that a had been previously dominated by men. Be prepared to pay more for a photograph with identification (name, location, military unit, and date) than for a photo with no accompanying information. Photographs are often taken from scrapbooks, which contain the identifying details.

On that note, any scrapbooks with photos and news clippings of Black soldiers or Black military units you can find will be a worthwhile addition to your collection.

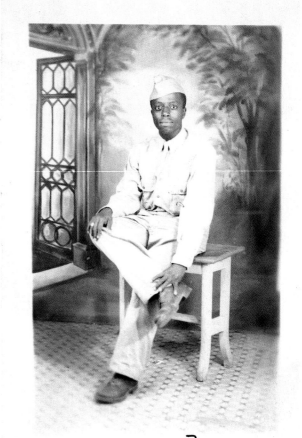

Interpreting the Informational Value

The United States military reflects American society-at-large when it comes to conflicts and changes in race relations. Most group shots taken prior to and during World War II show segregated military units of Blacks with one or two White officers seated or standing in the center. Photographs that include Black officers commanding Black military units contain vital historic information about African American advancement in the military prior to President Truman's executive order to integrate the armed forces.

When interpreting the informational quality of a military collectible, understanding some of the relevant racial issues of the period can be extremely helpful. During the Revolutionary War, one of the debates about Blacks in the military was whether Blacks could fight in combat or whether God created them to be a servile race. Prior to the Civil War, a major issue was whether Blacks could be trusted with weapons and if so, should they be armed. In Reconstruction and later the armed forces debated whether Blacks should be admitted to elite military training schools. During World War I, one of the debates focused on Blacks as officer candidate-material. The con-

THIS SPREAD AND NEXT:
Many soldiers had pictures of themselves or their surroundings taken when they were in the service for the benefit of their families back home. Many are quite charming. Some of the photographs on these pages are from a set a World War II soldier had taken and sent home to Harlem. Notice that one image features a few African American WACS in the group (definitely a rarely captured event).

LES ÉDITIONS ARTISTIQUES
Paris et ses Merveilles

Dear Sis.
 Having a fine time

here in Paris. Hope this
find you and the rest of
the family in the best
of health. Give my regard
to all the gang. Hope to
see you soon.

 Your Brother
 Chester

A. LECONTE, 38, rue Ste-Croix-de-la-Bretonnerie, Paris

102 West 143 Street

New York New York

Apt. 3.

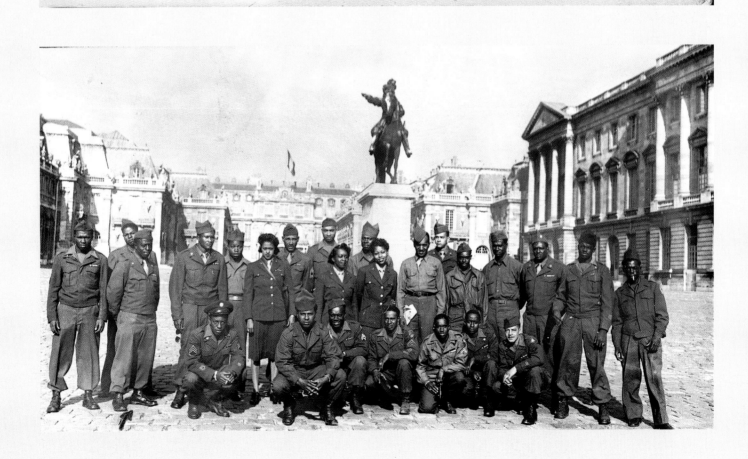

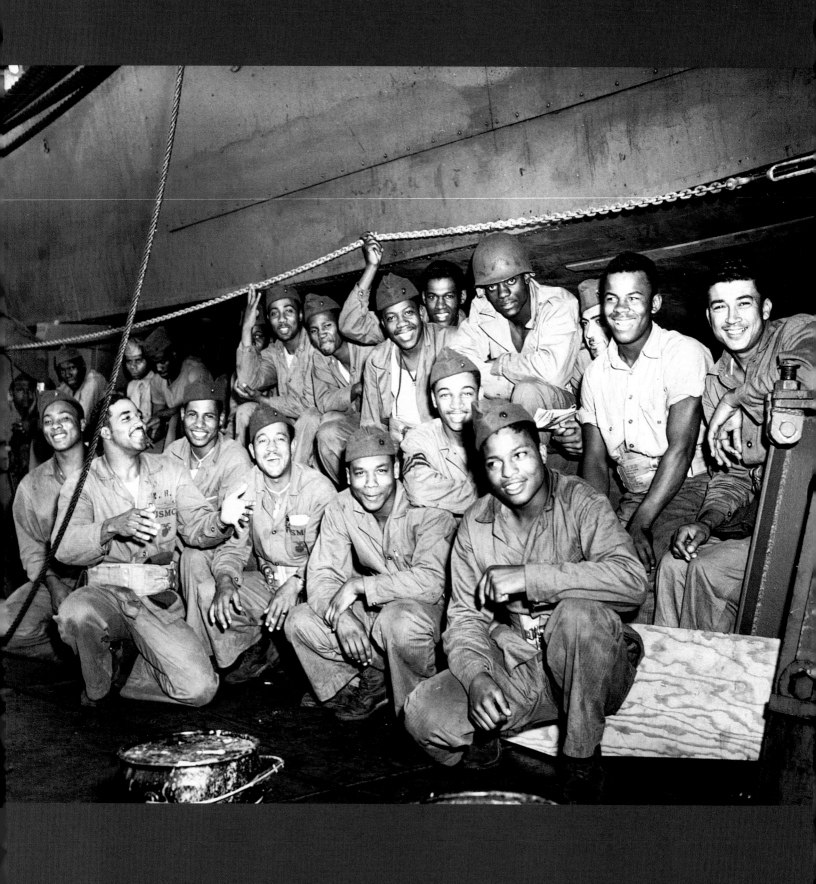

troversy during World War II was whether or not to integrate Blacks into the regular armed forces. The Korean War raised the issue of whether African Americans had fought well and whether they were receiving proper recognition for their military contributions. During Vietnam, there were several issues affecting Blacks in the military but the primary concern in the African American community was whether Black teenagers and men should sign up to serve their country or wait until they were drafted. In the post-Vietnam era, attention is being focused on how racism is continuing to affect Blacks' advancement in the military.

In addition to yielding information about race relations in the Armed Forces, Black military collectibles are one of the richest sources available for genealogical research. Even when African Americans were denied basic education and civil rights, they served their country in wartime. Military records, including basic service records, pension records, payrolls, muster rolls, and supply records, can provide missing data about an ancestor: name, place of birth, approximate age upon enlistment, relatives and spouses, places of enslavement, places visited, fate after military service, and/or time and place of death.

BDS 2001 STEREO

THE BUFFALO SOLDIERS

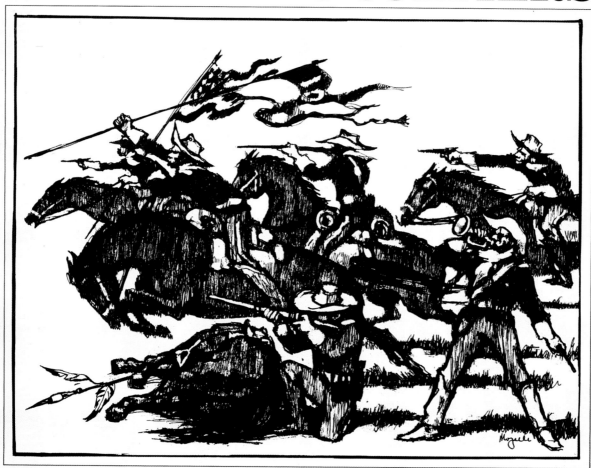

ABOVE: Spoken word records offer history in an inexpensive, accessible, and easy to understand format. Buffalo Soldiers was the name given to members of the African American cavalry regiments of the U.S. Army who served on the western frontier from 1867 to 1896. Collecting Buffalo Soldier material in other forms can prove to be quite a challenge.

OPPOSITE: African American involvement in the Civil War was a source of much discussion and concern. One of the causes for which Frederick Douglass fought vigorously is referred to here.

ADDRESSES

OF THE

HON. W. D. KELLEY, MISS ANNA E. DICKINSON, AND MR. FREDERICK DOUGLASS,

AT A MASS MEETING, HELD AT NATIONAL HALL, PHILADELPHIA, JULY 6, 1863, FOR THE PROMOTION OF COLORED ENLISTMENTS.

THE efficiency of colored troops having been demonstrated by recent battles in the Southwest, several hundred gentlemen of Philadelphia addressed a memorial to the Secretary of War, asking authority to raise three regiments for three years or the war, from among the colored population of Pennsylvania. Permission to this effect was promptly given by the following communication from the Adjutant-General's Office:—

HEAD QUARTERS OF THE ARMY,
ADJUTANT-GENERAL'S OFFICE.
Washington, June 22d, 1863.

THOMAS WEBSTER, ESQ.,
Philadelphia, Pa.

SIR: I am instructed by the Secretary of War to inform you that you are hereby authorized, as the representative of your associate petitioners, to raise in Philadelphia, or the eastern part of Pennsylvania, three Regiments of Infantry, to be composed of colored men, to be mustered into the service of the United States for three years, or during the war. To these troops no bounties will be paid.

They will receive ten dollars per month and one ration, three dollars of which monthly pay may be in clothing.

The organization of these regiments must conform strictly to the provisions of General Order No. 110, Current Series, War Department, a copy of which is herewith.

The prescribed number of Commissioned Officers will be appointed as provided in General Orders Nos. 143 and 144, War Department, 1863, copies of which are herewith inclosed and your especial attention invited thereto.

An officer will be detailed to muster these troops into service, by companies if necessary.

It must be distinctly understood that but one regiment is to be recruited at a time; thus, the organization of the first regiment must be completed and the regiment *mustered into the service* before the recruiting of the second is commenced.

The troops raised under the foregoing instructions will rendezvous at Camp William Penn, Chelton Hills, near Philadelphia, where they will be received and subsisted as soon as they are enlisted, and an officer will be assigned to duty at that post to take command of them on their arrival and make the necessary requisitions for supplies.

It is expected and desired that you should confer with Major George L. Stearne, A. A. G., U. S. Vols., and Recruiting Commissioner for U. S. Colored Troops, now in your city, for the purpose of assisting you in this work. You will please keep him advised of your progress.

I have the honor to be,

Very Respectfully,
Your obed't serv't,
C. W. FOSTER.

The better portion of the colored population of Philadelphia at once took a lively interest in the movement, and the first regiment is in process of rapid completion. To bring the matter fairly before their brethren, they resolved to call a mass meeting at National Hall, on the evening of July 6th. That spacious hall was densely crowded with a mixed audience, in which were a large number of women, and the utmost enthusiasm prevailed.

The following gentlemen were selected as officers:—

President—Rev. Stephen Smith.

Vice-Presidents—Rev. Jonathan C. Gibbs, William Whipper, Benjamin B. Moore, Rev. Jeremiah Asher, Jacob C. White, Rev. J. B. Trusty, David B. Bowser, James McC. Crummill, Rev. Jabez P. Campbell, Henry Minton, Rev. James Underdue, John P. Burr, Rev. Wm. J. Alston, Samuel Williams, John W. Page, James Brown, Henry Jones, Thomas Jordan, William H. Riley, Rev. Jessee Boulden, Henry W. Cropper, Thomas J. Dorsay, Wilkinson Jones, Robert Adger, Daniel George, John C. Bewers, M. Bascom.

Secretaries—Eben D. Bassett, Jacob C. White, Jr., Octavius V. Catto,

HONORED GUESTS

President HARRY S. TRUMAN
Mrs. HARRY S. TRUMAN
Mrs. ELEANOR ROOSEVELT
Governor THOMAS E. DEWEY
Mayor WILLIAM O'DWYER
Congressman ADAM C. POWELL, Jr.
Judge FRANCIS E. RIVERS
Police Commissioner WALLANDER
Commissioner of Correction SAMUEL BATTLES
Commissioner of Licenses PAUL MOSS
Councilman BENJAMIN DAVIS, Jr.
Judge JANE BOLIN
Lt. HERBERT H. WILKIE, National Chaplain, A & N U, USA
Lady MARION GALMBACHER
Past National Pres. Ladies Aux., A & N U
Lady MAUDE SHUCKMAN
National Pres. of Ladies Aux., A & N U, USA
Capt. HENRY GERBER, Past National Comdr., A & N U, USA
Rev. JOHN H. JOHNSON, Chaplain Police Dept., N Y C
Col. C. M. CHISUM, 15th Regiment, New York Guard
Col. C. M. HOOPER, Comdr. of the Former 369th CA (AA) Asst.
Deputy Controller, City of New York
Lt. Col. VERNON C. RIDDICK, 369th CA (AA)
Magistrate City of New York
Lady ROSE M. LEADBEATER
Past Dept. Pres., State of New York, A & N U
JOHN L. KOCH, Past Dept. Comdr. of New York, A & N U, USA
WALLACE E. KEHOE, Past Comdr. Queens County, A & N U, USA
EDWARD KAISER, Sr. Vice Comdr. Dept. of N. Y., A & N U, USA
Lady CATHERINE O'BRIEN
Sr. Vice Comdr. Dept. of New York, A & N U, USA
Comdr. DANNY MEYERS, Dept. of New York State, A & N U, USA
Major J. W. LANG, 2nd Brigade Headquarters
Lt. General H. DRUM
WILLIAM R. ANSLEY
Sr. Vice Comdr., Col. Charles Young Garrison, Cleveland, Ohio
Lady ESTELLE ANSLEY
President Armenta Young Aux., A & N U, USA, Cleveland, Ohio
Lady OLIVE GAINES, Past Pres. Ladies Aux., No.15, A & N U,USA
Lady MAYME V. FREEMAN
Past Pres. Ladies Aux., No. 15, A & N U, USA
J. FINLEY WILSON, Grand Exalted Ruler, I B P O E of W
HENRY A. TOPPIN
Hon. Comdr. Lt. Solomon O. Ward Garrison, No. 15, A & N U
Capt. HARMON PERRY
WILLIAM A. WALL
Jr. Comdr. Lt. Mikell Garrison, No. 15, A & N U, USA
THOMAS M. WYATT, Dept. Chief Aide, A. & N. U., New York

DISTINGUISHED GUESTS

•

Commander JOSEPH L. MATTHEWS
Lt. Solomon O. Ward Garrison, No. 15, A & N U, USA
PETER D. J. BEEKMAN, Sr. Vice Comdr.
Lt. Solomon O. Ward Garrison, No. 15, A & N U, USA
LOUIS D. LIEBERMAN, Jr. Vive Comdr.
Lt. Solomon O. Ward Garrison, No. 15, A & N U, USA
Lady M. ELIZABETH WALL
Pres. Aux. No. 369th, A & N U, USA
Lady L. HELEN WIGGINS
Pres. Aux. No. 807, A & N U, USA
Comdr. JOHN H. TURNER
Lt. Robert H. Wiggins Garrison, No. 807, A & N U, USA
Comdr. LOUIS E. NORTON
Dorrance Brooks Post, No. 528, V F W
Comdr. MILTON A. COOK
Queens County Council, A & N U, USA
Mr. FLOYD I. SILK
Welfare Officer New York County, A & N U, USA
Mrs. OLIVIA QUARLESS
President of Ladies Aux., American Legion
Mrs. GOLDIE ROSEMOND
President of Womens Aux., 369th & 15th Regiment
Lt. JOHN S. KENNEY, 15th Regiment
Mrs. LOUISE HATCHER
Pres. Harlem Childrens Fresh Air Fund, Inc.
JESSE L. ROSENBERG
RACHAEL V. CORROTHERS
Organizer Crispus Attucks Youth Center
Col. HUBERT FAUNTLEROY JULIAN
Mrs. VEREDA PEARSON, Guest Artist
Mr. JOSE MARTINI, Guest Violinist

GREETING FROM
THE LADIES AUXILIARY
LT. SOLOMON O. WARD GARRISON, No. 15
Army and Navy Union U. S. A.

JOSEPHINE G. SWANSON
Lady President

GERTRUDE WILKINS
Sr. Vice President
LILLIAN JOHNSON
Jr. Vice President
VIOLA COOPER LANIER
Secretary
ELIZABETH A. WILLIAMS
Treasurer
EMMA MULLIGAN
Chaplain

JULIA PASCO
Officer of the Day
FANNIE GRAY
Officer of the Guard
MILDRED SMITH (Deceased)
Historian
EMILY BOYD
Sentry
ROXIANNA HAYWARD
Pickett

HATTIE HARRIS
Field Marshall

PAST PRESIDENTS
Lady OLIVE GAINES Lady MAMIE V. FREEMAN

Greetings

•

The Officers and Members of the Ladies Auxiliary, of Lt. Solomon O. Ward Garrison, No. 15, Army and Navy Union, U. S. A. extend a most cordial Welcome to Our Honored Guests, Patrons and Friends, on this our Second Annual Military Dance and Hallowe'en Party.

We hope that while you are getting personal enjoyment and revelry from this evening of gaiety, you will not forget the Veterans of the Second World War and All Wars, and those men and women who are still in the services of their beloved Country, whether it be Army, Navy or Marine Corps. The sacrifices that they have made, and will be called upon to make for us, and their Country cannot be over-emphasied.

We the Ladies Auxiliary, feel that there is nothing to good for these Veterans, and the Men and Women in Service. Our slogan is to serve them as best we can during peace time as well as war. We will take the initiative in the battle for the care of the Veterans and their Families.

Please accept our sincere appreciation, thanks and gratitude to all who have made this Journal a Success. We hope that your hearts will always hold fond memories of a lovely evening spent with your many friends.

Cordially yours,

JOSEPHINE G. SWANSON
Lady President

Ladies Auxiliary of Lt. Solomon O. Ward
Garrison, No. 15

RIGHT: Quasi-military items are an important part of military collecting. The military related activities of the folks back home should be recognized and preserved. They contain much historical information on local and civic issues as well as military content per se.

OPPOSITE: Usually one would want clear, sharp images, but a blurred photo that captures something historic and unusual in action is a valued find. Had the back of the photograph not been marked, we might never know that it captures singer Marian Anderson as she christens the SS *George Washington Carver*. The ship, one of the so-called "41 for freedom," was a nuclear ballistic submarine. The incident is not well-known, which makes the photograph even more important as historical documentation.

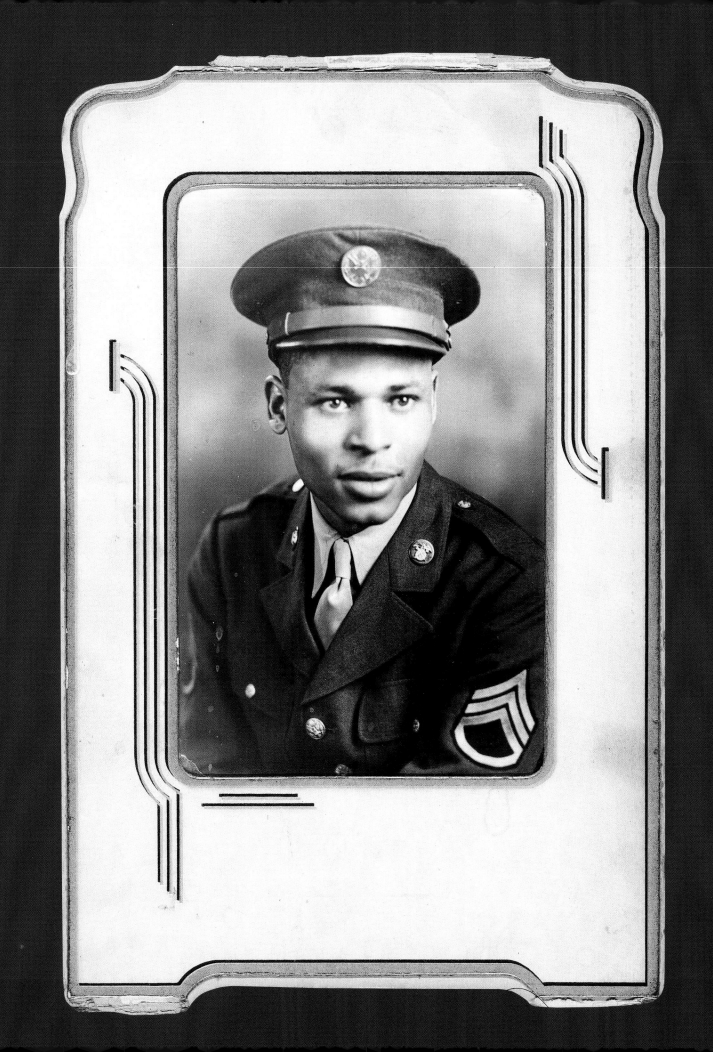

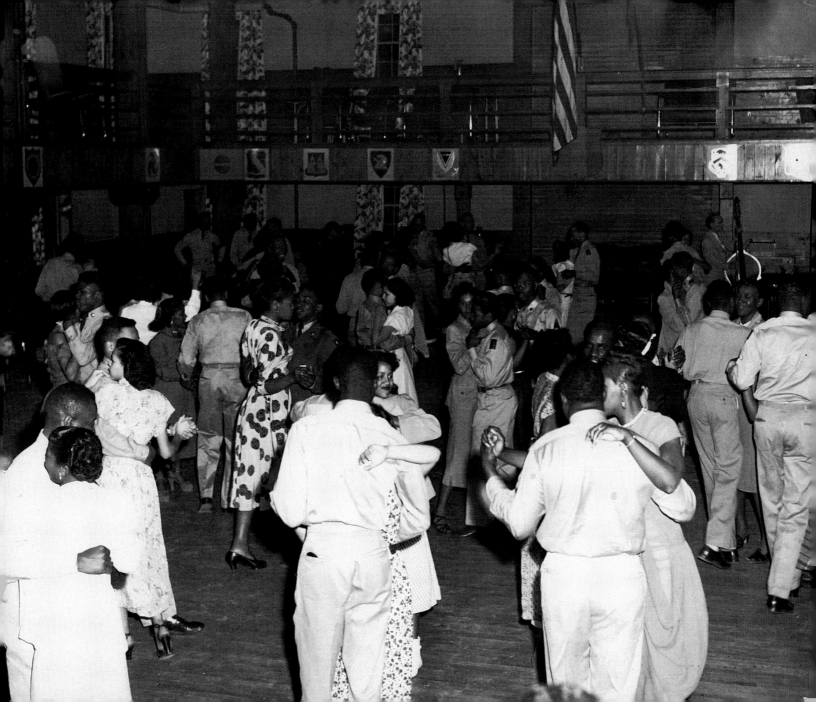

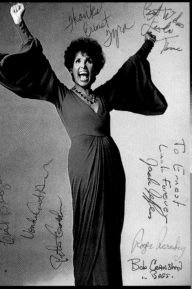

We're gonna lick the World!

"CORNBREAD, EARL & ME" starring MOSES GUNN
ROSALIND CASH · BERNIE CASEY · KEITH WILKES
also starring MADGE SINCLAIR · LAURENCE FISHBURNE III

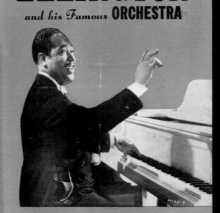

Duke
ELLINGTON
and his Famous ORCHESTRA

RECORDED BY RAMSEY LEWIS ON ARGO RECORDS
THE "IN" CROWD
By BILLY PAGE

AMERICAN MUSIC INC. 75¢

I'M COMING VIRGINIA
ETHEL WATERS
Africana
SOMETHING NEW IN A COLORED REVUE

DONALD HEYWOOD
LOUIS DOUGLAS
EARL DANCER

SMILE
CLORINDA
I'M COMING
VIRGINIA
AFRICANA
STOMP

ROBBINS MUSIC CORPORATION

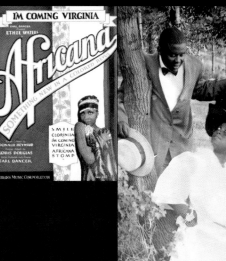

CHAPTER EIGHT
Music
and Entertainment

THE ROOTS OF THE AFRICAN AMERICAN MUSICAL LEGACY started early and remained strong and true to its origins even though it took on new languages, channels, variations, and mediums of expression over the last four centuries. The ability to make music and the ability to create more of it in new forms was one of the most important cultural assets slaves managed to bring with them from Africa. One of the most important features of Black music is its universality. Not only does Black music, like any good music, transport listeners to another world—be it jazz, blues, gospel, or classical music, African American music continues to break through geographical and psychological boundaries around the world. Today's new Black music continues to have the same effect on listeners, dancers, and critics. It is easy to see why music is the most popular genre of Black collectible among people of all races, even those would not consider themselves to be African American history collectors.

Other forms of entertainment and performing arts included in this genre are: elocution, the art of public speaking; humor; magic; film; dance; and circus performances. (Dramatic theater, preaching, and political speech fall under the rubric of elocution.)

What to Look For

Some collections are built around a specific type of music or entertainment, such as jazz or blues, the most popular music history collectibles. Spirituals, slave music, and folk music are the oldest sub-specialties. In the past few years, vintage Rhythm and Blues (R & B) has become a hot field with collectors grabbing period pieces as they become available.

Collections can also be assembled around specific time periods during which a particular style of music or entertainment was fashionable, for example, jazz in the 1930s. Artifacts from before 1900 include minstrel memorabilia, slave songs, Reconstruction era songs and sheet music, and publicity flyers for Reconstruction-era concerts. Key performances, famous productions, famous theaters like the Apollo in Harlem, and celebrity entertainers also make up themes of various collections. More specialized collectors may focus on a particular stage or theme of a performer's life or career.

Most African American performing arts collectibles are recorded performances on compact discs, vinyl records, audio tapes, film, or videotape. Paper-based performance memorabilia includes programs, sheet music, photographs, scrapbooks, autographs, and posters. In general, the larger, more colorful, and more personalized entertainment collectibles are considered more valuable and will command a higher price. Three-dimensional artifacts such as instruments, costumes, props, and awards are scarcer, more expensive, and harder to store and preserve.

The fraud factor is particularly virulent among sellers of purported celebrity memorabilia, and any potential collector of Black performing arts material needs to be especially cautious. Have costly items checked out by someone who knows what they are doing and insist on written guarantees that you can return any item within a specified number of days. Be particularly wary when examining celebrity autographs since sellers have been known to obtain false signatures, hide defects, and peddle high-quality duplicates.

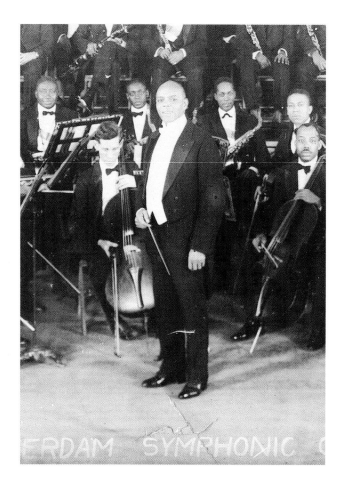

ABOVE AND OPPOSITE TOP:

This large (the actual image is eighteen by eleven inches), black-and-white photograph of the New Amsterdam Symphonic Orchestra, circa 1919, is an important visual record of Black culture in the early twentieth century. It is evidence of the history of Blacks in music both classic and popular. This photograph is the quintessential collectible: rare, in reasonably good condition, and useful for research.

OPPOSITE BOTTOM:

A small and seemingly unassuming ticket can be of enormous and important value. This Depression-era concert stub is an important piece of Black entertainment ephemera.

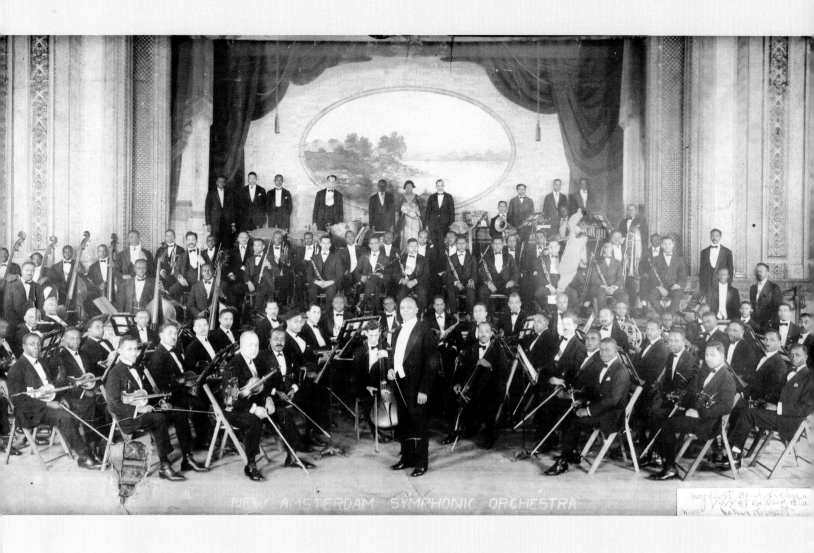

NEW AMSTERDAM SYMPHONIC ORCHESTRA

MILLS ARTISTS INC. PRESENTS

CAB CALLOWAY AND HIS COTTON CLUB ORCHESTRA

AT KINGSTON MUNICIPAL AUDITORIUM

Thursday Night, May 2, 1935

ADMISSION, :: $1.00+10c TAX

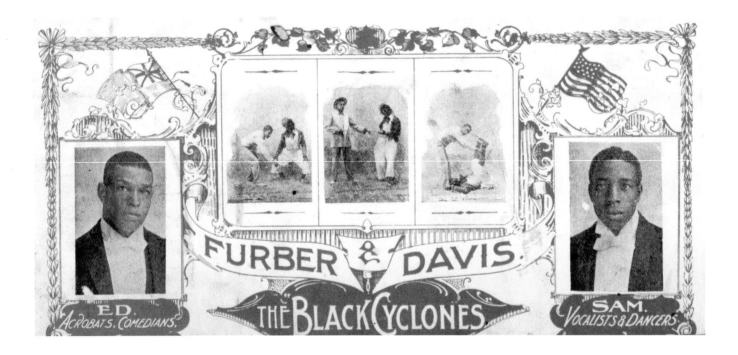

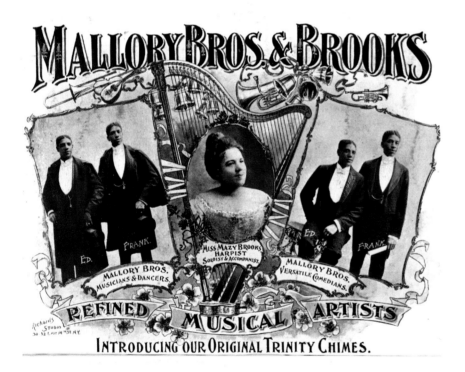

THIS PAGE: Scrapbooks can be a great source of Black history collectibles. These performer advertisements from the turn of the twentieth century were pasted onto the pages of a scrapbook; they are valuable souvenirs of Black art and culture before the Harlem Renaissance of the 1920s. This scrapbook also contains wonderful nuggets of African American history, mixed in with materials that are not specifically African American. These other items can help the intrepid researcher to date them and place them in historical context.

OPPOSITE: Discographies are particularly useful for research-oriented collectors. They provide a comprehensive list of an artist's work throughout his career. This Fats Waller discography is perfect for a music collector.

" America does strange things to its great artists. In any other place in the world Thomas Waller might have developed into a famous concert performer, for when he was eleven he was a gifted organist, pianist, and composer. But Waller was not white and the American concert field makes a racial exception only for a few singers. Waller's great talent for the piano has never received the acknowledgment that it deserves in this country. It was easier to exploit him as a buffoon and clown than as the artist he is."—John Hammond, in a Programme note to the Waller Carnegie Hall Concert, January 14th, 1942.

THE MUSIC OF
THOMAS "FATS" WALLER

WITH
COMPLETE DISCOGRAPHY

BY

JOHN R. T. DAVIES

(Revised by R. M. Cooke)

PUBLISHED BY

"FRIENDS OF FATS"

(The Thomas "Fats" Waller Appreciation Society)

PRODUCTION BY

THE CENTURY PRESS LTD.
79 Great Titchfield Street, London, W.1

SEPTEMBER 1953

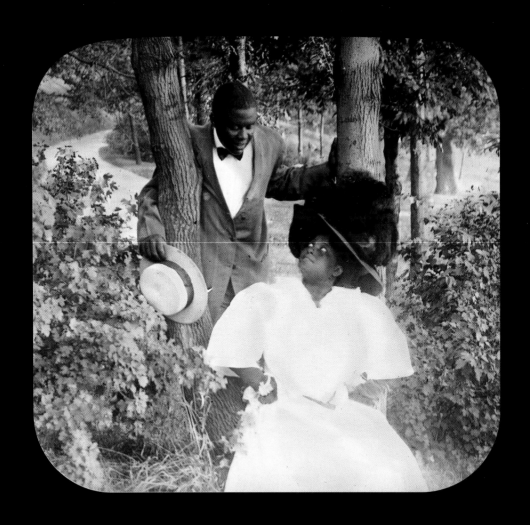
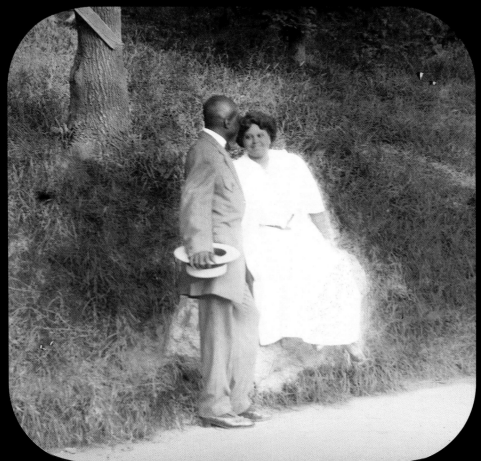

THIS PAGE AND OPPOSITE:
Photography collectibles aren't just
photos; negatives, stills, and in this case,
glass slides are just as noteworthy and
valuable as photographs. These slides
were used to project the lyrics of the title
song from the 1906 musical *I'm Happy
All the Time,* so that the audience could
sing along during the song. It is hard to
find glass slides in mint condition.
Negatives can be made from the slides.

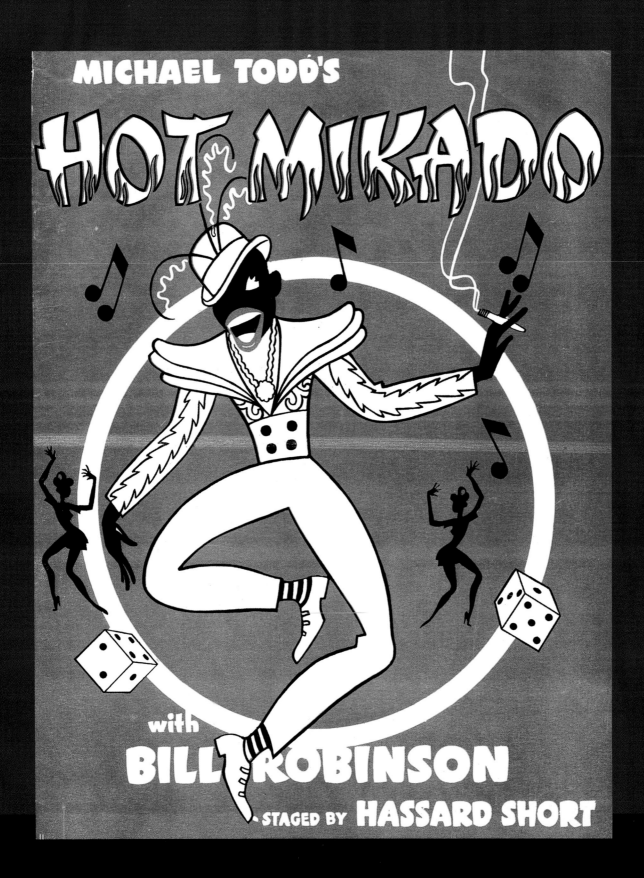

ABOVE: This souvenir program has wonderful illustrations and captures some of the creativity, excitement and showmanship of African American entertainment of the 1920s through the 1940s.

OPPOSITE: This sheet music from the Harlem Renaissance is not only interesting because it celebrates a famous song and a famous singer, Ethel Waters, but also because its title, "Africana," reflects the growing African consciousness in the 1920s—the use of the word "colored" over the word "negro" serves as a wonderful period marker for collectors and researchers.

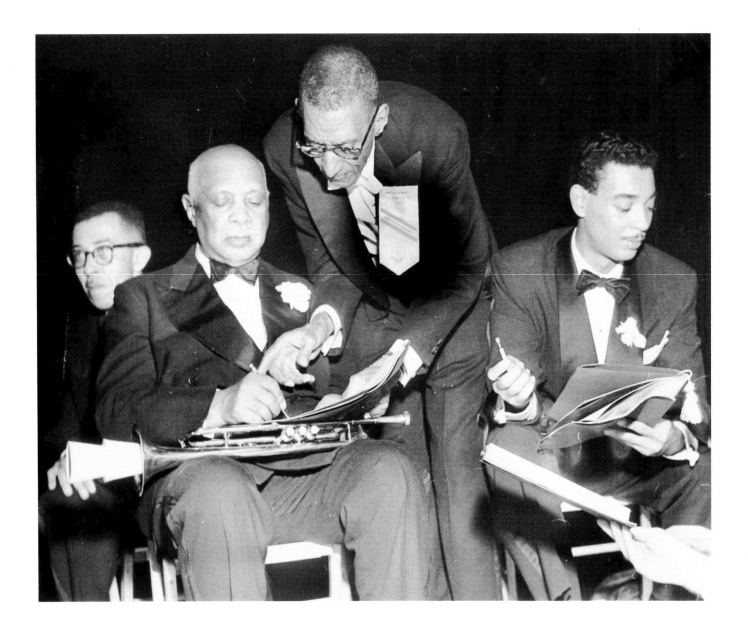

ABOVE: Occasionally unpublished photos of notable people appear on the collectible market. Savvy collectors quickly buy them all. This is such a photo of W.C. Handy and it is a great find for several reasons: His trumpet is in his lap; he appears with another major performer, Billy Eckstein; and the photographer has caught him in a relatively candid moment.

OPPOSITE: The association between Harlem and Sammy Davis Jr. is one of the key attractions of this piece. It shows his civic side as well as his performer status.

COMMITTEE *of* FRIENDS
HARLEM BRANCH YMCA

Presents

A ROYAL SALUTE

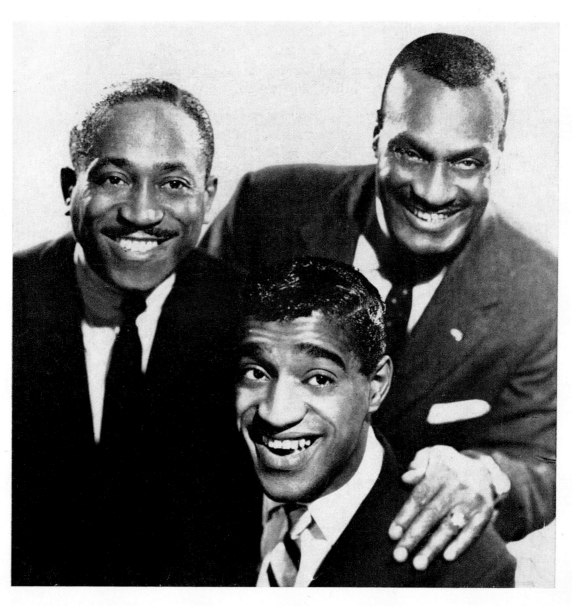

Honoring SAMMY DAVIS, JR.

with the Will Mastin Trio

4/21/55

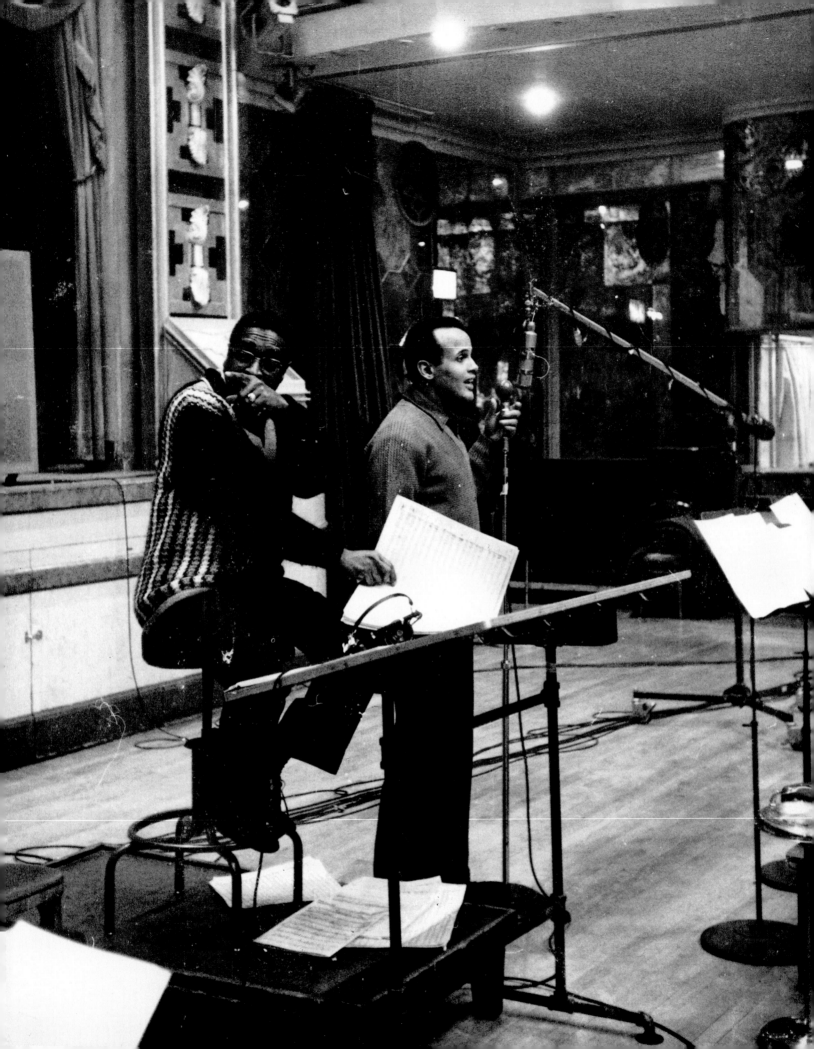

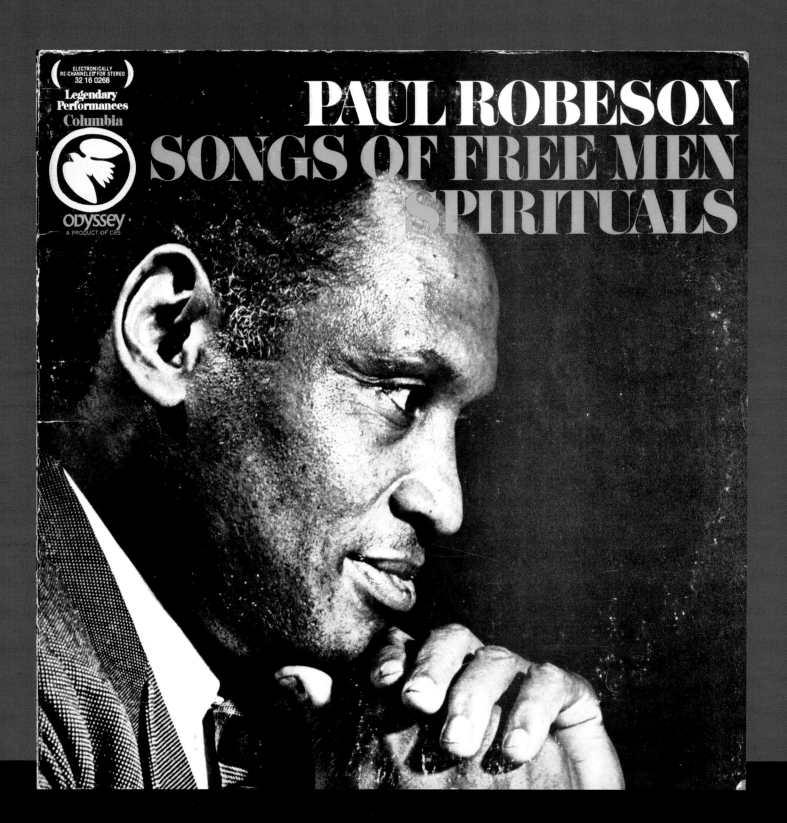

ELECTRONICALLY
RE-CHANNELED FOR STEREO
32 16 0268

**Legendary
Performances
Columbia**

oDyssey
A PRODUCT OF CBS

PAUL ROBESON
SONGS OF FREE MEN
SPIRITUALS

OPPOSITE: Collectors often like to document a historical figure's development over time and practicing their craft in an unguarded moment. This behind-the-scenes photograph captures Harry Belafonte in the recording studio in the 1950s or 60s.

ABOVE: The title of this Paul Robeson recording takes on greater meaning when viewed in terms of his life as a political activist. Robeson

in the title role of Eugene O'Neill's *The Emperor Jones*. His rich baritone made for dramatic renditions of negro spirituals, which he performed often. From the mid-1930s on, Robeson was increasingly associated with political and progressive causes.

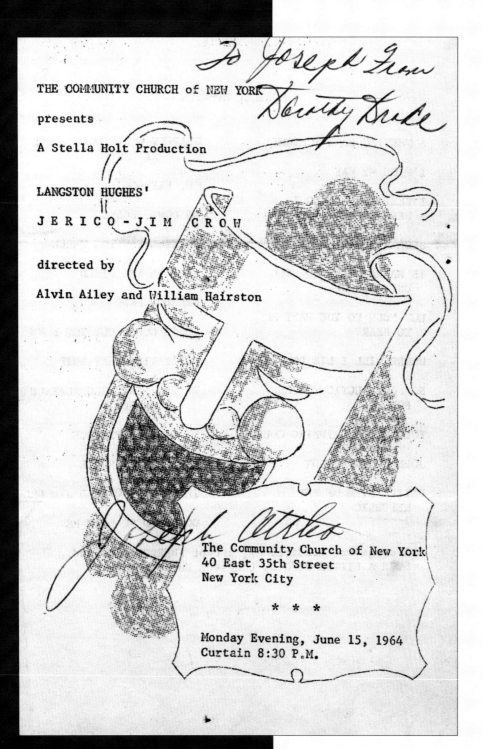

To Joseph From
Dorothy Drake

THE COMMUNITY CHURCH of NEW YORK

presents

A Stella Holt Production

LANGSTON HUGHES'

J E R I C O - J I M C R O W

directed by

Alvin Ailey and William Hairston

The Community Church of New York
40 East 35th Street
New York City

* * *

Monday Evening, June 15, 1964
Curtain 8:30 P.M.

LEFT: Poet and writer Langston Hughes is considered one of the foremost interpreters of Black life in twentieth-century America. This mimeographed program—signed by members of the company—is for a production of one of his plays, performed at a New York City church. Small local productions are necessary to document because often even great writers and performers could not get their works produced on a mainstream stage. Without programs such as this, the details of local productions of some of our literary heroes might be forgotten. Note as well the early directorial credit for future dance great Alvin Ailey.

OPPOSITE: Naturally, autographs of distinctive or popular performers are widely collected. *Amos and Andy* has always had a strong following, and the recent interest in vintage television has increased it. Actress Amanda Randolph played the role of "Sapphire's Mama" on the show.

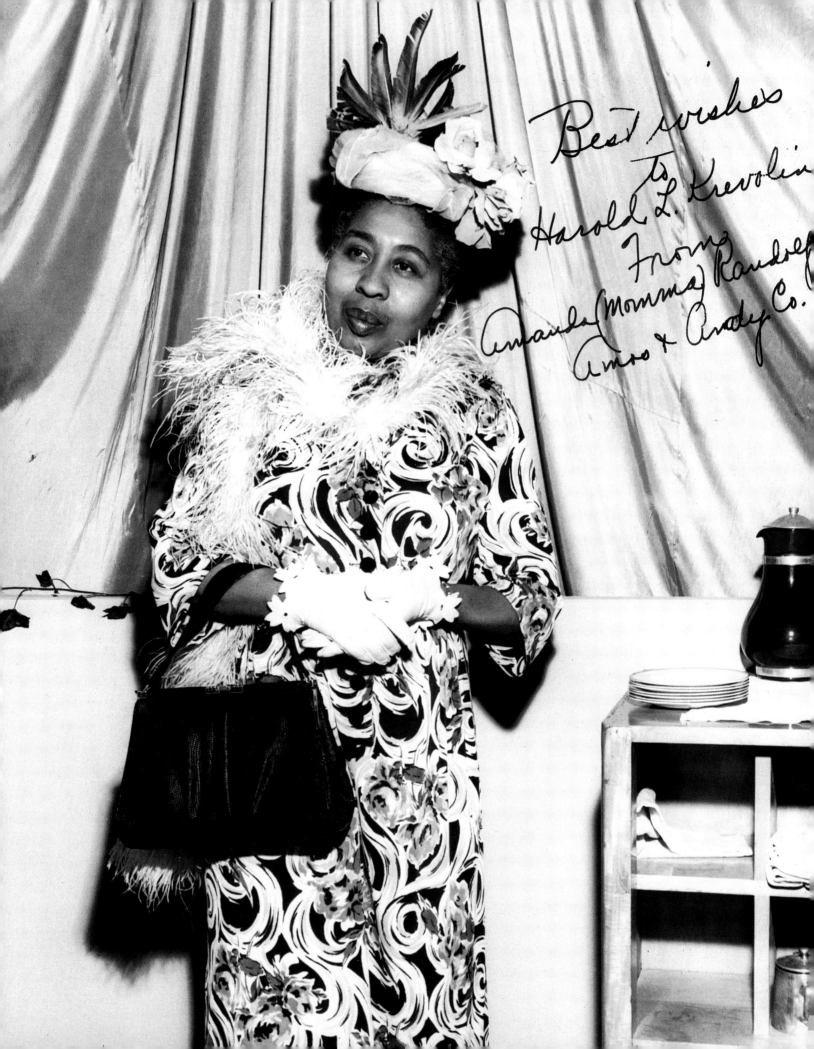

Best wishes
to
Harold L. Krevolin
From
Amanda (Momma) Randolph
Amos & Andy Co.

LANGSTON HUGHES

& MARGARET DANNER
WRITERS OF THE REVOLUTION

BLACK FORUM

BLACK FORUM

BB453

ABOVE: Records remain a popular form of Black history collectible, although many people no longer have record players. The condition of the recording itself can sometimes be secondary to the usefulness of the album cover as Black history art or decoration. Album covers attract many collectors since they are visually attractive and allow collectors to get history, music or—as in this case—literature, in a form and at a price that they could not otherwise get or afford. Spoken word recordings—which often feature a noteworthy figure—were made and they are now collected.

OPPOSITE: Duke Ellington is one of those notable Black figures whose memorabilia has fueled the creation of a new category of musical collectibles. Material about his life and career is becoming increasingly harder to find and more expensive.

Duke
ELLINGTON
and his Famous ORCHESTRA

THE GREAT PRETENDER

Words and Music by BUCK RAM

PRICE
50¢
In U.S.A.

as Recorded by
THE PLATTERS
on MERCURY RECORDS

SMILE

Theme from "MODERN TIMES"

Recorded by NAT "KING" COLE on Capitol Record No. 2897

BOURNE INC.
Music Publishers
STREET • NEW YORK 19, N.Y.

RECORDED BY RAMSEY LEWIS ON ARGO RECORDS

THE "IN" CROWD

By BILLY PAGE

Keys

AMERICAN MUSIC INC.

04425

75¢

OH HAPPY DAY

Words and Music by EDWIN R. HAWKINS

650

RECORDED BY
THE EDWIN HAWKINS SINGERS*

*Formerly The Northern California State Youth Choir

Recorded on
PAVILION

A Product of Lahtest Beach produced for Pavilion Records. Distributed by Buddah Records

United Artists Music
Entertainment from
Transamerica Corporation

UNITED ARTISTS MUSIC CO., INC.
NEW YORK, N.Y.

95¢

Distributed by

OPPOSITE: Illustrated sheet music is now eagerly sought after, especially if it pertains to well-known entertainers or songs. It can be very useful in tracking entertainer careers and various versions of a long-lived piece of music. Sheet music can also be useful in demonstrating when and how key concepts and words that were originally from Black entertainment entered the popular mind and mainstream culture. Its nostalgia value is immense and emotionally important since many people will remember and treasure the sounds of a bygone era even if they don't see themselves as social historians or collectors. Fortunately, sheet music is still relatively inexpensive in many places.

THIS PAGE TOP LEFT: Hall Johnson was a successful and multi-talented performing arts genius who was the musical brains behind many famous shows and plays. He was also a major force behind the traveling choir. The signed piece is especially significant since Johnson's choir performed the piece and it appeared in a well-known movie. However, illustrated or not, signed or not, evidence of Hall Johnson's life and work are important testimonials to the greatness of the African American concert music tradition.

THIS PAGE TOP RIGHT: There is sheet music and then there is special sheet music. Although usually, sheet music's value is connected to the visual appeal of its cover, sometimes the historic content is a greater source of value. In the case of this rare piece, there is no illustration, but the people involved and mentioned are of great historical importance in the history of African American music. Both Burleigh and Boatner were great concert singers. Also notable is the fact that many professional efforts of earlier African American performers were related to spirituals. Thus, performing or arranging Negro spirituals became something of an established tradition among religious, popular, classical and concert artists.

ABOVE: "Blaxploitation" movies of the 1970s enjoyed a surge in popularity among a new audience of movie lovers and led to films of more uplifting themes featuring Black performers. Not only was *Cornbread, Earl and Me* a commercially successful movie, it also featured an early performance by Laurence Fishburne—who later became one of Black Hollywood's brightest stars.

OPPOSITE: Bill Cosby is an internationally loved comedian, actor and educator. His 1980s sitcom *The Cosby Show* was consistently one of the highest rated television shows—unheard of for a Black show, even today. This fan, a commercial promotion, was plentiful in the 1980s, but not many exist today. This collectible also illustrates how advertising material, entertainment souvenirs, and pop culture icons are all often interconnected.

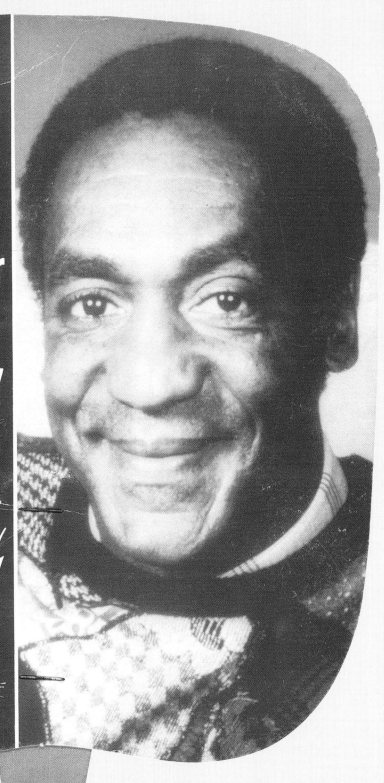

THE COSBY SHOW

Coming in October
on

5 tv

Keeping you in touch!

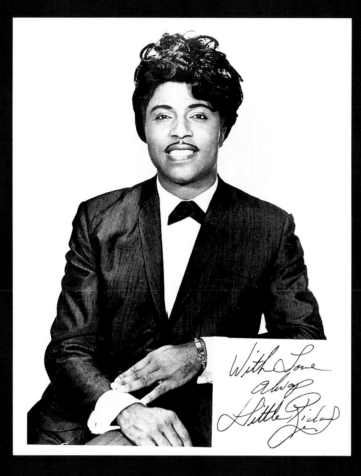

With Love
always
Little Richard

JOE TEX

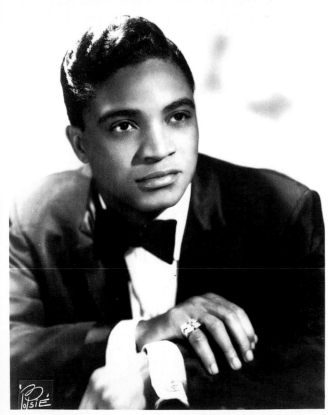

JACKIE WILSON

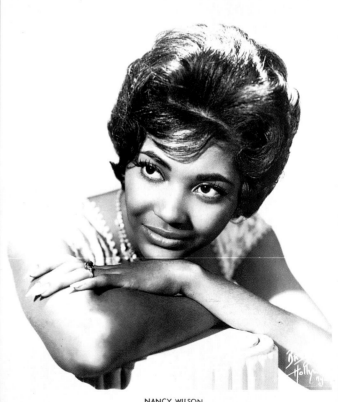

NANCY WILSON
Capitol Recording Artist

THIS PAGE AND OPPOSITE:
Many people seek and collect photographs of leading African American performers, especially those with distinctive styles or who have made tremendous contributions to their fields and society at large. Press photos are usually available and not terribly costly. Some people even seek the obscure performers who never "made it big" and who are known to or remembered by only a few. Photos from before 1970 are somewhat harder to find. There is usually a big dose of personal nostalgia in such collecting since most people seek those photos and artists that meant something personal to them at a certain time in the collector's life.

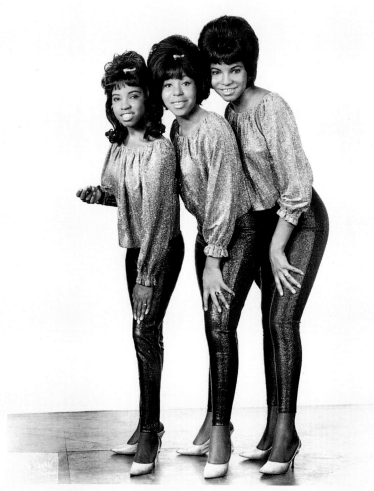

Personal Direction
JOE JONES
(212) 246-8798
N. Y. N. Y.

THE DIXIECUPS

Exclusively Owned By
SHEDEB MANAGEMENT, INC.
300 W. 55 St. N. Y., N. Y.

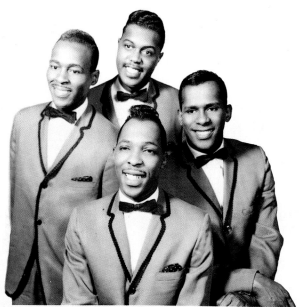

The *Contours*
Gordy Recording Artists

Direction:
International Talent Management, Inc.(ITMI)
2652 W. Grand Blvd.
Detroit, Michigan 48208

JAMES BROWN
New!
OFFICIAL PROGRAM

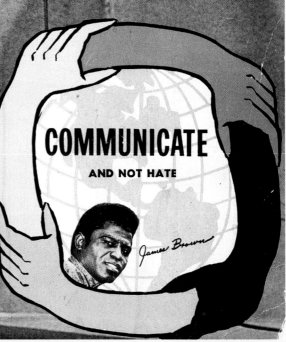

COMMUNICATE

AND NOT HATE

James Brown

OPPOSITE: James Brown is still the Godfather of Soul. His music contains a powerful message of Black love and achieved mainstream popularity. His memorabilia is actively sought by all types of collectors but is extremely hard to find.

ABOVE: A signed piece of memorabilia is always worth more than an unsigned item. Various members of the production have signed this Lena Horne program.

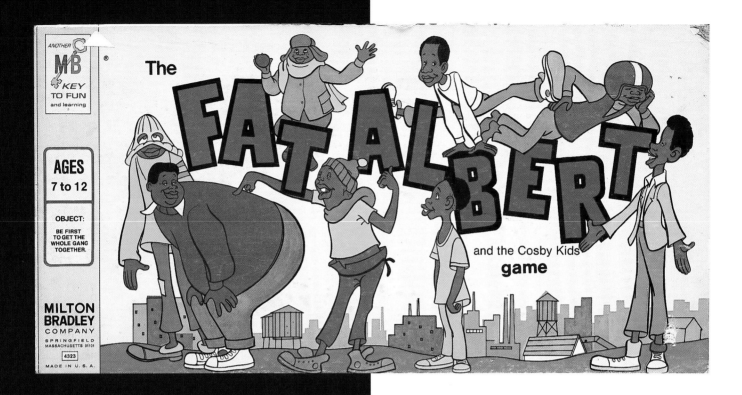

ABOVE: Increasingly, pop culture collectors and the general public are seeking "fun" items that remind them of their youth. Games such as this are harder to find than most people think. The emotional value and small number produced and kept make this game, and others like it, rare and expensive.

OPPOSITE BOTTOM: This photograph of Aretha Franklin, Willis Reed, and Livingston Wingate at a New York Urban League football game in the early 1970s is quite interesting because it was uncommon to see Black celebrities from different fields (music, sports, and civic life) pictured together.

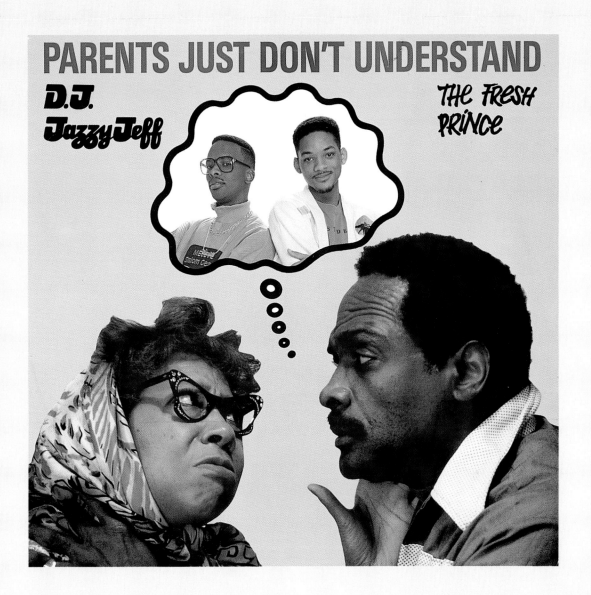

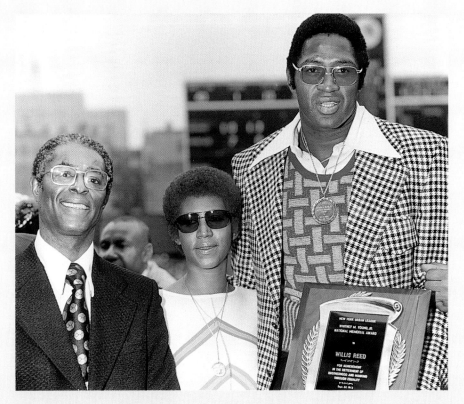

ABOVE: The views and pronouncements of popular entertainers are being collected for their content as well as their entertainment value. In this example, an important theme (parent-child relations) is addressed humorously but perceptively. This record album is relatively recent but yet not too common now. Since the entertainer involved has established a great career, this kind of item will grow in demand and value over time.

ALI vs FOREMAN

SPECIAL ALBUM

"For the highest paid moment in the history of mankind"

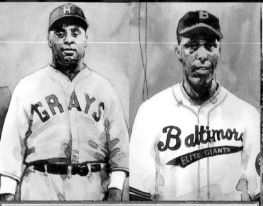

GRAYS

Baltimore
ELITE GIANTS

BLACK SPORT

DUANE
THOMAS
THE INSIDE STORY
OF A TROUBLED
SUPERSTAR

BRISCOE
POWER PUNCHING
BOXER WANTS
CHICAGO BEARS FOR WHOLE
NEIGHBORHOOD

THE HEART OF THE
CHICAGO CUBS

ON BLOOD & GUTS

THE IMMORTAL
JESSE OWENS

SPECIAL:
FREE in this issue
full color poster of
Hank Aaron

33

NEW YORK KNICKS

KNICKS vs CELTICS
JANUARY 27, 1973

MADISON SQUARE GARDEN

CHAPTER NINE
Sports

TYPES OF ARTIFACTS

Books: biographies, sports-related
history, and yearbooks

Sports magazines

Autographs

Scrapbooks

Photographs

Athletic objects: baseball bats, bas-
ketballs, gloves, and carrying bags

Trophies, medals, and insignia:
Banners, awards, commemora-
tive coins, and stamps

Clothing: uniforms, sweaters,
t-shirts, jerseys, caps, boxing
trunks, and sneakers

Commercial and promotional
objects: figurines, mugs, toys,
and key chains

Paper memorabilia: baseball cards,
posters, programs, tickets,
handbills, and prints

THE HISTORY OF AFRICAN AMERICANS IN SPORTS IS A vast and absorbing topic. Sports activity has been important in the Black community for a long time at the local, amateur, college, and professional levels. Historical material related to African American sports participation is both widely produced and widely collected—and because African Americans have such a well-established presence in sports, this is one of the fields in which many non-Black collectors will find themselves collecting Black history. A few brief historical observations are helpful for the collector.

Pre-twentieth century African American sports material is very rare and expensive when found. Little documentation exists about organized Black sports activity before the end of slavery—although it is known that slave owners often bet on competitions among athletically skilled slaves, especially in boxing. Both boxing and horse racing had strong Black participation in the late nineteenth and early twentieth centuries. This period also saw more organized sports activities among Blacks as they attended school and migrated North. Segregation meant that Blacks first achieved star status in individual sports or those that did not require expensive equipment or the use of exclusive facilities. As time went on, full participation in team sports became more possible. Today, much collecting is centered around individual achievement, whether in solo or team play.

After collections built around world-class Black athletes, boxing and baseball are the most popular specialties collected. Track and field, basketball, tennis, and golf are gaining in popularity as an increasing number of records are set and broken by African American sports stars.

What to Look For

As mentioned in the previous chapter, celebrity auto-graphs, which are among the hottest collectibles in any specialty, are also most prone to fraudulent misrepre-sentation. A good rule of thumb regarding any auto-graph or object allegedly belonging to someone famous is simply not to trust anything unless you are sure of the source and check it with an expert. Even then, you can be fooled. Be certain to obtain a written guarantee that you can return the item within a certain time period if it turns out to be unauthentic. Be wary of sports posters, tickets, handbills, and other objects that are mass-produced to have a vintage appearance.

While most collections are built around the successes and high points of a team's or athlete's success, you may find it interesting to focus on those behind-the-scenes moments which reveal something more natural and personal than public performances and photo opportunities. Some serious collectors of Black sports history focus on building archives and scrapbooks that trace the history of a sport, team, or individual over time. Such collec-tions will have greater historic value than eclectic collections of items lacking a central theme or subject. And they will have greater scope than collections built around one sporting event, no matter how important it was to the career of an individual athlete or to the status of African Americans in a specific sport.

One final word of advice: Unlike other types of historic artifacts for which age determines financial value, older items do not necessarily have greater financial value in the area of sports collectibles. Here, celebrity value weighs in more heavily. The publicity value of a particular sports item can blow the financial value out of proportion to its historic value.

ABOVE, OPPOSITE AND NEXT SPREAD: These 1950s photos are highly desirable because there is very little material available on the early days of African Americans in professional foot-ball and almost none that reveal their per-sonal lives, a subject that collectors love. These photos record the career and fami-ly life of Marion Motley, an important, groundbreaking African American athlete. Motley is a historic sports figure—one of the first Blacks to integrate and play in professional football, not to mention very successfully. He was born in Canton, Ohio, played high school football there, and was the second Black to become a team member (on August, 9, 1946) of the Cleveland Browns (following Bill Willis, the first by three days). Some of the pho-tos show Motley running on the field in his Cleveland playing days, some show family moments (Motley's wife and sons are featured), some show social moments and formal team portraits, and some show Motley in his later days, posing with a number of retired players (perhaps in connection with Hall of Fame activities).

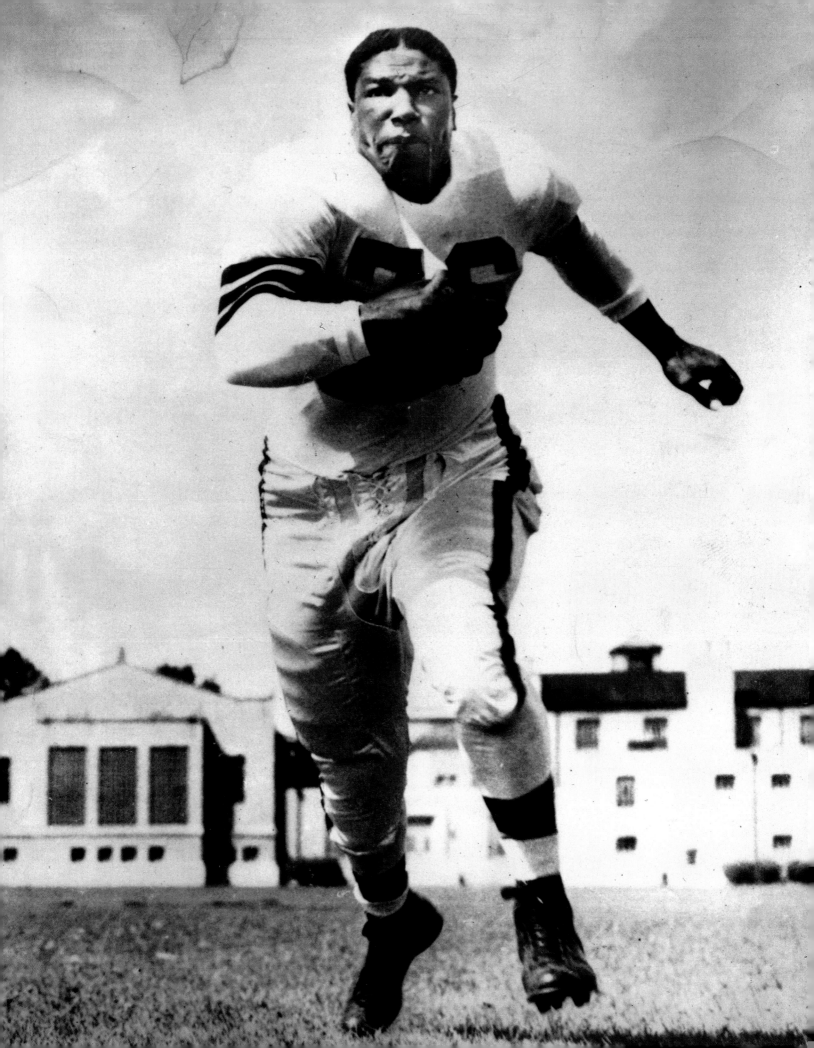

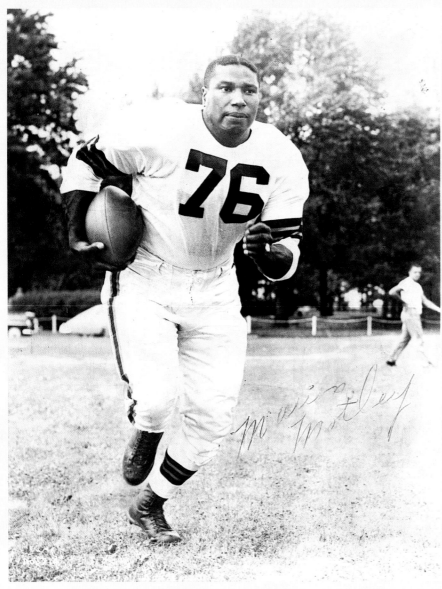

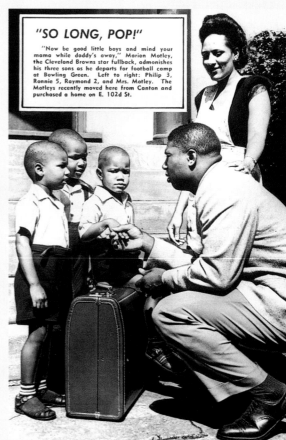

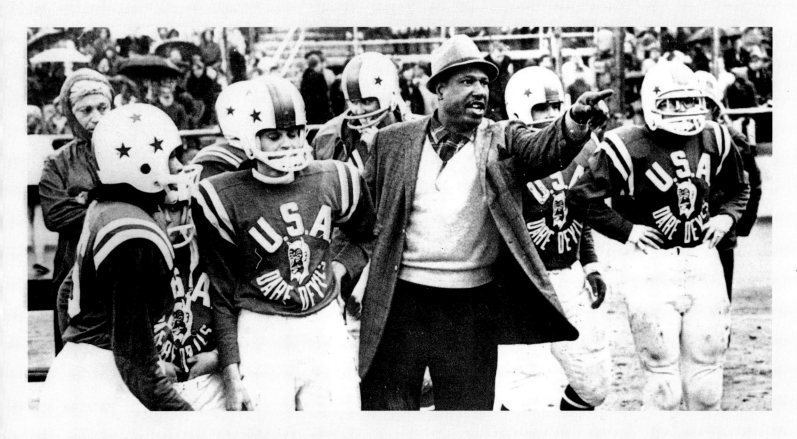

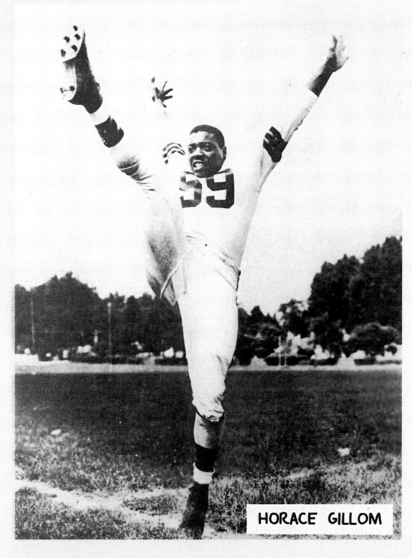

HORACE GILLOM

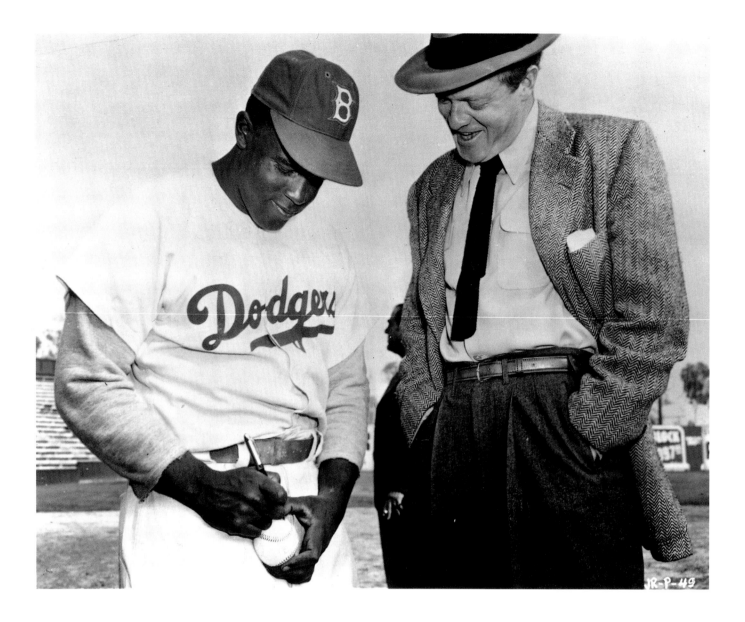

ABOVE: This clear, sharp, expressive shot of the great Jackie Robinson signing a baseball was a very lucky find.

OPPOSITE: When racism and "Jim Crow" laws forced the segregation of professional baseball at the turn of the twentieth century, Black players formed their own teams, "barnstorming" across the country to play all challengers. In 1920, official Negro Leagues were organized. Although some teams remained in existence until the 1960s, when Jackie Robinson was recruited from the Kansas City Monarchs to the all-White Brooklyn Dodgers, thus re-integrating baseball in 1945, much of the great history of the Negro Leagues passed into memory—along with much of its related memorabilia. In the mid-1970s, films such as *Bingo Long Traveling All-Stars & Motor Kings* and Hank Aaron's assault on Babe Ruth's home run record brought new attention to this legacy of the sport. This is an instance where newly made items and reproductions have become collectible—an item like this set of relatively modern cards is sometimes the only form most collectors can find and afford.

STARS OF THE NEGRO LEAGUES

A SET OF 36 CARDS

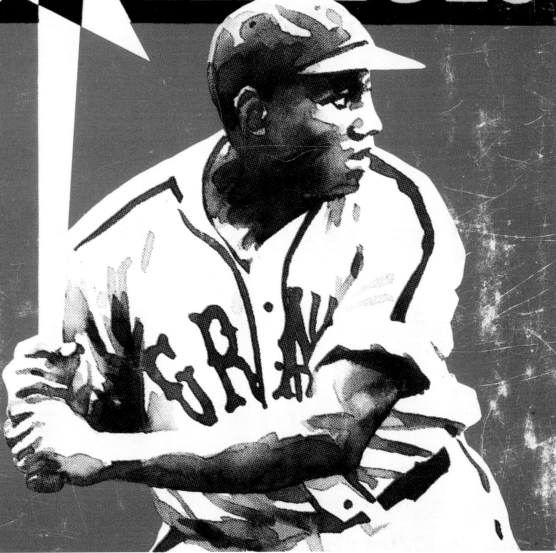

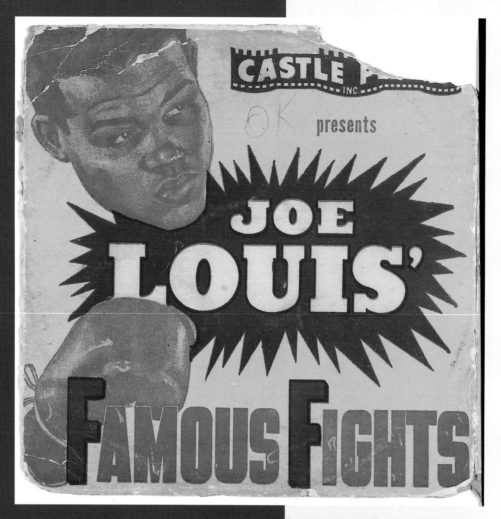

CASTLE FILMS INC.

presents

JOE LOUIS' FAMOUS FIGHTS

LEFT: Historical materials come in many forms. Here, an old film reel celebrates the renowned Joe Louis, who will always be included in the ranks of major Black boxing heroes. Its historical value far outweighs the poor condition of its box.

BELOW: It's both exciting and sentimental to see two boxing legends from different eras—Joe Frazier and Joe Louis—meet each other.

OPPOSITE: As in most collectible fields, sports objects showing athletes early in their careers are often more collectible than other standard fare. This photo also features a major boxer who is listed but whose photo is missing.

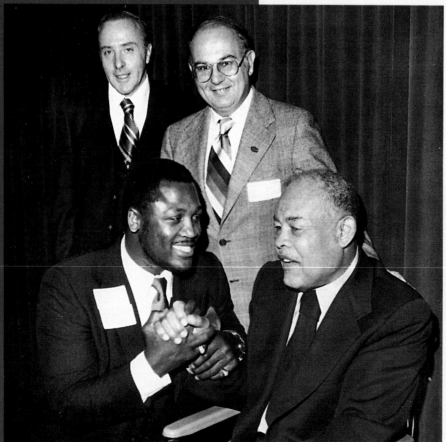

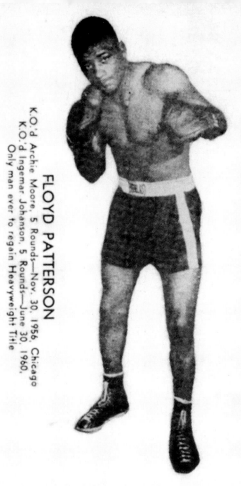

FLOYD PATTERSON

K.O.'d Archie Moore, 5 Rounds—Nov. 30, 1956, Chicago
K.O.'d Ingemar Johanson, 5 Rounds—June 30, 1960.
Only man ever to regain Heavyweight Title

JOE FRAZIER

Def. Jimmy Ellis, 5 Rnd. K. O., Feb. 16, 1970, New York

CASSIUS CLAY

DEF. SONNY LISTON, T. K. O. 7 RNDS.
Feb. 25, 1964, Miami, Fla. (Ret. Undefeated)

SONNY LISTON

K.O.'d Floyd Patterson, 1 Round—Sept. 25, 1962, Chicago

THE HOLY WARRIOR
MUHAMMAD
ALI

An Illustrated
Biography by
Don Atyeo and
Felix Dennis

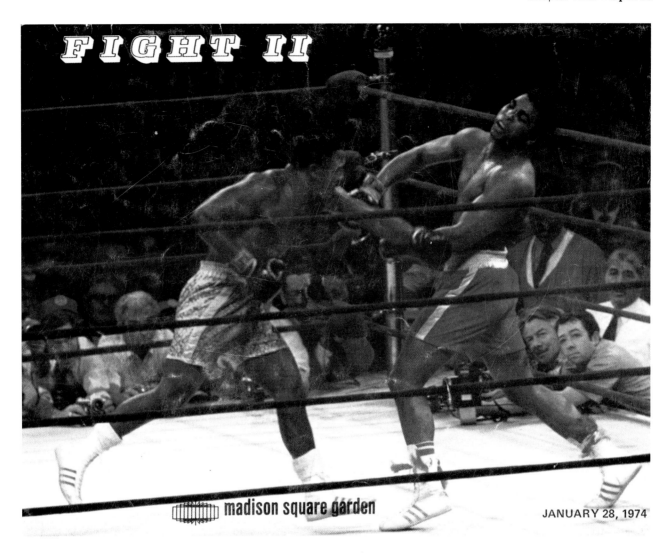

FIGHT II

madison square garden

JANUARY 28, 1974

THIS SPREAD AND THE NEXT
THREE SPREADS: Few people
have captured the hearts and minds of
the public like Muhammad Ali; indeed, he
remains such a popular icon that memo-
rabilia about his life and his career has
become its own category within Black
history collectibles. Not only do people
revere him, but demonstrate their devo-
tion at sales—digging deep into their wal-
lets in the process. Three-dimensional
objects like boxing gloves, autographs,
personal possessions, photographs and
collectibles concerning his personal
struggles outside the ring are most prized
among collectors.

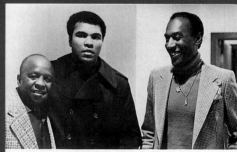

MUHAMMAD ALI ENDORSES WORLD BOXING FOUNDATION, INC.

Muhammad Ali is flanked by Dick Sadler, founder of The World Boxing Foundation, Inc., on his left, and William Riley, President of Roll's Productions on his right. The occasion was Muhammad Ali consenting to endorse The World Boxing Foundation and serve as Honorary International Chairman of the foundation. Additionally Muhammad Ali will host "A Superstar Night With Muhammad Ali And Friends" at the Hilton Las Vegas Pavilion on November 4, 1977. This affair sponsored by Roll's Productions will be the first major fund raiser for The World Boxing Foundation, Inc., for the pension plan and training program being initiated by the foundation.

5

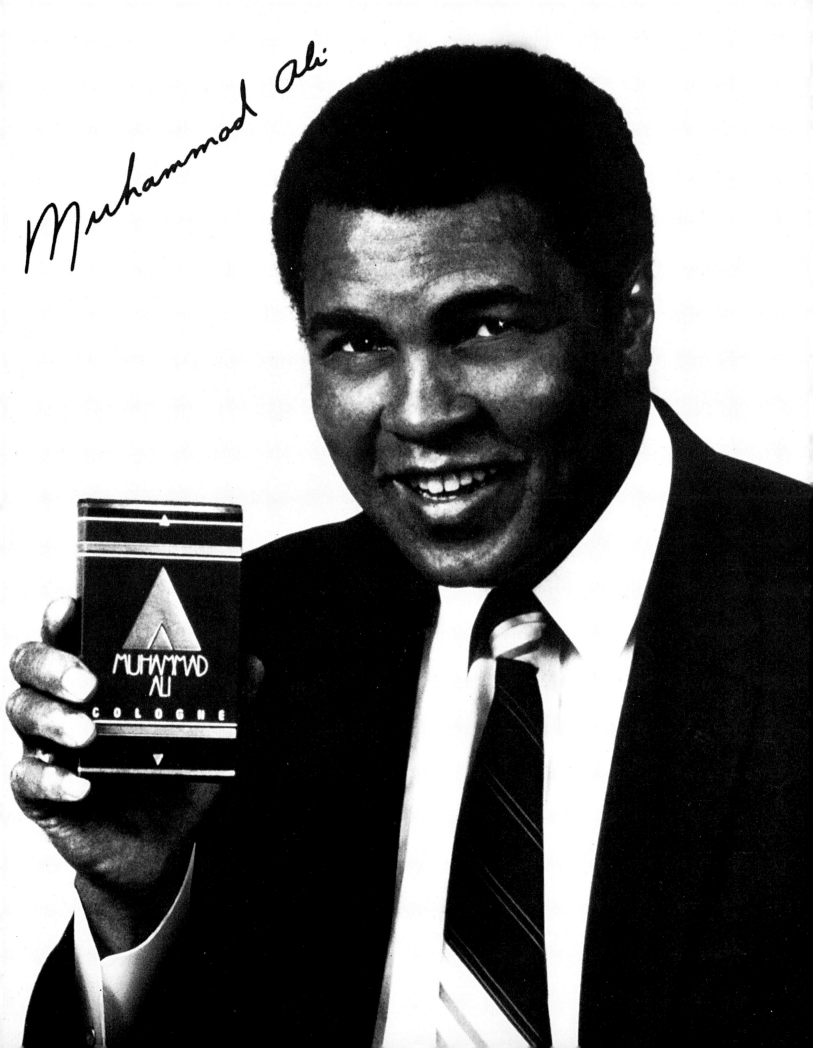

ALI/FRAZIER III

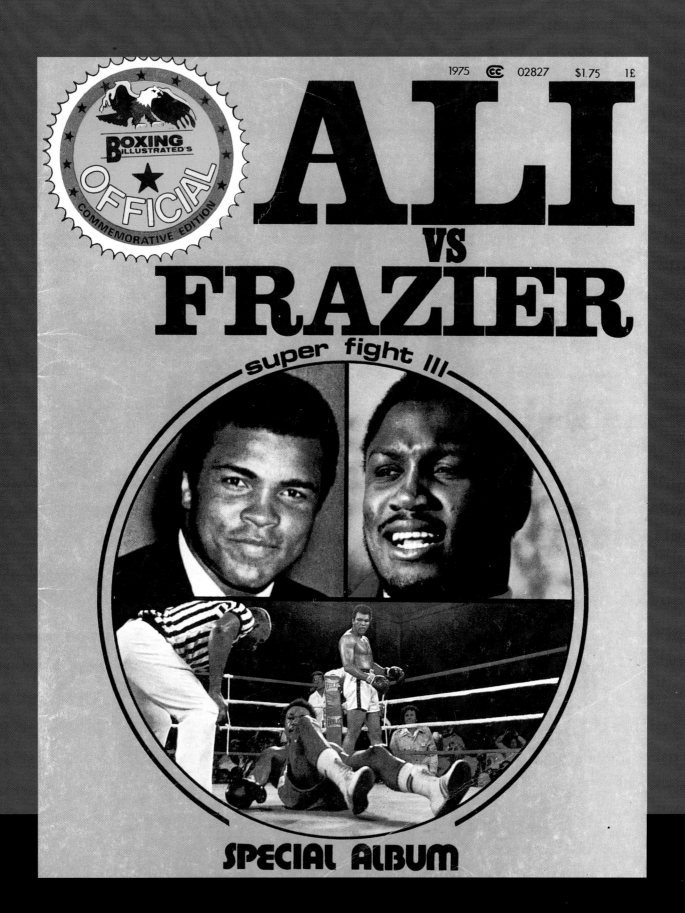

1975 ⓒⓒ 02827 $1.75 1£

ALI
VS
FRAZIER

super fight III

SPECIAL ALBUM

ABOVE: This souvenir material is more informative and detailed than most. Beyond the requisite promotional hype, there are interesting facts about the fighters and

A provocative article by Don King on his history with the fighters, using words usually forbidden in public, adds to the appeal for some collectors.

Down The Court

From the Lens of George Kalinsky

THIS SPREAD: Basketball is now widely collected, and items from before the 1970s and memorabilia documenting the rise of Black athletes in basketball are eagerly sought. The New York Knicks/ Madison Square Garden souvenir booklet (Knicks vs. Celtics) is from 1973 and well illustrated with many photos. Dean Meminger and Jo Jo White are on the cover holding basketballs. This program is an excellent example of how one piece can be of interest to collectors of varying interests. This was a championship year for the team, and the roster of players would be revered by any Knicks fan (Walt Frazier, whose autographed photo appears opposite, Willis Reed, and Earl Monroe, among them). Those interested in political history would also take great interest in the photos of "number 24," which graced the uniform of future senator Bill Bradley. In all, a desirable and worthwhile collectible.

To Odessie
&
Roy

you're the
best. Keep up
the good work.

Walt Frazier
"Clyde"

Best Wishes

Walt "Clyde"
Frazier

ABE SAPERSTEIN'S FABULOUS

HARLEM GLOBETROTTERS®

"MAGICIANS OF BASKETBALL"®

50¢

42nd SEASON
1968

LOU DARVAS

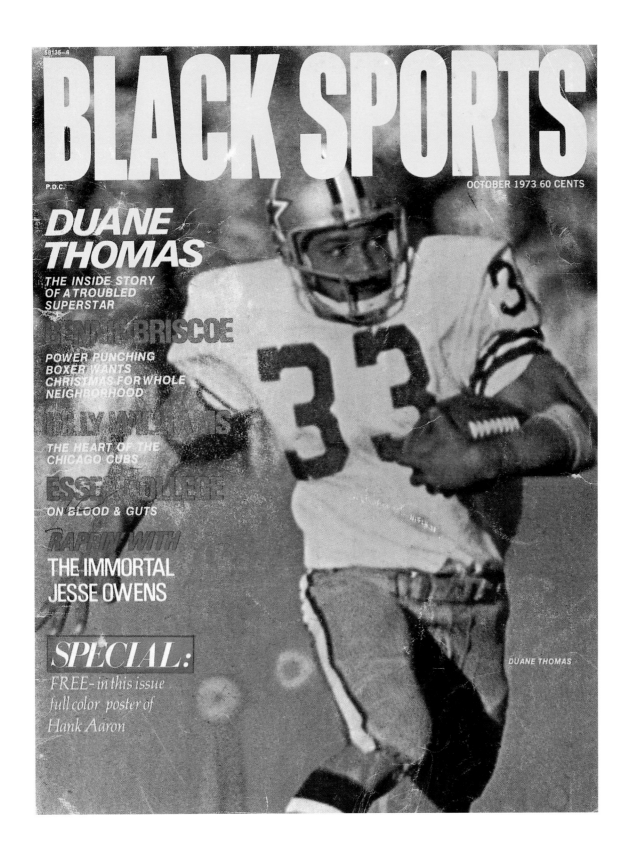

58135—6

P.D.C.

BLACK SPORTS

OCTOBER 1973 60 CENTS

DUANE THOMAS
*THE INSIDE STORY
OF A TROUBLED
SUPERSTAR*

BENNY BRISCOE

*POWER PUNCHING
BOXER WANTS
CHRISTMAS FOR WHOLE
NEIGHBORHOOD*

BILLY WILLIAMS

*THE HEART OF THE
CHICAGO CUBS*

ESSEX COLLEGE

ON BLOOD & GUTS

RAPPIN' WITH

THE IMMORTAL
JESSE OWENS

SPECIAL:
*FREE- in this issue
full color poster of
Hank Aaron*

DUANE THOMAS

OPPOSITE: Combining aspects of basketball and circus-type entertainment, the Harlem Globetrotters produced much promotional material. Most of it is quite collectible.

ABOVE: In the 1970s, the number of books, magazines and other types of publications devoted to Black sports proliferated. They are now collectible.

LEFT: Autographs on unusual surfaces, such as this signed Wilt Chamberlain T-shirt are generally more valuable than traditional signatures on paper or photographs.

BELOW: History comes in many forms, and those who like to wear their collection find hats such as this practical, relatively inexpensive and desirable because of the logo and the fact that it commemorates a time when the team was at the top of the game.

OPPOSITE: Michael Jordan became such an icon of his sport that he is easily recognizable here, even without the more familiar Chicago Bulls uniform. This large plastic figurine is a merchandising tie-in to the 1996 movie *Space Jam,* which paired Jordan with celebrated animated characters from the Warner Bros. "Looney Tunes" cartoons. Battery operated, this figurine "speaks" lines from the film when a button is pushed. Also shown is a McDonald's giveaway: a plastic stopwatch featuring Jordan's image.

CHARLES WHITE

Six Drawings

MASSES & MAINSTREAM · NEW YORK

BLACK ART *an international quarterly*

VOLUME 5 NUMBER 2 $4.50

Art

TYPES OF ARTIFACTS

Books and journal articles

Exhibition catalogues

Prints

Posters

Commercial art:

advertising art, graphics,
sheet music, record album
and book jacket covers,
and illustrations

Jewelry

Combs

Baskets

Textiles, quilts, and
sewing collectibles

Clothing with African motifs

BLACK ART DISTINGUISHES ITSELF FROM OTHER ART MORE through its subject and thematic matter than through the use of a medium. Whether a Black artist has produced a charcoal sketch, watercolor, sculpture, or oil painting, the work of art will often have cultural value because of its depictions of African Americans. Portraits capturing the subject's inner essence are highly sought after since they reveal something about the state of the African American psyche.

Black art, especially that produced in the twentieth century, expresses African themes, personalities, forms, and decorative motifs on such everyday items as greeting cards, calendars, jewelry, combs, clothing, and furniture. The 1960s and 1970s had a particularly profound impact on the African American art world. A new, Afrocentric aesthetic began turning up in sculpture, murals, sketches, and paintings. When looking at Black art, it is easy to identify pieces from this period. Art from the 1960s and 1970s often portrayed hot topics of the day, including the Civil Rights struggle, internalized racism and Black self-hatred, injustice, and the Vietnam War. You can tell artwork from this period because of the prominence of Afro hairstyles, African motifs, clenched fists, chains, and images of imprisoned Blacks.

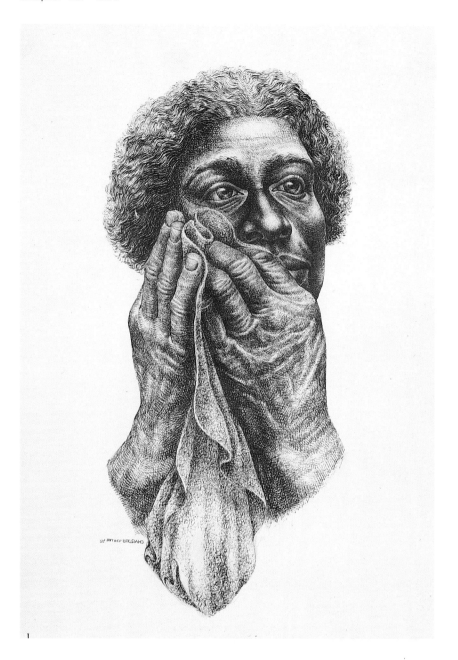

CHARLES WHITE

Six Drawings

MASSES & MAINSTREAM · NEW YORK

BLACK ART *an international quarterly*

VOLUME 5 NUMBER 2 $4.50

ABOVE: Most people cannot afford the original works of Black artists, but they can read and learn about them. This magazine has been responsible for providing a wealth of information about African American art and artists.

OPPOSITE: Another affordable option is prints reproduced in multiples, like this portfolio of drawings by mid-twentieth century artist Charles White.

What to Look For

As with most other African American collectibles, generally the older a piece of art is, the greater its historic and financial value. Having said that, very few old, original pieces of African American artwork appear on the market, but if you are resourceful and look in flea markets, garage sales, antique stores, you could come across something desirable. After reading about a particular artist, you might want to take a trip to his or her part of the country to do further research. Local galleries, exhibition halls, schools, and hospital gift stores can be excellent sources for acquiring artwork. Meeting a friend or family member of an artist can be the best way to uncover artwork for your own private collection. Remember: The closer a piece of art is to the hand of the artist who made it, the greater its value historically and financially.

Black folk art and crafts date back to the arrival of the first African slaves, who had to make everything they used and wore by hand. Female slaves who spent the day working in the fields were often spinners and weavers by night. Black folk art takes many forms: fabrics, clothing, tools, ceramics, furniture, accoutrements for horses, metalwork, and trimwork on homes.

Textiles, especially slave quilts, are among the most popular Black folk art collectibles. Some experts point out that there is little to distinguish a quilt made by a Black slave from a quilt made by a White woman, but some slave quilts made use of African motifs, cloth strips, and applique. Baskets and quilts from the slavery era are extremely rare and expensive.

Original artwork by well-known African American artists can be among the most expensive of all collectibles. Fortunately, high quality reproductions of a favorite artist's work can bring the price down to an affordable level for the average collector. Examples of well-known artists' work can also be found in coffee-table books, exhibition catalogues, and on posters and greeting cards. When evaluating Black art, keep in mind that a verifiable signature of an artist adds value to any work of art.

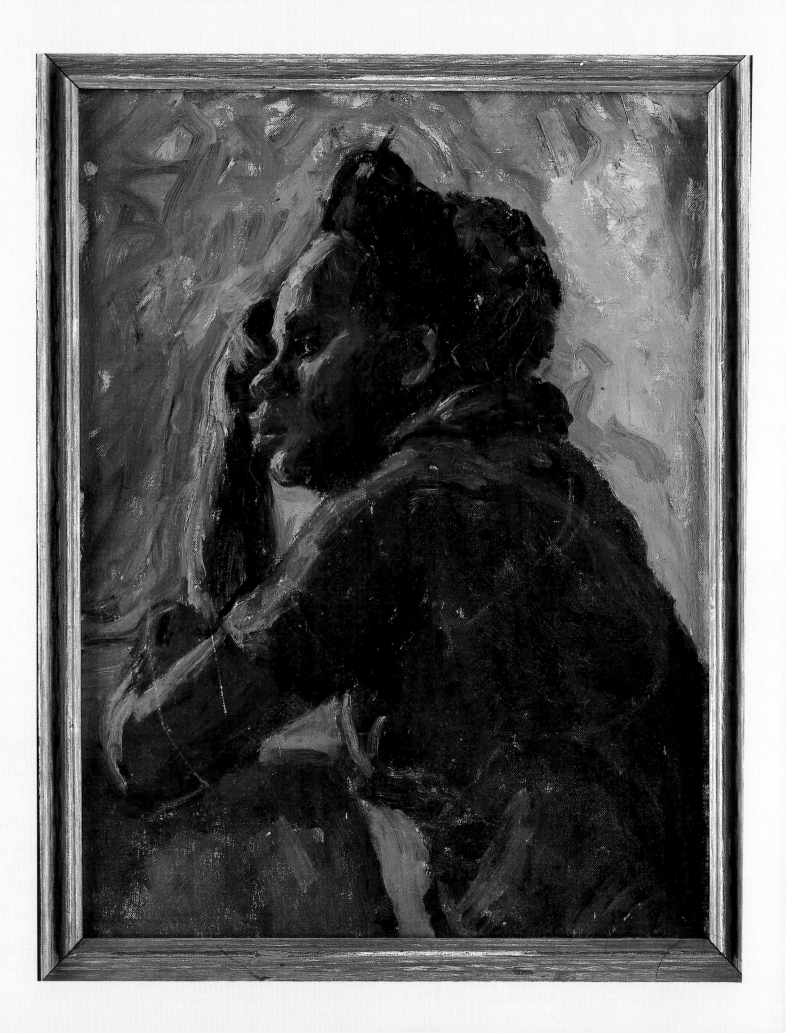

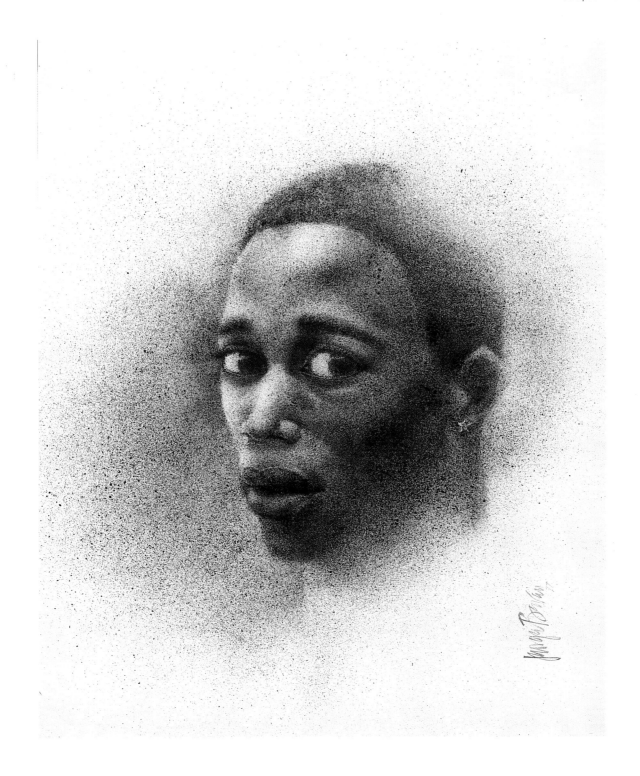

OPPOSITE: Collectors enjoy paintings like this because of its powerful mood, albeit somber here. This undated pieced is probably from the mid-twentieth century and reveals the personality of this unknown subject.

ABOVE: This realistic portrait from 1977 is a vivid sample of a pointillist-like effect, achieved perhaps with an airbrush or, perhaps, through a photographic-based technique.

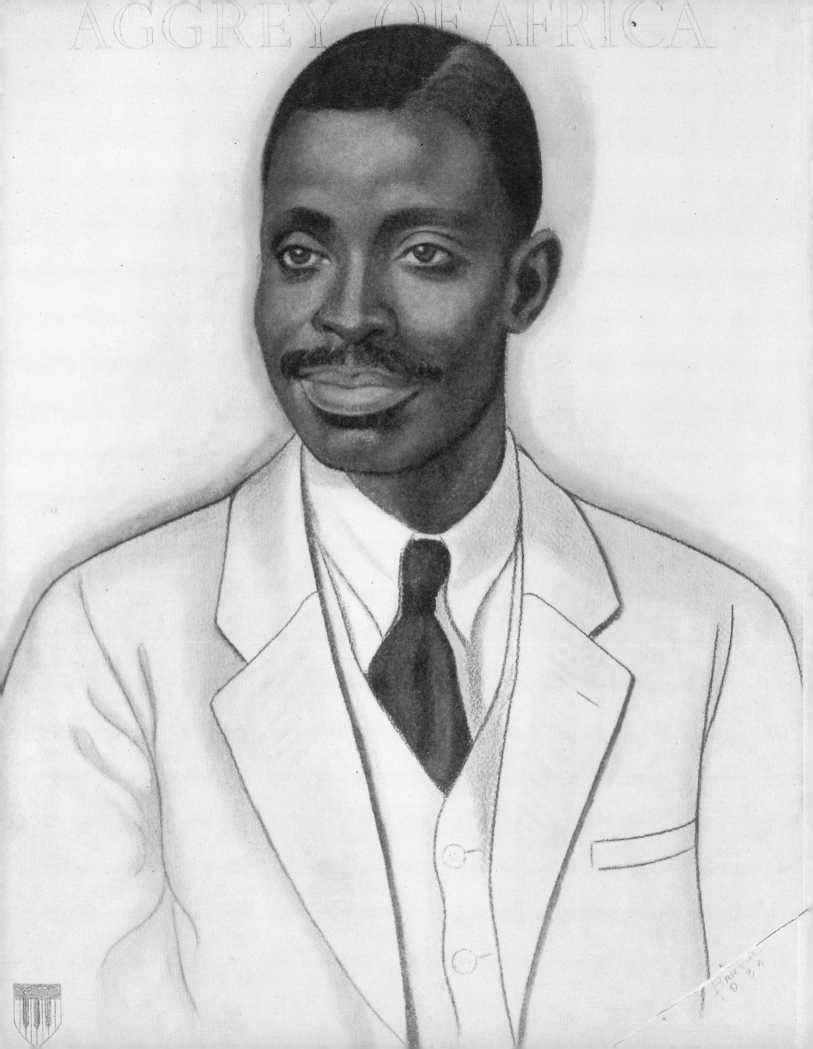

AGGREY OF AFRICA

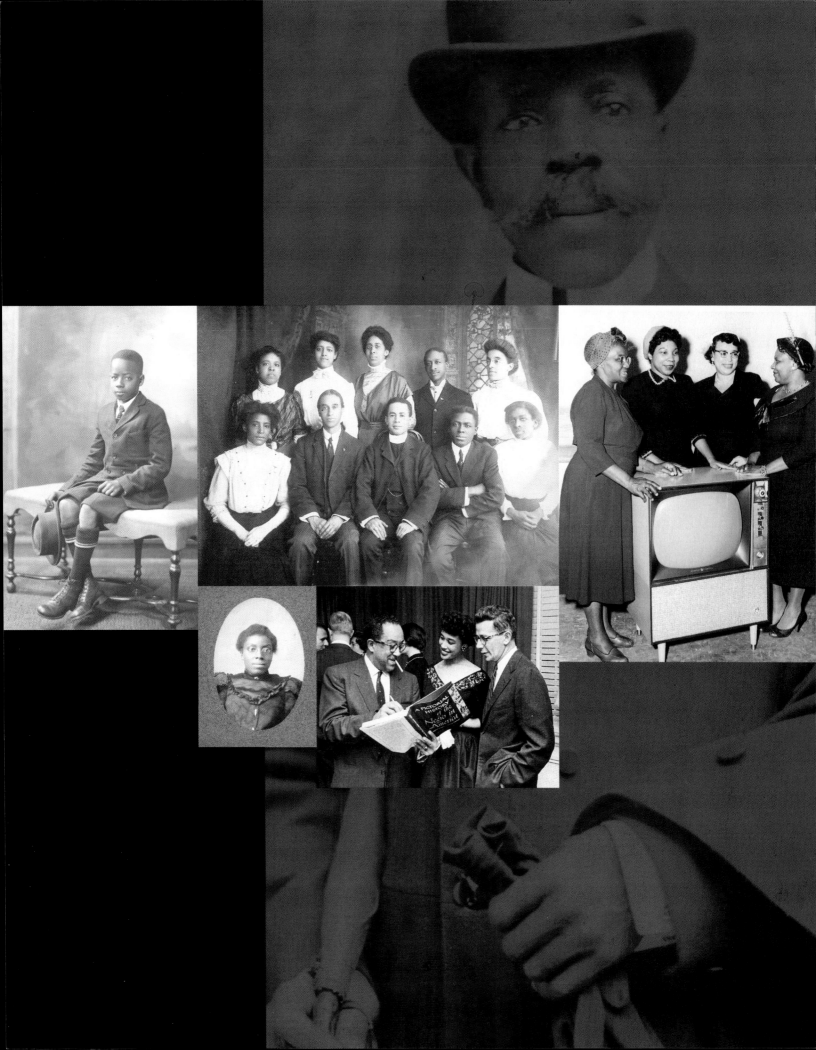

Photography

TYPES OF ARTIFACTS

Vintage portraits and scenes:
anonymous subjects taken
by unknown or amateur
photographers

Photography books and
magazines

Community life scenes shot by
local photographer

Images of famous photographers

Art and studio photographs

Photos of key events and
breaking news

Images on objects: posters, post-
cards, flyers, and jewelry

Newsfilm and movies

Videotapes and Digital Video
Disks (DVDs)

CD-ROMs

IMAGES, MOVING AND STILL, MAKE UP THE VISUAL RECORD of the African American experience. From the nineteenth-century daguerreotypes of Black soldiers in the Union Army, to brightly colored snapshots of a family's first college graduate, to news film of African Americans fighting in Vietnam, each image encapsulates a moment of history that can be seen and felt by generations to come. No wonder photographs and moving images have a universal appeal to people of all races, ages, and backgrounds.

Collections of historical images can include everything from wallet-sized family snapshots to colored slides, videos, and vintage photographs more than a century old. New formats for storing images on computer include CD-ROMs and DVD-ROMs. A collection of Black baseball players could include various media, from sepia toned black-and-white still photographs dating back to the 1920s to video highlights recorded off television broadcasts of live games in the 1980s to a CD-ROM with everything from vintage images to state-of-the-art picture-within-a-picture slow motion action footage. The possibilities are endless. And since still photography and cinematography are improving with the invention of new technology, future historians will have innumerably more options when it comes to accumulating valuable images of the way things were in the African American community back in the twenty-first century.

In addition to spanning different formats, photography collections can be equally idiosyncratic in their range of subjects. Portraits make up the bulk of most photography collections, but Black history collections also specialize in building exteriors and/or interiors, group events, and landscapes. In general, the most interesting photos show history in action, rather than stiff, posed portrait shots.

Beware of any purported vintage photo sold under glass, as it cannot be examined prior to purchase. Unscrupulous vendors have been known to duplicate original photos and sell them as vintage items to unsuspecting collectors. With the sophisticated reproduction techniques now available, extreme caution is required.

What to Look For

A photograph contains more historic value when it has identifying information, such as the name of the subject, location, date, and the event captured on film.

As with any other antique, the financial value of a photograph depends on its condition. Holes, tears, stains, fading, darkening, or bad cropping can ruin what would otherwise be a valuable historic item. However, if you are collecting for personal reasons rather than financial gain, you might overlook a frayed edge or chipped corner if you come upon an old photo that is the only image of your great-grandmother's former church. In that case, it is worth collecting no matter what its condition. (Old family albums are great resources for photographs that can also be used for genealogical research. Such albums are increasingly becoming more scarce and valuable on the open market, so if you find one, grab it!)

The majority of work by famous Black photographers, such as VanDerZee, Scurlock, P.H. Polk, and Gordon Parks, is in the hands of museums, institutions, and private collectors. While those rare images that come onto the market are much too expensive for the average collector, you can find excellent examples of these photographers' work in books written by them or about them. Of greater interest to collectors is the body of work by talented but obscure Black photographers whose vintage photos show aspects of African American life. You can find excellent images in flea markets, garage

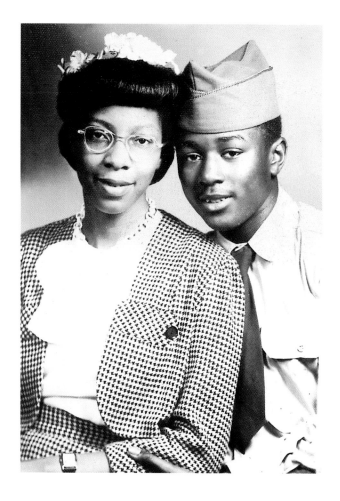

ABOVE: This small snapshot appeals to those who like to see evidence of emotional warmth in photographic subject matter.

OPPOSITE: This is the kind of photograph that attracts collectors who seek unusual, rough and folksy items. There is nothing we know about this woman except that she was probably in her finest dress, despite her shoes, and that she probably was not a member of the upper class. And yet, this image is compelling, especially because of the haunting expression on her face.

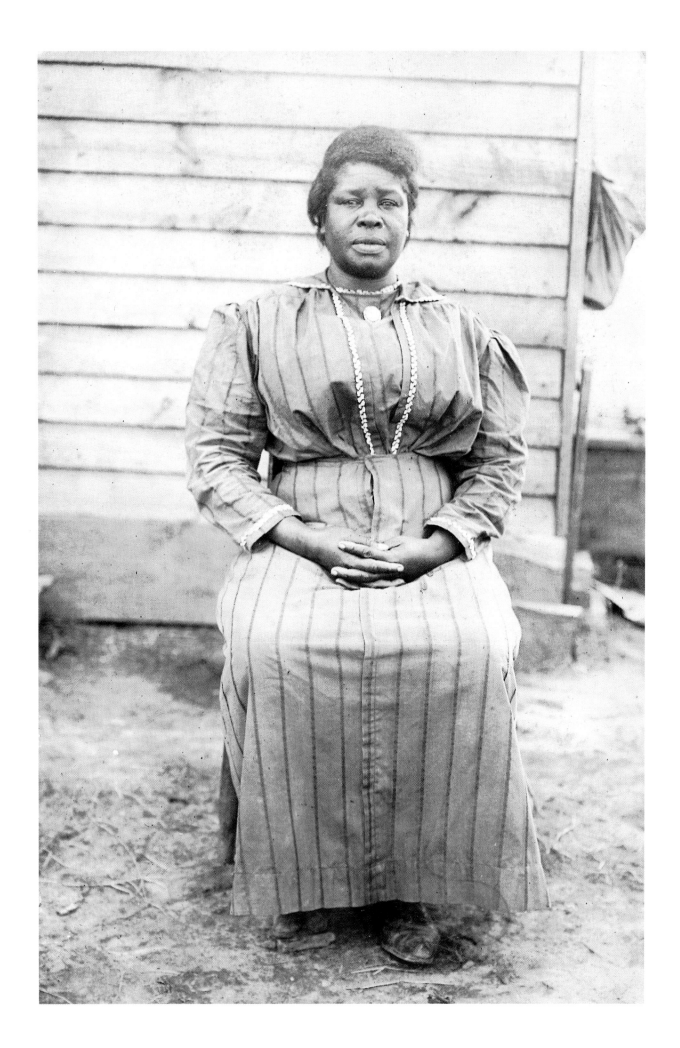

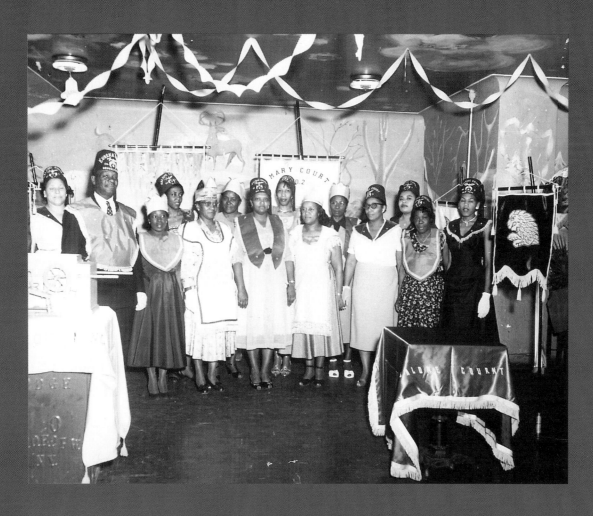

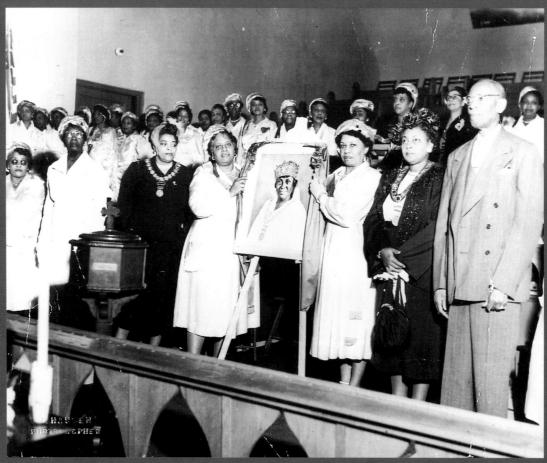

sales, and stores selling old books and prints. Contemporary photographs, especially those used in advertising, can form the basis of a stunning collection of African American life in the late twentieth and early twenty-first century. Keep your eye out for new talent as the young, unknown African American photographer or cameraman of today could provide your collection with several images that could be eagerly sought in the markets of the future.

Interpreting the Informational Value

Images contain far more information than we see at first glance. To an experienced eye, a photograph can yield information about the time period, social class, geographic locale, climate, lifestyles, and fashion tastes of its subjects.

The age of an undated photograph can be revealed by looking at the type of paper it is printed on and the quality of the image itself. The oldest photographs, dating from the mid-nineteenth century, are called daguerreotypes. The typographic styles used to mark the photograph can also help to time-stamp the image. Late nineteenth and early twentieth century type styles were more ornate. Images from World War I are often embossed with Art Nouveau type while those from the 1930s will often have Art Deco trim on the mountings. If the photographer's name appears on the mounting, it can be helpful in tracing the time period of the image.

Exceptional events, such as weddings, a Masonic convention, buying a first home or car, were deemed worthy of hiring a photographer so in that sense, a rare vintage photograph can capture and preserve the heart and soul of a bygone era and lifestyle. Examine the subjects in each photograph or frame of footage to retrieve information about their socioeconomic standing. Clothing is not always an accurate indicator of class since most people wore their best clothes when they were going to be photographed. Train your eye to notice the subjects' jewelry, hairstyles and accessories, such as handbags, pipes, cigarette holders, and umbrellas. Pay attention to the background of the image since old photographs are records of buildings and monuments that may no longer exist. Observe the size and professionalism of the photograph itself. Photography was cumbersome and expensive one hundred years ago, and only those who were relatively wealthy posed for a large professional quality photograph.

OPPOSITE AND ABOVE:

Lodges are a favorite subject for group photos from the past.

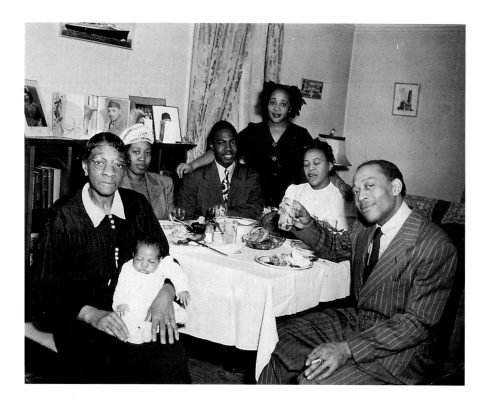

THIS PAGE AND OPPOSITE:
Many collectors seek interesting, charming or unusual scenes of the average (but interesting) African American. Ordinary community life or sentimental content in these photographs depict those features. It does not matter if the subjects are unidentified. Often collectors seek these items not for their historical value but their sentimental and aesthetic quality.

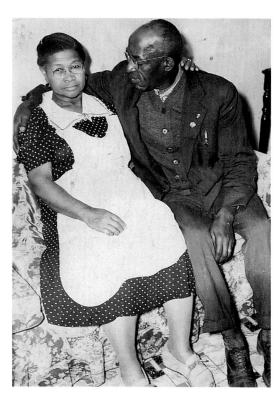

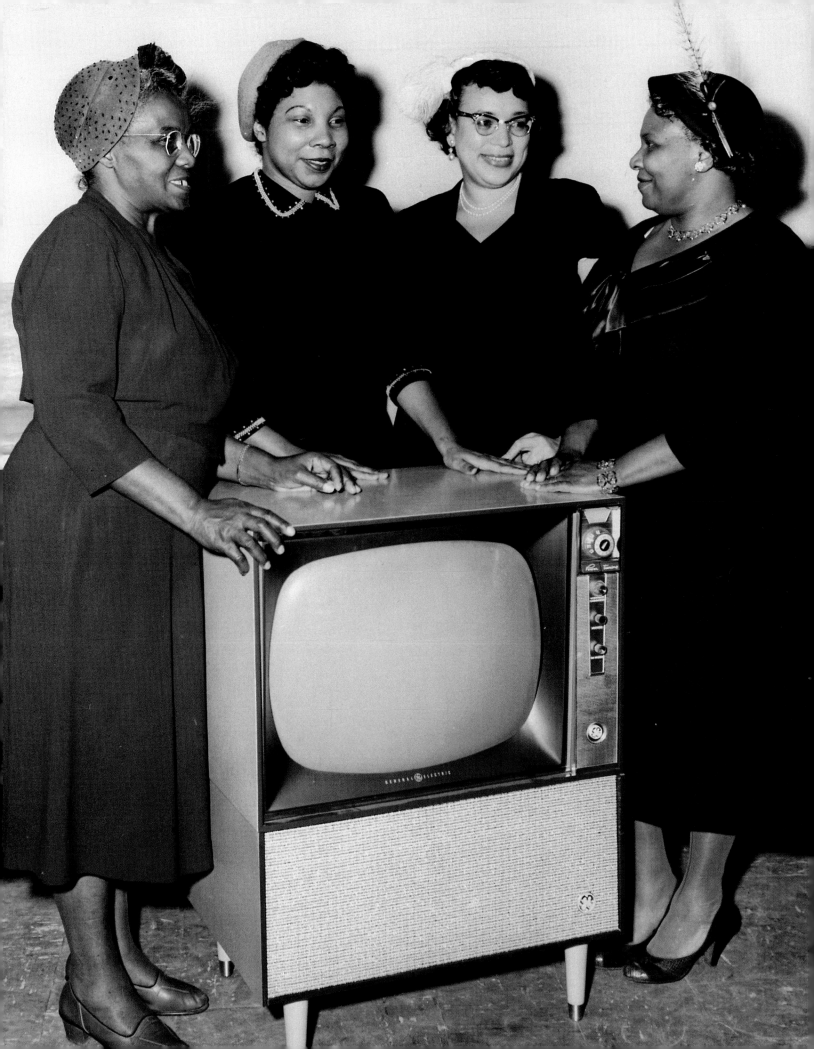

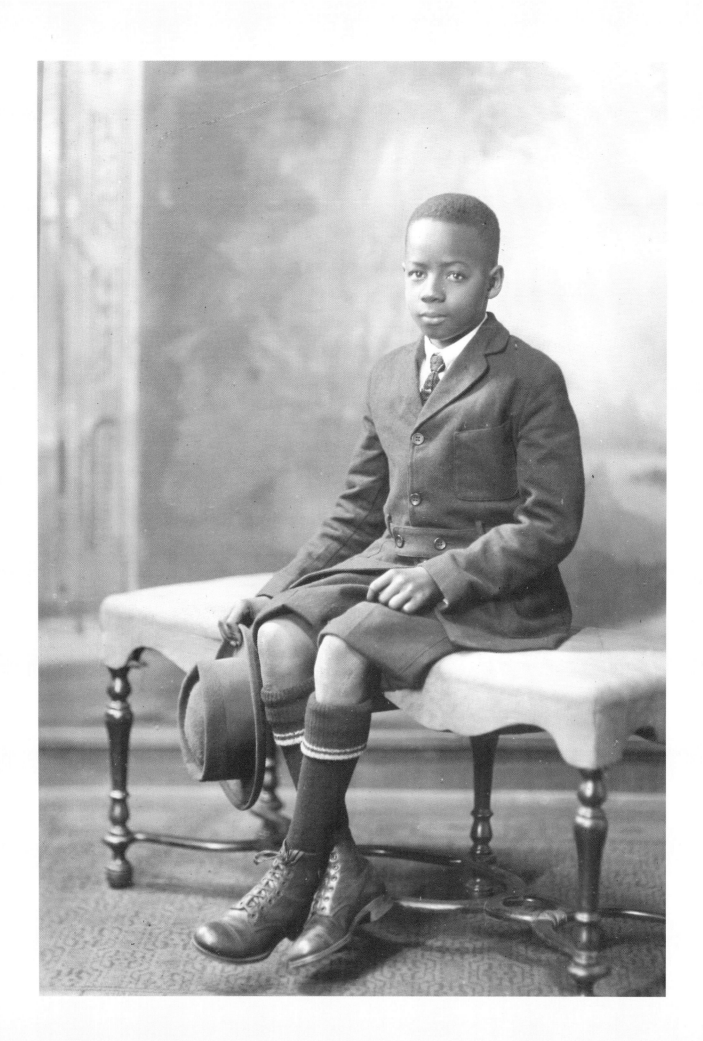

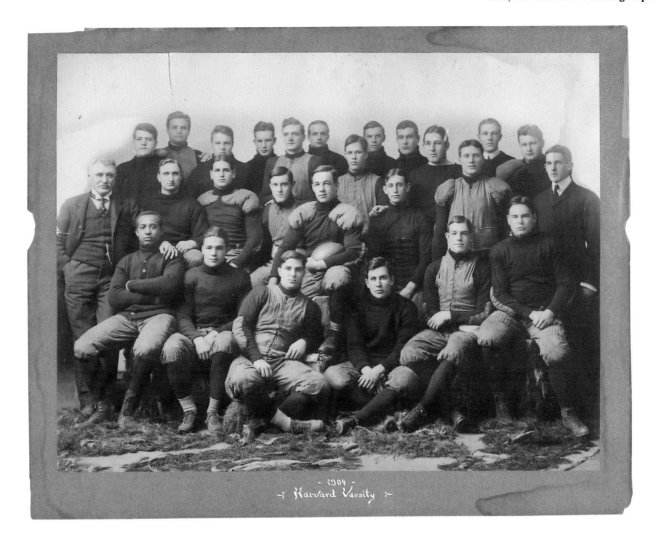

- 1904 -
-: Harvard Varsity :-

OPPOSITE: An anonymous subject that invokes an emotional response can almost "force" a collector to acquire a photo. Here it is not only the perkiness and warmth of the subject that makes this photo collectible, it is also the period clothes (the suit, the hat and the shoes) and the chair that is appealing.

ABOVE: Some items are so special and unusual that they are automatically classified as investment grade. This black-and-white 1904 Harvard team photo—almost 20 inches wide by 15 inches tall—shows a lone Black team member, junior William Clarence Matthews. Born in 1877 in Selma, Alabama, he trained at the Tuskeegee Institute before being sent north to study at Andover and then Harvard. From 1901 to 1905, he played shortstop on what was then one of the best college teams in the country. Although he faced discrimination off and on the field (unlike other Harvard players at the time, major league baseball was closed to Matthews), he was extraordinarily successful for an African American of his time, becoming a lawyer and earning appointments in the government and civic organizations before the first-half of the twentieth century. This photograph is very rare visual evidence of Black participation in main-stream Harvard life. Matthews is seated at the far left end of the first row.

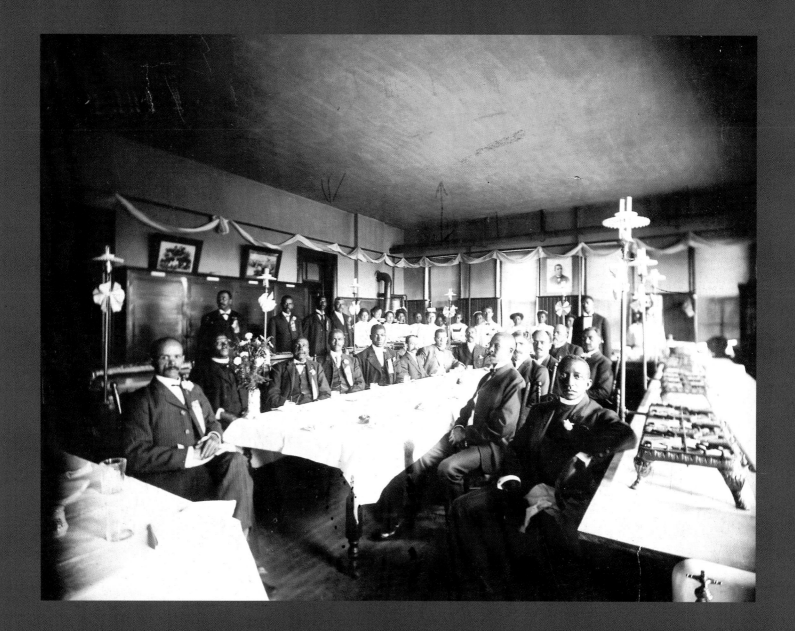

ABOVE: A very historic photograph of Booker T. Washington (seated seventh from the left, at the back of the room) in St. Joseph, Missouri, with local African American leaders from the early twentieth century. It was in innumerable gatherings such as this that national leadership was created in Black America at a time of great oppression.

OPPOSITE: An example of the work of the famed Scurlock Studio. Addison Scurlock, founder of the Scurlock Photographic Studio, was the foremost photographer of Black socie-ty in Washington, D.C. during the first half of the twentieth century. He opened his studio in 1911 and continued to photograph the city's elite— Black and White—until his death in 1964. The studio's clients included brides, achievers, conventioneers, and socialites; in the 1920s, he became the official photographer of Howard University and gained a national reputation. Scurlock also produced a series of portraits of African American leaders that historian Carter G. Woodson distributed to Black schools across the country.

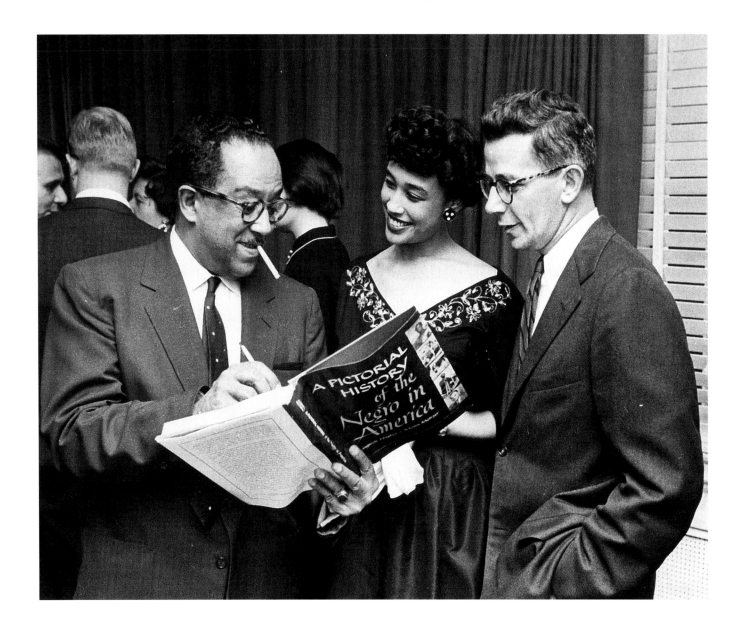

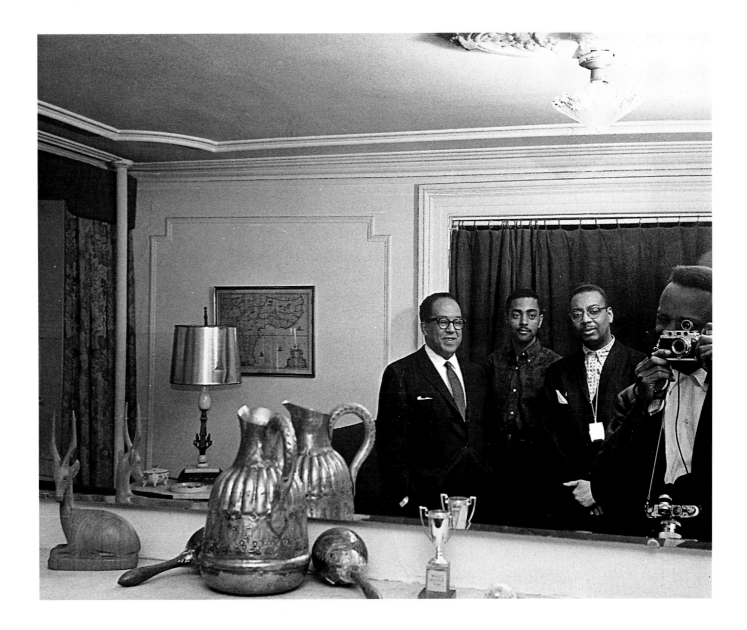

OPPOSITE: This is a photo of Langston Hughes signing a copy of his book *The Pictorial History of the Negro in America,* with his coauthor Meltzer looking on, and an unidentified woman smiling between the two. This photograph is important, charming, candid, and very unusual if not unique.

ABOVE: A little seen and possibly unpublished photo of Langston Hughes in the 1960s in New York City. The photographer has included himself and Hughes in a mirror. Further research that might yield the other identities could further increase its value.

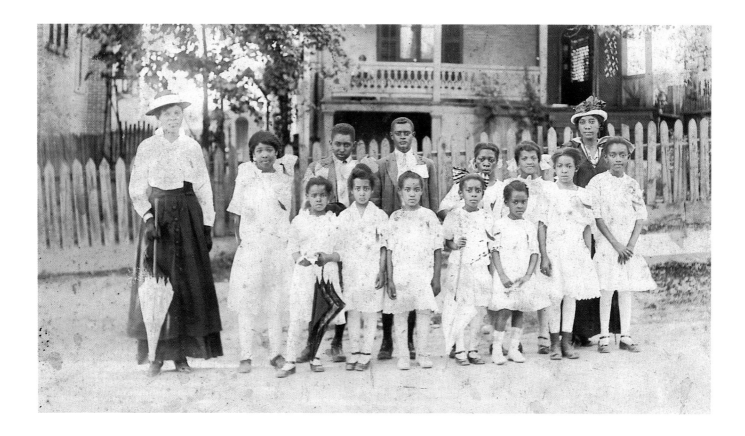

ABOVE: These children and their teachers show what formal education was like long ago. Relatively few group photos of children with adults can be found (which makes this one very uncommon). Once in a collection, this charming photo isn't going anywhere else. An unconfirmed report suggests that this group is from Tennessee (perhaps Nashville).

OPPOSITE: Old photographs contain much sociological content, usually implied rather than confirmed. Deciphering some of the "might be, could be" hints in old photographs is a large part of the fun of collecting. Group portraits from this time—within ten years of the turn of the century—with this many people are scarce. Although it has been suggested that these people were a Pennsylvania family, the ages of the people in this anonymous shot are similar. Thus, instead of being a family, which usually has people of varying ages, they might be members of an organization or a class. One of them, seated in the middle, is wearing a clerical collar, suggesting a church connection, another factor making this picture unusual and collectible. The skin shades within the group vary widely, which is notable because then color consciousness among African Americas was rampant and severe. Many collectors will pick up and consciously or unconsciously respond to these various factors in deciding to acquire photos such as this.

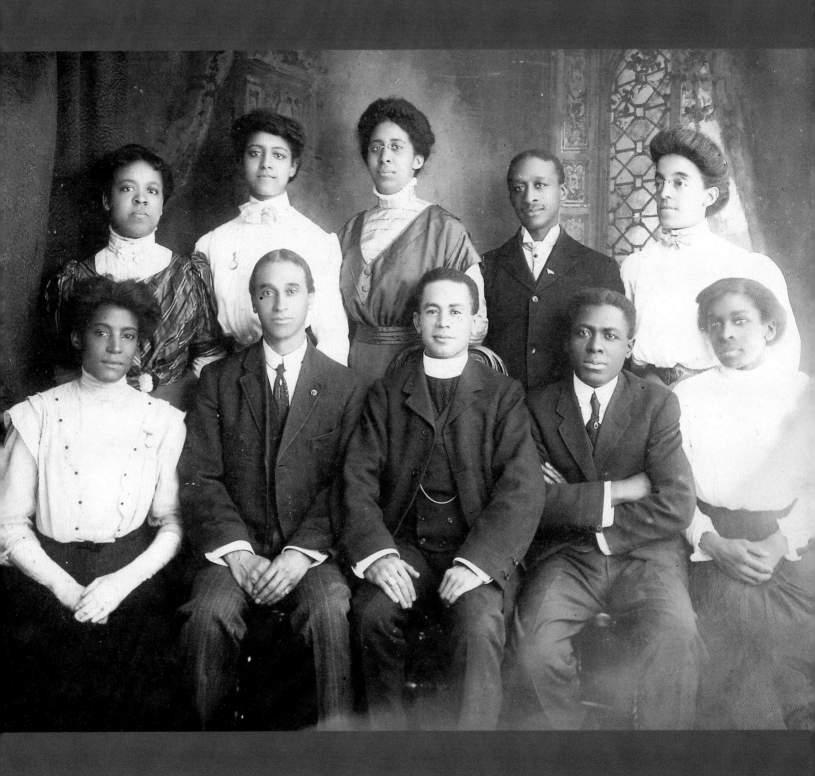

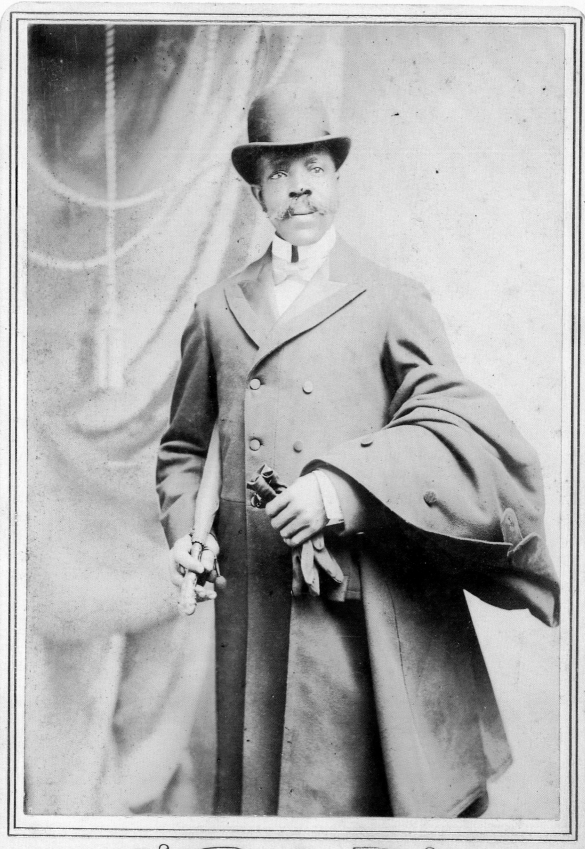

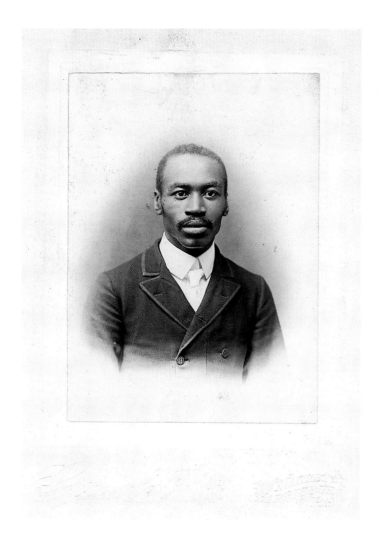

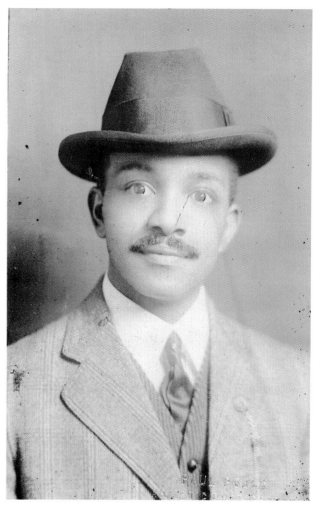

OPPOSITE: Some vintage portraits are more interesting and exert greater impact on the viewer than others. This finely dressed Richmond, Virginia, gentleman in bowler hat and frock coat with umbrella and an overcoat on his arm is "sharp," and knows it.

ABOVE LEFT: This man's features are clear and bold; adding to the artistic effect, the photographer has surrounded him with an aura-like, shaded, oval background with soft edges— a common device in old photograph.

ABOVE RIGHT: The subject's ever so slight smile, positive attitude, and lively eyes make this more appealing than the usual stiff, somber portraits so common of the time.

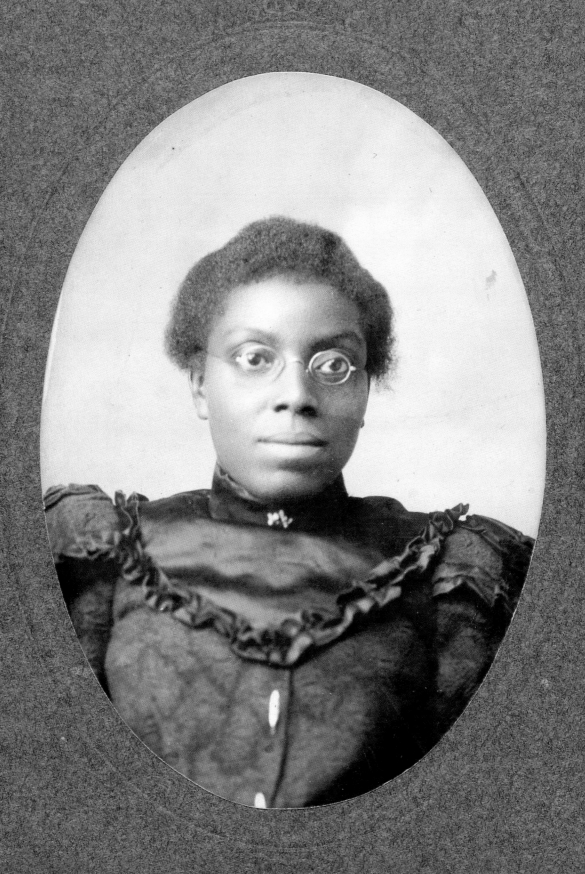

814 MARKET ST. Fasnacht
HARRISBURG, PA.

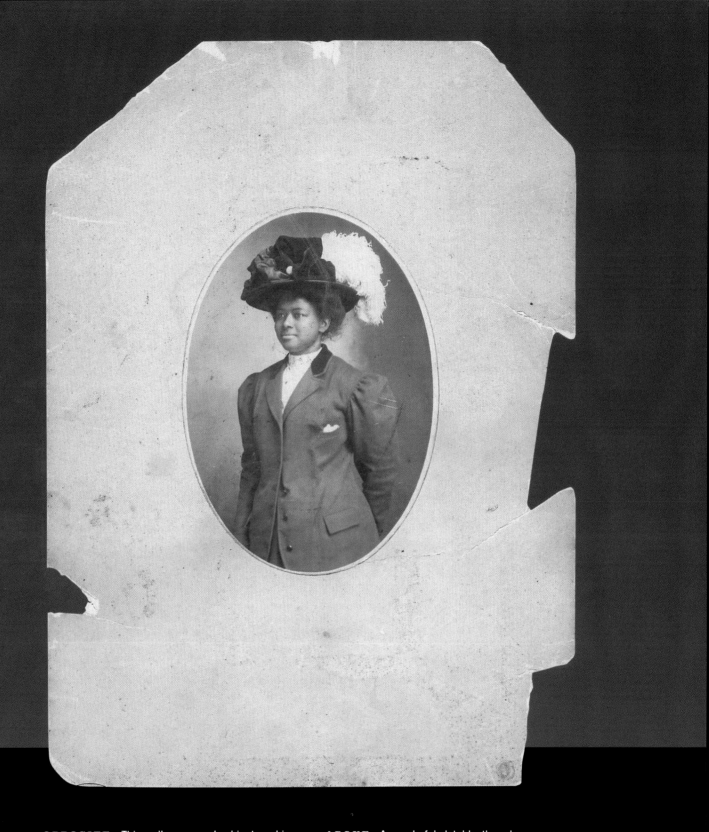

OPPOSITE: This well composed cabinet card is another example of what people look for in old photographs. The dress indicates a date somewhere near the 1880s and 1890s. The subject is serious but slightly smiling and somewhat confident-looking. Her features are clear. The contrasting lighter background frames and emphasizes her head.

ABOVE: A wonderful, datable, though anonymous oval photograph of a young African American woman in a large, conspicuously feathered hat is quite a find. The hat makes the photo. The subject is beaming and confident and obviously proud of her style, making this whole scene appealing to collectors. This kind of hat and the sleeves enlarged at the shoulder reveal that this photo was taken near the year 1900.

...IAMS:

FOR RECOGNITION?

GRACE JONES:

"I STILL LACK LOVE"

CHAKA KHAN:

THE SECRET SHE
COULDN'T HIDE

THERE'S MORE TO
ME THAN THAT

Books, Magazines, and Documents

BUILDING A BOOK COLLECTION DEVOTED TO AFRICAN American history is to build a collection of ideas, impressions, and insights that provide an enhanced understanding of a period of history, issue, or theme. Therefore, books, magazines, and vintage paper items known as ephemera are not collected purely for their historic merit or aesthetic as are other artifacts. They attract you because something in the writer's choice of words and phrases touches an emotional chord or makes you think differently about something you may have taken for granted.

Collections can be built around a subject, a political issue, a leader or celebrity, an author, or the type of book itself. Before the 1900s, few Blacks were educated or literate so the market for reading material focused on African American needs was tiny compared to the market for reading material geared to Whites. Nor did African Americans have the disposable income or leisure for reading. This makes early books by African Americans about African American subjects like slavery or religion very rare. And when it comes to books, very rare normally means very expensive. Antiquarian or rare books published before the twentieth century are sometimes good investments. Fortunately, there are numerous affordable alternatives available to avid readers and historians.

What to Look For

Old books can be found at book fairs, antique shows, and used book dealers. You can also search for them on the Internet. In general, the age, authorship, fame, and condition of a book determines its financial value. The first edition of a hardcover book is considered to have more historic value than a subsequent edition because it represents the original state of the work published. Some first edition books are numbered and signed by the author, increasing their value. Signed first editions are worth more than unsigned ones.

African American history books were first published at the end of the nineteenth century. The Harlem Renaissance, from the 1920s to the 1940s, was one of the most fertile periods for creative writing in the African American community. Between 1950 and 1970, hundreds of books exploring different dimensions of Black life began to appear on the nation's bookshelves. Even books about Africa and the Caribbean shifted their focus from exotic travelogues to thoughtful essays on what it means to be Black. From 1980 until now, publishers have been producing books specifically geared to African American readers in such genres as self-help, fashion, finance and investing, science, and etiquette. Older Black children's books are considered a hot collectible.

Even if you are not attracted to the idea of building a book collection, as a collector of African American history you will need to acquire reference books such as encyclopedias, almanacs, literary criticism, chronological references, biographies, and historical surveys. Although collectible reference books often become obsolete since newer works with updated information are published annually, some, like the Who's Who in Colored America series are worthwhile collectibles in their own right.

Magazines can be a cost-effective alternative to acquiring books. They are plentiful, easy to store, and usually easier to read. You can find old magazines in attics, basements, older people's houses, library sales, estate sales, and book shows. The illustrations, photos, and graphics often give more insight into a particular era than any other collectible. You can see how people dressed, what products they consumed, what cars (or horses) they used for transportation, and what excited them!

ABOVE AND OPPOSITE:

Ephemera often captures long lost events that are difficult to document otherwise. As this brochure indicates, the 1920s saw a cultural movement take root, not only in New York City, but all over Black America. Like much ephemera, this piece belongs to more than one collectible category: it is clearly a piece of ephemera and a musical item, revealing local history. In addition to major musicians (Nathaniel Dett, Marian Anderson, Clarence Cameron White, and so on) the lecturers were to include W.E.B. Du Bois, Mary McLeod Bethune, and other influential thinkers and leaders.

HISTORY IN A NUT SHELL

The Umbrians, with a membership of thirty men, have been organized for twenty-one years. They have made four annual tours and sung in twenty-four cities. The most recent additions to their excellent personnel are David B. Hawley, Traveling Manager; W. D. Giles, D.D.S., Pianist, and Dr. F. Eugene Butler, Violinist.

FORWARD

Despite the fact that all large cities have varied and many kinds of attractions for entertaining, yet how often do we hear people remark that they have no place to go, meaning that there is something about this class of entertaining which does not satisfy.

The Chicago Umbrian Glee Club during its twenty-one years of existence has been a pioneer in its endeavor to satisfy the desires of its patrons and friends by keeping constantly in mind the kind of entertainment best suited for social betterment and uplift. This is the excuse for its being the most unique singing organization in the middle west.

This pioneer spirit still pervades and as a consequence a new idea is here presented in keeping with our aim to present fitting attractions to our friends and patrons for their edification as well as entertainment.

A LYCEUM COURSE

We believe that there is great need for and that hearty support will be given to that kind of entertainment which has an educational as well as an entertaining value. The world around us is undergoing such rapid changes in our political, social, economic and physical status that for one to exist and be able to enjoy all that one should requires constant study and attention to the causes effecting these changes. All of us have not the time to study these problems, and even if we did, more could be gained by listening for an hour to a lecturer who is a specialist in a particular subject than could be gained in weeks otherwise.

A Lyceum Course is to be established to be known as the Chicago Umbrian Glee Club Lyceum Course to consist of four numbers, that is, four entertainments will be given during the season, one in each of the months of October, December, February and April.

The programs will consist of such nationally known lecturers as Dr. J. W. E. Bowen, Madam Mary Bethume, Prof. William A. Pickens, Clarence Darrow, W. E. B. Dubois, Maj. R. R. Moton, Miss Jane Addams and Mrs. R. H. McCormick; and musicians, such as Clarence Cameron White, Marion Anderson, Nathaniel Dett, Florence Cole Tolbert, Julius Bledsoe, Anita Patti Brown, Hazel Harrison and Jessie Zackery.

SEASON TICKETS

Arrangements have been made for two classes of admission to this Lyceum, namely, single admission and season ticket. Single admission will be 50c, 75c and $1.00 classified as general admission, reserve and special reserve seats. The season ticket will be the special reserve seat and will sell for $3.00. Patrons and friends of the Chicago Umbrian Glee Club will be solicited as purchasers of these season tickets and because of the degree of civic pride and loyalty shown such purchasers' names will be published.

FINAL

Chicago, the queen city of the middle west, boasts of her civic advancement and opportunities. She is both setting the pace and holding it because of the kind of cooperation given her worthy institutions. The Chicago Umbrian Glee Club believes this Lyceum Course is a forward step consistent with Chicago's civic advancement and solicits your continued patronage on the merit of its endeavorer.

Black magazines and periodicals were published in the nineteenth century but, like books, they weren't easily accessible to most African Americans because few people could read or afford them. During the 1920s, a number of Black magazines were launched, but failed to survive the Depression. Key long-term survivors include *The Crisis,* published by the NAACP, and *Opportunity,* published by the Urban League in the 1920s and 1930s. They are valuable collectors' items today. More recently, mass-market magazines targeted to the African American reader, such as *Ebony, Jet,* and *Essence,* reach millions of readers. Issues of now-defunct news and gossip magazines *Tan, Jive, Hep* and *Our World* offered readers a Black editorial perspective on breaking news and issues of the day. In addition to these general interest magazines, numerous others were published by professional and trade associations, civil rights organizations, business affairs groups, and Black colleges' alumni associations. Any Black magazine published before 1950 has some historic and financial value. Sometimes, obscure magazines and journals

THE TRUSTEES AND FACULTY

OF

BEREAN SCHOOL

CORDIALLY INVITE YOU TO ATTEND AN EDUCATIONAL

SYMPOSIUM

SUBJECT: "THE NEGRO"

AT

BEREAN CHAPEL

SOUTH COLLEGE AVE. AND NORTH NINETEENTH ST.

TUESDAY, JUNE 10, 1924, 8.30 P. M.

PRESIDING—DR. CARTER G. WOODSON
EDITOR OF "THE JOURNAL OF NEGRO HISTORY"

SPEAKERS:

DR. MATTHEW ANDERSON
"THE NEGRO IN ANCIENT HISTORY"

CHARLES WESLEY
PROFESSOR OF HISTORY—HOWARD UNIVERSITY
"THE STATUS OF THE NEGRO FROM THE TIME OF HIS INTRODUCTION INTO
AMERICAN CIVILIZATION THROUGH THE RECONSTRUCTION PERIOD"

A. PHILIP RANDOLPH
EDITOR OF "THE MESSENGER"
"THE PROGRESS OF THE NEGRO ECONOMICALLY"

HARRY T. BURLEIGH
COMPOSER
"THE PROGRESS OF THE NEGRO IN MUSIC"

CHARLES S. JOHNSON
EDITOR OF "OPPORTUNITY"
"THE SUBTLE INTERNAL AND EXTERNAL INFLUENCES WHICH TEND
TO RETARD THE NEGRO'S PROGRESS"

ALAIN LEROY LOCKE
PROFESSOR OF PHILOSOPHY—HOWARD UNIVERSITY
"THE GOOD INFLUENCES FROM WITHIN AND WITHOUT WHICH
ENCOURAGE AND ADVANCE THE NEGRO"

ARTHUR HUFF FAUSET
"NEGRO YOUTH FACES THE FUTURE"

A THE
AMERICAN
COLOR-VIEW

⚓ A Magazine of Distinction ⚓

GIVING A VIEW OF THE COLORED WORLD

DECEMBER 1936

Problems In Black
Reginald H. Clyne

The Opportunist
Allan MacFeeters

A Strange Inheritance
J. Augustus Hazzard

'Lo Kids, How 'Ya
Jas. A. Carmon

Editorials, Poems and Special Features

Vol. 1 No. 4 (New Series) 10 Cents

ABOVE: Rarely found on the open market and dating back to the Harlem Renaissance, this magazine would be welcomed in any collection. Interestingly, it claims to be the mouthpiece of the colored world, thus making it irresistible to collectors.

OPPOSITE: This old invitation is a great find; notice the range of Black leaders and thinkers who took part in a symposium on "the Negro."

targeted toward smaller audiences tend to be more expensive and have a high resale value because of their rarity. Although collectors often cut out magazines to extract articles and photos of special interest to them, this practice should be avoided when the magazine itself is a collectible. Cutting pages destroys the historic and investment value. When examining an old magazine, be sure to check to see whether any pages, sections, or pictures have been cut or torn out before you buy it. To preserve your magazine collection, avoid bending their covers back, and hold them about an inch from the spine to avoid splitting. Never crease or fold an old magazine's pages. It will reduce its resale value.

Interpreting the Informational Value

Ephemera of all kinds can prove to be of great value in terms of historical and cultural information. A simple list of attendees at a political convention can be a potential gold mine to researchers. Sheet music, souvenir programs, postcards, first day covers, stamps, playbills, programs, and advertisements from different time periods can be found for reasonable prices. Black advertising and commercial ephemera—sales brochures, labels, product containers, promotional calendars—are also somewhat accessible and affordable types of paper items. Slave documents, currency, and pre-twentieth century posters, contracts, and autographs are rare and expensive. Scrapbooks, which contained news clippings, photographs, invitations, notes, and photographs are invaluable sources of ephemera. Since ephemera is delicate, it must be stored in a dark, dry, acid-free environment. Keep it flat. Try to keep as much of your scrapbook contents together as possible, so that the ephemera can be viewed in context.

Negro Business Anniversary Number

The CRISIS
April, 1941 • Fifteen Cents

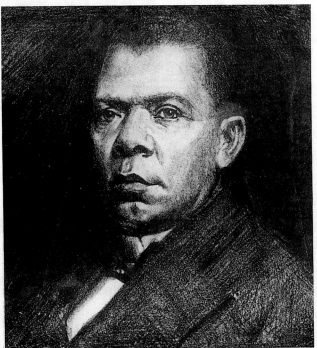

BOOKER T. WASHINGTON
Founder, National Negro Business League

Schomburg Collection

LEFT AND BELOW: *The Crisis* magazine is the official publication of the National Association for the Advancement of Colored People. Old copies of *The Crisis* (especially from before the 1950s) are hard to find and very informative when it comes to issues, events and people of national and sometimes even local interest. Vintage issues are always worth having and the supply is drying up since magazines are fragile. This issue is interesting and historically desirable because it focuses on business, a topic of great interest to today's entrepreneurs and those devoted to economic self-sufficiency.

OPPOSITE: A cover from *The Crisis* magazine in the 1930s shows that during the Depression jobs and economic survival were on everyone's minds.

THE CRISIS
Founded 1910
REG. U. S. PAT. OFF.

A Record of the Darker Races

Published by THE CRISIS PUBLISHING COMPANY, INC.

Volume 48, No. 4 Whole No. 364

NEXT MONTH

There will be a picture section on the 349th Field Artillery at Fort Sill, Oklahoma.

Also in the May issue will be an article on the terror in Memphis.

In June, The Crisis will indulge in a mild celebration and a little patting of itself on the back, for it was in June, 1921, that The Crisis printed Langston Hughes' poem "The Negro Speaks of Rivers."

For this twentieth anniversary Mr. Hughes has written for the June issue an article, "The Need for Heroes." There will appear in a subsequent issue a new story by him entitled "One Friday Morning."

OUR CONTRIBUTORS

Albon L. Holsey is the veteran secretary of the National Negro Business League. He has been active in Tuskegee life and in agricultural work for many years.

Joseph B. LaCour is generally considered to be the foremost Negro advertising man in America. He is advertising manager of the Washington, D. C., edition of the Baltimore Afro-American.

M. S. Stuart is the historian of the National Negro Life Insurance Association and an officer in the Universal Life Insurance Company, with headquarters in Memphis, Tenn. Major R. R. Wright, Sr., is the dean of Negro bankers in the U. S. and is active in many other fields of business and civic endeavors.

Louis L. Redding is an attorney of Wilmington, Delaware. Readers of The Crisis will remember his penetrating articles on the late Senator William E. Borah and John Nance Garner of Texas.

D. Sebastian Schiffer is in one of the Army camps in the North.

Dr. Charles Edward Russell of Washington, D. C., is one of the founders of the NAACP and a member of its board of directors. He is also the organizer of the D. C. Interracial Committee at one of whose mass meetings the speech published here was delivered.

Editorials

The President Speaks ON March 15, President Roosevelt issued a stirring call to the nation to bury all differences, to make all possible sacrifices, and to give the maximum in effort in support of the new policy of "all-out" aid to Britain. Said he:

"This decision is the end of . . . compromise with tyranny and the forces of oppression . . . The great task of this day, the deep duty which rests upon us is to move products from the assembly lines of our factories to the battle lines of democracy—now!

"A half-hearted effort on our part will lead to failure. This is an all-out effort—nothing short of all-out effort will win.

"And so tonight I am appealing to the heart and to the mind of every man and every woman within our borders who love liberty. I ask you to consider the needs of our nation at this hour and to put aside all personal differences until our victory is won.

"There will be no divisions of party or section or race or nationality or religion. There is not one among us who does not have a stake in the outcome of the effort in which we are now engaged."

Those are fine, thrilling words from Mr. Roosevelt. The trouble is that a great many people in this country have not understood what they mean. Mr. Roosevelt appealed for total effort on the part of all the people.

The men and agencies running the national defense program are excluding one-tenth of the nation's manpower, or are consenting to that exclusion. The only crime of this manpower is that it is not white.

On the very day Mr. Roosevelt spoke Negro men were being denied employment in factories which are supposed to be intensely at work moving "products from the assembly lines of our factories to the battle lines of democracy."

It is declared that the pressing needs are for ships, more ships; for airplanes, more airplanes. Yet only a few shipyards will employ Negroes; and virtually no airplane companies will hire them.

And all the while every avenue of communication is burdened with the sickening repetition that this "effort" is to defend and strengthen democracy, and to destroy, to use the President's own words, "tyranny and the forces of oppression."

Salute to Business THIS year marks the fortieth anniversary of the National Negro Business League, and this enlarged issue of THE CRISIS is a souvenir, in a limited way, of the progress which has been made since Booker T. Washington launched his plan.

In the history of the business league written for this number by Albon L. Holsey is the frank admission of its frail and unbusinesslike beginnings. But it has grown to be what its founder undoubtedly envisioned: an association of business firms mutually aiding one another toward greater success. It has spawned, also, associations of business men of great and varied types within the broad general framework.

Today our great insurance companies head a long list of businesses run by Negroes. Our banks have come through the fire of a great depression and a wave of bank failures. In the expensive and complicated publishing business, we have made a good record. Our retail establishments are numbered in the thousands.

THE CRISIS salutes Negro business on this significant anniversary and wishes for it greater successes in the next forty years.

Write a Letter THERE is still the necessity of writing letters to Washington on the national defense program and the Negro. If plain ordinary citizens realized how important and effective their letters to Congress are we are sure they would write more often. Write to President Roosevelt at The White House, and to Sidney Hillman and William S. Knudsen at the Office of Production Management, Washington, D. C., and protest against the barring of Negro workers from industrial plants handling national defense contracts.

Write Senator Elbert D. Thomas, chairman of the Senate Committee on Education and Labor, Senate Office Building, Washington, D. C., and ask that his committee report favorably Senate Resolution 75, which will authorize a Senate investigation of the treatment of the Negro in the entire defense program.

Army Air Corps Smoke Screen THE official announcements of the War department calling for Negro pilots, as detailed in the daily press, look suspiciously like a smoke screen to confuse and quiet Negro public opinion while doing very little about actual training of Negroes for the Army Air Corps.

As this is being written, the Army announces that its pilot training program has been stepped up to 30,000 men a year. But it plans to train only 33 Negro pilots. This tiny number constitutes one-tenth of one per cent of the total annual training program. This is in the face of Army officers stating that a "serious shortage" in pilots exists.

Even so, the 33 Negro pilots will have to wait until after October 1, 1941, to begin training because their jim crow training center at Tuskegee Institute will not be ready until then—manned with an all-Negro jim crow ground personnel. Although the Army is begging the young men of the nation by radio and press to enroll for pilot training in the great centers now open, no Negroes are being sent to these centers.

Moreover, the Negroes are to be trained off in a corner by themselves for a squadron of only 27 pursuit planes. How can they be effective without training with the larger units?

Once again the Army's pattern of segregation is doing the Negroes and America an injustice. There does not appear to be any good reason why Negro boys cannot be enlisted and trained in the established centers along with whites.

Byrnes? No! A READING of the article on Senator James Francis Byrnes by Louis L. Redding on page 113 of this issue ought to convince the hardiest skeptic of his unfitness for the high post of associate justice of the United States supreme court. He "has avowed that a citizen minority be forcibly excluded from political and social equality," says Mr. Redding . . . "can he be trusted to adjudge issues involving the applicability of the great generalities of the Constitution to a political or social right asserted by a member of that minority?" The answer is: No.

SEPTEMBER, 1934 FIFTEEN CENTS

THE CRISIS

Working On The Levee
(But not for ten cents an hour—see page 255)

BOYCOTTS TO GET JOBS?
George S. Schuyler vs. Vere E. Johns

NEGRO WORKERS AND THE NRA
By Gustav Peck

LIBERIAN NATIVES TELL THEIR STORY

The COLORED HARVEST

FEB.–MARCH 1940

COLORED *The* HARVEST

For the education of missionary priests For the aid of the Colored Missions

VOL. XXVIII Published by St. Joseph's Society of the Sacred Heart, 1130 N. Calvert St., Baltimore, Md. NO. 1

Squeaks from the Editorial Swivel-chair

by an Armchair Missioner

Thirty Days Prayer

Up to the 12th century, St. Joseph was not as yet the object of any devotion in the Church; he was looked upon as a personage of the Old Testament. St. Bernard first began to direct thoughts and hearts towards the holy patriarch by putting in prominent relief all his dignity and virtues. Because God honored St. Joseph, said St. Bernard, in the highest way by willing that he should be known as, and believed to be, the father of Jesus, He conferred upon him the highest dignity.

St. Bernard did not invite us to do honor to St. Joseph or to pray to him, but he laid down principles which soon prompted Christian piety to do so. If the greatness of St. Joseph were so undeniable, if his virtues were so perfect, his influence in Heaven must also be great. Why, then, not pray to him? Why leave in the shade one who took so considerable a part in the mysteries of the childhood of Christ?

Confident in the powerful intercession of St. Joseph, the Josephite Fathers for many years have been fostering the devotion of the Thirty Days Prayer in honor of this great saint. Many extraordinary favors have been attributed to this sustained prayer and no client of Christ's foster father ever neglects to make the Thirty Days Prayer in preparation for the celebration of the feast of St. Joseph, March 19.

Letters and petition slips have already been sent out to those whose names are in our files. If you have not yet returned your petition slip, do so at once in order that it may be placed on the altar for the devotions and Masses which begin this year on February 19.

Static Statistics or Sumpen!

Periodically, and perennially, it would seem, the following line of reasoning is dished out to create a sense of horror at thought of the neglect of the Negro Missions in the United States (we quote from a recent bulletin): "Of the 13,000,000 Negroes in the United States there are, at the highest estimate, only 250,000 Catholics. . . . In 1870 there were 250,000 colored Catholics in Maryland and Louisiana alone; at present, sixty-five years later, and in all the States, there are only 250,000."

With slight variations this unfinished syllogism has been popping up for more years than one cares to recall and from sources which should know better. With a not too sanguine hope that it will be finally interred we offer the following observations:

In the first place, no one ever gives a source for the figure on the number of colored Catholics at the end of the Civil War. We have found only two possible sources. One, a pamphlet printed some 45 years ago, hazarded the guess that "Only about 200,000 of them (the Negroes) are Catholics." Another writer 48 years ago wrote, "*At most 200,000 are Catholics.*" This same writer said, "It is estimated that 65,000 lost the faith in New Orleans alone" after the Civil War. These two figures were nothing more than personal guesses with no other authority than that of the writers themselves, and it might be added that neither one of them was in a very strong position to know. They probably based their estimates upon population statistics and the assumption that all the Negroes in southern Maryland and southern Louisiana were Catholic.

OPPOSITE: *The Colored Harvest* was first published in 1888, in association with St. Joseph's Seminary in Baltimore, Maryland. In 1895, its publication increased from once a year to quarterly. The purpose of the magazine—and the Seminary—was to gain support for Catholic evangelization in the African American community; the Seminary trained candidates for the priesthood who would service Black parishes.

ABOVE: *The Brown American* is a very hard to find Black general purpose magazine and contains interesting articles on the Alpha Kappa Alpha sorority, Black athletes, the *Tribune* paper and its staff in Philadelphia and Tuskeegee Institute among others. Aside from their collectible value, these old news magazines provide period insights and fragments of history not found elsewhere. Many old books and magazines had titles that suggested their target audience's color and ancestry.

OPPORTUNITY
JOURNAL OF NEGRO LIFE

October
1930

Price 15c.

OPPORTUNITY

JOURNAL OF NEGRO LIFE

College Opens

EDUCATION AND THE ART OF LIVING *By WILLIAM STUART NELSON*

THE PLACE OF THE WOMEN'S COLLEGE IN THE PATTERN OF NEGRO EDUCATION *By FLORENCE M. READ*

By CHARLOTTE CRUMP

THIS FREE NORTH

COLLEGE TRAINING FOR THE NEGRO—TO WHAT END? *By BUELL G. GALLAGHER*

THE COLORED GIRL ENTERS COLLEGE-- WHAT SHALL SHE EXPECT? *By LUCY D. SLOWE*

September, 1937 *15 Cents*

ABOVE AND OPPOSITE: These *Opportunity* covers from the 1930s focus on education, art, and culture. Some of the titles of the articles in the later (1937) issue seem comical by today's standards ("The Colored Girl Enters College—What Shall She Expect").

This datedness makes it very appealing to collectors.

THIS PAGE AND OPPOSITE:

Many historically minded people collect old newspapers. They not only provide a first-hand account of important issues, but also have interesting illustrations. Both articles and advertisements provide key factual details, all of which greatly facilitate research and historical writing.

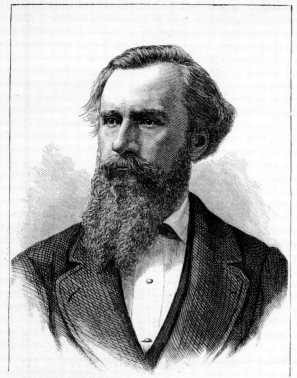

THE HON. ROBERT E. WITHERS, OF VIRGINIA.
[FROM A PHOTOGRAPH BY D. H. ANDERSON, RICHMOND, VA.]

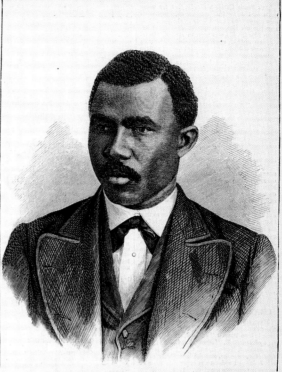

THE HON. ROBERT BROWN ELLIOTT, OF SOUTH CAROLINA.
FROM A PHOTOGRAPH BY GARDNER, WASHINGTON, D. C.—[SEE PAGE 150.]

THE HON. ROBERT E. WITHERS.

LIEUTENANT-GOVERNOR ROBERT E. WITHERS, who has just been elected United States Senator from Virginia, was born in Campbell County, in that State, 1821, and is therefore in the fifty-third year of his age, but in appearance looks much younger. He graduated as a student of medicine at the University of Virginia in 1841, and practiced his profession in his native county for fifteen years. From Campbell County Dr. WITHERS removed to Danville, Virginia, where, at the breaking out of the late war, he

was practicing medicine. He laid down the scalpel and took up the sword, and went to Richmond at the head of a battalion of volunteers. Subsequently he was made Colonel of the Eighteenth regiment of Virginia Infantry, and was in all the battles from the first Manassas to Gaines's Mill, where he was desperately wounded, and incapacitated for duty for a long time. Being unfit for field duty thereafter, he was assigned to the post of Danville, Virginia, and had charge of all the prisons and hospitals until his surrender to General WRIGHT, in April, 1865.

In 1866 Colonel WITHERS became editor of the Lynchburg (Virginia) News, and subsequently of the Richmond Enquirer. In the spring of 1868 he was nominated for Governor of Virginia, and canvassed the State in opposition to the adoption of the "Underwood Constitution." Before a vote was had, General CANBY, the military commander of the district, postponed the election, and the "Liberal movement" springing up, which contemplated a fusion of the Liberal Republicans and the Democrats in opposition to the radical party, and Colonel WITHERS being what was regarded as too ultra a Southerner for

the times, he withdrew, at the solicitation of his friends, in favor of Colonel GILBERT C. WALKER, the nominee of the Liberals.

In the last State campaign Colonel WITHERS was placed on the Conservative ticket with General JAMES L. KEMPER, as Lieutenant-Governor, and was elected by a large majority. He took the oath of office January 1, 1874. On the 13th of January, 1874, after a very warm contest, he was elected by the Legislature to the Senate of the United States, as successor to the Hon. JOHN F. LEWIS, Republican, and takes his seat March 4, 1875.

CONCERT FOR THE INMATES OF THE CHARITY HOSPITAL, BLACKWELL'S ISLAND.—DRAWN BY C. E. H. BONWILL.—[SEE PAGE 150.]

J. C. RANDOLPH, President - Treasurer

R. F. MORTON, Secretary

Tho Home Has Earned The Commendation Of The
Department Of Public Welfare Of The City Of
Richmond and Endorsed By The Depart-
ment Of Labor Of The United States

The Afro-American Old Folks' Home

A Charitable Institution
Organized September 1907
1115 W. MOORE ST., RICHMOND, VIRGINIA

May 17, 1939.

Mr Chester A. Arthur
16 N. 7th Street
Richmond, Va

Dear Sir,

Enclose you will find my check for three - dollars ($3.00) for erecting swing sign, for Afro- American Old Folks Home 1115 - St. Moore Street, Richmond, Va. Please return a receipt.

Respectfully, Yours
J. C. Randolph, Pres.

NEW YORK 22 August 1949 No. 1001

CHEMICAL BANK & TRUST COMPANY

1-12 / 210

UNITED NATIONS OFFICE
NEW YORK

PAY TO THE ORDER OF _Cash_ $ 200.00/xx

Two hundred and no/100 DOLLARS

RALPH J. BUNCHE &/OR RUTH H. BUNCHE

Ralph J. Bunche 15

NEW YORK 10 August 1949 No.

15

CHEMICAL BANK & TRUST COMPANY

1-12 / 210

NEW YORK
UNITED NATIONS OFFICE

PAY TO THE ORDER OF _Esso Standard Oil Co._ $ 5.15/xx

Five and 15/100 DOLLARS

Ralph J. Bunche

R1111052

NEW YORK 16 June 1953 No. 3553

CHEMICAL BANK & TRUST COMPANY

1-12 / 210

UNITED NATIONS OFFICE
(UNITED NATIONS, NEW YORK)
NEW YORK

PAY TO THE ORDER OF _Thos. Cook + Son_ $ 31.5-1/xx

Thirty-one and 57/100 DOLLARS

RALPH J. BUNCHE &/OR RUTH H. BUNCHE

Ralph J. Bunche

CHEMICAL BANK & TRUST
1-12
NEW YORK CITY N.Y.

15-133

OPPOSITE: Even the most humble-looking pieces of paper can provide deep insight into local Black history. A true collector will understand this item's importance—the letterhead reveals the existence, officers, location, and business activities of a local senior citizen's home.

ABOVE: Autograph and document collectors love items such as these checks, which were signed by Ralph Bunche around the time he received his Nobel Prize.

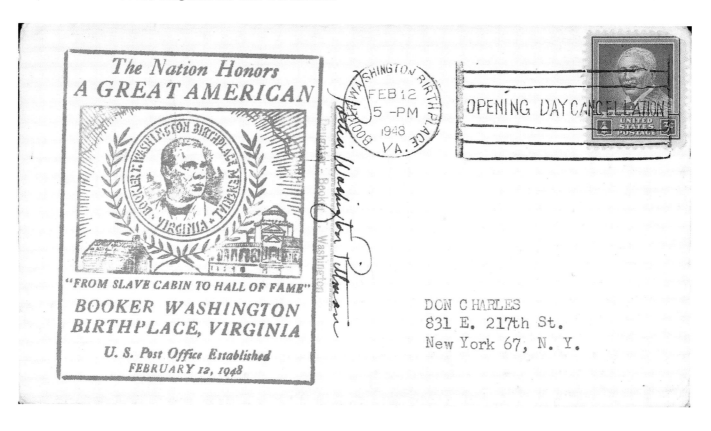

ABOVE: Stamps are among the most popular form of collectibles, easily accessible and usually afford-able. This first day cover signed by Booker T. Washington's daughter is a fascinating collectible. But note, signed versions are increasingly scarce and expensive.

LEFT: As a type of collectible ephemera, this bookmark shows that the concern with African American history is not recent. For many years, brave intellectual and historical pioneers pushed for coverage and documentation of what was then known as Negro history.

OPPOSITE: History isn't confined only to the pages of books. Postcards are a convenient, interesting and visually appealing way to collect African American history. The top postcard features a picture of the Booker T. Washington High School in Atlanta, Georgia, while the bottom image advertised a local Black business.

131—Booker T. Washington Junior High School, Atlanta, Ga.

123549-N

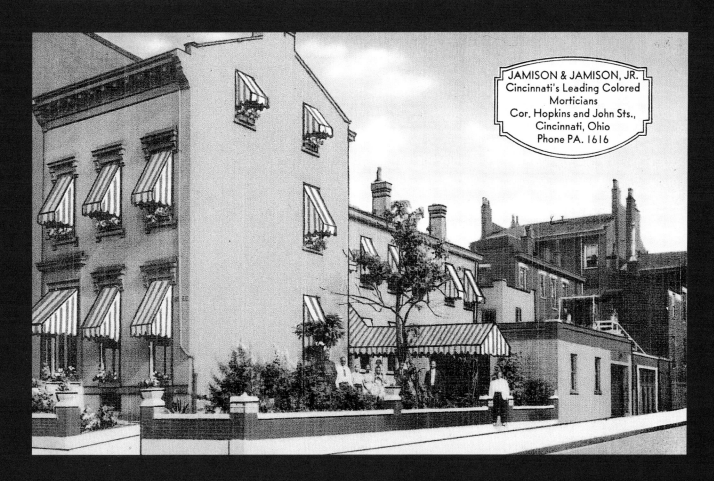

JAMISON & JAMISON, JR.
Cincinnati's Leading Colored
Morticians
Cor. Hopkins and John Sts.,
Cincinnati, Ohio
Phone PA. 1616

1222 Kearny Street, N. E.
Washington, D. C.
September 24, 1941

Dear Professor Talley:

Arthur Davis and Ulysses Lee, professors of
English at Virginia Union University and Lincoln
University, respectively, and I are editing The
Negro Caravan, an anthology of writings by Ameri-
can Negroes. We wish to use several of the secular
songs which you collected in Negro Folk Rhymes.

We are herewith asking your kind permission
to use Promises of Freedom; The Turtle's Song; He
Is My Horse; Simon Slick's Mule; Did You Feed My
Cow; Raise a Ruckus Tonight; I Would Rather Be a
Nigger than a Poor White Man; Run, Nigger, Run;
Die In The Pig-Pen Fighting; Song to the Runaway
Slave; and a few random stanzas.

We shall most certainly cite your name and
the name of your book in a credit line. In an in-
troductory section we state that your book is sig-
nificant as the first serious collection of Negro
secular songs.

We hope that you will grant us this permission.
We are, of course, applying to Macmillan's for pub-
lisher's permission.

I was very glad to see you at the Fisk University
Celebration. With best wishes from my family and me
to your family and you,

Sincerely,

Sterling A. Brown

1222 Kearny St. N.E.
Washington D.C.
September 30, 1941.

Prof. Thomas W. Talley,
Fisk University,
Nashville, Tenn.

Dear Prof. Talley :

My colleagues and I understand perfectly how, if you are enlarging _Negro Folk Rhymes_ you would not care to have any of the songs reprinted in the _Negro Caravan_.

We are asking you to reconsider your refusal in part, however, to permit us to use two or three of your songs. The first reason for our request is that we want the Caravan to be inclusive. As a pioneer collector of Negro folksong you should be included. Negro collectors have been so few and far between that we hate to have a _Negro Caravan_ without one of the first and best.

We have other variants of many of the folk-songs we wanted to use from _Negro Folk Rhymes_. But some of the variants that you have make superior reading and we'd certainly like to use them.

Could you reconsider your refusal to the extent of letting us use "Promises of Freedom", "Did You Milk My Cow" and "One Day As I Was Passin' By " ("He Is My Horse")? We should certainly give full credit to you and to Macmillan; we could call attention to your forthcoming enlarged book. _Negro Caravan_ should be good advertisement of such a book.

We want you among the people in this book, who range from Phillis Wheatley to contemporaries; we feel that we should represent in our folk literature section what few collectors we have, especially the producer of as important a volume as _Negro Folk Rhymes_. We have other seculars and of course some variants of some of the songs we wish from your book, so the loss in one sense will not be injurious; but we hate to lose you from our contributors.

Yours sincerely,
Sterling A. Brown

THIS PAGE AND

OPPOSITE: These personal letters of acclaimed writer, poet and Howard University professor Sterling Brown provide a remarkable inside perspective of the publication of a Black scholarly work. Brown wrote to Fisk University professor Thomas Talley—a literary scholar and author of _Negro Folk Rhymes_—asking permission to quote Talley's work. The two scholars engaged in a passionate back and forth before reaching an agreement.

Cover drawing by Peter Schwartzburg; calligraphy by Rachel Spitzer.

Illustrations: Peter Schwartzburg, pages 5 and 13; Hector Stewart, page 2; Tomi Ungerer, page 16. Titles and composition by Rachel Spitzer and Michael Aleshire.

Yūgen is published quarterly at seven morton street, #20, New York 14, N. Y. Subscriptions: $2.00 per year, single copies, 50¢. Manuscripts will not be returned unless accompanied by a stamped, self-addressed envelope.
Copyright 1958 by LeRoi Jones and Hettie Cohen.
Printed in New York by Troubador Press.

Editors: LeRoi Jones Y Ū G E N *
 Hettie Cohen

Philip Whalen	2	Further Notice
		Takeout, 4: II: 58
		Takeout, 15: IV: 57
Ed James	6	Two Poems
Judson Crews	7	Potaphor in a Wretched Wind
		When We Were Young
Tom Postell	9	Gertrude Stein Rides The El
		A Solid Piece of Sunlight
Allen Polite	11	Beg Him to Help
		Touching Air
Stephen Tropp	14	Early Poem For 2 People
Bobb Hamilton	14	Judgement Day
LeRoi Jones	16	Slice of Life
		Lines to Garcia Lorca
Diane Di Prima	18	Two Poems
Ernest Kean	20	The Glass is Shattered
Jack Micheline	21	Steps
Allen Ginsberg	22	4 Poems

*YŪGEN means elegance, beauty, grace, transcendence of these things, and also nothing at all.

ABOVE AND OPPOSITE:

This 1958 soft-cover copy of *Yugen,* an avant-garde literary journal, is a great example of rare collectibles that document the humble beginnings of notable people. Acclaimed playwright, poet, and activist LeRoi Jones—who later became Amiri Baraka—worked as coeditor on this journal, which also featured other emerging literary giants.

YŪGEN

a new consciousness in arts and letters

50c

LEFT:

An extremely rare book, not only due to its age, but also its subject matter.

THE WORK

OF THE

AFRO-AMERICAN WOMAN

BY

MRS. N. F. MOSSELL

SECOND EDITION

PHILADELPHIA
GEO. S. FERGUSON COMPANY
1908

THIS PAGE:

An author's signature always
makes a book more desirable,
especially if there are a few words
accompanying it.

SEPIA

JUNE, 1965
35¢

DIAHANN CARROLL

AN AMAZING
APE MAN
Moroccan throw-back
to civilization baffles
scientists

DIAHANN CARROLL--SIDNEY POITIER
What will it be . . .
ROMANCE OR MARRIAGE?

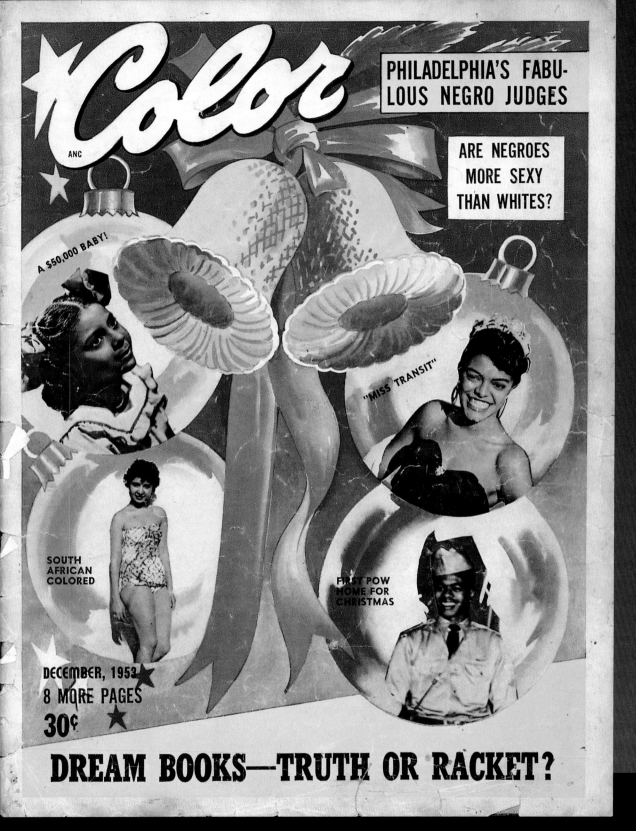

Color

ANC

PHILADELPHIA'S FABULOUS NEGRO JUDGES

ARE NEGROES MORE SEXY THAN WHITES?

A $50,000 BABY!

"MISS TRANSIT"

SOUTH AFRICAN COLORED

FIRST POW HOME FOR CHRISTMAS

DECEMBER, 1953
8 MORE PAGES
30¢

DREAM BOOKS—TRUTH OR RACKET?

ABOVE AND OPPOSITE: *Sepia* and *Color* were gossipy and sensationalist (which makes them desirable to modern collectors who seek publications that reflect what the common man was reading and being fed). The more outrageous and campy the cover, the greater the appeal and price.

ABOVE LEFT: *Flash* was another precursor to today's magazines for the African American market. As its name suggests, it was a picture magazine for the general public. In the 1930s, times were tough and the need to escape, dream, and live vicariously through the activities of the famous was very strong (since most people's lives consisted of a difficult, often unexciting struggle to survive). Magazines like *Flash* offered news but also glamour, gossip, sentimentality, and excitement.

ABOVE RIGHT: Describing itself as a "Monthly Negro Magazine" and being from the 1940s makes this well illustrated, rare news magazine a must for collectors of hard to find ephemera and Black nostalgia. Aside from a few archivists, most people alive today would not even know or remember this publication (which—aside from its content—is what makes it both collectible and historically desirable).

OPPOSITE: Many magazines are entertainment oriented. *Black Stars* (Johnson Publications) was a magazine for the Black general public, especially young people; it focused on entertainment celebrities and featured lifestyle articles. It was influential in the 1970s and reflected clothing styles and interest in Black entertainers, who were asserting themselves nationally.

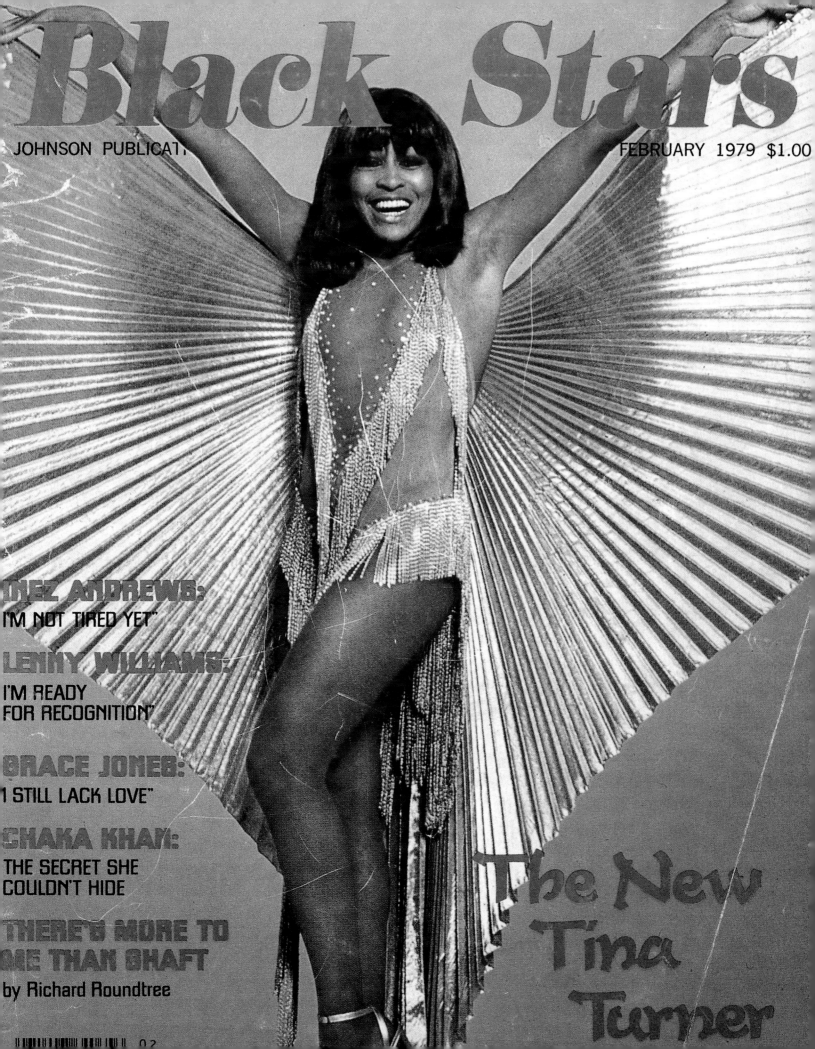

Black Stars

JOHNSON PUBLICATI

FEBRUARY 1979 $1.00

INEZ ANDREWS:
I'M NOT TIRED YET"

LENNY WILLIAMS:
I'M READY
FOR RECOGNITION"

GRACE JONES:
I STILL LACK LOVE"

CHAKA KHAN:
THE SECRET SHE
COULDN'T HIDE

**THERE'S MORE TO
ME THAN SHAFT**
by Richard Roundtree

The New
Tina
Turner

BISHOP H. M. TURNER, D. D. LL. D.

ATLANTA, GA.

DOWN MEMORY LANE

Final Tribute of Respect

Hazel Scott

THE ABYSSINIAN BAPTIST CHURCH
132 WEST 138th STREET
NEW YORK, N.Y. 10030

TUESDAY, OCTOBER 6, 1981
1:00 P.M.

SAMUEL D. PROCTOR, Th.D.
Minister

CALVIN O. BUTTS, M. Div.
Executive Minister

LEON E. THOMPSON, D.M.A. HILDRETH J. BAPTISTE
Minister of Music *Assistant Minister of Music*

JEWEL THOMPSON
Organist

SIXTH ANNUAL REPORT
OF THE

EXECUTIVE COMMITTEE
OF

Colored Evangelization

TO THE

GENERAL ASSEMBLY

SITTING AT

CHARLOTTE, N. C., MAY 21, 1897

AND THE

Catalogue of the Tuscaloosa Institute

1896-97

BIRMINGHAM, ALA.
ROBERTS & SON, PRINTERS AND BINDERS
1897

Spirituality
and Religion

TYPES OF ARTIFACTS

Photographs: churches, congregations, and ministers.

Church bulletins and newspapers

Convention and meeting booklets

Denominational histories

Biographies of ministers and key members of the church

Vestments and memorabilia: usher badges and choir robes

Letterhead: letters, announcements, and invitations

Religious education books and posters

Event and outing souvenirs: menus, programs, and prizes

Records of business transactions of churches and mosques: deeds, blueprints, and receipts

Church furnishings: pews, pulpits, musical instruments, and altars

Decorative artifacts: fans, commemorative plates, calendars, signs, and musical recordings

Statuary and fountains

THE HUMAN INSTINCT TO CONNECT WITH SOME higher power is as strong—if not stronger—as the instinct to procreate or the instinct to survive. During periods of harsh adversity and repression, men and women intuitively draw on this spiritual instinct to give them the strength and courage to endure suffering. Few cultures have exemplified this capacity for spiritual survival with as much grace and tenacity as have the African American people.

Religion, in various forms, is and has always been a very important force in the lives of Africans and their descendants—before and after their arrival in the Western Hemisphere. People of African descent have made religious expression a richly emotional, highly-developed art that shows—more than anything else in their lives—what they feel, what they care about, and what they want to connect with. Many African Americans feel that strong religious beliefs is the primary reason African Americans have survived. Notably, slave rebellions as well as the Civil Rights Movement were inspired by religion feelings mixed with the desire for racial advancement, and led by religious figures.

Perhaps because religion was such an integral part of the daily lives of many African Americans as well as Black culture, most thought it did not have to be

collected. Now that the importance of religion in shaping Black culture has been recognized by collectors, interest has surged in religious items, which often reflect social life, political efforts, community leadership, trends in music and charitable activities. Recent collector interest in religion is not a moment too soon, for choice religious artifacts are not often released to the general public; and many old churches have disappeared or have been modernized without preserving their physical heritage. Tangible remains of religious practices among slaves are very scarce in the collector market. Although many religious congregations were formed after the Civil War, during Reconstruction much of the documentation of their activities were lost, or is unavailable for collecting—except for a few old histories in book form. Even books on religious topics published before 1960 are relatively scarce, yet desirable for the information they contain. Anything before 1950 should be acquired, and items before 1920 should be especially treasured: the ephemera of Gospel choruses, organ sheet music, Sunday school booklets, Bibles, photographs of religious events and other items.

REV. L. K. WILLIAMS, D.D.
PRESIDENT NATIONAL BAPTIST CONVENTION, U. S. A.
3101 South Park Avenue, Chicago

ABOVE AND OPPOSITE:

Ephemera like this 1920s item helps track the events and movements of key people at specific times and places. Reverend. L.K. Williams, the honored guest, was a nationally known Chicago Baptist minister who led one of the largest Protestant churches in the country. As both the reception announcement and the photo indicate, Rev. Williams was also president of the National Baptist Convention.

What to Look For

Keep in mind that every religious tradition within the African American community has collectible material. However, some have fewer written records than others. Methodists have centralized record keeping that makes their files useful for genealogical and historical research. Baptist records show their strong emphasis on preaching and Bible studies within the church. Baptists also have strong traditions of holding conferences and musical gatherings within the greater community.

Certain forms of religious material are considered more rare than others. Bibles, hymnbooks, Sunday school textbooks, and convention materials are relatively plentiful. Photographs of religious occasions (which are more scarce) tend to be kept because of the reverence Blacks give their religious life. In comparison, church logbooks, membership lists, charters, records of marriages, funerals and baptisms tend to be rare. In general, the more illus-

"ONE LORD, ONE FAITH, ONE BAPTISM"

Program

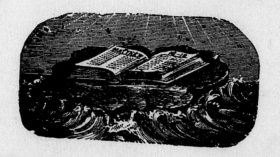

RECEPTION

IN HONOR OF

Dr. L. K. Williams

PRESIDENT OF THE NATIONAL BAPTIST CONVENTION

GIVEN BY THE

MINISTERS' CONFERENCE

OF PHILADELPHIA, PA.

TO BE HELD AT

FIRST AFRICAN BAPTIST CHURCH

(CHERRY MEMORIAL)

16th and Christian Streets

MONDAY, MAY 25TH, FROM 5 TO 7 P. M.

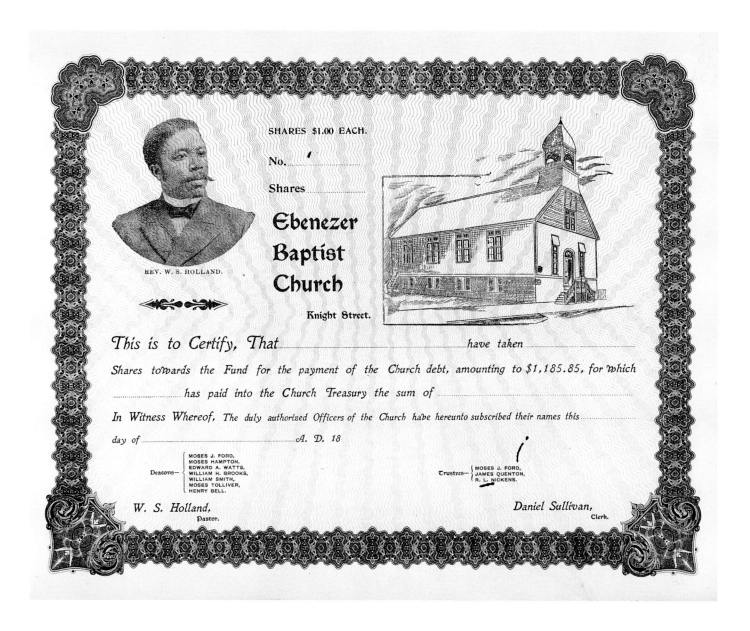

trated and detailed a paper-based religious collectible, the greater its historic and financial value is. When old churches are razed, interior furnishings and fixtures tend to vanish as do furnishings, implements or architectural fixtures. On those few occasions when such objects do turn up, they usually lack documentation to verify their origin, making it impossible to find out who owned what and during which period of history. Extant churches, on the other hand, tend to keep and preserve their memorabilia since they are considered part of that religious community's sacred heritage. Most likely, religious collectibles that come on the market will have come from older African Americans who have held onto them over the years for personal reasons, or from their estates.

ABOVE AND OPPOSITE:
Churches are not only the focus of religious activity but also business and community activity as well. This old stock certificate is a remarkable piece of memorabilia and was possibly issued in connection with the building of a new church edifice. In general, stock certificates connected with African American activity are rare and historically important.

Interpreting the Informational Value

Collectibles from a community church, mosque, or temple contain a mother lode of information about the psychological, spiritual, and social lives of that congregation's parishioners. After all, the church was, and continues to be, the center of many people's social lives. Here, they gathered to pray, meet their future spouses, discuss racial issues, and comfort each other in times of war and natural disaster. Picnics, banquets, and concerts were organized through the community church. Fraternal lodges, social clubs, benevolent societies, and political groups met in church basements and continue to do so. During the Great Migration, churches helped uprooted African Americans relieve the adjustment pressures and social stress. People often joined the same denomination they had belonged to back home and in many northern cities, people from a particular town or state formed clubs or societies within that church, such as the Antigua Society or the Virginia Club. Births, baptisms, confirmations, communions, marriages, and deaths were duly recorded and stored in the congregation logbooks and journals, making them as important as military records for genealogical research. Items related to ministries and seminaries are also excellent resources for historical research.

Other religious collectibles that provide vital information for genealogical research include:

Church souvenir books and programs: In addition to the history of the church, these contain data on families, individuals and local businesses that often placed advertisements in the programs. The more detailed and pictorial these books are, the more valuable they are considered. References to visiting celebrities and civil rights leaders can enhance the informational value of a church program.

Church congregation and convention literature: These items contain data on ordinary individuals, families, and clubs.

Do not expect to find religious collectibles from the slavery era as these are very scarce. However, you can find accounts of slaves' religious practices in scholarly books and journals. Look to these books for prints of religious gatherings, narratives, songs, and eyewitness accounts of religious ceremonies. Congregations that were formed during the Reconstruction era may have collected their documents into record books that are kept in church archives, but anything that is not preserved this way may be lost.

In general, African American religious books published prior to 1950 are in shorter supply and are considered more valuable than those published after that date. If you find a Black religious book published before 1920, grab it!

REV. W. S. HOLLAND.

History of the Woman's
Missionary Society

In the Colored Methodist Episcopal Church

Comprising

Its Founders, Organizations, Pathfinders, Subsequent
Developments and Present
Status.

By

MRS. L. D. McAFEE
of Columbus, Ga., Wife of Dr. L. D. McAfee, Presiding Elder of the
Columbus District, Southwest Georgia Conference

THIS PAGE: Books are known to contain vital historical information, like the written history of this women's missionary society, detailing their home counties and towns. It also documents the rich and greatly unrecognized history of rural Black women.

OPPOSITE: Methodist Bishop Henry McNeil Turner was one of the most important activists and radical thinkers of the nineteenth century. This line drawing illustration of him as a relatively young man is a fine example of a religious collectible that is also a racial advancement collectible.

BISHOP H. M. TURNER, D. D. LL. D.

ATLANTA, GA.

YEAR OF JUBILEE

1932-1982

Canaan Baptist Church of Christ

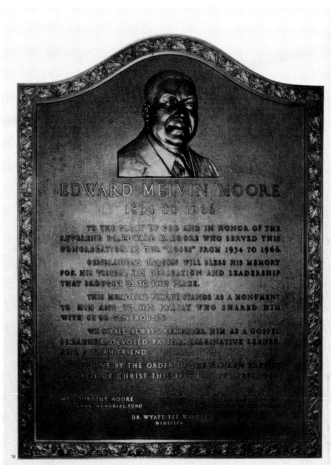

DOWN MEMORY LANE

ABOVE AND OPPOSITE:
Anniversaries and souvenir books are wonderful sources of information about that most important institution in African American life. Unlike other sources (which tend to focus on prominent or famous ministers), souvenir books have much content on the congregation and the ordinary, "salt of the earth" people who make a church (and a community)

run. Such books can also be excellent sources of family and local history information but are not as frequently found as we might hope. Even recent editions are produced in limited numbers (perhaps only as many as people in a congregation might buy), and families tend to hold onto them (and rightly so). Thus collectors must hunt for them and purchase quickly when they appear.

Dedication Service in Memory of the Late Pastor, Congressman Adam Clayton Powell Jr.

ANYSSINIAN BAPTIST CHURCH
1:30 P.M. — December 1, 1974

Final Tribute of Respect

Hazel Scott

THE ABYSSINIAN BAPTIST CHURCH
132 WEST 138th STREET
NEW YORK, N.Y. 10030

TUESDAY, OCTOBER 6, 1981
1:00 P.M.

SAMUEL D. PROCTOR, *Th.D.*
Minister

CALVIN O. BUTTS, *M. Div.*
Executive Minister

LEON E. THOMPSON, *D.M.A.*
Minister of Music

HILDRETH J. BAPTISTE
Assistant Minister of Music

JEWEL THOMPSON
Organist

SIXTH ANNUAL REPORT

OF THE

EXECUTIVE COMMITTEE

OF

Colored Evangelization

TO THE

GENERAL ASSEMBLY

SITTING AT

CHARLOTTE, N. C., MAY 21, 1897

AND THE

Catalogue of the Tuscaloosa Institute

1896-97.

BIRMINGHAM, ALA.:
DISPATCH STATIONERY CO., PRINTERS AND BINDERS
1897.

LEFT AND OPPOSITE:

Certain religious collectibles are much more historically useful than others due to their subjects and detail. Black Presbyterian material is generally hard to find. This book, which outlines the training of African American Presbyterian ministers during the late nineteenth century, contains immense informational value. It reveals interesting details about the politics and controversies present in Black church life.

CATALOGUE

OF THE

OFFICERS AND STUDENTS

OF THE

Institute for Training Colored Ministers

AT

TUSCALOOSA, ALABAMA

1896-97

UNDER THE DIRECTION OF THE

Executive Committee of Colored Evangelization.

FACULTY.

Rev. A. L. Phillips, D. D.,
Superintendent.

Rev. R. B. McAlpine, A. M.,
Professor in Theological Department.

Rev. O. B. Wilson, A. B.,
Professor in Academic Department.
(Absent by detail.)

40 THE SIXTH ANNUAL REPORT

STUDENTS WHO HAVE ENTERED FROM OCTOBER, 1876.

PRESBYTERIANS.

GRADUATES.

NAME	PRESBYTERY	CLASS
R. H. Alston	Central Mississippi	1889
T. B. Bailey	Central Alabama	1893
E. P. Burns	Athens	1889
L. C. H. Champney	Central Alabama	1894
E. M. Clark	North and South Carolina	1885
E. D. Covington	Tuscaloosa	1890
G. W. Covington	Tuscaloosa	1885
C. G. Gavins	Ethel	1897
J. D. Gibson	New Orleans	1890
S. J. Green	Tuscaloosa	1890
H. P. Hawkins	Central Mississippi	1887
S. W. Hudson	Central Alabama	1892
J. J. Hunt	Ethel	1896
S. Jackson	New Orleans	1893
S. W. James	North and South Carolina	1893
B. F. Lewis	Memphis	1896
J. B. Lindsay	Tombeckbee	1893
W. P. Lloyd	Nashville	1885
C. J. Maclin	Memphis	1895
N. N. Maclin	Memphis	1894
T. R. Maclin	Memphis	1875
John McKellar	Fayetteville	1885
Prince Maxwell	Savannah	1885
Z. W. Middleton	Tuscaloosa	1888
R. A. Miller	West Hanover	1890
J. S. Morrow	Mecklenburg	1890
S. H. Pickens	Pine Bluff	1891
L. Pool	North Mississippi	1892
W. H. Sheppard	Lexington	1887
J. D. Taylor	Mecklenburg	1891
W. L. Terrell	Florida	1892
A. Thomas	Tuscaloosa	1887
T. T. Thompson	Athens	1894
H. P. Thurman	Tuscaloosa	1888
S. G. Walker	Orange	1890
W. Ward	New Orleans	1888

TO THE GENERAL ASSEMBLY. 41

L. J. Washington	Tuscaloosa	1888
L. L. Wells	Ethel	1891
D. F. White	Transylvania	1892
B. M. Wilkinson	Tuscaloosa	1889
Total, 40.		

NON-GRADUATES.

NAME	PRESBYTERY	ENTERED
D. N. V. Abney	Ethel	1893
C. A. Bardwell	New Orleans	1884–86
A. B. Brodie	Harmony	1890–91
G. W. Brown	Mississippi	1878
C. L. Butler	North Alabama	1893
W. E. Carr	Central Mississippi	1885–86
W. A. Carr	Ethel	1895
I. A. Cæsar	Florida	1884
J. M. Coleman	Tombeckbee	1885–87
Alfred Cooper	Tombeckbee	1882–83
S. Covington	Tuscaloosa	1884–85
M. Crawford	Tuscaloosa	1884
W. L. Driver	Central Alabama	1893
W. P. Driver	Central Alabama	1894
B. J. Ervin	Tuscaloosa	1884–86
Wm. Edwards	Central Alabama	1890–91
J. Graham	Ethel	1894
A. D. Green	Central Mississippi	1882–84
G. P. Goode	Tuscaloosa	1880–90
York Graham	Louisville	1884–85
J. D. Grimes	Central Mississippi	1886–87
E. H. Hall	Memphis	1884–85
A. Hanna	Ethel	1893
W. H. Hardy	New Orleans	1884–85
H. H. Harris	Tuscaloosa	1882–83
Alex. Hemingway		1890
J. Jones	West Hanover	1894
W. H. Lane	Ethel	1892
J. H. Lee	Red River	1886–87
W. M. Lee	Florida	1893
A. Long	Orange	1895
Cornelius McAlpine	Central Alabama	1891
W. S. McGill	Tombeckbee	1887
Wm. McIntyre	New Orleans	1891
R. R. McKie	Memphis	
H. McKinney	North Alabama	1890
A. J. McQueen	North and South Carolina	1895

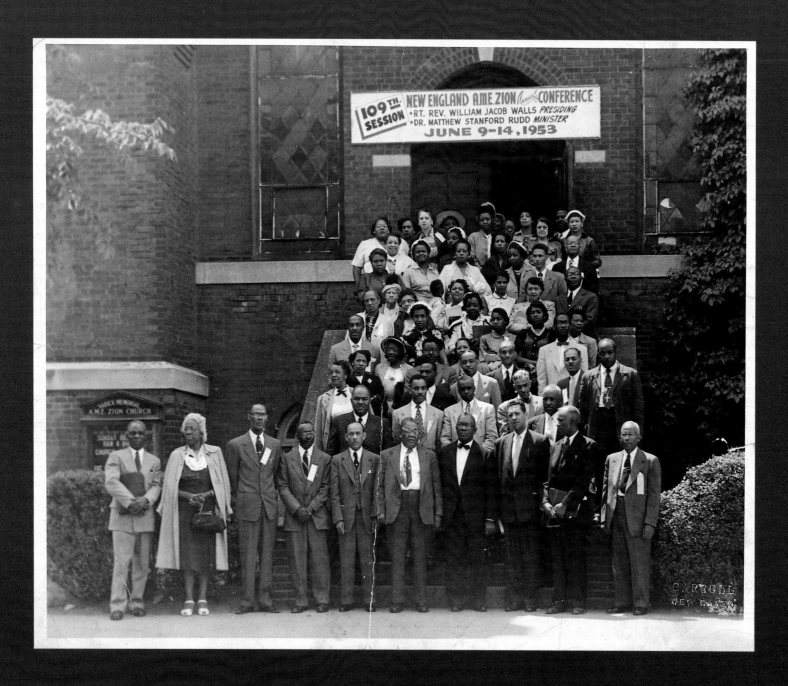

THIS SPREAD: These photos are interesting because they show African American communal and religious life thriving in widely different places.

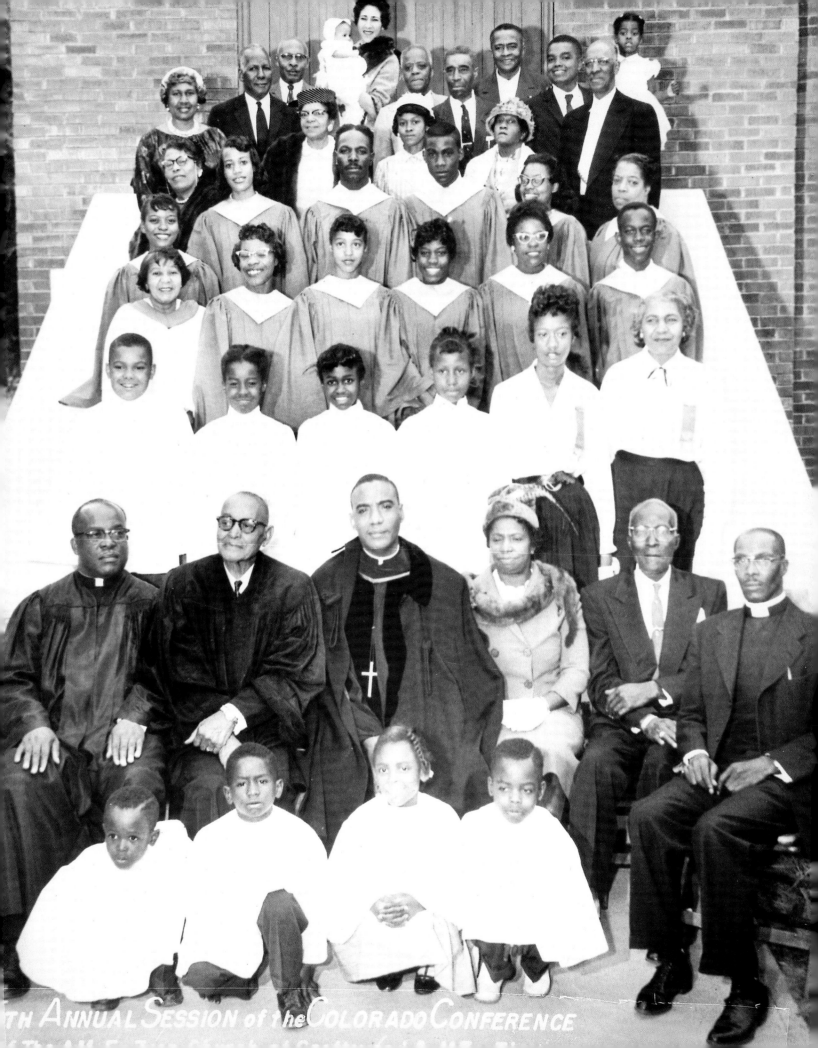

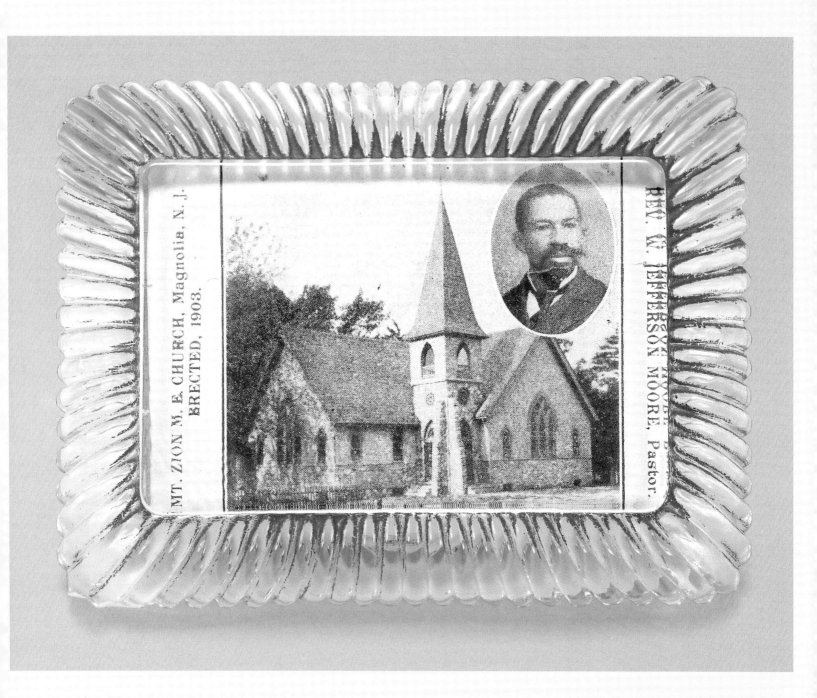

MT. ZION M. E. CHURCH, Magnolia, N. J. ERECTED, 1903.

REV. W. JEFFERSON MOORE, Pastor.

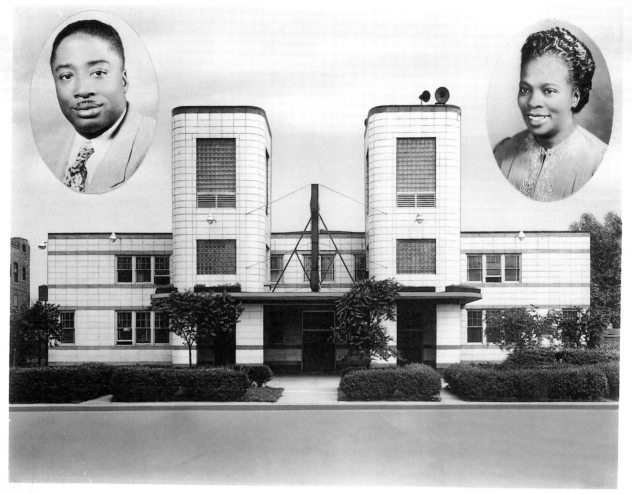

FIRST CHURCH OF DELIVERANCE
4315 South Wabash Avenue
Chicago, Illinois

REV. CLARENCE H. COBBS, PASTOR
REV. MATTIE THORNTON, ASST. PASTOR

PATTON'S STUDIO
355 E. 47th St.
Chicago, Ill.

OPPOSITE: Very few artifacts, such as this glass paperweight featuring a Black church and minister, were created and have survived. It shows that the church was of the utmost importance in the local community's life and that it was what they were most proud of and chose to advertise in this form. The photograph and words are printed on a small card that folds up and is inserted into the back of the paperweight. The glass paperwieght itself was probably mass produced and widely distributed.

ABOVE: Well-illustrated church memorabilia is appealing to a number of collectors for both its religious history and local history content. Visual documentation before the 1960s is hard to find.

HOMECOMING

SOUVENIR PROGRAM 25¢

Lincoln University Vs. Tennessee State College

Saturday November 17, 1945, 2:00 P.M.

JEFFERSON CITY PUBLIC SCHOOL STADIUM

HOWARD UNIVERSITY

CLASS OF 1941

PRESENTS ITS

PROM

MAY 6TH, 1938

SOUVENIR PROGRAM

CLASS OFFICERS

JAMES T. WRIGHT, PRESIDENT
ELIZABETH BANKS, VICE PRESIDENT
CATHERINE L. COTTMAN, SECRETARY
HAROLD MANCINI, TREASURER

COLORS
SILVER AND BLUE

FLOWER
WHITE CARNATION

MOTTO
WE CAME AS THE CLASS OF "41"
AND THUS WE WILL DEPART - -

FAREWELL TO THE CLASS OF 1960

THE SPOKESMAN

Vol. 19, No. 7 — VOICE OF THE MORGAN STUDENT — JUNE 1, 1960

FINAL SPOKESMAN ISSUE

HISTORIAN TO ADDRESS 270 GRADUATES

See Story On Page 3

ISSN 0192-3787 — VOL. 10. NO. 2 OCTOBER/NOVEMBER 1979 — $1.50

THE BLACK COLLEGIAN

THE NATIONAL MAGAZINE OF BLACK COLLEGE STUDENTS

HAITIAN ART

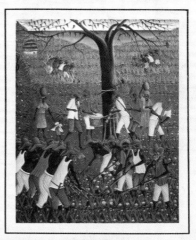

CAREERS IN DATA PROCESSING - COMMUNICATIONS MARKETING AND SALES

9th ANNIVERSARY

Education

TYPES OF ARTIFACTS

College yearbooks

Newspapers

Newsletters

 Social histories

Letters

Photographs

Scrapbooks

Autographs books

Graduation invitations and
 programs

Posters and flyers announcing
 campus events

Memorabilia of celebrity visits
 to campus

Sports items: key chains, banners,
 music boxes, and balls

Clothing: sweatshirts, sweaters,
 hats, T-shirts, and uniforms

Personal insignia: rings, pins, and
 watches

Insignia: flags and banners

Other memorabilia: fraternities,
 societies, theater groups,
 and language clubs

AFRICAN AMERICAN INSTITUTIONS OF HIGHER LEARNING have been in existence since the nation's first twenty-three Black colleges were founded in the post-Civil War Reconstruction years. For many years, they have been educating African American ministers, educators, and professionals who take leadership roles in the churches, schools, and businesses that make up the backbone of Black American society. In the last half of the twentieth century, thanks to the G.I. Bill and other scholarship opportunities, millions of African Americans pursued college level and graduate educations.

Collectors of all races normally favor collegiate memorabilia from schools with which they have a personal connection. They tend to be alumni, students, or proud family members of students and alumni. The college may have been located in their hometown or home state. Sports fans can turn into avid collectors of collegiate memorabilia because they follow that college's football, basketball, or baseball team.

Since most Black colleges are located in the South, their histories are interwoven with the greater racial advancement themes that have dominated that part of the country since before the Civil War, making collegiate memorabilia a more attractive specialty to a diverse group of collectors.

Pam.
8-12
1912

Educ.-Hampton

THE SERVANT QUESTION

By Virginia Church

DEPARTMENT OF
NEGRO LITERATURE AND HISTORY

28

THE SERVANT QUESTION

BY VIRGINIA CHURCH

"WHAT'S the good of Hampton, anyway? I can't get a servant," has been a remark not infrequently made by housewifes visiting the school and seeing the possibilities in it, according to their ideas, and failing to realize its spiritual significance and ultimate end. Men, accustomed to considering situations as affecting local or national conditions, are wont to regard an institution as large and far-reaching as Hampton as something to be considered relatively and not dismissed without trial. But women, to whom the personal equation is ever present, refuse to look below the surface of their own needs.

The subject of servants, along with the race question and other matters that have been tabulated as problems, is one that does and

29

What to Look For

As a genre of collectibles, educational memorabilia is still a developing field. Because collectors tend to be emotionally attached to the memories of their college years, this field, like genealogical research, incites strong feelings of identity. After all, college memorabilia is manufactured and sold by the colleges themselves to foster that sense of identification. A college or university, in the end, is more than just a place where you attend classes for four years. It is a symbol of the transformative years during which you change from a teenager to an adult. It is a symbol, too, of the values that set your college apart from others.

Black colleges produce thousands of commemorative and promotional items every year. Some of the older colleges and universities maintain their own museums and historical collections. These are great resources for genealogical research and reference books about local history.

ABOVE: This 1912 booklet addresses several issues that remain hot topics today: the role of women; the role of the Black college, specifically Hampton; and the long history of African Americans in menial and domestic work roles.

OPPOSITE: A football souvenir program that contains valuable information about Black college sports that is hard to find elsewhere: wins and losses, photos of the team and coaches, the cheerleading squad, and so on.

HOMECOMING

SOUVENIR

PROGRAM

25¢

WALKER

Lincoln University Vs. Tennessee State College

Saturday November 17, 1945, 2:00 P.M.

JEFFERSON CITY PUBLIC SCHOOL STADIUM

ALPHA·PHI·ALPHA
·1919·

·KAPPA· ·CHAPTER·

BAKER ART GALLERY.

HOWARD UNIVERSITY

CLASS OF 1941

PRESENTS ITS

PROM

MAY 6TH, 1938

SOUVENIR PROGRAM

CLASS OFFICERS

JAMES T. WRIGHT, PRESIDENT

ELIZABETH BANKS, VICE PRESIDENT

CATHERINE L. COTTMAN, SECRETARY

HAROLD MANCINI, TREASURER

COLORS
SILVER AND BLUE

FLOWER
WHITE CARNATION

MOTTO
WE CAME AS THE CLASS OF "41"
AND THUS WE WILL DEPART - -

OPPOSITE: This framed composite photo of members of the Alpha Phi Alpha chapter of Ohio State University has several intriguing features. The faces are clear and the identities of the subjects are researchable. Taken thirteen years after the fraternity was established, the photo features second-generation members. During the early twentieth century, few African Americans graduated from high school and even fewer continued with higher education. Documentation of black college life in this period is relatively rare, especially in non-Black colleges and especially in the Midwest. Only a very few such examples could possibly be in existence.

ABOVE: The social life of past generations captivates many collectors. As this 1938 prom souvenir illustrates, they were having fun then just like they're having fun now.

ISSN 0192-3757

$1.50

THE BLACK COLLEGIAN

VOL. 10, NO. 2
OCTOBER/NOVEMBER 1979

THE NATIONAL MAGAZINE OF BLACK COLLEGE STUDENTS

HAITIAN ART

CAREERS IN
DATA PROCESSING - COMMUNICATIONS
MARKETING AND SALES

9th ANNIVERSARY

ABOVE: Magazines devoted to various aspects of the Black experience (such as college life) multiplied in the 1970s and are collectible today.

OPPOSITE: College newspapers are a delightful form of African American history collectible. Noted achievers might be captured early in their lives in college newspapers and yearbooks.

FAREWELL TO THE CLASS OF 1960

THE SPOKESMAN

FINAL SPOKESMAN ISSUE

Vol. 19, No. 7

VOICE OF THE MORGAN STUDENT

JUNE 1, 1960

HISTORIAN TO ADDRESS 270 GRADUATES

See Story On Page 3

A QUEEN IS CROWNED—Mrs. Martin D. Jenkins, wife of Morgan's President, crowns Miss Elva Hicks Queen of May. Miss Hicks is a graduating senior from Annapolis, Maryland.

"MISS MORGAN"—Miss Yvonne Brown, art major from Baltimore, will reign as "Miss Morgan" next year. Miss Brown won the honor in the recent campus-wide elections.

Fierce, Jackson Claim Top Government Posts

See Stories On Page 2

Fine Arts Building Dedicated In 2-Week

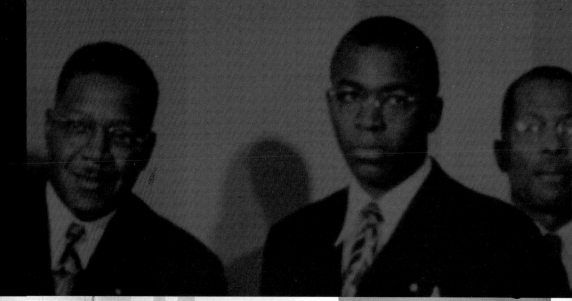

Fidelis

1953

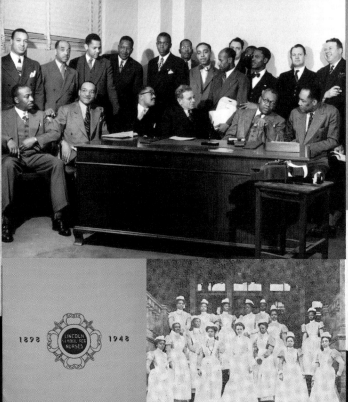

John Merrick
Founder-President
1899-1919

That Men May Help Themselves

1898 LINCOLN SCHOOL FOR NURSES 1948

Business
Economics and Careers

TYPES OF ARTIFACTS

Promotional literature: brochures, flyers, pamphlets, guides and letterheads

Letters

Uniforms and work clothing

Licenses and I.D.: chauffeurs' licenses, name tags, and union pins

Souvenir and even programs

Placards and sandwich boards

Picket signs

Work-related implements: pens, tools, ashtrays, scalpels, gavels, hammers and wrenches

News clippings

Newspapers and magazines

Books

AFRICAN AMERICAN BUSINESS PEOPLE AND WORKERS of all types have played a huge role in building the economy of the United States. Even when they were not paid or allowed to benefit from their own work, Black workers cleared the land, tilled the soil, picked the crops, built barns, homes, and factories, and stood on assembly lines to produce the goods that America exported to the rest of the world. It would be nearly impossible to collect objects pertinent to Black history without bringing together at least a few items related to African Americans' contribution to the work force!

Blacks made significant contributions to the start of the American labor movement, taking part in rallies and confrontations with big business to secure better working conditions for all workers. In the 1940s, Black labor leaders like A. Philip Randolph were regarded as political visionaries, working hard to make their constituents' lives better.

Black neighborhoods and communities have always provided fertile ground for African American entrepreneurs to start and grow local businesses. As educated Blacks left their communities in the 1960s and 1970s for corporate and government work, many of these older Black businesses died out.

Certain occupations that were traditionally engaged in by African Americans have developed a mystique which is something of a subspecialty to Black history collectors. Anything pertaining to an occupational grouping like the Pullman porters, skycaps, bellhops, or railway engineers has an irresistible nostalgia to those collectors with a passion for work-related memorabilia.

What to Look For

Serious collectors of work-related memorabilia are looking with interest at occupations and industries, which formerly had a high concentration of African Americans: sanitation, mining, gardening, and horse racing. Although Blacks are not confined to these fields alone anymore, a considerable amount of relevant memorabilia can be found if you are persistent. Black-owned family businesses such as restaurants, barber shops, funeral parlors are excellent resources for historic collectibles, as well. Some of these items are considered "crossover" material because the clientele serviced came from other racial and ethnic backgrounds.

Be sure not to overlook local, state, and national organizations, such as chapters of labor unions, craftsmen's guilds, firemen's and policemen's associations, veterans' groups, and both male and female-oriented networking associations for business owners, entrepreneurs, and executives.

Interpreting the Informational Value

Old newspapers, magazines, newsletters, and programs from churches, social clubs, and local organizations often contain advertisements from businesses that flourished years ago. These publications and ephemera can yield a phenomenal informational quality in the form of names, addresses, phone numbers of businesses, products and services, testimonials, credentials, and affiliations. Many of these ads are the only remaining sources of information about Black business communities of the past. You may come across an ad that was designed by an artist who became famous later in his career or an ad that refers to a local resident who became famous years later.

ABOVE AND OPPOSITE:

The ability of past African American communities to mobilize to meet their collective needs in some areas was nothing short of miraculous. There was greater oppression then but also a greater sense of community and shared struggle. Of special note, one of the people who was active in this effort to support health care for African Americans in Richmond was Maggie Lena Walker, the first African American woman banker in the United States and one of the first women bankers in the nation.

RICHMOND COMMUNITY HOSPITAL CAMPAIGN

for $200,000.00--JUNE 10-25, 1927

Headquarters: 200 E. CLAY STREET

RICHMOND COMMUNITY HOSPITAL FOR COLORED PEOPLE

JAS T. CARTER	VIRGINIA RANDOLPH	Mrs. MAGGIE L. WALKER	B. L. JORDAN
Dir., Speakers' Bureau	Secy., Campaign Committee	Director, Business Div.	Chair., Campaign Com.

Fidelis

1953

THIS PAGE AND OPPOSITE:
Nursing is an important part of African American economic history. It was one of the few professional career paths open to African American women (and men) for many decades. There was segregation in nurse training as there was in everything else. Yearbooks are important sources of information about professions, individual careers, and personal information such as how people looked when they were younger.

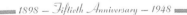

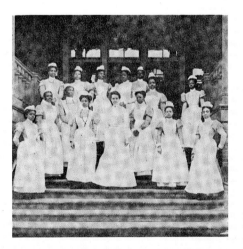

AN EARLY GRADUATING CLASS

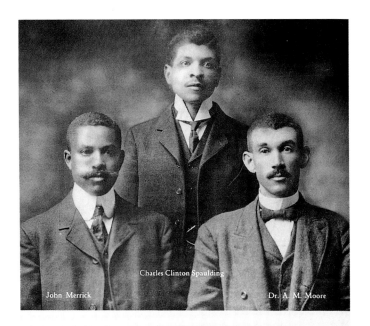

Charles Clinton Spaulding

John Merrick

Dr. A. M. Moore

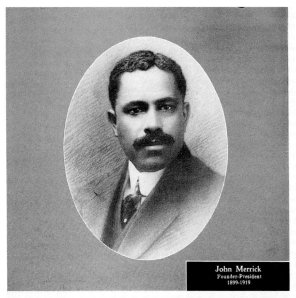

John Merrick
Founder-President
1899-1919

... That People ... Might Enjoy the Blessings of Economic Independence

On April 1, 1899, John Merrick was forty years old, Dr. Aaron McDuffie Moore, thirty-six, and Charles Clinton Spaulding, twenty-five. The two older men had recently bought out the interests of five of their partners after an unsuccessful venture into the insurance field had caused the five to withdraw. Dr. Moore and Mr. Merrick had been business associates since October 20, 1898, when they organized the North Carolina Mutual and Provident Association. At the time Mr. Spaulding was employed, he was given the high-sounding title of General Manager, but his actual duties consisted of collecting premiums and performing janitorial chores around the office.

In 1920, one year after John Merrick's death and just three years before Dr. Moore's passing, R. McCants Andrews, the biographer of Mr. Merrick, pointed out the singularity of the circumstances that brought the three men together.

The three were born in out-of-the-way places less than fifty miles apart,—one in slavery, one at the dawn of freedom, one almost a decade later during Reconstruction. Out of poverty came one, in low estate; the other two were farmer boys, born on the lands of their fathers.

The first had no schooling and was poor, but rose by hard work and simple faith. The second had the choice of a career, went to college and became a missionary of health. The third was little schooled but applied himself vigorously to books and things and gamely sought opportunity.

To Mr. Merrick, Andrews attributed "a charm that won men's hearts, a vision that pierced men's souls and a transforming intelligence that absorbed an idea, impregnated it and give it fruitful offspring for the service of his generation."

Dr. Moore, Andrews continues, "has been systematically trained and intellect completely dominates impulse."

That the two older men should have exerted a profound influence on the impressionable and ambitious younger man who made the third member of the triumvirate is confirmed by Andrews' statement that Mr. Spaulding "gave himself to the two, and is of them; he is neither, yet is both . . . His endowment is sincerity and his genius is work!"

That Men May Help Themselves

John Merrick may well be regarded as the architect of the North Carolina Mutual way of life. As exemplified in the life of Mr. Merrick, the Mutual way of life may be regarded as an attitude toward society that emphasizes faith in God, the dignity and worthwhileness of any type of labor that advances mankind, self-reliance as exemplified in collective self-help, assiduous study, constructive participation in community affairs, and long-term planning to merit acceptance into the main-stream of American culture.

Mr. Merrick was born September 7, 1859 in Clinton, North Carolina. From the beginning his life was a series of challenges. At an early age he had the responsibility of supporting his widowed mother. Rising manfully to this challenge, the youth migrated to Raleigh where he later became a skilled brickmason, working on some of the first buildings at Shaw University. And although he never attended the university, he seemed to have absorbed something of the university's spirit of "For Christ and Humanity."

By 1880, Mr. Merrick had moved to Durham where he engaged in the barber business. He was soon half owner of a barber shop that was patronized by some of Durham's most prominent

businessmen, the Dukes, the Watts, the Cobbs, the Fullers and their associates. That he learned much about the practical and theoretical aspects of business from these contacts is generally acknowledged.

In the course of his work as barber, Mr. Merrick came in contact with many less fortunate Negroes whose lives were fraught with economic insecurity. To meet this challenge, he organized some of Durham's Negro businessmen and professional men into a company that was the first outline of what is today the great North Carolina Mutual Life Insurance Company.

Mr. Merrick was encouraged by the success that eventually came to the insurance company. Later, he turned his business acumen into other areas that promised to improve the civic, religious, and educational life of his city and state.

The humanistic appeals of practical Christianity found in John Merrick a devoted servant who firmly believed that God helps those who help themselves. In one of his few public addresses extant, Mr. Merrick said, in words familiar to members

"As long as it is God's will, I want this institution to move; for men to support their families; and God will let it live."

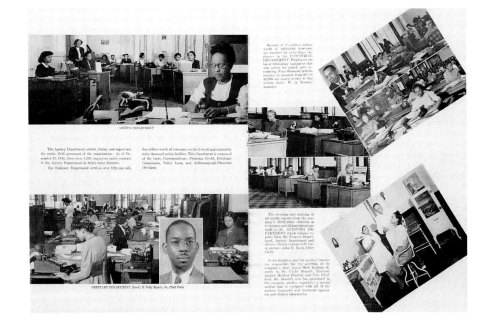

THE AGENCY DEPARTMENT

The Agency Department selects, trains, and supervises the entire field personnel of the organization.

ORDINARY DEPARTMENT (Inset) R. Kelly Bryant, Jr., Chief Clerk

THIS PAGE AND OPPOSITE: Certain businesses and industries (such as insurance firms and funeral homes) have long been a major part of the fabric of African America life, especially in the days before integration. Most were local, but a few were nationally prominent. Older memorabilia from these industries and establishments is now recognized as historically valuable. Those that have portraits of founders have a particularly strong inspirational effect on today's entrepreneurs and aspiring moguls.

FIFTIETH
ANNIVERSARY
NORTH CAROLINA MUTUAL
LIFE INSURANCE COMPANY
1899 - 1949

THIRD NATIONAL
NEGRO CONGRESS

Corinne
Grayson

UNITED STATES DEPARTMENT OF LABOR APRIL 26, 27, 28, 1940

WASHINGTON, D. C. PRICE TWENTY-FIVE CENTS

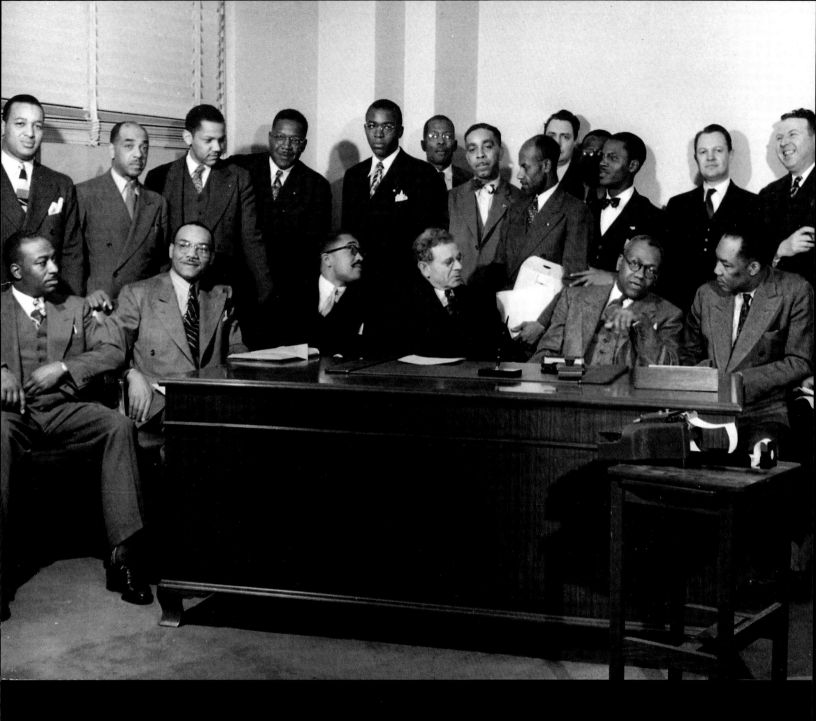

OPPOSITE: The National Negro Congress was a major civil rights coalition active in the 1930s and 1940s. Its main emphasis was promoting Black participation in organized labor, concern over the rise of fascism abroad, and promoting the use of mass-protest tactics to challenge racial discrimination. When this event took place, much nationally organized activity had occurred, the Depression was still a strong force in people's minds, and World War II had not yet begun.

ABOVE: The collaboration between Blacks and organized labor, though at times uneasy, has been an important part of the political equation for decades. It is very difficult finding material that visually captures historic events (most of it is already collected or owned by press organizations). Photographs of events such as this historic labor gathering are judged and collected because of the information content and visual documentation of history they contain rather than the artistry of the photographer.

Skin Bleach
ACTIVE INGREDIENT - AMMONIAT
VALMOR PRODUCTS CO.

HAVE

ME

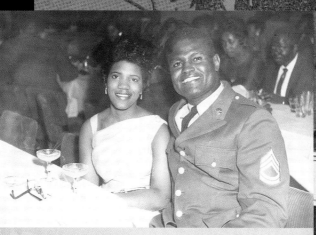

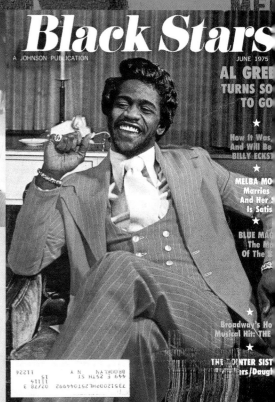

Black Stars

A JOHNSON PUBLICATION JUNE 1975

AL GREE
TURNS SO
TO GO

★

How It Was,
And Will Be
BILLY ECKST

MELBA MO
Marries
And Her
Is Satis

★

BLUE MAG
The M
Of The

★

Broadway's Ho
Musical Hit: THE

★

THE OINTER SIST
ers/Daugh

KNOW THE JOY OF A LIG
APPEARING COMPLEXIO

YOUR SKIN should be cleaned w
Cleansing Cream. Clean your Skin ev
and evening. Keep your Skin appearing
BRIGHT.

Day and Night Treatmen

MORNING—Apply Cream after washir
move with soft cloth. Next put on Swe
Brown Vanishing Cream and Face Pow
NIGHT—Do not wash face. Put on
wipe away. Off comes Dirt and Dust.
and allow to Stay on All Night.
FANCY JAR — No. V-2
PRICE WITH TAX

Have
BRIGHTER
LOOKING
PRETTIER
SKIN
Use Madam You
Frien

CHAPTER SIXTEEN
Lifestyle
and Popular
Culture

TYPES OF ARTIFACTS

Advertisements with Black models

Promotional material for historically
 relevant movies and television
 shows

Popular magazines: tabloids,
 celebrity rags, and gossip
 magazines

Calendars

Household articles

Personal articles: key chains,
 wallets, and accessories

Clothing with logos of
 Black celebrities

Toys

Menus

POPULAR CULTURE IS A CATCHALL TERM THAT OVERLAPS and includes the categories of art, music, sports, media, and advertising. Objects that pertain to the lifestyles, experiences, and tastes of the ordinary man or woman can be considered a pop culture collectible. Toys, household items, containers, small implements, hobbies, and mass-produced articles fall into this category. They are often designed and marketed to help promote or advertise a product, such as a soft drink or sneaker, or a sport. Whereas a historic collectible pertaining to African Americans in sport will contain specific information about a Black athlete, team, or sporting event, a pop culture collectible is more likely to be a marketing-oriented graphic of a celebrity on a soda can or a breakfast cereal box. Black popular culture material has increased dramatically in the past fifty years with marketing campaigns targeting Black consumers.

Whether an object qualifies as an example of pop culture or an artifact of historic importance is a topic that can be debated ad infinitum among collectors, historians, archeologists, and anyone who has ever saved a picture of a singer or an athlete on a can of soda. Prices vary and a hip-hop CD giveaway may be the crème de la crème of someone's pop culture collection five years from now.

What to Look For

Unlike "mega" history collectibles that relate to important national issues, political leaders, celebrities, and great events, popular culture collectibles are examples of "micro" culture and history that have personal or sentimental meaning to ordinary people and their social lives.

When searching for popular culture objects, be on the lookout for menus, invitations, souvenir photos, banquet place cards, and dance cards. The information on menus and souvenir photos in cardboard jackets with nightclub and restaurant logos can fill in missing pieces of information about the social activities, dining patterns, drinking traditions, dances, and parties of people very much like ourselves. Pop culture ephemera like restaurant checks and bar bills can help you understand the social life and the economic climate of a particular time, as well, since you can compare the price of meals and drinks from that era with the prices of today.

So, don't throw out that Muhammad Ali ashtray. Save your matchbooks and CD covers in a dry, dark place. Remember: Today's pop culture objects are tomorrow's valuable memorabilia. Future historians studying African American culture will treasure those celebrity socks and t-shirts, studying them for a better understanding of how African Americans lived in the twentieth and twenty-first centuries, much like archeologists searching for clues to some past civilization.

BELOW LEFT: Fans were indispensable in the days before air conditioning and served as the perfect medium for community level advertisement. Many fans were connected to churches and funeral parlors and had religious themes on one side of the advertisements on the other.

BELOW RIGHT: Every now and then an interesting artifact of African American life in the past can be found. Artifacts in general are often rarer than paper based memorabilia. This souvenir spoon was the kind of thing given out at theaters as a premium to induce the audience to return or buy refreshments.

OPPOSITE: An unfortunate trend of self-hatred has been present throughout African American history. Often it presents itself in the attempt to mimic and look like Europeans and White Americans. As this advertisement shows, skin bleaching and hair straightening was a lifelong infatuation for many before the advent of the "Black is beautiful" campaign and the acceptance of African hairstyles, such as dreadlocks. Black people were regularly assailed with appeals from advertisers to use a variety of products to change their looks and attempt to make themselves look far different from the way nature and ancestry intended them to look.

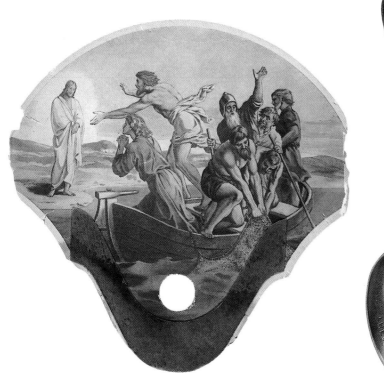

BEAUTY TREATMENT

Sweet Georgia Brown SKIN BLEACH CREAM

HAVE LIGHTER LOOKING SKIN

Is a **TOO DARK** looking **SKIN** making you feel sad and worried? Are you being neglected by those who Love you because of your complexion? Use **SWEET GEORGIA BROWN** Skin Bleach Cream to help Your Skin Look **Prettier** and more **Attractive.** Order a Jar NOW.

BEAUTIFUL JAR
No.V-3 Price with Tax **60c**

LOOK AT HER PRETTY LOOKING SKIN

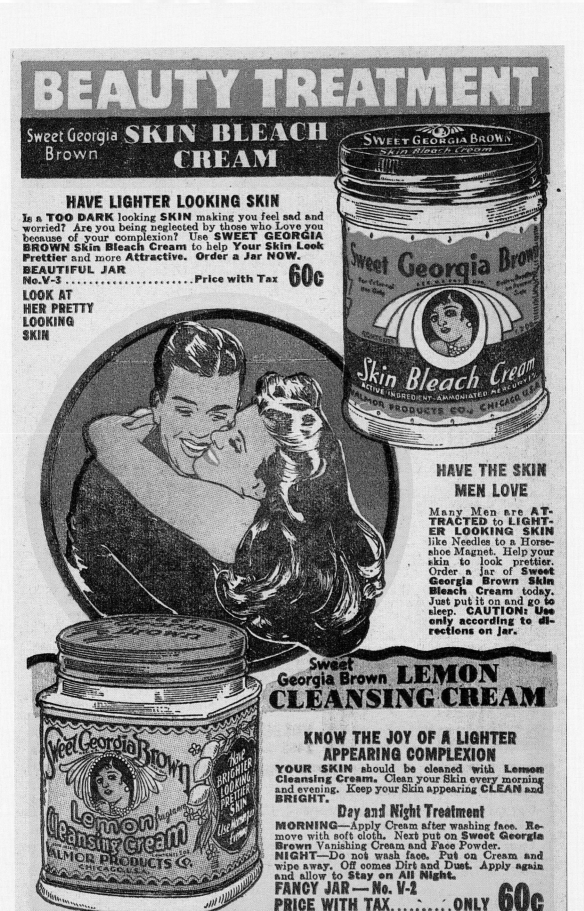

HAVE THE SKIN MEN LOVE

Many Men are **ATTRACTED** to **LIGHTER LOOKING SKIN** like Needles to a Horseshoe Magnet. Help your skin to look prettier. Order a jar of **Sweet Georgia Brown Skin Bleach Cream** today. Just put it on and go to sleep. **CAUTION: Use only according to directions on jar.**

Sweet Georgia Brown LEMON CLEANSING CREAM

KNOW THE JOY OF A LIGHTER APPEARING COMPLEXION

YOUR SKIN should be cleaned with **Lemon Cleansing Cream.** Clean your Skin every morning and evening. Keep your Skin appearing **CLEAN** and **BRIGHT.**

Day and Night Treatment

MORNING—Apply Cream after washing face. Remove with soft cloth. Next put on Sweet Georgia Brown Vanishing Cream and Face Powder.

NIGHT—Do not wash face. Put on Cream and wipe away. Off comes Dirt and Dust. Apply again and allow to Stay on All Night.

FANCY JAR — No. V-2
PRICE WITH TAX.........ONLY 60c

Order Both Sweet Georgia Brown Creams Now.
Use according to directions on jar.

Order Lemon Cleansing and Skin Bleach Cream. Send $1.20 including tax for both. We pay postage if you send money. On COD orders you pay $1.20 plus postage.

THIS PAGE AND OPPOSITE:
In the pre-integration era, much attention was paid to the difference in skin color and hair texture of African Americans. This scarce book was an unusual attempt to help dark-skinned people harmonize clothing colors with their own skin, eye and hair coloring. The author, a Black person herself, based the book on an Master's thesis in home economics on the same subject and saw herself as providing a service to dark-skinned people who had been ignored in previous literature on costume. Much of the book consists of theories and assertions about color matching and there are numerous pages with small samples of colored pieces of paper to use in planning outfits.

THE HISTORICAL COOKBOOK OF THE AMERICAN NEGRO

THIS PAGE AND OPPOSITE:

This is a prime example of a collectible cookbook being both rare and important because of the people who put it together. Many prominent Black women were involved in its production. It is engaging and collectible from an African American history point of view because it associates historical groups and personalities with specific recipes.

JANUARY 5

*A PEANUT FESTIVAL WITH GEORGE WASHINGTON CARVER
(his own original recipes)

PUREE OF PEANUTS

1 pint of peanuts blanched and ground 1 tablespoon butter
1 pint of milk 1 egg, well beaten
1/2 cup cream

Let the milk and cream come to a boil; stir in all the other ingredients; add more milk if too thick; salt and pepper to taste; serve at once with peanut wafers.

* * *

PEANUT BREAD

1/2 cup sugar 1/2 cup sweet milk
2 teaspoons baking powder 1 egg, beat in
1/2 cup blanched and chopped nuts 2 cups sifted flour

Mix these ingredients; make into small loaves or biscuits; let rise for one-half hour; bake in slow oven until done, which will require about fifty minutes.

* * *

PEANUT CAKE WITH MOLASSES

2 cups molasses 2 teaspoons cinnamon
1 cup brown sugar 1/2 teaspoon cloves
1 cup lard 1/4 nutmeg, grated
2 cups hot water 1 heaping teaspoon soda
4 cups flour 1 egg
1 pint ground peanuts

Mix the peanuts, spices, and soda with the flour; heap the measure of flour slightly; mix the molasses, sugar, lard, and water; stir in the flour; add the beaten egg last. Bake in shallow dripping pan, and sprinkle with powdered sugar just before putting in the oven.

*George Washington Carver, agricultural chemist, worked his way through high school and college to become the world-famous scientist whose labor at Tuskegee Institute would go far to change the eating habits of the South.

PEANUT SAUSAGES

Grind 1/2 pound of roasted peanuts, 1/2 pound pecans, 1 ounce hickory nuts, and 1/2 pound walnut meats. Mix with six very ripe bananas; pack in a mould, and steam continuously for two hours; when done remove lid of kettle or mould, and when mixture is cold turn out and serve the same as roast meat sliced thin for sandwiches, or with cold tomato sauce or other sauce.

* * *

PEANUT MACARONI

1 cup broken macaroni 1/4 to 1/2 pound cheese
2 quarts boiling salted water 1/2 teaspoon salt
1 cup rich milk 1 cup coarsely ground peanuts
2 tablespoons flour

Cook macaroni in the boiling salted water; a dash of cayenne pepper; drain in a strainer, and pour cold water over it to keep the pieces from sticking together; mince cheese, and mix with all other ingredients except the macaroni; put sauce and macaroni in alternate layers in a well-buttered baking dish; cover with buttered crumbs, and bake slowly until crumbs are brown.

* * *

PEANUT SALAD

1 small cabbage 1 cup vinegar
1 teaspoon flour 1/2 teaspoon pepper
2 teaspoons salt 2 eggs
1 teaspoon mustard 1 pint peanuts
1 teaspoon sugar

Chop cabbage and peanuts up fine; add the salt and pepper; cream the butter, mustard, sugar, and flour together; stir in the vinegar; cook in double boiler until stiff; add yolks of the eggs; pour over nuts and cabbage, and serve.

PEANUT ICE CREAM

1 pint peanuts 1 pint cream
2 quarts milk 3 eggs
2 cups sugar 2 teaspoons vanilla

Roast, shell, and roll the peanuts until they are quite fine; brown one cup sugar and add to milk; next add the remainder of sugar. Add the cream, vanilla, and lastly the peanuts; freeze.

TO HONOR RICHARD ALLEN:

SCRIPTURE CAKE

Judges 5:25	1 cup butter	Genesis 43:11	1 cup chopped walnuts
Jeremiah 6:20	2 cups sugar	Exodus 16:21	3 tablespoons honey
Isiah 10:17	6 eggs	First Kings 10:10	Spices to taste
Genesis 24:17	1 cup water	Leviticus 2:13	1/2 teaspoon salt
Samuel 30:12	2 cups raisins	1st Corinthians 5:6	2 teaspoons baking powder
Samuel 30:12	2 cups chopped figs	First Kings 4:22	3-1/2 cups sifted flour

Follow Solomon's advice for making good men out of growing boys that is found in Proverbs 23:14, and beat well. This is an old recipe — delicious. Bake slowly until a toothpick inserted in it will come out clean.

(THE PHILADELPHIA COUNCIL)
PENNSYLVANIA

SOUTHERN FRIED CHICKEN

Select a young plump chicken. Remove pin feathers, wash the chicken, cut into pieces suitable for serving and wipe dry. Sprinkle with salt and pepper and rub well with flour. Heat a generous quantity of fat to just below the smoking point. Put chicken in pan and let fry to golden brown, reduce heat and cook until tender. Make gravy with milk and add chopped parsley.

(WOMEN'S MISSIONARY SOCIETY
AFRICAN METHODIST EPISCOPAL CHURCH)

WEST INDIAN BANANA JAM

5 bananas	2 cups water
2 oranges	sugar
2 limes	

Cut bananas into thin slices; boil in water until soft. Add the juices of oranges and limes; measure. Add equal parts of water. Cook until thick, stirring occasionally to prevent burning.

HAWAIIAN COCONUT DESSERT

| 4 cups shredded coconut | 1/2 cup water |
| 2 cups sugar | 1/2 teaspoon anise or vanilla flavor |

Combine sugar and water and boil until syrup forms a soft ball in cold water. Add coconut and continue cooking slowly for 20 minutes until the coconut is transparent. Cool and add flavoring. Serve cold.

30

Richard Allen, born a slave in 1760, purchased his freedom with $2000 in continental money and in his hometown, the City of Brotherly Love, became a member of Old Saint George Methodist Episcopal Church.

There came a fateful Sunday when Allen and two or three of his Negro companions knelt in prayer at the church, that ushers came to pull them up off their knees and send them to the gallery. "There was much scuffling and low talking", as Allen reports. "I raised my head up and saw one of the trustees having hold of Absalom Jones, pulling him off his knees and saying 'you must get up — you must not kneel here.' Mr. Jones said, 'Wait till the prayer is over.' 'No, you must get up now or I will call for aid and force you away . . .' By this time, the prayer was over and we all went out of the Church in a body and they were never plagued with us again."

Allen did indeed go out to organize the African Methodist Church, the Charter of which is dated, June 10, 1794. Meeting first in a little remodeled blacksmith shop, the movement spread across the century and around the world into each of the 48 states, the West Indies, Africa, Central America, Hawaii and Canada.

Absalom Jones, his associate, proceeded to found the first Negro Protestant Episcopal Church in the United States.

While in New York City — Peter Williams finding his people unwelcomed at John Street Methodist Church founded, with his supporters, the AME Zion Church in 1796. To this denomination later belonged Frederick Douglass, Harriet Tubman and Sojourner Truth.

The Women's Missionary Society of the Church Founded and presided over by Bishop Allen, until his death, March 26, 1831, is an affiliate of the National Council of Negro Women. The recipe for Southern Fried Chicken contributed by its National President, Anne E. Heath, was a favorite of the former National President, the late Mrs. L. M. Hughes, a Texan, under whose leadership the two important women's groups of the denomination were merged into one official organization.

31

WATERMELON SHERBET

1 envelope unflavored	2 tablespoons fresh lemon juice
1/4 cup cold water	4 cups watermelon (diced)
1 cup sugar	dash salt
1 egg white, unbeaten	

Soften gelatin in container in cold water. Place in pan of hot water to melt. Combine sugar, lemon juice, watermelon and salt. Refrigerate. Rub through sieve. When cooled stir in melted gelatin. Freeze until firm stirring only once. Put into large bowl of electric mixer with unbeaten egg white and beat at high speed until fluffy. Return to tray and freeze again until firm, stirring once.

THE SAN ANTONIO COUNCIL

*The Councils of Texas have given us a feast for June 19. This date known as "Juneteenth", is celebrated in Oklahoma and Texas, in preference to the official Emancipation Proclamation Day, January 1, in other parts of the country. It was not until June of 1863, that recognition was given and action taken regarding the White House Proclamation. The finest "barbecues", picnics and outings of both states, take place on "Juneteenth".

**CRAB MEAT DELIGHT

1 pound crab meat	6 or 8 eggs
1 medium size onion	1/4 medium size green pepper
1/4 cup celery	6 or 8 strips bacon
1 teaspoon poultry seasoning or herbs of choice	
salt and pepper to taste	

Fry bacon crisp. Remove from pan. Sauté chopped onion, green pepper and celery in bacon fat. Add crab meat. Beat eggs separately, add to crab meat mixture. Stir constantly until eggs are cooked. Serve hot garnished with paprika, parsley and bacon.

GRAND TEMPLE, DAUGHTERS OF ELKS

**Buena V. Kelley Berry, has contributed the favorite dish of her mother, Mrs. Emma V. Kelley, founder of the Grand Temple, Daughter of Elks, on June 13, 1902, served as its Grand Secretary, until her death December 14, 1932. This National Affiliate of NCNW with its broad educational program has given active, enthusiastic leadership to the Council beginning with the Grand Daughter Ruler, Abbie Johnson, a charter member to Nettie Carter Jackson, who holds the same position today. A charming room at Council house has been furnished by the "Daughter's" memory of the founder, Emma V. Kelley.

58

Mary McLeod Bethune

59

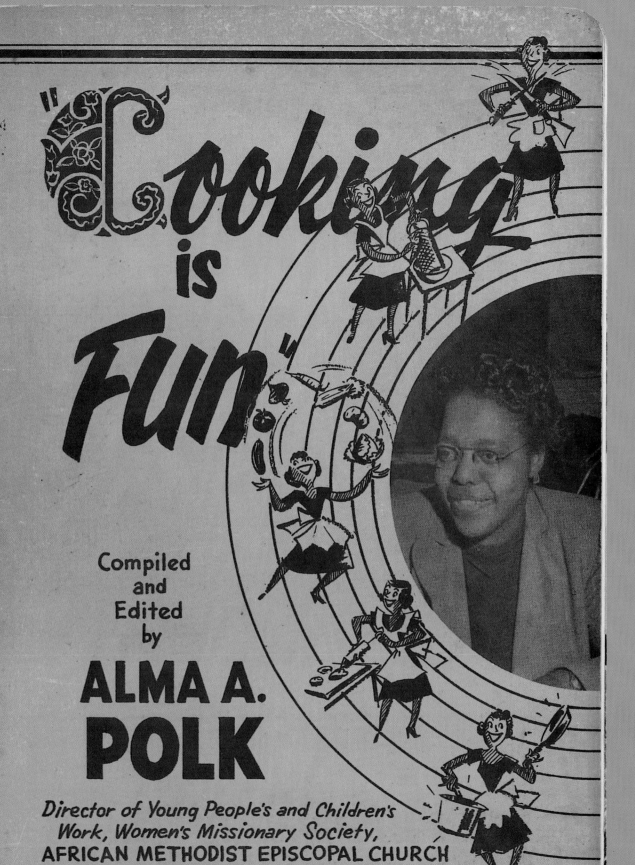

"Cooking is Fun"

Compiled
and
Edited
by

ALMA A. POLK

Director of Young People's and Children's
Work, Women's Missionary Society,
AFRICAN METHODIST EPISCOPAL CHURCH
JUNE 1955

PRINTED IN U. S. A.

Price $3.25

MEAT DISHES

SLUM GULLIAN

1 pound hamburger	½ tablespoon cayenne pepper
1 small mango pepper	1 large size can tomatoes
1 large Bermuda onion	1 can tomato sauce
4 to 6 stalks of celery	1 package frozen okra or
1 tablespoon chili powder	½ pound fresh okra diced
Dash of garlic salt	1 can whole kernel corn

Cook hamburger in patties, brown, then take out of pan to cool. Add extra vegetable shortening to pan and dice onions, mango and celery and simmer over low fire until done. Then add gradually all the other ingredients, including the hamburger patties crushed with a fork into small bits. Allow mixture to steam over low heat for 15 or 20 minutes while rice is being cooked. (Cook quantity of rice according to the number of persons to be served.) Serve slum gullian over rice and with saltine crackers instead of bread. Add a dash of garlic salt and table salt to taste. — *Mrs. Charles L. Hill, Wilberforce University, Wilberforce, Ohio.*

* * *

"The true rule, in determining to embrace or reject anything, is not whether it has any evil in it, but whether it has more of evil than of good. There are few things wholly evil or wholly good. Almost everything is an inseparable compound of the two, so that our best judgment of the preponderance between them is continually demanded." — ABRAHAM LINCOLN.

EASY SAUSAGE BREAKFAST

Hot as the sizzle of succulent fresh pork sausage is this happy idea for a crisp, fall morning breakfast. You'll be sure of bright, smiling faces at your breakfast table when you serve this tasty threesome of pancakes, pork sausage links, and apple rings in a king-size breakfast to start a busy day. These foods are flavor partners that really hit it off together, and the fried apple rings add a pleasing touch to this hearty breakfast everybody will like.

To cook sausage, place links in cold frying pan and fry slowly 12-15 minutes, turning occasionally with 2 forks, being careful not to puncture the casings. That way you keep the juices in the sausages where they belong. Pour off fat as it accumulates, saving some to fry the apple rings. Store the remainder in small covered jars in the refrigerator, ready to be used for seasoning vegetables, sauces and gravies, frying eggs, potatoes, French toast, as shortening in waffles, pancakes, or hot breads.

Sprinkle brown sugar on ½-inch thick apple slices and fry them in sausage fat for 8 minutes. Serve piping hot arranged on platter with sausage links.

Nutritionists recommend drinking at least three cups of milk a day, or 1½ pints for the population as a whole.

36

MEAT DISHES

SWISS STEAK

3 pounds round steak	3 tablespoons shortening
½ cup flour	2 cups tomatoes
2 teaspoons salt	2 tablespoons chopped onion
½ teaspoon pepper	1 green pepper, finely sliced

1. Wipe steak with damp cloth. Mix flour, salt and pepper together. Pound mixture into steak.

2. Heat shortening in skillet. Brown steak on both sides.

3. Add tomatoes, onions, and green pepper.

4. Bake 2 hours at 325°F. — *Mary Persons, So. Calif. Conf. Br., Director of Y.P. and C.W.*

* * *

THE SIZE OF YOUR HEART

It isn't the size of your house so much
That matters so much at all,
It's the gentle hand, its loving touch,
That maketh it great or small
The friends who come, in the hour they go,
Who out of your house depart,
Will judge it not by the style you show
It's all in the size of your heart.

CHICKEN SURPRISE

(This may be used with scraps of chicken or with a fricassee.)

In a casserole by layers:	strips of pimento
cooked rice	Top with rice—cover with
diced chicken	chicken jelly
sauteed mushrooms	Serve hot with chicken gravy
blanched almonds	

—*Mrs. R. C. Stevens, Erie, Pa.*

STEAK A LA CASSEROLE

½ cup tomatoes	1 small onion
1 pound round steak	½ teaspoon butter
3 potatoes	1 tablespoon flour
2 carrots	Salt

Cut the round steak ½ to ¾-inch square. Sear in frying pan. Cube potatoes, carrots and slice onion. Put all in baking dish, almost cover with water. Dot with butter, add salt and scatter flour over the top. Cover and bake slowly for 2 or 3 hours. — *Mrs. Anna Lawson, Erie, Pa.*

37

Exotic Hints

LET'S EAT AFRICAN STYLE

By INEZ BENNETT, *Chairman of World Friendship*

How would you like to sit down to a typical African meal? Judging from some of the misconceptions we often get concerning African culture, this idea might not be so inviting. However, let's take a look at some well chosen African menus.

DINNER — MIDDAGETE		DESERTS — NAGEREG	
I.		jello peaches custard	
chicken	cabbage	jellie perske poeding sous	
hoender	kool		
gravy	rice	ten met milk	
sous	rays	tee mit melk	
II.			
soup	beef	Other meats for dinner:	
sop	beevleis	veal	turkey
potatoes	cauliflower	kalfsvleis	kalkoen
aartappels	biomkool		
III.			
pork	beets	carrots	
varkvleis	beetroot	wortels	

Wouldn't you say that any of these menus could be served at our own dinner tables? Perhaps you would like to serve an African dinner at your church. The proceeds from such an affair could be used by the Y.P.D. to help further the missionary work in our foreign fields.

Our thanks and appreciation for these suggested menus go to Mrs. N. J. Bonner, wife of Bishop I. H. Bonner, who presides over the Ninth Episcopal District.

* * *

Pile a mixture of cottage cheese and chives on slices of crisp cucumbers which have not been pared, then stick several slices of pimento-stuffed olives into the cheese.

132

EXOTIC HINTS

CREAM WAFFLES AND ICE BOX DESSERT

I am way out here in Pietersberg, Tlv., South Africa and am trying to think of my favorite recipes. I discover that I have made cream waffles and an ice box dessert so long without a recipe that I do not know what proportions I use. I took a "pinch" of this and used enough flour to make the batter of the consistency I wanted, and then a "pinch of that," etc. The waffles I served so often to my guests, they came back asking for more. — *Artishia W. Jordan, Episcopal Supervisor of the South African Work in the African Methodist Episcopal Church.*

* * *

"I have learned, in whatsoever state I am, therewith to be content." (Philippians 4:11) Read I Peter 5:6-11.

* * *

"Here am I; send me." (Isaiah 6:8) Read Acts 6:1-8.

HOW TO COOK HUSBANDS

A good many husbands are spoiled by mismanagement in cooking, and so are not tender and good. Some women go about it as if their husbands were bladders and blow them up. Others keep them constantly in hot water. Some keep them in a stew by irritating ways and words. Others roast them.

In selecting your husband, you should not be guided by his silvery appearance, as in buying a mackerel. Be sure to select him yourself, as tastes differ. By the way, do not go to the market for him. The best is always brought to the door.

* * *

The high production of eggs, and the low prices at which they're selling, is the big news on food markets this winter. The U. S. Department of Agriculture says egg prices are cheaper than they've been in a blue moon. That's the housewife's cue to buy eggs often and serve them often.

133

THIS SPREAD:

This collectible cookbook was created before "soul food" was popular and universally accepted. It focuses more on food and less on history. It is sought by collectors (often food connoisseurs) because of its authenticity, shown by the inclusion of old "down home" recipes that aren't widely known now.

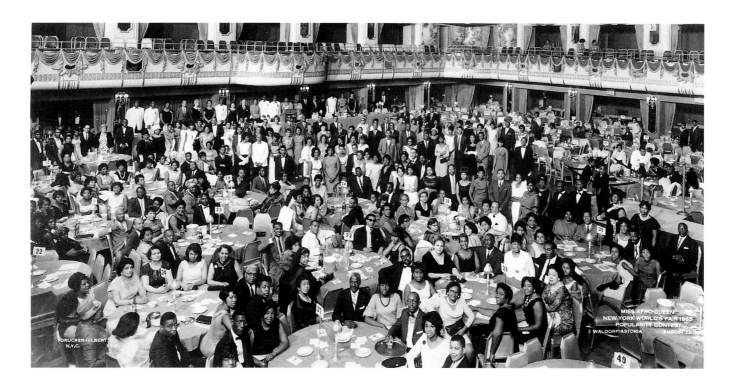

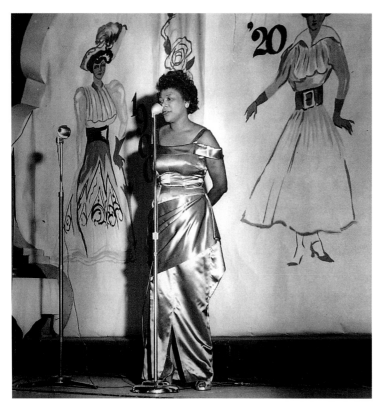

ABOVE: One of the great characteristics of old photographs is that they show events that could be forgotten were it not for the visual evidence. Even though it occurred in the 1960s, few people know or remember that there was a Miss Afro-Queen of the New York World's Fair.

LEFT: Fashion and fashionable events are very interesting to many collectors (including institutional ones). Here, Rose Morgan, a well-known beauty shop entrepreneur, is hosting a gala fashion show in Harlem in 1950 at the famous Renaissance Ballroom. The photo captures the dresses, the background scenery and the interior of the room, all now gone and thus important to have documented visually.

OPPOSITE: A stunning photograph of Josephine Baker and Molly Moon at a very dressy New York event (probably an Urban League Guild Dance). Baker's high-fashion outfit and her sparkling demeanor almost outshine the young lady being honored.

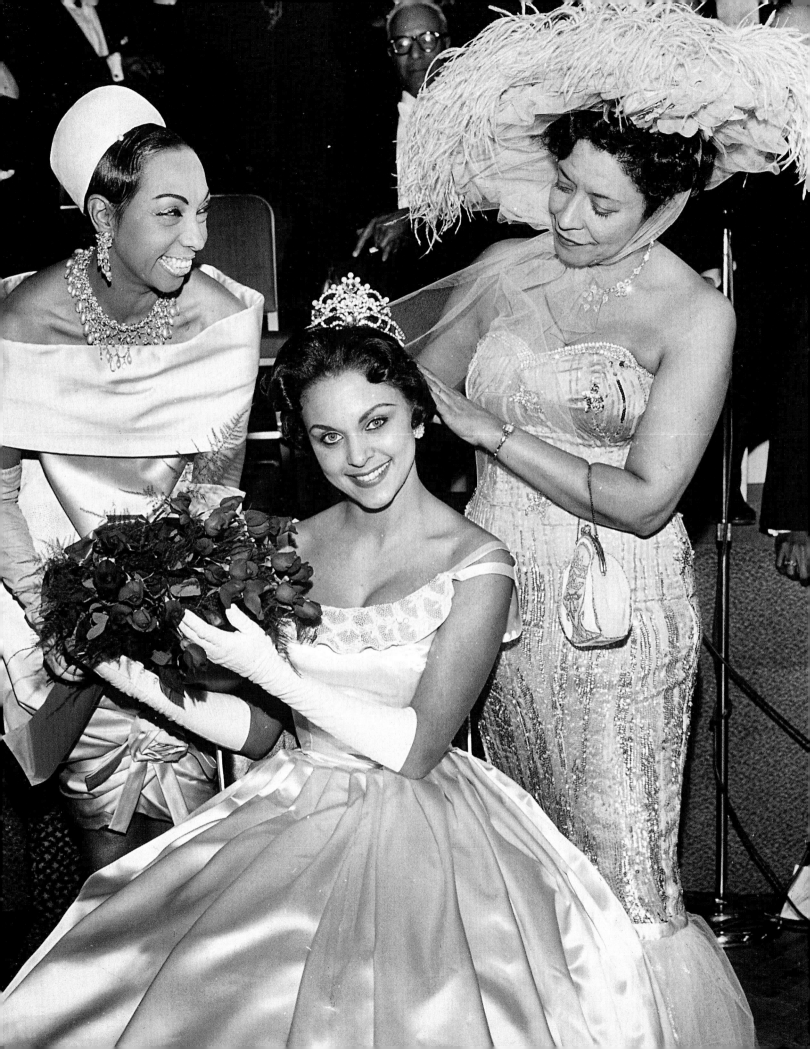

Souvenir of

AUDUBON BALLROOMS, INC.

WEDDINGS DANCES

MEETINGS

136th Street and Broadway New York City

Telephone TOmpkins 7-2877-8

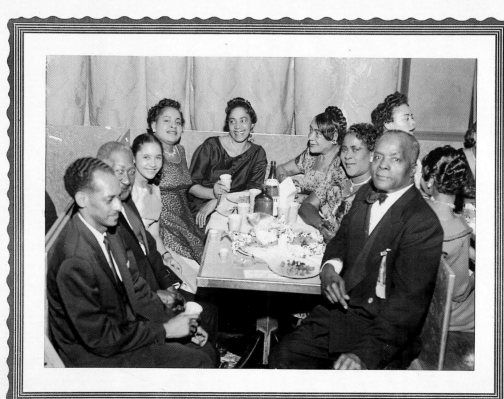

1/31/58

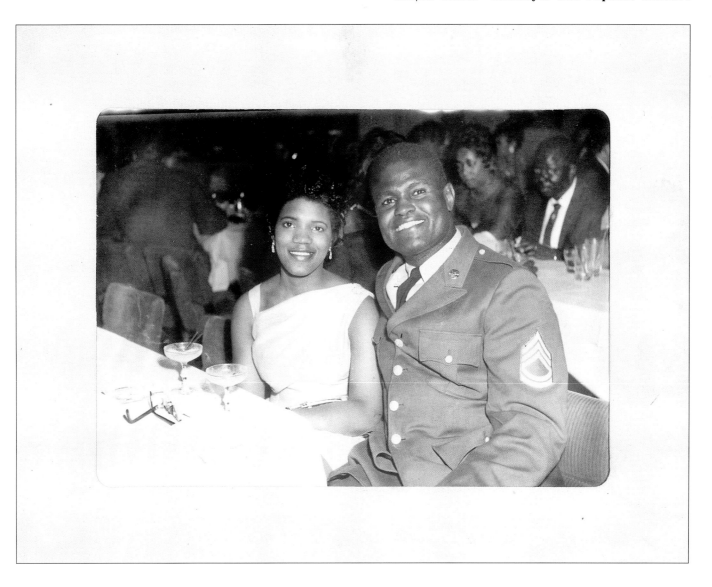

OPPOSITE: Local recreation and nightlife has become a subject of great interest to collectors and social historians. African American nightlife has always been exciting and people have always romanticized certain well-known venues. In its glory days, the Audubon Ballroom was a celebrated entertainment, dancing and performance club in Harlem. Later, it became the scene of critical, and sometimes tragic, political events.

Fortunately, many photos like this are still in the possession of the people who had them taken or their families, thus making them inexpensive and generally accessible.

ABOVE: This souvenir photo is a great document of pop culture is decades past. Here a young couple enjoys a night on the town—complete with dinner and dancing at the Club Baby Grand.

The Nubian Baby Book

THE NUBIAN BABY BOOK

To Dr. Helen Johnson:
 It is my hope that this book will
serve as a headstart for our preschool-
age children to develop a positive and
enduring image of themselves.

Clarence L. Holte
January 14, 1973

THIS PAGE AND OPPOSITE:
Unusual books that have been specially
printed or not widely produced are very
attractive to book collectors who seek
rarities. Relatively few such books were
written by or for African Americans
(which makes this one even more sought
after by connoisseurs). Another attractive
feature, likely to be overlooked by most,
is the fact that this book was written by
a great African American book collector,
whose inscription appears on the
opening page.

The Bundle

HERE I AM!

On the _____ day of _____

_____ 19 _____

at _____ o'clock _____

PLACE _____

ADDRESS _____

DELIVERED BY _____ ASSISTED BY _____

A child is the greatest of blessings.
AFRICAN PROVERB

Identification

Weight _____ Pounds _____ Ounces

Length _____ Inches

Color of Eyes _____

Color of Hair _____ Birthmarks _____

My First Photograph
(OR PHOTOSTAT OF BIRTH
CERTIFICATE)

My Footprints

God loved you and did he I know.
Why do I think so?
Because He tinted your body that beautiful hue
So angels might guard you from Heaven on through.

Based on Little Brown Boy
BY ANNETTE CHRISTINE BROWNE

8 9

Our Baby's First Seven Years

CLARENCE L. HOLTE, *Editor*

Illustrated by
ROBERT S. PIOUS

Nubian Press, Inc.
NEW YORK

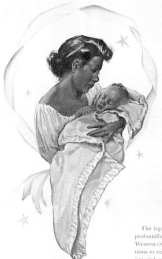

Preface

The legacy which your generation inherits is profoundly a sick society. The power elite of Western civilization has been unable to find solutions to eradicate poverty, war, corruption, racism and oppression. It falls, therefore, to your generation to conceive new values and ways of thought and reasoning which will produce a healthy human society.

In this connection, your contribution can be incalculable. It is necessary, however, to studiously acquire as much knowledge as possible. This accomplishment will reinforce the wisdom which stems from the ancient world of Africa, where highly developed democratic institutions flourished before intrusion of Western civilization.

Clarence L. Holte

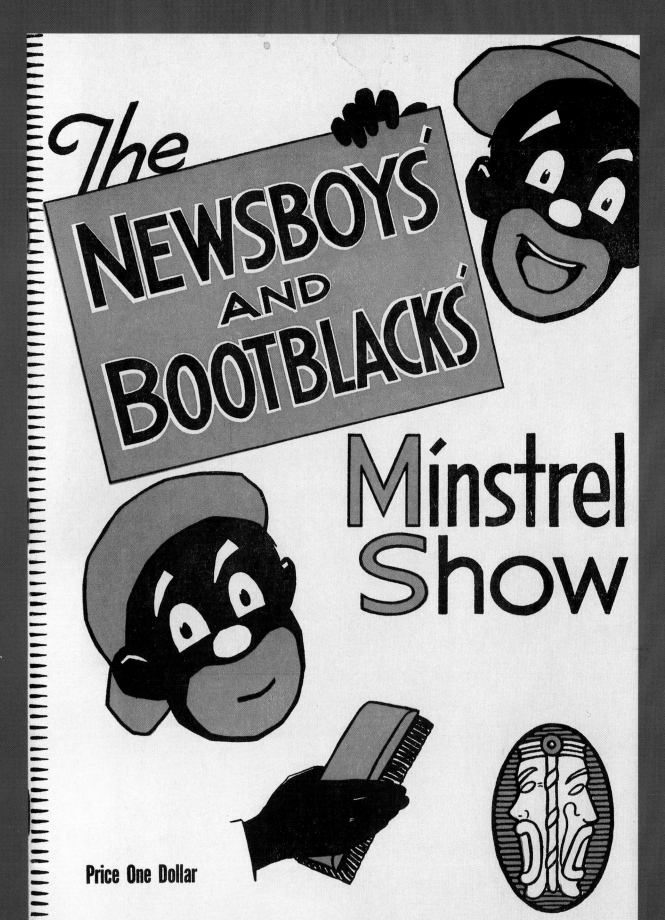

The NEWSBOYS' AND BOOTBLACKS' Minstrel Show

Price One Dollar

T. S. DENISON & COMPANY - Publishers - Minneapolis, Minn.

Racism

OPPOSITE AND NEXT TWO SPREADS: The insistence on seeing African Americans only in comical, menial roles is often the main theme of racist materials. Exaggerated facial features, smiling simple-minded behavior and the implements of servile work (note the shoeshine brush) are common features of racism items. Words such as "Coon" are used to call attention to the laughability of African Americans. Minstrel music and performances were a very popular type of entertainment. White performers, appearing in blackface, exploited Black images while excluding Blacks from participation and profit. These types of items were avidly advertised to, and bought by an audience that considered ridiculing Blacks amusing.

RACISM IS AND ALWAYS HAS BEEN A FACT OF LIFE FOR African Americans. Over the centuries, many objects have been produced that reflect racist feelings, attitudes, and motivations. These objects express in various ways the belief that African Americans are inferior, animallike, ridiculous, and in many ways deserving of scorn. Such objects are now widely collected and erroneously called "Black memorabilia." A better name for them is racism collectibles, since that is what they truly are. They are certainly not memorabilia of the Black experience as it actually happened or was created by African Americans. Rather, racism collectibles reflect the mistaken, self-serving sense of superiority that others tried to perpetuate.

The are several major characteristics of racism collectibles that should always be kept in mind. First and foremost, they are un-factual and do not show what actually happened to African Americans or what African Americans created or produced or lived through. Second, racism collectibles are designed to justify racist reactions, portraying Blacks in such a way to makes them seem to deserve inferior treatment. Third, it sometimes happens that collectors of racist objects do not extend themselves to collect more than that. Thus, they miss out on the full and valuable range of African American history in the process of pursuing a small, distorted corner of it.

Many historically minded collectors feel little attraction to racism collecting as a pursuit nor do they consider racism collectibles as objects worthy of significant time, money, or attention. This attitude is certainly justified in terms of accomplishing the all important task of telling the African American story accurately. To many historical collectors, racism collecting is monotonous, faddish, overvalued, and a preoccupation of limited minds. However justified the criticism, it would be a mistake to ignore racism collectibles completely. Though they are not actually historical since they do not portray real people or events, they should be mentioned in a book on Black history collecting because they reveal the attitudes and psychological environment that Blacks suffered from, yet managed to live through for centuries. Such items also help to understand the

Black reaction against racist beliefs that occurred in the Civil Rights and Black Power eras, as African Americans began to reject the racist thought patterns that pervaded America and infected even themselves. Finally, racist collectibles do have educational value in teaching the young and the unbelieving about the unfairness and scorn that millions of African Americans had to endure for hundreds of years to become part of American society.

What to Look For

Racist objects portray African Americans as ignorant, foolish, or dangerous stereotypes who have only a few ignoble ways of thinking and acting and who are not deserving of admiration or respect. Racist objects also depict Blacks in situations that are designed to elicit laughter from others at the expense of Blacks who are the subjects of contemptuous jokes. Many of these situations show a Black person being threatened and rather than feeling sympathy, the observer was supposed to be stimulated to laughter. Blacks are often portrayed acting unintelligently, eating watermelon, stealing chickens, being pursued by alligators, serving in menial roles, not understanding the English language, or exhibiting any number of demeaning traits.

Racism collectibles reveal the full range of racist feelings and beliefs prevalent in America at any given time. Most racist objects will refer to one or more of the following themes: Blacks are intellectually inferior, unintelligent and simple minded; Blacks were born to be slaves or servants and should not aspire to be at the same social and economic level as Whites; Blacks are happy with a low station and a meager lot in life and need or want little else; Blacks are morally inferior and given to crime and various forms of dishonesty; Black speech (Negro dialect) and culture should be ridiculed; the physical features of Blacks are ugly and strange; Blacks do and believe things that are ridiculous, superstitious, and laughable; Blacks have and should be called various derogatory names, which are fun to use; Blacks are subhuman and at the same level as animals; Blacks are associated with subservient menial occupations (cooking, domestic service, and unskilled labor); Blacks are good at entertaining others but have few other skills and little else to think about.

Some items are not so much rabidly racist as they are perpetuating of negative stereotypes. These items convey the sense of warmth and sympathy that one might feel for a pet. But in overt and subtle ways they carefully maintain a status differential and reinforce the inferiority of the Black subject as compared to the viewer. For example, the Cream of Wheat and Aunt Jemima characters reflect actual social conditions and were often seen as happy, positive figures. Nevertheless, they are racist in that they confine the Blacks portrayed to a servant role, do not convey respect for them, and do not allow them to be equal to the onlooker (who is presumed to be White).

Some racism collectibles go beyond the "comic" or "humorous" (terms often used for racist items that seek to produce laughter and derision at the expense of Blacks). These more sinister and destructive racist items advocate or justify oppression and discrimination. Items related to the Ku Klux Klan, pro-segregation, pro-slavery, and genetic inferiority fall into this category. Rather than seeing Blacks as entertaining and humorously ridiculous, these items view Blacks as a menace to society who must be oppressed, contained, restrained, and terrorized.

Racism collectibles are generally valued on the basis of several characteristics:

Rarity: Many were produced and some are still found today. Those that are less frequently seen are more avidly collected by today's experienced collectors.

In Period Authenticity: Many modern reproductions have been made, and these should not be at all in the same collectible category or price range as those that are vintage.

Artistic Quality: The colorfulness and detailed execution of the graphics, weaving or carving.

Size and shape: Larger or more unusually shaped items are more eagerly sought after.

READY MARCH 15th, 1900.

THE COON SENSATION

"Mah Tiger Lily."

By CLAY M. GREENE & A. B. SLOANE.

As sung in the Comedy Hit

AUNT HANNAH!

at the Bijou Theatre, N. Y.

NO SONG EVER RECEIVED MORE PROMINENCE IN NEWSPAPER NOTICES

FROM 9 to 11 ENCORES EVERY NIGHT !

Other Song Hits of "AUNT HANNAH"
in work :

By CLAY M. GREENE & A. B. SLOANE,

"Little Bo=Peep."

"When the Cat's Away the Mice will Play"
What's the Matter with Hannah."

JUST COMPLETED.

.. THE WITMARK ..
MINSTREL OVERTURE AND
OPENING CHORUS
No. 2.

BY ISIDORE WITMARK.

A VERITABLE REVELATION IS THE NEW WITMARK
MINSTREL OVERTURE AND OPENING CHORUS.

EXPERIENCE TEACHES ! ! !

While the Witmark Overture No. I. is an unquestionable success, the No. II. is surely bound to surpass it from every standpoint.

In the first place, No. II., while constructed on the same lines as No. I., it is arranged and harmonized so that it can be done in a minstrel performance composed either of male or female, or on a program where both ladies and gentlemen take part.

In the second place, there is no "Gentlemen be seated" or announcement in introducing the End-men. They make a novel cake-walk entrance instead, which is very effective.

In the third place, an unusually good collection of songs, introducing excellent and novel business in each, has been compiled and some clever surprises have been specially invented.

CONTENTS :

Chorus behind curtain.

"Darktown is Out To-Night."

Novel Cake-Walk Entrance for End-men.

"Open Your Mouth and Shut Your Eyes."
"All Coons Look Alike to Me." (2 bars only to introduce dialogue)
"We All Have Troubles of Our Own."
"I'm Prepared for It."
"Bells of Fate."
"My Black Baby Mine."
"The Raccoon and the Bee."
"When the Cat's Away the Mice Will Play."
(Introducing amusing cat fight.)
"Give Me Your Eye."

Special selection from "Carmen."

FINALE.

These overtures are so radically different that both can be used on the same program (one as an opening chorus, the other as a first part finale) with the most satisfactory results.

By general demand from those who have used the No. I. Overture we have published the No. II., and sincerely hope it will meet with the same approbation and success that was accorded our former effort in this particular line.

PRICE, ONE DOLLAR.

Voice Parts, 25c. each. **Full Orchestration, $1.00.**

Extent of the racism that is obvious: In racism collecting, bad is good and the more bad an object is the more it is desirable to own. Objects that are more grossly racist are valued more highly in this field than those that are more subtle, patronizing or more humanitarian. For example, those that use the word "nigger" or other derogatory insulting terms such as "coon" cost more than others. The general idea is the more racist the more collectible, the more desirable it is to collect.

Collectors should exercise great caution if they plan to acquire vintage or expensive racist items since many clever and expert reproductions have flooded the market in recent years. In addition, large collections of racist items are being sold or broken up as early collectors cash in on the boom or pass on to a place where these collectibles cannot be taken.

Types of Items Available

Racist objects come in a variety of forms and materials (paper, wood, metal, plastics, and ceramic). Many of them are made of paper and have racist graphics and illustrations (postcards, sheet music, greeting cards, trade cards, and cartoons). Others are household objects (cookie jars, table cloths, napkins and table accessories, spoons, salt and pepper shakers) while another type of racist item is souvenirs intended for the tourist trade (figurines, trays, ceramic containers, and menus).

The Economics of Black History Collecting

THERE IS NO IGNORING THE FACT THAT money has become a major factor in collecting African American history—some might say it has been a factor for some time now. Black history is no longer merely a field of study, it is now an industry. Prices are soaring, speculation is rife, and many people who care on a historical and cultural level are being priced out of the market. However, not every item is investment grade and not everyone is seeking to make an investment when they collect. Many, perhaps most people want to collect for enjoyment rather than speculation, and they just want to know how to do so an a limited budget.

Collecting Black History on a Limited Budget

Despite the fast-climbing, almost dizzying prices that can be asked for desirable African American objects, a thoughtful, clever collector can put together a desirable collection on a limited budget. Collecting Black history with little money requires accumulated skill, not just luck. Clear goals and honesty with oneself about why one wants certain items are a big help in knowing when to buy and when to pass on an item. It's not true that only the rich can invest. People without a lot of money to spend collecting can often resell items they've bought for a profit and apply the proceeds to something expensive they really want or just pay bills that need to be paid. Buying inexpensive items will not usually lead to large, windfall profits and much depends on when one sells and who one sells to (finding the right buyer is the key to profitability). But a collector who uses his or her head and works at it can usually make more on the sale of some items than what they paid for them.

It is rare that an item purchased for a very low price will yield a high profit at resale; the time needed for such an appreciation in value is often longer than most collectors can afford to wait. In such cases, only verifiable, original vintage pieces in good condition will merit considerable resale value and therefore investment potential. Here are some tips that pay off for the impecunious collector:

Develop a good general working knowledge of Black history, especially the period and subject you are interested in. Study diligently and learn from knowledgeable people to be able to recognize good buying opportunities and find undervalued material. If you know more than the seller, you're bound to get a good many items at a reasonable price a fair percentage of the time.

Select a few areas to specialize in. It is very expensive to collect everything and impossible to do it well. It is generally wiser to concentrate and specialize, buying a number of related items or accumulating a collection of similar items in a specialized field rather than buying miscellaneous, scattered, unrelated items. Potential buyers are willing to pay high prices for a collection—or part of a collection—that really says something about a given subject in detail with examples of different facets of the same theme.

Invest in reference books and read them. They are necessary tools that will teach you what you need to know—not just about Black history, but how to select items worth buying, identify and value what you have already, and decide whether what you encounter and purchase is historically important.

Talk to experienced collectors and learn from them if they are willing to part with knowledge. They can tell you about mistakes they've made that you can avoid, offer their opinions on changing trends in the field, and provide new contacts and and information on key events such as auctions, exhibitions, and lectures. Some collec-

tors might even trade you for something you have that they want (though knowing what constitutes a fair trade takes experience and clear goals on your part). Some advanced collectors are admittedly selfish and don't want anyone to know what they know or have access to their sources but others see Black history as a treasure to be preserved and shared rather than hoarded and competed for.

Form a relationship with a few honorable dealers. They can teach you a lot, hold items for you if they know of your interest, give you generous discounts, offer you items as a trade rather than for cash, or allow you to purchase an item on time payments. There are decent dealers who will sell you things at a discount or on workable credit terms because they feel that if you are truly interested in a subject, certain items were "meant for you and you should have it." This is their way of honoring the historical content of their merchandise. Occasionally, you may become friendly enough for a dealer to turn you on to their wholesale sources. Some dealers will even let a committed collector they know and trust establish a barter arrangement in which the collector works or does favors for them in return for receiving a significant discount on an expensive item. Such friendly, helpful dealers are admittedly not found every day, but with patience and persistence (and a lot of good people skills) they can and have been found. On the other end of the spectrum, there are many dealers who look at Black history as strictly a business affair and have no room for flexibility. Like everything else in life, you've got to work to find good dealer sources.

Keep aware of news about events that might affect the availability of Black history items in your area. Look beyond traditional outlets like flea markets and auctions for a "going out of business" sale or the "cleaning out" of old school or church files. Take notice when elder people are moving from large homes to smaller quarters. There may even be instances when the family of those recently deceased could be willing to offer items at low or no cost to someone who really cares about Black history as a memorial.

Don't let friends or relatives needlessly throw things away that have historical content. Many great pieces that people don't value when new have gone on to become scarce, expensive collector's items. Get an inexpensive storage space and let people know that you are interested in history and have a place they can donate those old magazines, stuff from their days in college that takes up too much space or whatever it is that they don't want. Much good Black history is thrown away by people cleaning up their garages or cleaning out an old apartment after someone dies. Such salvaged items also give the one smart enough to keep them something to bargain with when they see things they want but can't afford to buy from dealers or other collectors.

Remember, if you don't have money, get knowledge, work hard, spend time learning what you're doing, and form relationships for sources and advice. If you think Black history is important and meaningful enough to work for, you'll be able, over time, to form an investment grade collection on a very limited budget.

Black History Collectibles as Investments

An investment-grade object is one that will rise in market value and provide a significant increase over the original purchase price over a period of time. It should be noted that most Black history items are not investment grade but some will be in future years. Despite exciting potential, Black history collectibles are a new field of investment and collecting for profit has definite risks. All forms of investment are complex, unpredictable, and losses as well as gains are possible. The collector of Black history faces many uncertainties, potential pitfalls, and swiftly changing market forces. Considerable knowledge, shrewd decision making and hard work is required to

safely produce an adequate return. Unfortunately, there is little published information such as price history data to guide investors. This book expresses personal opinions and experiences and is intended to inform people about collecting trends and issues but under no circumstances is it to be construed as offering investment advice.

Key Points to Remember When Collecting for Investment

It can never be stated enough: investment in collectibles (or anything else) is fraught with the possibility of loss as well as gain. Proceed with caution and don't invest more than you can afford or are willing to lose.

Know why you are buying and distinguish investment purchases from collecting as a hobby, for aesthetic reasons, or for research.

Think about who is likely to buy items after you in order to gauge appreciation potential. Some find it more practical to invest in items that have wide appeal across the spectrum of categories, but specialty items can be worth more to other buyers.

Scarce, original-in-period, vintage items are more likely to increase in value. Avoid newly manufactured, mass-produced "collectibles of the future" that have little resale value because they will remain common. Old is usually better than new but original is definitely better than reproduction for investment purposes.

Knowing what is rare and what is not is one of the major challenges for those daring enough to invest in Black history collectibles. Unless a person has many years of experience, it is often necessary or at least wise to get the assistance of a specialist in the field (a dealer, a curator, an appraiser, etc.) to assess the rarity and salability of a major, expensive item or collection.

When collecting historical pieces for investment, items that contain information and tell a story are usually much more desirable than anonymous items that are difficult or impossible to research, define, or put into sig-nificant historical context. Items that can be defined in terms of a specific time, place, or person have more appeal than those that confront the next buyer with many unknowns.

To gain maximum profits from collectibles, plan to invest more than just the purchase price of the item. Consider also the time needed to research the item's historical significance and the expense of appraisal, insurance, conservation and marketing to potential buyers.

Buying and holding historical items for a period of months or years often leads to greater returns than a quick "flip." Time is needed to research rarity and historical value, locate the best buyers, and allow market demand to reach a peak.

To maximize long-term profit, one must buy "ahead of the market" and invest in things that are currently undervalued and have not yet been widely appreciated or fully priced.

Just as when one is buying on a budget, it can be wiser to concentrate and specialize, buying a number of related items or accumulating a collection of similar items in a specialized field. Specialist buyers will pay higher prices for a collection that makes an in-depth statement on a subject area.

Stay aware. Read books, attend exhibits, lectures, films and other events that relate to one's investments. Collect books, exhibition catalogs, publicity materials and scholarly papers related to your field.

Reaping a gain on an investment in collectibles usually requires knowing to whom one will sell an item or a collection that one has acquired. Thus, knowing the market and the characteristics of each type of market participant is essential in trying to invest in Black history collecting. In terms of selling, different buyers have different buying characteristics. Some buyers know more than others. Some buyers may know more than you. Some buyers may spend more but take longer to pay. Some pay more quickly but demand bigger discounts.

Some demand more documentation in terms of description and provenance than others.

New areas of collecting emerge constantly. Some traditional specialties will always retain value but newer, emerging areas—though more risky—might appreciate faster. One's goals and circumstances as well as market conditions and opportunities should determine one's collecting and investment strategy

Buying, Pricing, and Valuation

Though a few of us are lucky enough to get Black history collectibles through barter, inheritance, or as a gift, most people and institutions have to buy it. Thus, advice on buying, prices, and valuation can save new collectors from learning the hard way. Many sad experiences and lost opportunities can be avoided by absorbing a few simple principles that it takes most experienced collectors years to learn.

Buying

Know why you are buying and let your purchases be chosen on this basis. Buying for investment or for family genealogy research is different than buying for educational material for a class or decoration for the home. Each different buying motivation has different rarity, condition, and price requirements. Of course, no one likes to be overly confined by rigid guidelines and it's important that collecting be fun. Nevertheless, a disciplined buyer will know their reasons for purchasing and act accordingly. They will also know that when buying in one type of situation, one faces different risks, opportunities and prices than if buying in another.

If the buying is successful, then eventually the selling will be successful too. Collectors should treasure good sources and maintain good relations with them because in the long run (and there always is a long run) they count very much. First, one always wants to have the right of first refusal for rare and highly desirable items.

Second, the time involved in continuing to search for an item at a "better" price is often not worth it. A source that carries one good item will most likely have other desirable things later on.

We all like to bargain, but keep in mind that some items might never be found again. If a piece concerns your family, fills in a long vacant hole in your collection, or can strengthen an important study, then by all means don't let it get away.

Hone your researching skills and invest in reference books. A collector without research capability lacks the tools to be successful in the long term and is at the mercy of everyone else (sellers and other buyers waiting for mistakes to be made).

Pricing and Valuation

Assigning fair and reasonable values to Black history collectibles is not a simple matter nor is it an exact science. The same is true throughout the antiques and collectibles industry but in the Black history field there are several additional complications that make valuation more difficult. Accurate, well-publicized long-term price histories for Black history objects are often lacking. Nor are there many appraisers and consultants experienced in African American history and culture and its collectibles. Unfortunately, among many art, antiques and historical professionals there is still much uncertainty about the historical importance and scarcity of various items. Finally, constantly changing trends and evolving demand patterns make it difficult to establish stable valuations and price trends.

Demand and scarcity are generally the most important factors in pricing but other factors matter almost as much, particularly condition, the extent to which an item being sold is widely advertised and timing in terms of when an item is being sold. Demand is tricky since a few wealthy people will bid prices up for something they want and when those who have the means to pay these

high prices are no longer in the market, these same items can go begging for buyers at even much lower prices. Condition very much counts in pricing and purchasing decisions but there is no hard and fast rule as to when to reject an item and when to consider it over-priced because of condition. Much depends on why one is collecting and what one plans to do with things collected. The fact of the matter is that few things are in absolutely perfect condition. Thus, condition involves a subjective, relative judgment. Timing is also a crucial pricing concern with many considerations to be accounted for since news moves the market. The same item that brings low prices one year (because people don't know or care much about its subject matter) will command high prices shortly after the occurrence of a blockbuster movie or exhibition, an influential book or study or a television show on that subject.

Age matters—but not all the time and not in all subject areas. Items dated prior to 1900 tend to be more scarce and therefore more costly than those dated after the turn of the last century. However, there are many important exceptions to this general guideline. Depending on the supply and demand, many types of collectibles from the 1920s and 30s or even as recently as the 1970s can be more expensive than items that are much older. For example, Harlem Renaissance items from the 1920s and 30s or Mohammed Ali collectibles from the 1970s have a more interested following and thus there is greater demand than supply.

The level of authenticity should affect prices during purchase. The less certain a buyer is about whether an item is what it is said to be, the less they might pay for it. But again, this is only a general guideline and there may be exceptional circumstances.

Experienced, active collectors who do their research can be among the best sources of information about prices and value factors. But don't rely solely on the advice of other collectors. Many have been collecting for

years and don't necessarily keep up with the current prices of items they've owned for a long time. What they bought something for five or ten years ago is not what it would cost today. The Black history field has gotten so large and changed so much in recent years that a specialist collector cannot know about prices in its many sub-specialties or in recent months.

The best recourse in trying to establish reasonable, approximate prices and costs is to ask the assistance of an experienced, active dealer who is constantly buying and selling—and who keeps up with his or her research. Though some collectors can be very helpful, many usually only know about the buying side of collectibles prices: what things cost at the retail level. Collectors often don't know the costs involved in the selling side and the profit levels necessary to stay in business. In addition, some dealers do extensive research and others merely sell with little or no effort devoted to understanding an object's historic value. Obviously this can sometimes work to the advantage of the buyer who knows more than the seller and reduces the dealer's ability to assess proper value and make rational prices.

At the end of the day, there are a few other factors that can affect not only the price of an item but the entire transaction. Whether or not business has been good for the seller that day—and whether another seller in close proximity has a similar item for sale—can have a great deal of impact on the price you'll pay. If the seller judges you to be a good customer who will return and buy more things, the negotiation process may end more happily. On the other hand, if the seller judges a piece to be a good long term investment, it will be worth the wait for the right buyer who will pay what the seller thinks the item is truly worth.

A SAMPLING OF ORGANIZATIONS AND RESEARCH CENTERS

Association for the Study of African-American Life and History
7961 Eastern Avenue
Suite 301
Silver Spring, MD 20910
Tel. (301) 587-5900
Fax (301) 587-5915

The Afro-American Historical and Genealogical Society, Inc.
P.O. Box 73086
Washington, D.C. 20056-3086
Website:
www.rootsweb.com/~mdaahgs/

A SAMPLING OF RESEARCH LIBRARIES AND COLLECTIONS

Atlanta University Center
Woodruff Library
111 Chestnut Street, S.W.
Atlanta, GA 30314
Tel: (404) 522-8980
Fax: (404) 577-5158
Website: www.auc.edu

Amistad Research Center
Tilton Hall-Tulane University
6823 St. Charles Ave
New Orleans, LA 70118
Tel: (504) 865-5535
Website: www.tulane.edu/~amistad
An historical research library
devoted to the collection and use of primary source materials on the history of America's ethnic minorities.

Birmingham Public Library
Dept of Archives and Manuscripts
2100 Park Place
Birmingham, AL 35203
Tel: (205) 266-3610
Several collections containing information on the Civil Rights Movement in Birmingham.

Brown University
John Hay Library
Harris Collection
20 Prospect Street
Providence, RI 02912
Tel: (401) 863-2146
Fax: (401) 863-2092
E-mail: hay@brown.edu

Chicago Historical Society Library
Clark Street at North Avenue
Chicago, IL 60614
Tel: (312) 642-4600
Fax: (312) 266-2077
Website: www.chicagohs.org
Extensive holdings of twentieth-century Black history, including papers of noted individuals.

Chicago Public Library
G. Woodson Regional Library
George C. Hall Branch
9525 S. Halsted St.
Chicago, Il 60628
Tel: (312) 747-6900
Fax: (312) 747-3396
Website: chipublib.org
Houses the Vivian G. Harsh Collection on Afro-American History and Literature.

College of Charleston Library
Special Collections Dept.
66 George St.
Charleston, SC 29401
Tel: (843) 953-5540
Fax: (843) 953-8019
Website: www.cofc.edu/library
Holdings include the Septima Poinsette Clark Papers representing the many activities of the educator and civil rights leader.

Columbia University Libraries
Rare Book and Manuscript Library
Butler Library
535 West 114 Street
New York, NY 10027
Tel: (212) 854-2231
Fax: (212) 222-0331
The L.S. Alexander Gumby Collection on the American Negro and the Paul Magriel Boxing Collection on the history and literature of pugilism.

Detroit Public Library

Music and Performing Arts Dept.

5201 Woodward

Detroit, MI 48202

Website: www.detroit.lib.mi.us

The E Azalia Hackley Collections
document achievements of Blacks
in the fields of music, dance,
theater, motion pictures, and
broadcasting.

District of Columbia Public Library

Martin Luther King Memorial
Library

Black Studies Division

901 G. Street, N.W.

Washington, D.C. 20001

Tel: (202) 727-0321

Website: www.dclibrary.org/mlk/

Duke University

William R. Perkins Library

Durham, NC 27706

Tel: (919) 660-5922

Houses the John Hope Franklin
Collection of African and African
American Documentation

Website: www.duke.edu

Enoch Pratt Free Library

African American/ Special
Collections Dept.

400 Cathedral St.

Baltimore, MD 21201-4484

Tel: (410) 396-5468

Indiana Historical Society Library

315 W. Ohio Street

Indianapolis, IN 464202

Tel: (317) 232-1882

Website: www.indianahistory.org

Holdings include the records of the
Madam C.J. Walker Company

Langston University

M.B. Tolson Black Heritage Library

P.O. Box 1600

Langston, OK 73050

Tel: (405) 466-3292

Fax: (405) 466-3459

Website: www.lunet.edu/lib

Library Company of Philadelphia

1314 Locust Street

Philadelphia, PA 19107

Tel: (215) 546-3181

Fax: (215) 546-5677

Website: www.librarycompany.org

With its holdings from the
collection of The Historical Society
of Pennsylvania, one of the
richest collections of manuscripts,
books, and other materials on
the slave trade and the abolitionist
movement.

Library of Congress

American Folklife Center

Archive of Folk Culture

Thomas Jefferson Building

1st and Independence Ave

Washington, D.C. 20540

Tel: Reading Room (202) 707-5510

Website: lcweb.loc.gov/folklife

Gullah spirituals and dialect
stories recorded in the 1930s
and at other times.

Louisiana State Library

760 Riverside N.

P.O. Box 131

Baton Rouge, LA 70893

Tel: (225) 578-LOLA

Extensive items documenting
several generations of the Mathews
and Butler Families, spanning the
years 1811 to 1945, detailing the
accounts and affairs of slaves,
sharecroppers, and tenant farmers
from at least six different
plantations.

Meharry Medical College Library

1005 DB Toel Blvd.

Nashville, TN 37208

Tel: (615) 327-6454

Fax: (615) 327-6448

Black medical history collection

Moorland-Spingarn Research Center

500 Howard Place, NW

Washington, D.C. 20059

202-806-7241

New Bedford Free Public Library

Genealogy Room

613 Pleasant Street

New Bedford, MA 02740-6203

Tel: (508) 991-6275

Correspondence, family papers and business accounts of Paul Cuffe, Black merchant involved in the resettlement of Black Americans in Sierra Leone.

New York Public Library

Countee Cullen Regional Branch

104 West 136th Street

New York, Ny 10030

Tel: (212) 491-2070

Fax: (212) 491-6541

Large circulating collections of materials and information related to African history and culture, as well as the African American experience. Includes the James Weldon Johnson Memorial Collection, a reference collection of childrens' books about the African American experience.

Prince George's County Memorial Library System

Oxon Hill Branch Library

Sojourner Truth Collection

6200 Oxon Hill Road

Oxon Hill, MD 20745

The Sojourner Truth Collection on Blacks in America is a representative collection of materials by and about Black Americans, their historical problems and accomplishments.

Providence Public Library

225 Washington Street

Providence, RI 02903

Tel: (401) 455-8000

Fax: (401) 455-8080

The Edna Frazier Memorial Collection at the South Providence Branch contains several thousand circulating volumes devoted to Black studies spanning the years 1619 to the present, with a unique emphasis on children's books.

Secretary of the Commonweath

Archives Division

220 Morrissey Boulevard

Dorchester, MA 02133

Tel: (617) 727-2816

Permanent Massachusetts state records from the early 1600s to the present, including Civil War colored regiments muster rolls and southern recruitment records.

Schomburg Center for Research in Black Culture

515 Malcolm X Blvd.

New York, NY 10037

Tel: 212-491-2200

Fax: (212) 491-6760

Temple University Libraries

Special Collections Dept.

Rare Books & Mss Section

Philadelphia, PA 19122

Tel: (215) 204-8211

The Charles Blockson Afro-American Historical Collection contains approximately 25000 items of Afro-American literature, history of slavery and African and Caribbean history and culture.

Tougaloo College

L. Zenobia Coleman Library

500 West County Line Rd.

Tougaloo, MS 39174

Tel: (601) 977-7704

Civil rights cases in Mississippi 1960 to 1968; also Blacks in the military.

University of California, Berkeley

University Library

Afro-American Studies

Berkeley, CA 94720

Website: www.cal.edu

Extensive holdings with materials collected by more than twenty campus libraries.

University of California, Los Angeles

Research Library

Dept. of Special Collections

405 Hilgard Avenue

Los Angeles, CA 90024-1575

Website: www.ucla.edu

Various holdings include the Ralph J. Bunche papers, George P. Johnson Negro Film Collection, and Arthur B. Spingarn Collection of Negro Literature.

Yale University

Beinecke Rare Book & Manuscripts Library

Wall and High Streets

New Haven, CT 06520

Website: www.yale.edu

The James Weldon Johnson Collection contains papers of a number of the most prominent Harlem Renaissance writers.

A SAMPLING OF MUSEUMS AND GALLERIES

African American Museum of Fine Art

3025 Fir Street, Ste. 27

San Diego, CA 92102

Tel: (619) 696-7799

Fax: (619) 239-1318

African American Museum in Philadelphia

701 Arch Street

Philadelphia, PA 19106-1557

Tel: (215) 574-0380

Fax: (215) 574-3110

American Jazz Museum

1616 E. 18th Street

Kansas City, MO 64108

Tel: (816) 474-8463

Website:

www.americanjazzmuseum.com

Amistad Foundation

At the Wadsworth Atheneum

Museum of Art

600 Main St.

Hartford, CT 06103-2990

Tel: (860) 278-2670

Fax: (860) 527-0603

Anacostia Museum

1901 Fort Place, SE

Washington, D.C. 20560

General Smithsonian Museum

Tel: (202) 357-2700

Website: www.si.edu/anacostia

Atlanta History Museum

130 W. Paces Ferry Rd. N.W.

Atlanta, Georgia 30305-1366

Tel: (404) 814-4000

Birmingham Civil Rights Institute

520 Sixteenth Street, North

Birmingham, Alabama 35203

Tel: (205) 328-9696

Black American West Museum & Heritage Center

3091 California Street

Denver, CO 80205

Tel: (303) 292-2566

Black Fashion Museum

2007 Vermont Avenue, NW

Washington, D.C. 20001

Tel: (202) 667-0744

Website:

anyiams.com/Fashion_museum.htm

California African American Museum

600 State Drive Exposition Park

Los Angeles, CA 90037

Tel: (213) 744-2132

Website: www.caam.ca.gov/

Charles H. Wright Museum of African American History

315 East Warren Ave.

Detroit, MI 48201

Tel: (313) 494-5800

Fax: (313) 494-5855

Chattanooga African American Museum

200 East Martin Luther King Blvd.

Chattanooga, TN 37403

Tel: (423) 266-8658

Dayton Art Institute

456 Belmont Park North

Dayton, Ohio 45402

Tel: (937) 223-5277

Fax: (937) 223-3140

Website:

www.daytonartinstitute.org/

DuSable Museum of African American History, Inc.

740 E. 56th Place

Chicago, IL 60637

Tel: (773) 947-0600

Hampton University Museum
Hampton University
Hampton, Va 23668
Tel: (757) 727-5308

Harrison Museum of African
American Culture
523 Harrison Avenue, NW,
P. O. Box 194
Roanoke, Va 24016
Tel: (540) 345-4818
Fax: (540) 345-4834

Howard University Gallery of Art
2455 Sixth Street, NW
Washington, D.C. 20059
Tel: (202) 806-7070

James E. Lewis Museum of Art
Morgan State University
Coldspring Lane & Hillen Road
Baltimore, Md 21239
Tel: (410) 319-3030
Fax: (410) 319-3835

King-Tisdell Cottage Foundation
502 East Harris St.
Savannah, GA 31401
Tel: (912) 234-8000

Museum of African American Art
13 North Marion Street
Tampa, FL 13360
Tel: (813) 272-2466
Website: www.maah-detroit.org/

Museum of Afro American History
Administrative Office
14 Beacon St., Suite 719
Boston, MA 02108
Tel: (617) 725-0022
Fax: (617) 720-5225
Website: www.afroammuseum.org/

National Afro-American Museum and
Cultural Center
P.O. Box 578
1350 Brush Row Rd.
Wilberforce, OH 45384
Tel: (800) 752-2603 or
(937) 376-4944

National Civil Rights Museum
450 Mulberry St.
Memphis, TN 38103-4214
Tel: (901) 521-9699

Negro Leagues Baseball Museum
1616 E. 18th St.
Kansas City, MO 64108-1610
Tel: (816) 221-1920
Website:
www.nlbm.com/history.html

Pullman Porters Museum
10406 South Maryland Avenue
Chicago, IL 60628
Tel: (773) 928-3935
Fax: (773) 928-8372

Studio Museum in Harlem
144 West 125th Street
New York, NY 10027
Tel: (212) 846-4500
Fax: (212) 666-5753
Website: www.studiomuseum.org

Troy State University
Rosa Parks Library and Museum
252 Montgomery St.
Montgomery, AL 36104
Tel: (334) 241-8661

Tubman African American Museum
340 Walnut St.
Macon, GA 31202
Tel: (912) 743-8544
Fax: (912) 743-9063

Vaughn Cultural Center
525 N. Grand Street
St. Louis, Mo 63103
Tel: (314) 535-9227
Fax: (314) 289-0358

DO'S & DON'TS FOR INVESTORS:

Do

- Understand that investing is a business. Take a businesslike approach.
- Understand the risks.
- Proceed with caution.
- Be clear about why you are buying.
- Evaluate the resale potential before you buy an object.
- Learn to love learning. You will have to become an expert in your field.
- Value good sources over cheap prices.
- Develop a network of knowledgeable, reputable sources.
- Buy objects that contain informational quality.
- Expect to spend money to make money.
- Buy ahead of the market.
- Specialize.
- Stay informed and pay for knowledge. Attend exhibits, films, and conferences about your specialty.
- Build a reference library of books, catalogues, and papers on your specialty.
- Study the behavior, personalities, and motivation strategies of other buyers.
- Recognize new trends.

Don't

- Invest more than you can afford to lose.
- Expect predictability.
- Confuse being a investor with collecting for personal reasons.
- Forget your objectives.
- "Flip" an object for a quick profit. Historic collectibles gain value over time.
- Check the authenticity and provenance papers.
- Buy too many mass-produced materials.
- Original items have greater investment value.
- Buy objects that cannot be researched or verified.
- Expect something for nothing. It takes money to make money.
- Collect a mish-mash of objects with no coherent theme.
- Get careless in how you store your collection.
- Rip or tear photos or pages from magazines, books, or ephemera.
- Ever refinish anything!
- Be afraid to ask questions. The only stupid question is the one you didn't ask.

A CHECKLIST FOR PLANNING A PURCHASE

1. Why do you want to acquire this particular object?

2. How will it fit in with the rest of your collection?

3. What is the demand for this type of object?

4. How rare is it?

5. How do you know that?

6. What is its historical importance?

7. How would you rate its condition? Excellent, Good, Fair, Poor? Comments:

8. What is this object's price history? When and where has it sold before? To whom?

9. How can you determine its authenticity?

10. What is the current asking price for the object?

11. What is its marketability? In other words, how easy or difficult will it be to sell?

12. How old is the object?

13. What is the object made of? What parts or components does it have? Size? Shape? Weight?

14. What observations and comments have experts made about this object?

15. What do the provenance documents tell you about the previous owners and original owner?

16. What is the replacement value?

17. How much is this object's value likely to appreciate in the next year? Two years? Five years?

18. How do you arrive at that assessment of its appreciation potential?

19. Who is likely to be a future buyer of this object?

20. How was the object used?

21. How would you rate the source (seller) in terms of trustworthiness and expertise?

22. What sentimental value does this object have?

Informational value checklist:

1. What period in African American history does this object come from?

2. Were the events, issues, and people the object refers to ahead of their time, behind their time, or a reflection of their time?

3. What types of people are described or depicted? Or, what type of person used this object and for what purpose?

4. What were the social and demographic characteristics of the people referred to in this item?
(For example: working people, shopkeepers, wealthy urbanites, or oppressed sharecroppers, preachers, dancing girls, farm laborers, merchants, etc.)

5. What ages were the people referred to in this item, or what ages were the people who used this object?

6. To which activities and events does this object refer? Why do these activities make a difference in our understanding of African American history?

7. What does this object say about people's lives and living conditions?

8. What does this object tell us about oppression, segregation, or the struggle for equality at the time?

9. What is the spiritual or religious belief system of the people referred to in this object?

10. What major issues or conflicts in African American history does this object refer to or reflect?

11. How did Blacks see the issues or conflicts referred to at the time in history when this object was made and/or in use?

12. How do Blacks see those issues now?

13. What were the different points of view within the African American community at the time that this object was made or in use?

14. How is the African American reaction different from other races' points of view?

15. Does this object refer to little known or neglected aspects of the African American experience?

16. How does this item reveal something new or not well understood about African Americans?

17. Do educational and cultural institutions have other examples of this type of object? Is this type of object frequently found in libraries and museums? If not, how is it a worthwhile new discovery to the field of African American historical research?